Backcountry Ro

IDAHO

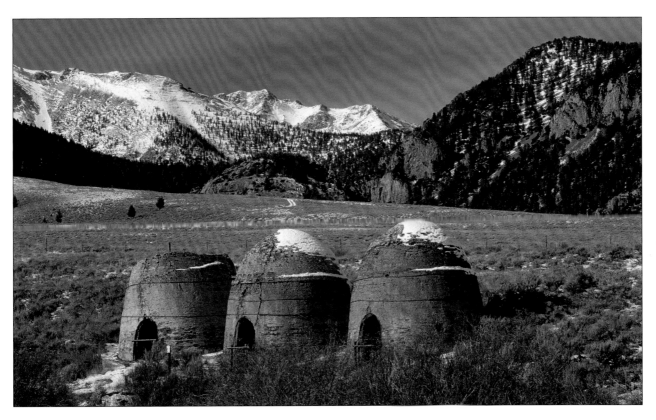

Text by **Lynna Howard** Photography by **Leland Howard**

CAXTON PRESS
2008

Library of Congress Cataloging-in-Publication Data:

Howard, Lynna.
Backcountry roads—Idaho / text by Lynna Howard ;
photography by Leland Howard.
 p. cm.
Photo-oriented book of 114 color photographs.
ISBN 978-0-87004-459-5 (pbk.)
1. Idaho—Tours. 2. Automobile travel—Idaho—Guidebooks.
I. Howard, Leland, 1953- II. Title.
F744.3.H69 2008
917.9604'34—dc22 200802647

ISBN-10: 087004-459-1 •**ISBN-13:** 978-0-87004-459-5
Text: Lynna Howard, © 2008. All rights reserved.
Photography: Leland Howard, © 2008. All rights reserved.
Editors: Krystl Hall, Leslie Ovard, and Craig Keyzer
Designer: Craig Keyzer (front cover design by Abram Siemsen)

Other books by Lynna and Leland Howard:
· *Montana and Idaho's Continental Divide Trail: The Official Guide*
· *Along Montana & Idaho's Continental Divide Trail*
· *Utah's Wilderness Areas: The Complete Guide*
Other books by Leland Howard:
· *Idaho Impressions*
· *Idaho Wild and Beautiful*

Please Note: Risk is always a factor in backcountry, high-mountain, and desert travel. Many activities described in this book can be potentially dangerous. Idaho weather can be unpredictable—snow in August is not unheard of. Washed-out roads, gumbo-like desert mud, rock slides, snow avalanches, and high winds are just a few of the hazards you may encounter. Judge your driving skills and your outdoor experience objectively, choosing expeditions that fit. The author has done her best to provide readers with accurate information about backcountry travel, as well as to point out potential hazards. It is the responsibility of users of this guide to learn the necessary skills for safe backcountry travel, and to exercise caution in potentially hazardous areas. The author and publisher disclaim any liability for injury or other damage that may be caused by traveling in the backcountry, or from performing any other activity described in this book.

Lithographed and bound for

CAXTON PRESS

312 Main Street, Caldwell, Idaho 83605

174870

Printed in Canada

Acknowledgments

Many thanks to the Chrysler Corporation for letting us test the Wrangler Jeep® Rubicon on Idaho's backcountry roads. Go online and visit *www.jeep.com/en/wranglers* for more information.

The maps for this book were created with TOPO!® software © 2007 National Geographic Maps. To learn more, go to *www.topo.com*. Most of the routes featured in this book were drawn at map level 5 (7.5' map series), and printed at map level 3 (500K). A scale guide in miles and kilometers appears on each map. For a complete set of GPS waypoints, see the "Expedition Directions" throughout this book. There are more waypoints given in the text describing each expedition than appear on the maps.

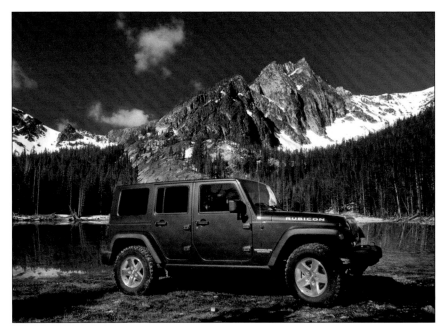

The end of the trail. A tough journey in Idaho's Lemhi Range leads to an alpine lake and snow fields that linger into July.

We are indebted to Krystl Hall, Leslie Ovard, and Craig Keyzer for their assistance in editing the text.

We would like to thank both federal and state land managers for their commitment to enlightened land management, and for their assistance in confirming facts provided in this book. See Appendix A for a list of land management agencies.

The photographs in this guidebook were taken by Leland Howard. Visit *www.wildernessbooks.com* for more information on Leland's photography.

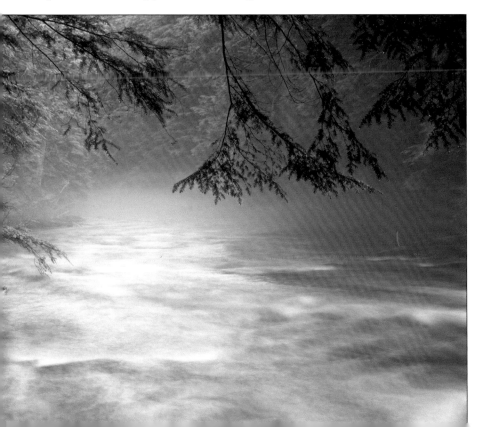

Conifers that look like fine green shawls drape over streams and rivers in the Upper Priest River Scenic Area. This photo was taken on the Upper Priest River Trail in Expedition 4.

Contents

State Map 6

Preface . 7

Idaho Superlatives 8

Backcountry Travel 14
 •GPS Coordinates 17
 •Abbreviations & Terms 26
 •Checklists 26-27

North-Panhandle 28

1: Coeur d'Alene River •Fern Falls •Lake Pend Oreille View 31

2: Moyie River •Copper Falls •Purcell Mountains 39

3: Priest Lake State Park (Lionhead Unit) •The Wigwams 45

4: Upper Priest River and Falls •Selkirk Mountains 51

North-Central Idaho 56

5: Salmon River •Florence •Gospel-Hump Wilderness 61

6: Selway River •The Crags of Selway-Bitterroot Wilderness 69

7: Lolo Motorway •Lewis & Clark National Historic Trail 74

8: Magruder Corridor Road •Frank Church and Selway-Bitterroot Wilderness Areas 81

9: Dworshak Reservoir •Elk Creek Falls Recreation Area 87

10: Hells Canyon National Recreation Area •Seven Devils 91

11: Hells Canyon National Recreation Area •Pittsburg Landing 95

West-Central Idaho 100

12: Washington Basin •White Cloud Peaks 105

13: Beaver Creek–Loon Creek Corridor •Frank Church–River of No Return Wilderness 111

14: Deadwood River •Yellow Pine •Big Creek 119

15: Wildlife Canyon Scenic Byway •South Fork Payette River 127

16: Historic Mining Towns •Trinity Lakes •Boise National Forest 131

Stunning displays of wildflowers emerge in mid-July as soon as the snow melts in upper Washington Basin (Expedition 12).

Southwest Idaho 138

17: Zeno Falls •Owyhee Canyonlands 143
18: Owyhee Uplands Back Country Byway 149
19: Bruneau Canyon Rim 153

South-Central Idaho 158

20: City of Rocks National Reserve •Albion Mountains 161

East-Central Idaho 166

21: Upper Pahsimeroi •Lost River Range 169
22: Wet Creek and Dry Creek •Lost River Range 175
23: Little Lost Valley •Lemhi Range •Spring Mountain Canyon 181
24: Charcoal Kilns •Bell Mountain Canyon •Lemhi Range 187
25: West Fork Wimpey Creek •Beaverhead Mountains 193
26: Craters of the Moon •Pioneer Mountains 199
27: Sun Valley •Trail Creek Road •Big Lost River 205

Eastern Idaho 208

28: Medicine Lodge Road •Beaverhead Mountains 211
29: Red Rock Pass Road •Centennial Mountains 217
30: Mesa Falls Scenic Byway •Cave Falls 221

Southeast Idaho 226

31: Fall Creek •Snake River •Caribou Range 229

Appendix A: Resources for Additional Information 236
Appendix B: Map Sources 239

State Map

The map shows eight geographic regions of the state that are described in *Backcountry Roads, Idaho*. These regional chapters are color-coded and named as follows:

- **North-Panhandle**
- **North-Central Idaho**
- **West-Central Idaho**
- **Southwest Idaho**
- **South-Central Idaho**
- **East-Central Idaho**
- **Eastern Idaho**
- **Southeast Idaho**

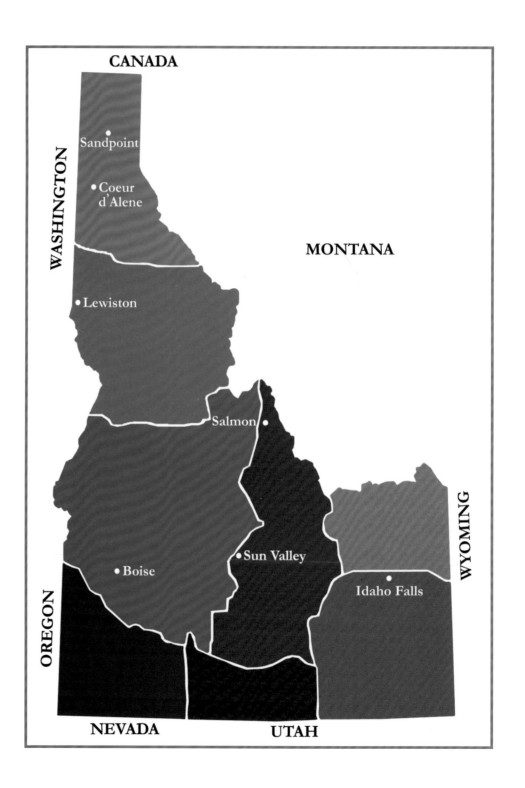

Preface

Solitude

Even when we are in a designated "Wilderness," most of us are surrounded by a cocoon of humanity in the form of signs, regulations and designated routes. We get a taste of aloneness, a hint of solitude, without the risks of real solitude.

Being truly alone is different, an experience so far removed from day-to-day life most people don't know they've lost it. Short of hauling you out into true solitude and dumping you there, I'm not sure how to explain the experience and the value of it. Discomfort may play a part, but the sweep of the land will be open to you, the way it changes from mountain to high desert to low desert to river canyon. You will pay attention because you have to find your own way. At night, if you turn a slow 360 degrees to look into the dark, there will be no light except from stars and moon. There will be no city light reflecting off distant clouds, no truck rumble from a highway, no fellow camper telling you about his new boots. Then something happens that you had forgotten was possible or that you never knew was possible. Your whole self, your idea of yourself, will uncurl like a fist relaxing. A tight fist you didn't know you were holding loosens, and you can be as big as the emptiness, as small as nothing. You can matter or not; it doesn't matter. This is a plain thing, as plain as dirt. Not that you can't come by this feeling some other way, but real solitude may thrust it upon you. That's the value of solitude. You're boundless for the time you are there.

The state of Idaho is unique in the lower 48 states. There are more opportunities for solitude, and fewer people to take advantage of those opportunities. *Backcountry Roads, Idaho* will guide you to places where you can feel solitude right down to your bones, or if

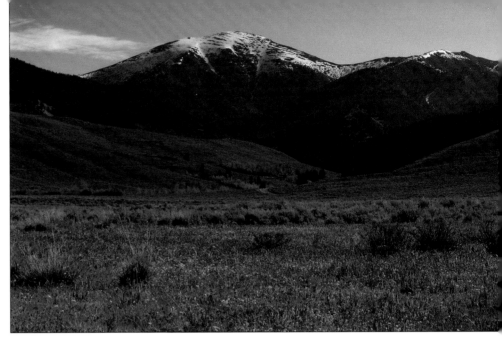

Wildflowers bloom in the Little Lost River Valley, on the west side of the Lemhi Range. Big Windy Peak (10,380 feet) wears a coat of snow into late June or early July. Sawmill Canyon Road leads up into the mountains here in Expedition 23.

you're just not ready to be that removed from civilization, choose an expedition with a comfortable cushion of towns even paved roads in some cases.

Modern modes of transportation and high-tech gear for outdoor recreation have expanded our margin of survival, but the margin is still surprisingly thin—a fact soon discovered if you make a few mistakes when you venture into the backcountry. I've done my best to provide the information needed for a safe expedition, but risk is always a factor. Travel and other activities described in this book can be dangerous. Judge your driving skills and your outdoor experience objectively, choosing expeditions that fit. Expand your skill set slowly. Travel with more experienced backcountry friends whenever possible. Read the introductory material in this book before you tackle one of the more difficult trips. Being prepared for any situation gives you the peace of mind to truly enjoy the backcountry roads of Idaho. Safe travels!

—Lynna Howard

Idaho Superlatives

In a gift shop we find mugs shaped like potatoes, potato key rings, and potato postcards. My brother asks me, "What is Idaho famous for?" I answer, "Uh, potatoes?" What's wrong with this reply is not that it's incorrect, but that it's woefully incomplete. People love to advertise the "Only, First, Last, or Biggest" attributes of their state. In Idaho one doesn't have to stretch the truth to make a list of impressive superlatives.

•Idaho has the most undeveloped land in the lower 48 states —about 10 million undeveloped acres and almost 4 million of this is designated wilderness. Idaho boasts ten major mountain ranges, with over fifty peaks that top 10,000 feet above sea level. Mountainous uplands cover 25,000 square miles of the state —5,000 more square miles than Switzerland boasts.

•Idaho is home to more whitewater river miles than any other state—over 3,000. The Middle Fork Salmon, Upper Priest, Selway and other rivers are listed in the *National Wild and Scenic River Act*. The Selway River is the longest Wild and Scenic River with no dams. The Bruneau River in southwestern Idaho is the most inaccessible river in the lower 48 states.

•Hells Canyon, cut by the Snake River, is the deepest gorge in North America—even deeper than the Grand Canyon. Hells Canyon is incised more than a mile below Oregon's west rim, and 8,000 feet below Idaho's Seven Devils mountain range. The middle and main forks of the Salmon River flow through canyons almost 7,000 feet deep in some spots, also deeper than the Grand Canyon. The Bruneau River flows through the deepest gorge for its width in North America (very narrow for its depth). Shoshone Falls on the Snake River drops 212 feet (higher than Niagara Falls). Upper Mesa Falls on Henrys Fork of the Snake River is the largest undisturbed waterfall in the entire Columbia River system.

•The National Geophysical Data Center lists 232 hot springs in Idaho, making Idaho the state with the second highest hot spring density per square mile (California tops the list, and Nevada comes in a close third).

•According to Idaho Fish & Game, Idaho is the only inland western state with ocean-run salmon and steelhead. State records are 54 lbs. for salmon and 30 lbs. 2 oz. for steelhead. Idaho also hosts wild blue-ribbon trout streams, including the Henrys Fork, Silver Creek and the St. Joe River. Idaho's mountain ranges harbor more than 1,500 lakes. Most Idaho fishing waters are located in the public domain where access is free.

•Hunters in Idaho can find trophy species of moose, bighorn sheep and mountain goat, as well as deer (mule deer and white-tail), elk and antelope. Black bear, mountain lion, grouse, turkey, and waterfowl round out a varied hunting experience. Most licenses and tags are available over the counter.

•The Red River Ranger District of the Nez Perce National Forest was the last place in the lower 48 states mapped by the USGS. Good topographical maps did not become available until 1979.

•The Hells Canyon Wilderness Area is home to one of the largest elk herds in North America. The only band of mountain caribou remaining in the United States roams proposed wilderness in northern Idaho, where the caribou share their territory with grizzly bears.

•The three richest silver mines in the United States are located in northern Idaho's Shoshone County.

•The inland temperate rainforest of northern Idaho, which also extends into Montana and Washington, is the only place on Earth where a temperate rainforest is found so far inland from an ocean.

•The Great Rift system in Idaho is 62 miles long, the longest known rift zone in America. It is a series of north-northwest-trending fractures in the Earth's crust. In 2000, President Clinton expanded Craters of the Moon National Monument to include most of the Great Rift area.

•Humans have been present in the Idaho area since about 14,500 years ago (some archaeologists say as long as 25,000 years ago). Archaeological digs at Wilson Butte Cave, and at other sites along the Snake River Plain, include some of the oldest dated artifacts in North America.

•The Snake River Birds of Prey National Conservation Area, located south of Boise, has one of the world's densest concentrations of nesting birds of prey. Nesting raptors include golden eagles, prairie falcons, red-tailed hawks, and american kestrels. Migrating raptors include bald eagles, gyrfalcons, sharp-shinned hawks and peregrine falcons.

•Idaho is prime wine country. Vineyard elevations range up to 3,000 feet—higher than any others in the Northwest. Volcanic ash in the soil, combined with warm days in the growing season and cool desert evenings, produces high-quality wine grapes.

•And don't forget the potatoes—Bingham County is the largest potato-producing county in the U.S. The potato harvest regularly yields about two billion pounds of spuds.

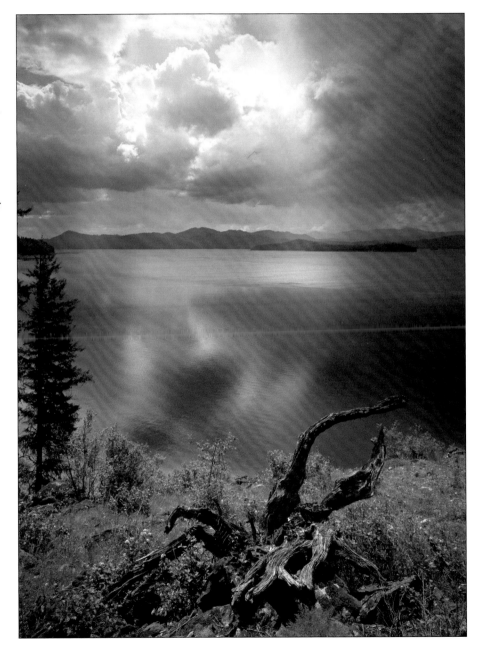

Clouds diffuse sunlight above the eastern shore of Priest Lake in Idaho's Panhandle (Expedition 3).

Wilderness and Wilderness Study Areas

Designated and proposed wilderness plays a large part in Idaho's backcountry. Many of the expeditions in this book highlight roads that skirt wilderness boundaries, or that take advantage of the unique opportunity to drive corridor or cherry-stemmed roads into wilderness areas.

Congress passed *The Wilderness Act* in 1964, defining wilderness. In part, the act reads:

A wilderness, in contrast with those areas where man and his own works dominate the landscape, is hereby recognized as an area where the Earth and its community of life are untrammeled by man, where man himself is a visitor who does not remain...
an area of undeveloped Federal land retaining its primeval character and influence,without permanent improvements or human habitation, which is protected and managed so as to preserve its natural conditions and which (1) generally appears to have been affected primarily by the forces of nature, with the imprint of man's work substantially unnoticeable; (2) has outstanding opportunities for solitude or a primitive and unconfined type of recreation; (3) has at least five thousand acres of land or is of sufficient size as to make practicable its preservation and use in an unimpaired condition; and (4) may also contain ecological, geological, or other features of scientific, educational, scenic, or historical value.

The largest contiguous area of designated wilderness in the lower 48 states, the Frank Church–River of No Return Wilderness, is in Idaho. National Forest land included in this wilderness totals 2,373,331 acres. The BLM manages additional acreage.

The Selway-Bitterroot Wilderness is separated from the Frank Church by the slender Magruder Road corridor, adding another 1.8 million acres of designated wilderness (250,000 acres of it in Montana). Also in west-central Idaho is the Sawtooth Wilderness, a large 217,088-acre chunk of the Sawtooth National Recreation Area (SNRA). White Cloud Peaks and Boulder Mountains east of the Sawtooths have been proposed to Congress for wilderness

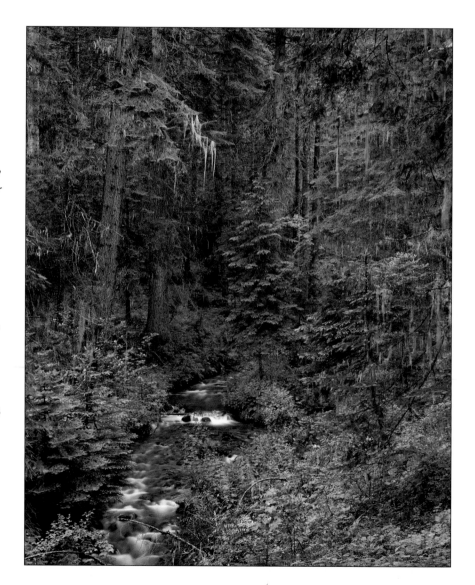

Northern Idaho's rainforest is the only place on Earth where a temperate rainforest is found so far inland from an ocean (Expedition 5).

designation, and are being managed to protect wilderness values. Further west is the Gospel-Hump Wilderness, a mere 206,000 acres that would be impressive in any other state. Hells Canyon Wilderness is a 214,000-acre section of the larger Hells Canyon National Recreation Area (76,721 acres in Idaho, the rest in Oregon). Craters of the Moon National Monument contains 43,243 acres of designated wilderness. There is also proposed wilderness in the Owyhee Canyonlands of southwestern Idaho.

Citizen groups, as well as federal land managers, have submitted various wilderness proposals to Congress, and not all of them are listed here. It is likely that we will see significant changes in land management in Idaho within the next decade. When it comes to travel near and in wilderness areas, we've chosen roads likely to remain open.

In 1964, *The Wilderness Act* left the Bureau of Land Management out of the picture. In 1976, the *Federal Lands Policy and Management Act* initiated an inventory of BLM lands. The BLM has recommended 972,239 acres in Idaho for designation as wilderness. Backcountry travelers will see Wilderness Study Area signs all over the state. As one local aptly put it, "They've been studyin' a long time." These areas are managed to protect wilderness values, and restrictions are posted.

A sliver of Yellowstone National Park extends into eastern Idaho, and the National Park Service manages other lands like Craters of the Moon, but there are no National Parks located entirely in Idaho. There are six National Wildlife Refuges, and twenty-nine state parks.

Idaho—What's in a Name?

We'd like to think that not only does the name "Idaho" make sense, but that it is a description of the land that harks back to our Native American heritage.

"Idaho" may be the only state name that is a complete fraud —at any rate, its name may mean nothing at all. Many sources derive the word Idaho from a Shoshonean Indian word meaning "gem of the mountain," but the Idaho State Historical Society claims that there never was any such Indian word and that Idaho and its translation was the phony creation of a mining lobbyist who suggested it to Congress as the name for the territory we now know as Colorado. Congress rejected the name, but it caught on among gold prospectors along the Columbia River and when it was proposed in 1863 as the name for what we know today as Idaho, Congress approved it and the Idaho Territory was born. The origin of the word may be Shoshonean, though it does not mean "gem of the mountain" or "Behold! The sun is coming down the mountain," as another

writer suggested. Idaho residents, in fact, ought to forget about the real Shoshone word that Idaho may have derived from, for that word would be "Idahi," a Kiowa curse for the Comanches that translates roughly as "eaters of feces," "performers of unnatural acts," "sources of foul odors," etc.

That excerpt, which makes me proud to be an Idahoan, was reprinted with permission from *QPB Encyclopedia of Word and Phrase Origins* by Robert Hendrickson. The "mining lobbyist" mentioned was Dr. George M. Willing, a man who presumed the right to be elected to Congress before he had a constituency. Maybe he invented the name "Idaho" and maybe he did not. He lost an already questionable election in Colorado in 1859, but went to Washington D.C. and claimed to be an elected delegate—two false claims so far. *The Congressional Globe* of 1860 mentions his proposal for the Territory of Idaho, and notes "Idaho" as an Indian name signifying "Gem of the Mountain." Willing was probably the source for the "Gem of

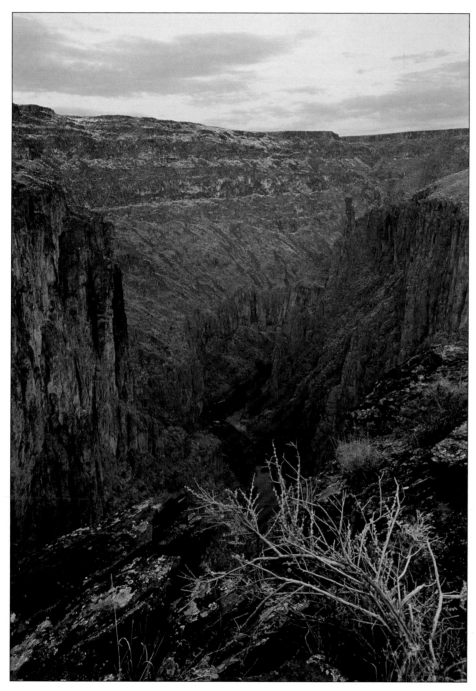

the Mountain," but may have backed down when it was discovered that there was no Indian source for the name. At any rate, he later proclaimed that he based the name on a little girl named Ida. Luzena Wallace, wife of the first territorial Governor, W.H. Wallace, claimed in an 1892 reminiscence that she suggested the territory be named after her niece named "Idaho." Maybe there was a little girl who was named "Ida" or "Idaho," and maybe not.

Embellishments to the name-source myth include variations from Joaquin Miller, the "poet of the Sierras." He wrote in the winter of 1861-1862 a piece that included "E-dah-hoe," which was offered as an Indian word meaning "the light or diadem on the line of the mountain." Mrs. Wallace's story is suspect because she put her own twist on the myth, writing in the *Tacoma Daily Ledger*, "Well, if I am to name it, the territory shall be called Idaho, for my little niece…whose name is Idaho, from an Indian chief's daughter of that name, so called for her beauty, meaning the 'Gem of the Mountains.'" Washington State residents accepted Mrs. Wallace's version, but it's possible that the elderly Mrs. Wallace mixed her own memories with other sources, all suspect. The Indian princess connection is a boilerplate element that appears in many Wild West narratives of the time. Likewise, self-promotion via embellished tales of bygone days was common. We need to go back in time and see if a little girl named Idaho ever lived in Colorado Springs—and if she did, what stories did her parents tell her about her name.

At any rate, Idaho is now known as "The Gem State." Myth has been elevated to fact. No present-day historian or linguist has been able to find a Native American word

To see Bruneau Canyon (Expedition 19), visitors must walk to the rim. The Bruneau River below is one of the most inaccessible rivers in America.

resembling "Idaho" that means anything close to "Gem of the Mountains." The Territory of Idaho was signed into being by Abraham Lincoln only after also being rejected as a name for Montana.

Despite all the folderol over names, Idaho became a state in 1890. Native Americans may not have named the state, but several tribes played a major role in Idaho history, and continue to add to the state's cultural richness. These include: Coeur d'Alene, Kootenai, Kalispel, Palouse, Nez Perce, Northern Paiute, and Shoshone-Bannock. There are four Native American reservations in Idaho: Coeur d'Alene, Fort Hall, Duck Valley, and Nez Perce. The Nez Perce National Historic Park main visitor center is eleven miles east of Lewiston on Highway 95. The town of Salmon is in the homeland of the Lemhi-Shoshone (AgaiDika) tribe, the birthplace of Lewis & Clark's guide and interpreter, Sacajawea.

Idaho has been described as being shaped like a pistol, a pork chop, a hatchet, or a pan with a long handle (hence the use of "Panhandle" for northern Idaho). The state is 479 miles long, and 305 miles at its widest, but the Panhandle narrows to about 44 miles wide. The lowest point is 710 feet above sea level near Lewiston. The highest point is Borah Peak at 12,662 feet. The flattest part of Idaho (well, relatively flat) is the Snake River Plain, a smile-shaped swath of high desert from the Idaho Falls area to Boise and beyond. Most of the rest of the

state is hills and mountains, with an emphasis on mountains. An oft-repeated evocation of the state's ruggedness is "Flatten it with a rolling pin and it would be bigger than Texas!"

> *Along the River of No Return*
> *aspen trees spend their gold.*
> *The blending of sun and leaves*
> *makes whiskey, beer and lemonade*
> *in the autumn air we breathe.*
> —Trail notes by Lynna Howard

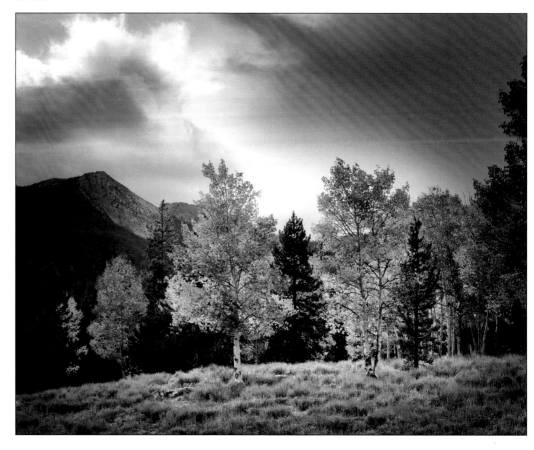

An aspen grove near Expedition 23. The root system from a single parent can clone an entire grove of aspen, and individual trees can survive 50-100 years, with new clones continuing to surface. Clones can be identified by the color of autumn leaves and can continue for 10,000 years or more. Aspen groves may be the longest-living organisms on the planet.

Backcountry Travel

How to Use This Guide

The expeditions in *Backcountry Roads, Idaho* are grouped into chapters that represent eight geographic regions of the state (see the state map on p. 6). Each region's boundary was drawn to match road and terrain features that affect featured expeditions. In a few cases, optional side trips may cross region boundaries. The chapters are color-coded for easy reference as you flip through the book:

- **North-Panhandle**
- **North-Central Idaho**
- **West-Central Idaho**
- **Southwest Idaho**
- **South-Central Idaho**
- **East-Central Idaho**
- **Eastern Idaho**
- **Southeast Idaho**

Each chapter begins with an overview of the geographic region and is followed by the various expeditions that will guide backcountry adventurers along specific routes. Each expedition begins with an introduction describing scenic features travelers will encounter along the way. This is followed by information on approach routes from various cities, recommended maps, land administration agencies, road ratings, and mileage. A small expedition map is included, plus boxed information on the best time of year to visit and important information to know ahead of time.

The expedition description continues with detailed travel directions using GPS coordinates, mileage and elevation at specific points along the route. Nearby sidetrips and excursions are also noted in many of the expeditions in this book.

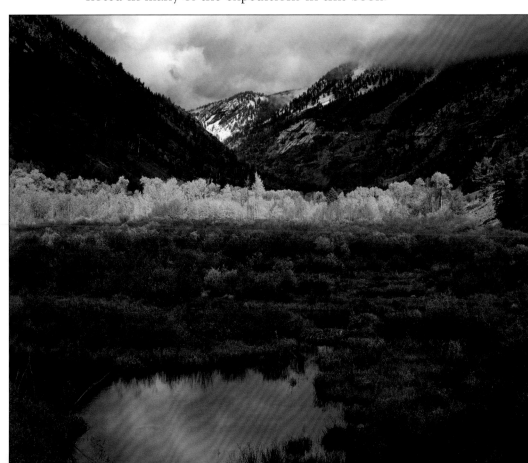

Beaver dams on Trail Creek (Expedition 27) create a riparian area that flares with color in late September.

This "Backcountry Travel" section contains very important information that is not repeated later in the book. Please refer to this section when planning an expedition into Idaho's beautiful backcountry.

Roads

This book presents the most accurate and current information available at the time of printing. Backcountry road conditions can change with weather and amount of use. Land administrators may open, close, improve, or decide not to maintain backcountry roads. It's a good idea to check with local land administrators before you go. See the "Land Administration" information for each expedition, as well as Appendix A, for additional contact details.

In most areas, vehicle use is restricted to designated roads. Forest Service and BLM signs may read "Motor Travel Vehicle Restricted Area" or "Wilderness Study Area—Limited Motor Travel Area," or signs may specify seasonal restrictions. The Forest Service has free "Travel Plan" maps that show vehicle restrictions, but they are difficult to read for other purposes. Use Travel Plan maps in conjunction with Visitor maps. Sawtooth National Forest administrators print combination Visitor and Travel Plan maps.

One example of specific road restrictions are the signs for the Beaver Creek–Loon Creek road corridor through the Frank Church –River of No Return Wilderness: "Entering Frank Church–River of No Return Wilderness Corridor. Wilderness boundary 300' off road." Yes, there are road corridors and cherry-stemmed roads in wilderness areas. Wilderness boundaries are drawn around the roads so that the wilderness remains technically roadless. That 300 feet on either side of a road is standard on public land, and not just in designated wilderness areas. Even in motor vehicle restricted areas, road corridors include 300 feet on either side of the road. You can legally picnic or park near roads; you can drive to an undeveloped campsite off backcountry roads. For reference,

the length of a football field is 360 feet. Most people don't know about or understand the implications of the 300' rule, and few land-use brochures spell it out.

In compliance with *Tread Lightly* and *Leave No Trace* guidelines, use common sense and avoid resource damage. The Tread Lightly! organization provides excellent guidelines for vehicle-based recreation on public lands. See the "General Information" section of Appendix A for contact information. Some of these guidelines include:

- Pledge to Tread Lightly by traveling only where motorized vehicles are permitted.
- Respect the rights of hikers, bikers, equestrians, campers, skiers and others.
- Educate yourself by obtaining travel information and regulations from public agencies.
- Avoid streams, lakeshores, meadows, steep hillsides, wildlife and livestock.
- Drive responsibly to protect the environment.

Some backcountry roads cross private land on their way to public land. These are the most restrictive road corridors. Do not depart from the road without the land owner's permission. It can be difficult to tell private from public land in Idaho's backcountry. Private property may be marked only with red or orange paint on fence posts, gates or trees—and the paint may be faded almost to invisibility. Respect private property, and learn to spot the more subtle markers.

Cattle control gates on both private and public land should be kept closed. Some gates are tight, and it may require two people to open and close them. If you are traveling alone, bring a crowbar to lever the gates closed. Open range cattle have the right of way on Idaho roads.

Trail/Road Markers and Restrictions

•Motorcycles may drive on game or livestock trails only if the trails have had established and repeated use by motorcycles in the past. Motorcycles may travel on single-track established roads and trails.

•ATVs may drive within established two-track roads or on trails that are wider than the vehicle. Vehicles may travel on existing routes where plants grow in obvious wheel depressions. ATVs should not drive on undisturbed ground, nor on single-track trails.

•Jeeps, pickups, SUVs and other 4WD vehicles should not drive on two-track trails smaller than the width of the vehicle. Do not drive vehicles on livestock or game trails. Vehicle travel to a temporary campsite is allowed within 300 feet of a designated road or trail.

•Roads that are well-maintained for passenger car travel are marked with signs like this. These roads are usually graded gravel for two lanes of travel, or a wide single-lane with turnouts. They may be closed in winter.

•Roads maintained for passenger car travel (this is often an optimistic rating by land managers) are marked with signs like this. 4WD is recommended in this book for many of these roads. They are frequently one or one-and-a-half lanes wide, with fewer turnouts. Stream fords may not be bridged, and sections of the road may be steep, muddy, and/or rocky. These roads may be 2WD only in good weather.

•Roads not maintained for passenger cars are marked like this, and usually appear on maps as a 4WD road or "Jeep Trail." In Idaho many 4WD roads and tracks are not signed at all and may not appear on maps.

Damian Within and Brian Veseth took a $1 bet to make snow angels on the road corridor into Gospel-Hump Wilderness (Expedition 5).

•Mountain bikes are allowed on all road categories previously listed, and may be allowed on additional trails marked for foot/horse/bicycle travel. Mixing mountain bike and motorized traffic can prove dangerous. Bikers must always ride defensively, assuming they may not be seen or expected by drivers.

•Oversnow vehicles (snowmobiles) are allowed on most designated roads on a seasonal basis. Travel management signs may specify both a season and a minimum of twelve inches of snow. Most of these same roads, as well as many trails, are open to crosscountry skiing with four inches of snow.

•Trails that are open to only foot and horse traffic are often marked with hiker and horseback symbols. Where the trails are not signed, assume that use is restricted to foot and horse traffic unless there are obvious signs of established and repeated vehicular use.

•Activities and vehicles that are prohibited appear on signs with a red slash through them. A yellow slash indicates that the activity is not recommended.

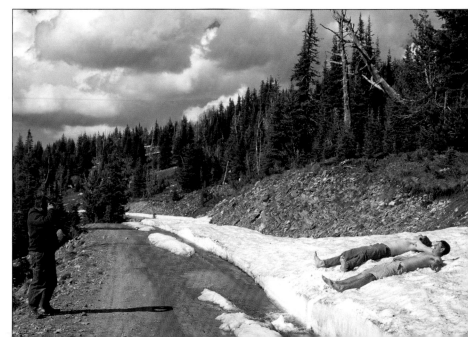

Road Ratings

In this book we take difficulty ratings for roads very seriously, giving drivers the approximate route miles that are 2WD; 4WD Recommended; 4WD Required; and 4WD Experience Required. Weather is a big factor. The ratings are based on dry road conditions. No routes that routinely require winching or non-stock vehicles are included.

•**2WD:** These roads are paved, graded gravel, or graded dirt. Grades are gentle and the road is wide enough for vehicles to pass with care along most of its length. Water crossings are shallow or bridged. Road surfaces are generally stable.

•**4WD Recommended:** Four-wheel-drive is recommended for roads where higher clearance is preferred, but where a careful and experienced driver can work a 2WD vehicle around ruts, rocks, water crossings and short steep sections. Light-duty 2WD trucks with higher clearance than passenger cars may be sufficient. Road surfaces may include short sections of unstable road surface.

•**4WD Required:** Four-wheel-drive is required for roads where clearance of 6-inch to 8-inch rocks is needed; where ruts or stream crossings are common; and where the careful placement of tires is required to negotiate infrequent higher obstacles. There may be longer sections of steeper grades, and a narrower driving lane. Road surfaces may be unstable.

•**4WD Experience Required:** Four-wheel-drive experience is required where the route demands high clearance (8-10 inches) and careful placement of tires for even higher obstacles; a short wheel base is a plus for tight switchbacks, sharp gullies, or narrow squeezes between rocks and trees; stream crossings may be eighteen inches deep; steep sections challenge vehicle traction; shelf sections may be long and narrow, with steep drop-offs on one or both sides, requiring nerves of steel; and reversing skills should be

Western larch trees fool the eye in summer, but are revealed in the fall to be deciduous. They drop their needles after a display of bright yellow. Grouse eat the buds and leaves, and a natural sugar in the gum tastes like bitter honey.

finely honed in case a driver has to back up to let another vehicle pass. Road surfaces may be extensively unstable or deeply rutted.

Route descriptions in each expedition provide more details. If you are in doubt regarding the skill level required, be sure to read the entire route description when planning your expedition.

Mileage

Odometer readings vary for every vehicle. Your mileage may differ from that shown in the route descriptions. GPS coordinates and maps should be used in conjunction with odometer readings to verify your location.

GPS Coordinates

An on-board or handheld GPS system is not required to use this guidebook, but is extremely helpful. Careful attention to odometer readings, route instructions, and maps will get you there. Maps in this book show some, but not all, of the GPS coordinates provided in the text.

Latitude/Longitude coordinates were recorded on the ground. Waypoints have been checked against computer mapping software

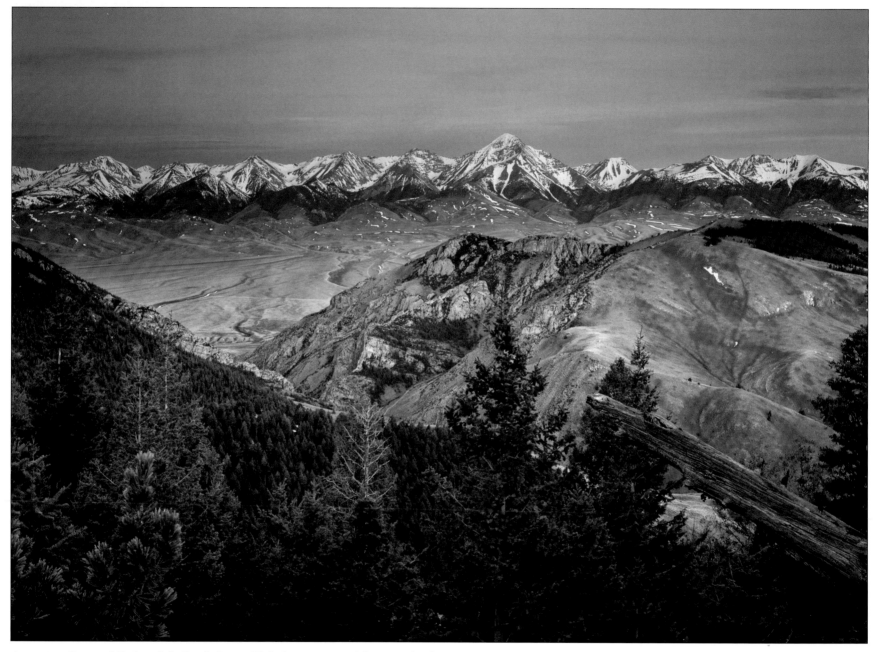

At sunrise, Diamond Peak and the Lemhi Range fill the horizon west of the Beaverhead Mountains near Expedition 25. This view is from the head of Skull Canyon, overlooking Birch Creek Valley.

where possible, but some roads and landmarks that exist as ground truth do not appear on maps. In this book, latitude and longitude coordinates are given in the Degrees and Decimal Minutes format, using NAD83/WGS84 Datum. Names for this format may vary, but it looks like this: 42° 33.157' N, 115° 53.876' W.

The degrees and minutes shown above will be familiar to users of another format, Degrees Minutes Seconds—but the last three digits can cause confusion. Seconds in the Degrees and Decimal Minutes format are represented as decimal fractions of minutes. The fractions may extend for ten or more places in mapping software, but for our purposes decimal fractions to the third place are more than accurate enough. If you wish to convert Degrees and Decimal Minutes to Degrees Minutes Seconds, multiply the decimal part by 60. For example, multiply the .157 portion of N 42° 33.157 by 60 to get 9.42. The coordinate will now look like this: 42° 33'09.42" N. Most handhelds display a shortened version, so the conversion looks like this: 42° 33'09" N.

Another popular coordinate system is UTM (Universal Transverse Mercator). This military grid system is used extensively in Canada. UTM grid lines are printed on all Canadian and military maps, and increasingly on specialty maps for backcountry travelers in the United States.

Remember to do the math for both latitude and longitude if you are converting coordinates. You can use GPS handhelds or computer mapping software to automate conversions. To use this guidebook, we recommend that you select the Degrees and Decimal Minutes format in your GPS device so that no conversion is required. For more information and GPS basics, go online to: *www.gpswaypoints.co.za/FAQ_basic.htm*.

Maps

We recommend that you supplement the maps in this book with additional overview maps, and with detailed maps from other sources. Maps can be viewed at different scales with computer software and printed out for on-the-road use. For this book, we used *National Geographic* TOPO!® software. Paper maps like those issued by the Forest Service, the Bureau of Land Management (BLM), or in atlas form, will also give you good overviews. Forest Service maps are the most accurate in terms of road numbers, trailheads, and campgrounds. For routes that may be particularly difficult to navigate, this book also lists the relevant 1:24,000 USGS topographical maps. See Appendix B for map sources.

Where are these landmarks: Sheep Mountain, Deer Creek, Elk Creek, Chamberlain Basin, Antelope Ridge, Dry Gulch, Dry Fork, Lost Horse (canyon, camp, creek), Rock Creek, Bear Creek, Last Chance? Those are just a few examples of landmark names that appear in multiples all over the western United States. It's easy to mistake one landmark for another when you're planning an expedition, so be sure to check your map(s) and note other details that will keep you on track.

My brother and I were exploring a trail about two miles from a well-known lodge when we came across two tourists in a panic. Despite trail signs giving the direction and distance to all destinations except Heaven and Hell, the tourists were lost and only our arrival kept them from hiking further away from the lodge. If you're not used to backcountry travel, especially in thickly forested areas where sightlines are limited, take a map, your GPS, and a backup compass with you when you leave your vehicle. Plan your route, even if it is just a one-day drive or hike. We have seen travelers get lost in spite of, and sometimes because of, carrying a handheld GPS. People misread the GPS, or are misled by the scale they are viewing on the small screen. Mark your vehicle as a waypoint before you leave it.

Backcountry Travel Tips

No list of travel tips can substitute for experience. If you do not have a lot of backcountry experience, take it easy, and build your skills as you go. Ignore the ads you see on TV—slow and steady is usually the first choice. When in doubt, turn back.

•**Know your vehicle:** Know what your vehicle can and cannot do. You should know if you have full-time 4WD, part-time 4WD, a manual system to switch to 4WD, or an automatic switching system. Does your vehicle have a low-range transfer case option? Low-range is needed for negotiating many of the backcountry roads in Idaho—both uphill and downhill sections. Know your differential(s): locking center differential, lockers on front and rear, manual or automatic lockers, limited-slip differential, locking differential with a viscous coupling, etc. All have their advantages and disadvantages, and the driver must know how and when to use what the vehicle provides. It is dangerous to drive with a locking differential engaged on pavement. It can be equally dangerous to drive in slippery backcountry conditions without choosing the appropriate settings in your 4WD system.

•**Brakes:** Use the correct gear settings for both uphill and down-hill. Lower gears can help slow your vehicle going downhill—don't rely on brakes alone. On loose surfaces try first to slow down with gears alone, without touching the brakes, or just lightly touching the brakes. Chock the wheels with large rocks if you park on steep terrain—don't depend on a parking brake alone.

•**Tires:** Passenger-car tires come standard with many 4WD vehicles. These tires are not suitable for backcountry travel in Idaho. Buy multiple-ply tires rugged enough to prevent most sidewall damage, and with an aggressive all-terrain tread. Mud-specific tires are seldom needed in Idaho.

•**Clearance:** Removing side steps increases the door clearance. Larger tires will increase a vehicle's overall clearance. Choose a 4WD vehicle with 16-inch wheels, if possible. Note that larger-than-standard tires affect odometer readings, gear ratios, brakes, vehicle handling, and more. Consult a specialist if you want to install larger-diameter tires. No matter how much clearance the vehicle has, a skid plate(s) is recommended for extended backcountry travel. Skid plates come in several types and sizes. Consult a specialist if you are unsure about adding them. On some vehicles that are designed for backcountry travel, skid plates are standard.

•**Water, Mud, and Snow:** Muddy water can hide the condition and depth of stream or river crossings. If in doubt, try wading the cross-ing first, using trekking poles for stability. Avoid water that is over a foot deep unless you have extensive experience with both water crossings and your vehicle's capabilities. Swiftly-flowing water exerts far greater force against a vehicle than most people realize. Every year hapless drivers float downstream with their vehicles. If you cross too slowly in water over a foot deep you may bog down, but if you cross at a high speed you may push water into your engine compartment and stall, or water may even be sucked into the air intake. Mud holes or spongy, water-logged ground should also be tested on foot before driving across. The key to crossing mud is to keep your vehicle moving

Intense reds of mountain maple stand out against the white trunk of an aspen tree.

forward without spinning out or sliding out of control. If a sidehill (off-camber) section of road is muddy, do not attempt it—the vehicle will slide down the incline and off the road. Some types of mud are like grease, and are more difficult to drive across than ice. For snow, carry chains and don't drive on roads with more than eight inches of snow. Most of Idaho's backcountry roads are closed in winter to all but oversnow vehicles (snowmobiles).

•**Scout difficult sections:** Choose the best line to drive through difficult road sections by scouting on foot. Stop and review the situation, picking a route that will allow you to ease tires over high obstacles rather than straddling them; ease both up and down obstacles, with judicious use of brakes to keep from bouncing the vehicle; use a spotter for tight spots; check for obstacles on very steep sections before driving; do not attempt to turn around on steep climbs—you can back down gingerly and try again. When traversing sharp dips or gullies you may need to adjust your angle of attack to get the best clearance. This is an easier task with a short-wheel-base vehicle.

•**Common mistakes:** The most common mistakes drivers make in the backcountry are cutting blind corners on narrow roads and driving too fast around blind corners—or both. Slow down, move toward your side of the road as much as possible, and ease around blind corners. It can be easy to become complacent on Idaho's backcountry roads because there's so little traffic. Another common mistake is to assume that conditions at higher elevations will be the same as conditions at lower elevations—or that the weather will not change as the day progresses. Two-thousand feet of elevation change can be the difference between spring and winter. If you are planning your expedition with weather and snowfall or snowmelt in mind, read the details in the region overviews and in the expedition descriptions to determine when roads will be open, and what survival gear you should carry.

A miner's cabin on the crest of the Lemhi Range (Expedition 23). At 10,007 feet, it is the highest road elevation in this book.

•**Rescue:** Leave an itinerary with friends. There are huge swaths of Idaho where there is no cellphone coverage. Don't depend on your phone to summon help. Travel with more than one vehicle whenever possible. If I could give only one bit of advice, it would be this: Turn around and go back if the going gets too rough for your skill level.

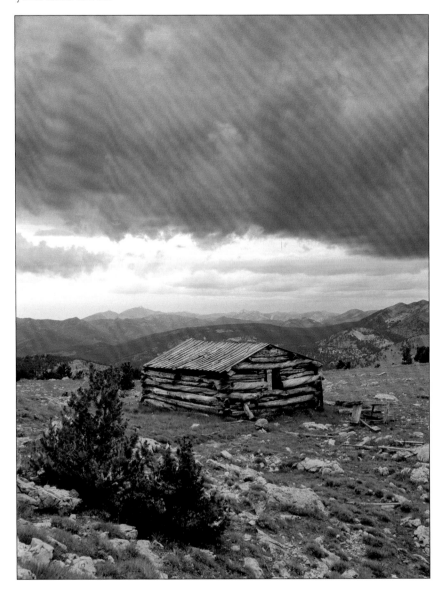

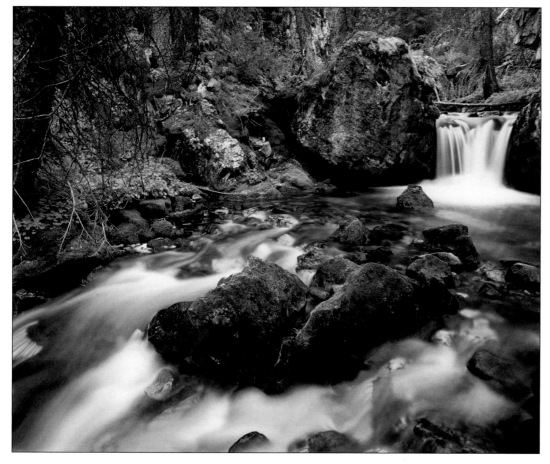

A lovely waterfall along the West Fork of the Pahsimeroi River (Expedition 21). Trails lead up the West Fork to Merriam and Pass Lakes below Leatherman Peak.

•**Survival:** It is important to always carry essential vehicle and survival gear—see the "Checklists" on pp. 26-27 for vehicles and camping. You should always be prepared to spend the night in the backcountry, even on daytrips. Secure your camping gear and everything in or on your vehicle with straps rated for the weight they will be holding. Bungee cords are not good enough, choose ratcheting straps. If your vehicle breaks down, stay with it unless you are absolutely certain of an easy route to help that you can walk in a few hours. Raise the hood and trunk to signal that help is needed. If you leave the vehicle, be sure to write a note saying where you're headed and your time and date of departure. Never leave your vehicle without a daypack containing the basic essentials of survival gear. In higher temperatures you should limit your hiking to early morning and evening.

▌ *Respect our Public Lands*

To truly enjoy and explore most of Idaho's backcountry, you need backcountry camping skills. Friends from more heavily-populated states ask, "How do you know where to camp?" While there are many designated campgrounds, there are more areas in Idaho with no designated campgrounds than in any other state except Alaska. So how do you know where to camp? My nephew knew the answer by the time he was ten years old, "Any place you can get to that's flat." Backcountry roads usually have a 300-foot corridor on both sides that accommodates unofficial camping in any flat spot. As noted previously in the "Roads" section, avoid damaging resources, and choose spots that have already been used for camping. Unsigned spur roads often lead to camping spots. There are no amenities in such campsites, so you have to bring your own. See the checklist of items we usually carry with us for primitive camping (p. 27). One of the great advantages of being able to camp almost anywhere is solitude. In some areas visitors are required to camp in designated campgrounds, but they are few and far between. Quiet and solitude is so prized by backcountry adventurers that you should avoid camping next to others if possible.

•**Campfires:** Campfires are prohibited in some areas, so check the rules for the area you will be visiting. If you must have a fire, never create a new fire ring or build a fire in or near an archaeological site. I'm soured on the "scatter your ashes" rule. This advice has been given out for years and, as a result, many camping spots are black all over. In such campsites you cannot walk or set up a tent without acquiring a layer of greasy carbon. The idea behind scattering ashes is that the fire will definitely be out and ashes will blow away or be absorbed into the terrain. Unfortunately, it doesn't work that way in real life. To help minimize this problem, empty the old ashes from an established ring with a shovel and bury them in a nearby hole or put them in a waste bag to carry out. Build a small fire, not a big one, and put it out thoroughly with water and dirt before you leave.

•**Human waste:** With the exception of human waste, leave nothing in the woods that wasn't there before. Pack out all personal hygiene items, and uneaten food. Dispose of solid human waste via the "cat hole" method. Dig a hole 6 to 8 inches deep and fill it in after use.

•**Archaeological sites:** State and federal laws prohibit any destruction or vandalism of archaeological sites. This includes historical buildings, old mines, and ghost towns. Abandoned mines can be hazardous, with aging explosives, cave-ins, cyanide, and other chemicals among just a few of their life-threatening features. Stay out of mines.

•**Water:** *Giardia lamblia*, a microscopic parasite, is transmitted via the fecal matter of animals. It survives even in cold water at high altitudes and causes severe intestinal discomfort in humans. There are several methods of water treatment: boiling for three to five minutes, treating with iodine tablets, sterilizing with an ultraviolet light "pen," or using a filter. When traveling by vehicle, you may be able to carry all the drinking water you will need, but it's good to have a backup treatment method.

•**Poisonous Plants:** Poison ivy grows in the moist pockets of canyons and near springs that issue from rocky cliffs, particularly in the Owyhee Canyonlands of southwestern Idaho. It is more virulent in the spring and these plants can wreak so much havoc that medical intervention is necessary. Read a good plant identification book before going into the backcountry and memorize this dastardly plant. Though not poisonous, cactus can cause a problem if your footgear is not tough enough for desert travel. Leather boots that cover your ankles are recommended.

•**Poisonous beasties:** Rattlesnake, scorpion, and spider bites account for fewer injuries than one might think. Never try to suck the venom from a wound with your mouth, as getting venom on your tongue will hasten its effect. If you are bitten, seek medical assistance. As preventative measures, inspect and shake out your clothes and boots before you dress, keep your tent zipped, or your camper closed, and don't put your hands and feet where your eyes can't see.

•**Hypothermia:** Rain that is accompanied by wind can cause hypothermia, the lowering of the body's core temperature to dangerous levels. Symptoms include loss of coordination, shivering, and exhaustion. Prevention is always the best medicine, but if hypothermia sets in, immediately warm and protect the victim from the elements. Shelter the victim in a tent or vehicle and give him or her many layers of dry clothing, as well as hot liquids —but no alcohol.

•**Acute mountain sickness:** This high-altitude malady can strike anyone at anytime, but visitors from lower elevations are more susceptible. Prevention, in the form of a few days of rest on arrival at altitude, is recommended. Symptoms of acute mountain sickness include headache, nausea, dizziness, shortness of breath, loss of appetite, and insomnia. The best treatment is to descend to a lower elevation, drink plenty of water, and rest. Roads and trails in Idaho's mountains seldom climb above 10,000 feet, so it is

unlikely that you'll experience acute mountain sickness; nor a much more serious condition, pulmonary edema, the buildup of fluid in the lungs.

•**Wildfires:** In Idaho's designated wilderness areas, wildfires are usually allowed to burn. Wilderness or not, many wildfires burn large swaths of backcountry terrain before nature or man gets them under control. A fire's speed and intensity will vary greatly depending on conditions. Assume that all wildfires are a threat and move to an area clear of fuel, or already burned over. If necessary, lie face down in a burned area or in a depression until the fire passes over. Check fire forecasts before you travel by contacting the appropriate land administrators (listed in each expedition); or check the website *geomac.usgs.gov*.

•**Pack Animals:** Where pack animals are allowed, weed-free feed is usually required. Horsepackers can get more information on responsible practices by requesting the *Backcountry Horse Use* booklet from the Leave No Trace Office listed in Appendix A.

•**Avoiding Bears:** Most of Idaho's backcountry areas support at least a small population of black bears, and a few also have grizzly bears. When camping, secure food in a vehicle or hard-sided camper. If you are backpacking, hang your food at least 10 feet up and 4 feet out from a tree trunk or rock. We use waterproof food bags and hang our food to keep rodents out as well. Use only fragrance-free soap (no perfumed deodorant, lotion, shampoo, or laundry soap).

If you run from a bear, you are acting like prey. Bears can sprint up to 35 miles per hour, twice as fast as an adrenaline-pumped human. Don't run!

You may opt to carry oleoresin capsicum spray to deter bears. Sprays designed to deter humans are not good enough. Bear spray will only work if it is sprayed in the animal's eyes, nose, or mouth.

If you come upon a bear on the trail, slowly back away, talking softly. The bear might stand on its hind legs to get a better view or smell of you. Standing is not an aggressive display. Bears show agitation and aggression by swaying their heads, huffing, clacking their teeth, lowering their heads, and laying back their ears. If a bear charges you, remain standing at first. The charge could be a bluff charge. Don't run. If the bear doesn't stop, use your pepper spray. If the bear does not retreat, assume a cannonball position on the ground, or lie on your stomach, with your arms and hands covering your head and neck. Leave your pack on to help protect your back.

Recent research on bear attacks suggests that black bears can be fought off if you seize and maintain the high ground. Unlike grizzly bears, black bears apparently don't become more aggressive if you defend yourself. There is some disagreement on the best technique—should you play dead or fight back? It depends on the bear, so there is no one-size-fits-all recommendation. If you are close enough to photograph a bear, you are too close.

•**Avoiding other animals:** Many bear avoidance techniques will work for other large animals. Be particularly wary of females with young. Put up a fight if a mountain lion, elk, or moose attacks you. Experts suggest standing tall, waving your arms, making noise, and slowly backing up. Throwing rocks at or using a trekking pole against attackers might also prove effective. Children and small adults are more vulnerable to attack than are larger adults. Retreat to a vehicle if possible.

A winding dirt road in Expedition 26 leads to the Pioneer Mountains.

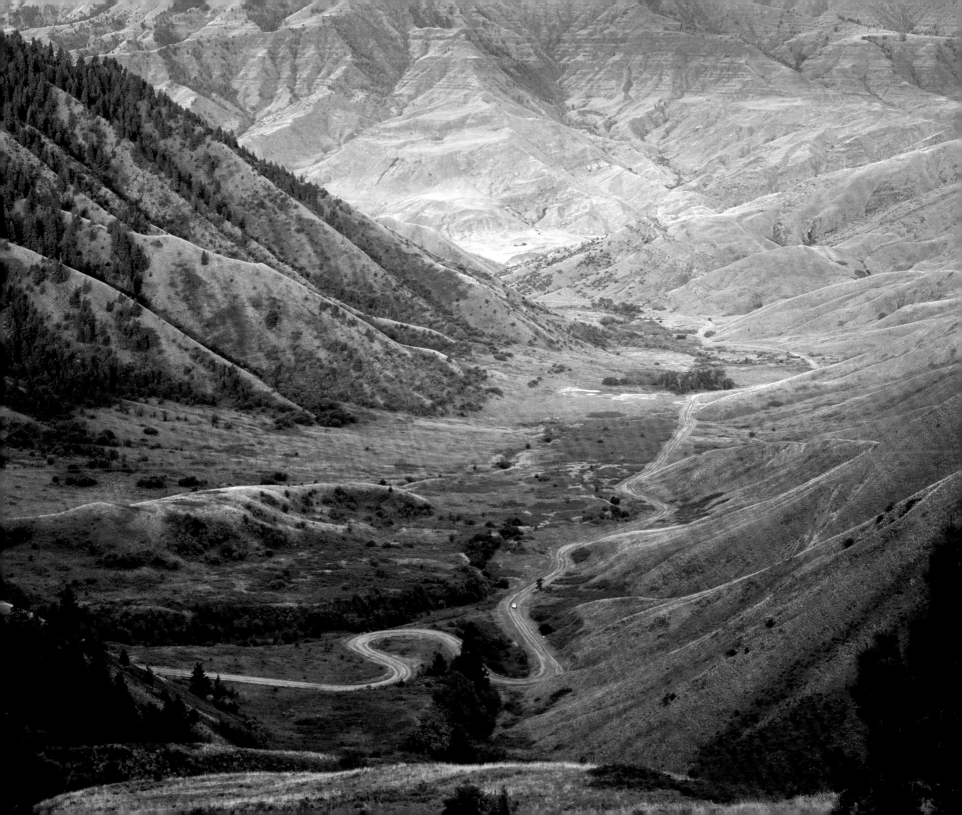

Abbreviations and Terms

These abbreviations and terms are used throughout this book:

2WD = Two-wheel-drive

4WD = Four-wheel-drive

ATV = All-Terrain Vehicle (see "ORV"); "4-wheelers" and "dirt bikes"

BLM = Bureau of Land Management

Cherry-stemmed road = a road corridor that looks on the map like a cherry stem of non-wilderness within a designated wilderness.

FR = Forest Road

The Frank Church = The Frank Church–River of No Return Wilderness

FS = Forest Service

Informal campsite = an unnamed, unofficial campsite established through use, but not maintained by land managers, and not noted on maps. Land managers sometimes use "primitive" or "undeveloped" to describe campgrounds they maintain, but at which they don't have facilities such as pit toilets, water, etc.

NCA = National Conservation Area

NF = National Forest

NM = National Monument

NPS = National Park Service

NRA = National Recreation Area

NWR = National Wildlife Refuge

ORV = Off-Road Vehicle (see "ATV")

Playa = a lake bed that is dry most of the time

Topo = Topographical map; USGS 7.5-minute maps, 1:24,000 scale

Two-track = Route where two tracks cut by motorized vehicles are visible, but the road is not graded and has grass or small shrubs growing in its center.

USDA = United States Department of Agriculture

USGS = United States Geological Survey

WSA = Wilderness Study Area

Vehicle Checklist

There is inherent danger in using specialized equipment such as high-lift jacks, pull straps, and saws. If you don't already know how to use the equipment safely, practice at home, preferably with help from an experienced friend or instructor.

•**Pre-flight your vehicle:** Experienced backcountry drivers have a vehicle checklist that would be a couple of pages long if they ever bothered to write it down. If you are inexperienced, or only moderately experienced, have an expert check your vehicle. Ask for a mechanic with backcountry driving experience, and let them know what expedition(s) you are planning.

•**Spare Equipment:** full-sized spare tire; an adequate selection of tools you may need for repairs.

•**Vehicle Equipment:** high-lift jack; tow strap and a heavy-duty nylon pull strap; jumper cables; chains if needed for mud or snow; spare key(s) to carry on your person in a secure pocket.

•**Other Equipment:** shovel; flashlight or headlamp; first aid kit; knife or multi-tool; saw or small chainsaw (to remove trees that may have fallen across the road).

•**Kitchen Sink (items not required, but nice to have):** portable air compressor and tire gauge; flares; fire extinguisher; winch and associated straps etc. (an electric, vehicle-mounted winch is best; a hand-operated come-along is better than nothing); bucket; extra tie-down straps.

Camping/Hiking Checklist

- Matches, lighter, and other fire-starting aids
- Maps, handheld GPS, and compass
- Rain gear (parka and insulating layers for protection against wind and colder temperatures)
- Gloves (deerskin for road work, gathering firewood or vehicle maintenance; insulated gloves for cold weather)
- Hat and sunglasses
- Day pack (and/or backpack if needed)
- Sunscreen for skin and lips, and mosquito repellant
- Water (5-gallon jugs for longer trips; water bottles for daypacks)
- Food (bring emergency rations even on day trips); insulated cooler
- Toilet paper; baby wipes (use a shovel to bury human waste)
- Camp stove for longer trips; eating and cooking utensils; garbage bags
- Cellphone (you may have to walk or drive to an area with reception)

- Sleeping bag; blanket or space blanket
- Sleeping pad for overnight or longer trips
- Shelter (camper or tent for overnight or longer trips)
- Headlamp
- Knife
- Hiking boots; foot care products, including blister prevention; spare socks
- Water filter or other water treatment device for longer trips, and for extended hiking
- Kitchen sink (items not essential for survival, but good to have): pillow; folding chair; folding table; collapsible bucket; wash pan; towel; toiletries; trekking poles; camera; guidebook; journal; binoculars; water-proofing for boots; watch; anti-bear spray; rope; changes of clothing; lantern
- Recreational gear: to your checklists, add gear for fishing, hunting, rock climbing, photography, water-sports, skiing, snowmobiling, or other gear that suits your needs

Help!

- **Isn't there any place I can go without having to carry all of this stuff?**

Yes. If you're not ready for full-fledged backcountry travel, choose expeditions in this book that stay on 2WD roads throughout, and that never stray far from towns or cities. The "Approach Routes," "Know Before You Go," and "Road Ratings" for each expedition will tell you how far the route takes you from civilization, and what road conditions to expect. Some routes are even paved all the way, like the Wildlife Canyon Scenic Byway (West-Central Idaho chapter) and Mesa Falls Scenic Byway (Eastern Idaho chapter).

This alpine meadow in Expedition 25 is on the Idaho/Montana border.

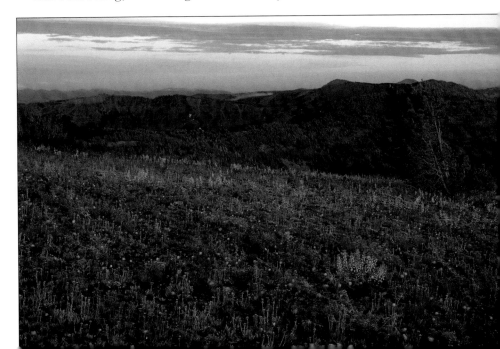

North-Panhandle

Coeur d'Alene, Pend Oreille, Priest and Upper Priest—the largest and deepest natural lakes in Idaho are nestled in the thin "Panhandle" of the state. From the Canadian border south to Interstate-90 this portion of the state is one recreational opportunity after another.

Unlike southern Idaho, northern Idaho is very thickly forested. Lower elevations and a lot more rainfall, along with lots of winter snow, make for a kinder climate when it comes to trees. Idaho's inland temperate rainforest is in its prime here. Conifers that look like fine shawls of green drape over streams

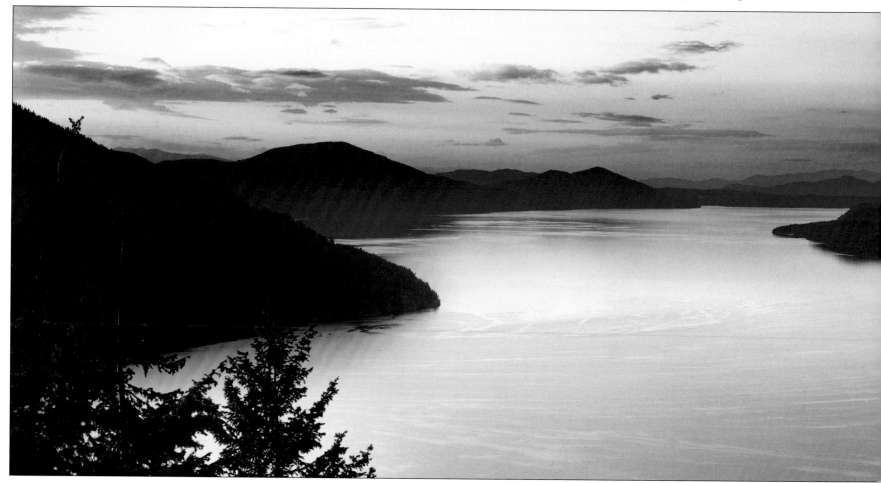

and rivers. The most impenetrable darkness I have ever experienced was under a canopy of western redcedar near Priest Lake. You may think you have experienced darkness in the wilderness, but until you have fumbled around on a cloudy night in northern Idaho you just don't know...a white shirt, the pale of your palm, nothing can be seen even an inch in front of your face.

The climate is people-friendly as well. The population density is in stark contrast to Owyhee County in southwestern Idaho, and to the drier mountain ranges that are described in the East-Central section of this book. In the northern part of Idaho there are fewer informal campsites and unsigned roads. This doesn't necessarily make it easier to find your way around. The roads remind me of a tangled ball of string, further complicated by ATV trails and logging cuts. There are fewer clear views to get your bearings. This is one part of the state where you cannot just "wing it" when it comes to camping. Plan ahead and select your destinations for camping and sightseeing.

Lake Pend Oreille as seen from a ridgetop overlook on the southern end of the lake.

Needless to say, fishing and hunting are major activities in the Kaniksu, Couer d'Alene, and Kootenai National Forests. It also can be difficult to tell when you cross from Idaho into Montana, or into Washington. Always carry a good map, and be sure to check with local land administrators for land use regulations.

Major mountain ranges here include the Coeur d'Alene Mountains (SE), Selkirk Mountains (NW), and the Purcell Mountains (NE). The Bitterroot Range forms the Idaho/Montana border east of Coeur d'Alene. On the Washington state side, Salmo-Priest Wilderness touches Idaho's northeastern border. The Kootenai River, Priest River, Pack River, Clark Fork, and Coeur d'Alene River are fed by hundreds of tributaries.

The largest concentration of city life is where Post Falls, Coeur d'Alene, and Spokane forest the I-90 corridor with buildings. Sandpoint, centered on Lake Pend Oreille, is a city, but it still has a small-town feel. As you travel further north, paved highways are dotted with civilization, but each community seems to get smaller than the last until you arrive at Bonners Ferry, the final city-sized outpost before the Canadian border. This section of the state includes Boundary, Bonner, Kootenai, Benewah, and Shoshone counties.

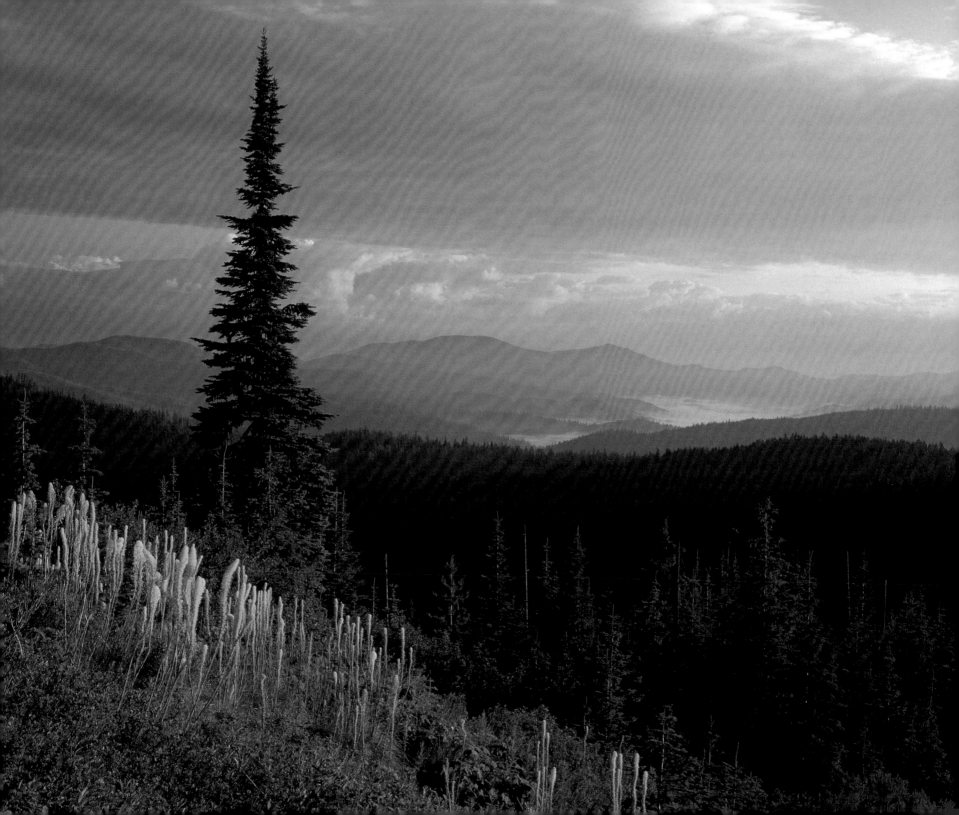

Coeur d'Alene River • Fern Falls
Lake Pend Oreille View

Other Nearby Excursions: Trail of the Coeur d'Alenes

When We Were There

Late August in the Panhandle: river floaters are lazing down the Coeur d'Alene River on inflatables of various types, some quite ingenious and attached to each other to make a floating party. Sunshine glints off the water. The river banks are not intimidating cliffs, but a blurred border of sand and river rock that gives way to grass, trees, and shrubs heavy with berries. This is one of those scenes that makes Idaho's backcountry look almost benevolent, as if kindly inclined to cradle humans in it's beauty.

By late afternoon storm clouds bruise the horizon. Pelting rain drives the parties out of the river, and they will have to sleep late into the morning the next day if they want to hang onto the illusion of endless summer—frost gilds the grass at dawn.

You have to be ready for wet weather in the Panhandle. This narrow strip of the state hosts an inland temperate rainforest and is also chock full of water in the form of lakes and rivers—more than half of all the surface waters in Idaho are here. This expedition explores the Coeur d'Alene River and its tributaries, then tops the trip off with a wonderful view over Lake Pend Oreille.

Fishing is big business here—regulations are posted along most of the rivers and streams. On the Coeur d'Alene River, the trout season is from Memorial Day to November 30 (catch and release December 1 to March 31). Cutthroat trout limits are restricted and bull trout are strictly catch and release.

Beargrass blooms in Coeur d'Alene National Forest in August. Misty low clouds forming over lakes and rivers are scenes worth waiting for at dawn and sunset.

As might be expected with all that water, there are prime wetlands in the Coeur d'Alene and Kaniksu National Forests. Teepee Creek Wetlands is on the route featured in this expedition, and is one of the best wildlife viewing areas.

Residents of Spokane, Washington, tend to think of Idaho's Panhandle as their recreational backyard, but the area has its own culture with Coeur d'Alene as the centerpiece for several satellite cities. U.S. Highway 95 going north from Coeur d'Alene is now town-to-town all the way to Sandpoint. For this expedition, the closest city is Coeur d'Alene, and Kellogg is the closest mid-size town. Many of the smaller towns offer tourist services, including gas stations and bike or boat rental.

Approach Routes

- **From Coeur d'Alene or Spokane, Washington:** East on I-90 to Exit 43, signed for Kingston, and for Trailhead 9 (Trail of the Coeur d'Alenes).
- **From Missoula, Montana:** West on I-90 to Exit 43. See above.
- **From St. Maries:** North on Highway 3 to I-90; east on I-90 to Exit 43. See above.
- **From Sandpoint:** South on Highway 95 to I-90; east on I-90 to Exit 43. See above.

Maps (See map sources in Appendix B)

Idaho Panhandle National Forests (Coeur d'Alene NF; Kaniksu NF). The Kaniksu map is needed for the detail it provides as you approach the Lake Pend Oreille viewing point, but it does not show the rest of the route.

Land Administration (See Appendix A)

- **National Forest Service:** Coeur d'Alene and Sandpoint Offices
- **BLM:** Coeur d'Alene Field Office
- **Idaho Fish and Game:** Panhandle Region
- **Idaho Parks and Recreation:** Trail of the Coeur d'Alenes
- **Chambers of Commerce:** Coeur d'Alene, Sandpoint, St. Maries, and Silver Valley

Total Miles/Road Ratings

- **Total Miles:** 105.2 (includes Fern Falls side trip)
- **2WD paved or graded gravel/dirt:** about 79 miles paved; about 12.3 miles graded dirt
- **4WD recommended:** 12.3 miles of graded dirt roads (above) in bad weather
- **4WD required:** about 5.8 miles (includes backtracking to access paved road). The 4WD-required rating may be 4WD-recommended in good weather. Logging truck activity is unpredictable, so the road to the overlook may be in good condition, may be improved by loggers, or may be damaged by truck traffic.

Know Before You Go...

This is black bear country. Backcountry roads in this area are heavily used during deer and elk hunting season, from mid-August through October. At the northern end of this route there is logging activity and truck traffic. Some maps incorrectly depict the northern end of Road 209. The route of Road 385 where it connects to Road 209 and Road 332 is also wrong on some maps. See "Navigation Alert!" in Expedition Directions. There is intermittent cellphone coverage along the route. The best time to visit is June–October. Lower elevations along the main Coeur d'Alene River can be accessed in April and May. River runners can check *http://waterdata.usgs.gov/nwis* for river flow information. Coeur d'Alene Lake is accessible year-round. Check for forest fire activity in summer. Snowmobiles are allowed on most of the road corridors in winter. Nordic ski trails are abundant.

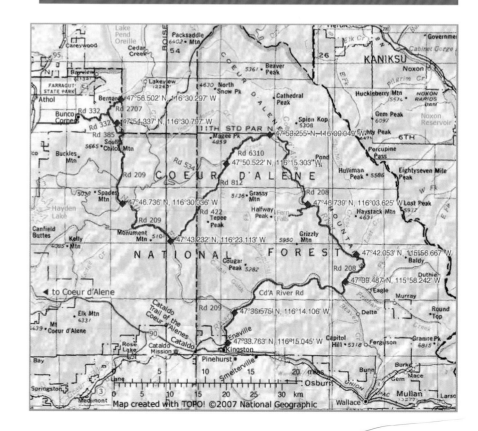

Expedition Directions

Set your GPS to display Degrees and Decimal Minutes. This expedition begins at Exit 43 on Interstate-90. It follows the Coeur d'Alene River east and then northwest, with a short side trip to Fern Falls. Where Teepee Creek joins the river, the trip continues southwest along Teepee and Leiberg creeks. We turn north again along North Fork Coeur d'Alene River. Along the North Fork we travel to the headwaters, then climb to ridges that overlook the southern end of Lake Pend Oreille. From the lake view, the route travels west to end at the small town of Athol on Highway 95, located between Coeur d'Alene and Sandpoint.

The river names are so long here that signs abbreviate them: Coeur d'Alene River Road becomes "Cd'A River Rd.," and North Fork Coeur d'Alene River Road becomes "N. Fk. CDA Rd." In most instances, road numbers as well as names are posted.

After the route turns north at Pritchard, the forest is threaded with 4WD roads and ATV trails. These roads and trails are not noted here except as necessary for directions.

GPS: 47° 33.061' N •116° 16.251' W
Mile 0.0 •Elevation: 2,174 ft.

Turn northeast at Exit 43 off Interstate-90, which is signed for Kingston, Trail of the Coeur d'Alenes, Thompson Pass, and other destinations. Turn right at the stop sign to continue northeast to Enaville on Forest Route 9 (FR 9), also signed as "Cd'A River Rd." FR 9 is paved, two lanes with a center line, and few turnouts.

GPS: 47° 33.763' N •116° 15.045' W
Mile 1.2 •Elevation: 2,202 ft.

Enaville Resort (rustic, 1880s-era history) and Trail of the Coeur d'Alenes trailhead for biking and in-line skating. There's a parking area, fishing regulations, toilets, informal camping, RV park, etc. Continue north on FR 9 ("Cd'A River Rd."). There are beautiful views of the river near here with a few small turnouts for stopping and gawking.

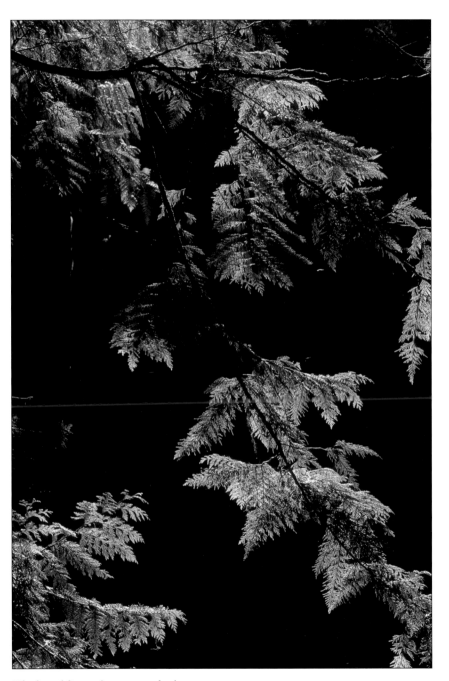

The lacy foliage of western redcedar trees creates an aromatic shelter from sun and rain for recreationists.

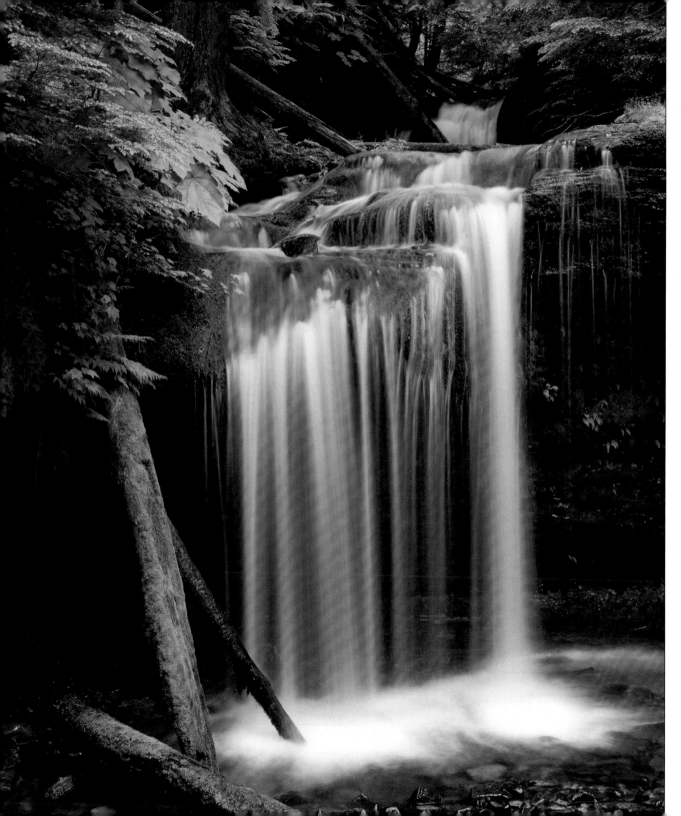

Fern Falls is one of the most beautifully shaped water-falls in Idaho's inland temperate rainforest.

GPS: 47° 36.575' N • 116° 14.106' W
Mile 5.3 • Elevation: 2,209 ft.

Forest Route 9 and Old River Road (Bumble Bee Cutoff). This expedition stays on the south side of the river and continues northeast on FR 9 to Pritchard.

At mile 6.3 is Babins Junction gas station, Golden Beaver Saloon, and roads leading south to Wallace—stay on the main road to Pritchard.

Pritchard Bridge Picnic Area is at mile 7.2.

Option: A side trip at mile 5.3 on the left (northwest) leads to Bumble Bee Campground or to Forest Route 1C (Old River Rd.) on the north side of the river. Old River Road loops back to join the main road in about 4 miles. It is dirt 2WD (narrow in spots).

GPS: 47° 39.487' N • 115° 58.242' W
Mile 8.1 • Elevation: 2,465 ft.

Bear left (northeast) on Road 208 at a stop sign. Road 208 is also paved, two lanes, and is signed as "CDA River Rd." Thompson Pass is 16 miles to the south on Forest Route 9.

At mile 11.3 is the Avery Picnic Area.

GPS: 47° 42.053' N • 115° 56.667' W
Mile 14.0 • Elevation: 2,533 ft.

Keep straight on Road 208 at this junction with Road 442, about 0.2 mile south of Shoshone Base Camp. Shoshone is a firefighting center with a heliport, campground, and an RV dump.

At mile 17.2 is the Kit Price Campground.

Devils Elbow Campground is at mile 20.2.

GPS: 47° 46.739' N • 116° 03.625' W
Mile 21.8 • Elevation: 2,677 ft.

Turn left (west) for a 4-mile side trip to view Fern Falls (see the photo at left). The turn is signed at Beetle Creek Road. Leave the pavement of Road 208 and drive on a dirt road that is 2WD in good weather to the signed trailhead. There are spur roads on the way to Fern Falls, but all turns are signed. From the trailhead it is a short walk to the waterfall. The trail is good, but not handicap accessible. Some maps depict the access roads incorrectly. Yellowdog Road doesn't go to Fern Falls. After viewing the falls, retrace the route back to Road 208 and then **ZERO YOUR ODOMETER**.

At mile 4.5 is the Big Hank Campground.

At mile 5.9 is Miners Creek Road 804 (stay on main road).

At mile 9.3 you will find Cinnamon Creek Bridge with excellent river and wetland views.

GPS: 47° 53.255' N • 116° 09.649' W
Mile 11.9 • Elevation: 2,871 ft.

Road 208 (and the pavement) ends and Road 6310 and graded dirt/gravel begin. **ZERO YOUR ODOMETER.** There is a mixture of private property and public land along Road 6310. Low rock cliffs and cottonwood trees mixed with conifers enhance views of Teepee Creek. ATV trails intersect the road here and there, and most of these trails are not signed. The road narrows between mileposts 2 and 4. Near milepost 7, the Magee Ranger Station Historic Site (built in 1922) is open to visitors. Magee Picnic Ground is located nearby. Whitetail deer and sandhill cranes were near the creek when we were there. Magee Rangers Cabin is furnished with heat, hot water, etc. For reservations, go online to *http://www.recreation.gov*.

GPS: 47° 50.522' N •116° 15.303' W
Mile 7.6 •Elevation: 2,988 ft.

Bear left (south) on Road 422 (Road 812 on maps, but not signed on the ground). This is the junction of Road 6310, Road 422, and Road 534. Road 422 is only signed after you turn onto it and cross the bridge over the creek, south of Magee Ranger Station. The road is 4WD recommended in wet weather, but may be negotiated with care in a 2WD vehicle.

At mile 8 is Teepee Creek Wetlands with a trailhead for walking Trail 325.

At about mile 10 there are more hiking trailheads.

GPS: 47° 48.215' N •116° 16.601' W
Mile 10.5 •Elevation: 3,165 ft.

Bear right (southwest) on Road 422 at this junction with Road 812 (now signed). The road is narrow and winding as it climbs, but still graded gravel/dirt, and still 2WD in good weather. (Leiberg Saddle, the next landmark on this expedition, is signed about 4 miles from the turn described above.)

At mile 10.9, bear left to stay on Road 422 (Road 911 is on the right). The left fork is signed "Little N. Fk. CDA River."

At mile 14.3, Leiberg Saddle, stay on Road 422 (the middle route). Switchback downhill from the saddle and drive carefully around blind corners. At about mile 18 the road is signed as "one lane with turnouts."

At about mile 18.6, Road 812 rejoins Road 422, but stay on Road 422.

GPS: 47° 43.232' N •116° 23.113' W
Mile 20.9 •Elevation: 3,047 ft.

Turn right (northwest) at this "T" junction with Road 209. Road 422 ends. Road 209 is one-and-a-half lanes wide, well-maintained gravel, and is signed as "Little N. Fk. CDA Rd".

Splash Dam Point of Interest is at mile 24.8.

GPS: 47° 44.364' N •116° 28.366' W
Mile 26.2 •Elevation: 2,757 ft.

Bear right (north) to stay on Road 209 at this junction with Road 612 (Deception Creek Rd.). Honeysuckle Campground is near this junction. There are several road intersections north of this junction, but stay on Road 209.

GPS: 47° 46.736' N •116° 30.036' W
Mile 31.1 •Elevation: 2,912 ft.

Bear right (northwest) to stay on Road 209 at this junction with Road 206. The right fork is signed for Pend Oreille Divide. The road climbs narrow switchbacks, with some blind corners as it makes its way to the divide—still graded and 2WD in good weather. We saw several wild turkeys in this area.

Horse Heaven Airstrip is at mile 34.8.

GPS: 47° 51.275' N •116° 29.690' W
Mile 38.0 •Elevation: 3,174 ft.

Navigation Alert! Bear left on Road 385. Some maps show Road 209 ending here and becoming Road 385 on the left fork —this is not correct. Some maps show a road on Tom Lavin Creek as Road 385, and this is also not correct. Some maps show Road 209 as the main road continuing to the ridge and connecting with Road 332—this is not correct either.

Ground Truth: Road 209 continues for a short distance and is then closed to vehicular travel. At this junction with Road 385, Road 209 shows less evidence of use, and Road 385 is a much better road than shown on most maps. To confuse the picture even more, there are additional spur roads that are not numbered nor signed. You must turn left here on Road 385 to continue. Stay on Road 385 to Road 332.

GPS: 47° 54.337' N • 116° 30.797' W
Mile 43.3 • Elevation: 4,123 ft.
Navigation Alert! Bear left (west) on Road 332. Road 332 appears on maps, but is not signed on the ground with its road number or name "Pend Oreille Ridge Road." You can identify Road 332 by its snowmobile route sign, a small orange diamond with "23" in white letters.

GPS: 47° 55.096' N • 116° 31.945' W
Mile 45.0 • Elevation: 4,314 ft.
Turn right (northeast) on Road 2707 at this "Y" intersection. Remember this junction of Road 332 and Road 2707—you will return to it after visiting the lake overlook. Just 0.2 mile after the turn onto Road 2707 a new logging road is not signed on the right (and doesn't appear on maps)—stay on the main road. Road 2707 is rated 4WD required, but may be 2WD in good weather, or if logging truck traffic has not degraded it.

At mile 45.4 (the first right turn that appears on most maps), bear right to stay on Road 2707. Logging operations were going on in the vicinity when we were there. Counter intuitively, you'll drive a bit downhill from this junction to find the lake overlook.

GPS: 47° 56.502' N • 116° 30.297' W
Mile 48.1 • Elevation: 3,650 ft.
Pull into a small turnout on the left (north) side of the road. It is not signed. Follow a footpath onto the ridge for a few hundred yards. The ridge is narrow here, with the road hung on its south side. The ridge offers by far the best view of Lake Pend Oreille. This viewpoint is located about one mile west/southwest of the official "Bernard Overlook." The view at the actual Bernard Overlook is blocked by trees.

Retrace your route to the junction of Road 2707 and Road 332. Bear right (west) on Road 332 to exit from this area and descend to Highway 95 (about 11.4 miles). Road 332 is paved further into the mountains than is shown on most maps. A large parking lot for snowmobiles and ATV trailers is located at the National Forest boundary sign. Near the boundary, Road 332 becomes Bunco Road (still identified as Road 332 on some maps). Continue west on Bunco Road at Bunco Corners or turn south to Nunn Road. Both Bunco and Nunn make a couple of 90° turns as they trend west to Highway 95.

This expedition ends at Highway 95 near the small town of Athol, and near Silverwood Theme Park. Turn south for Coeur d'Alene; turn north for Sandpoint. See Expeditions 2, 3 and 4 for other trips in the Idaho Panhandle.

Other Nearby Excursions...

Trail of the Coeur d'Alenes
This 73-mile paved bike and in-line skating trail spans Idaho between the towns of Mullan and Plummer. Motorized vehicles are not allowed. Trail of the Coeur d'Alenes closely parallels and sometimes crosses the auto route described in the first third of this expedition. If you aren't up to 73 miles of riding, it is easy to pick a short section, and the gentle grades are kind to your quads. The Coeur d'Alene Tribe manages a section of the trail within their reservation.

Expedition 1 — 37

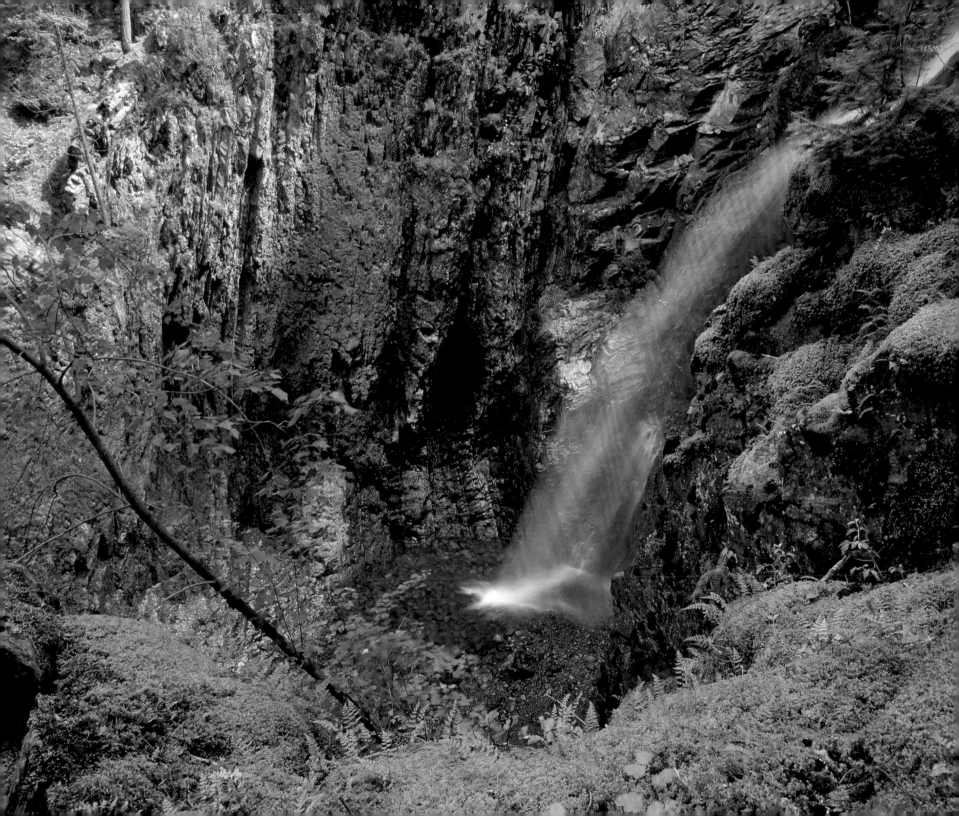

Moyie River • Copper Falls Purcell Mountains

Other Nearby Excursions: Wild Horse Trail Scenic Byway Kootenai Wildlife Refuge • Vista Overlook

When We Were There

Rainbows flare in the clouds near Bonners Ferry. With the flood-high Kootenai River at its doorstep, a farmhouse is surrounded: river in front, rainbow-mist overhead. As the morning advances so do the rainbows, climbing mountains of mist and crowning a train of clouds. A real train, heralded by echoes of its whistles off the rock face, finally arrives. Clacking and huffing, two engines pull a long line of cars onto flatlands near the river. The sun finds a hole in the clouds and rainbows the windows on passenger cars. One after another, the train engine pulls its cars into brilliance. Passenger cars, log cars, freight cars...all disappear into the mist until only the whistle remains, calling back.

We leave the "Vista" on Road 24 and travel back to Bonners Ferry to cross the Kootenai River. On the north side of the river we travel east. The Moyie River, a tributary of the Kootenai, is also in full spate. Runoff and erosion debris churn down-canyon in a brown and white flood. We drive north on Moyie River Road, looking for a campsite. A 4WD road leads to the river's edge at the site of an old dam. In a vertical cascade, a smaller tributary stream enters directly across from our campsite. Just before the daily rain arrives, we set up our tents. The month of May is a good season to visit. The forest is dressed in fresh greens, and biting insects have not yet arrived in full force.

Copper Falls drops 225 feet in two sections.

The Kootenai sub-basin is one of the wettest areas in Idaho. "Moyie" is a corruption of the French *"mouiller,"* a verb meaning "to wet" and dates to the early 1800s when French trappers from Canada explored the area. Bring good rain gear. If you are tent camping, bring a tarp or shelter to set up over your cooking area.

Bonners Ferry is the only full-service town in the area. Small outposts of civilization like the Good Grief Café offer a cold drink on a hot day, or a nice, dry place to get out of the inevitable rain. All of these outposts, large and small, are on the Wild Horse Trail Scenic Byway (see "Other Nearby Excursions" at the end of this expedition).

Approach Routes

- **From Bonners Ferry:** East on Highway 2 to Moyie River Road.
- **From Sandpoint:** North on Highway 2/95 to Bonners Ferry. See above.
- **From Coeur d'Alene:** North on Highway 95 to Sandpoint. See above.
- **From Libby, Montana:** Northwest on Highway 2 to Moyie River Road.

Maps (See map sources in Appendix B)

Idaho Panhandle National Forests (Kaniksu National Forest); Kootenai NF if you plan to extend your trips into Montana.

Land Administration (See Appendix A)

- **National Forest Service:** Bonners Ferry Office
- **Idaho Fish and Game:** Panhandle Region
- **Idaho Parks and Recreation:** Trail of the Coeur d'Alenes
- **Chamber of Commerce:** Bonners Ferry
- **International Selkirk Loop:** see *www.selkirkloop.org*
- **U.S. Customs at Porthill:** (208) 267-5309

Total Miles/Road Ratings

- **Total Miles:** 26.7 (more for side trips)
- **2WD paved or graded gravel/dirt:** about 9.5 miles paved; about 17 miles graded gravel or dirt
- **4WD recommended:** about 8 miles in wet weather. Suitable for SUV and for mountain bikes. If you are pulling a trailer, we suggest you skip the southern 8 miles of Moyie River Road and approach Meadow Creek Campground from the north (travel south from Good Grief Café).
- **4WD required:** optional side trips

Know Before You Go...

This is grizzly and black bear country. Visitors to Canada must check in at the Porthill/Rykers Port of Entry on Highway 1, or at the Eastport/Kingsgate crossing on Highway 95. Bring your passport. Cellphone coverage in Bonners Ferry only. The best time to visit is May–October. Check for forest fire activity in the summer. Snowmobiles are allowed on some roads in winter.

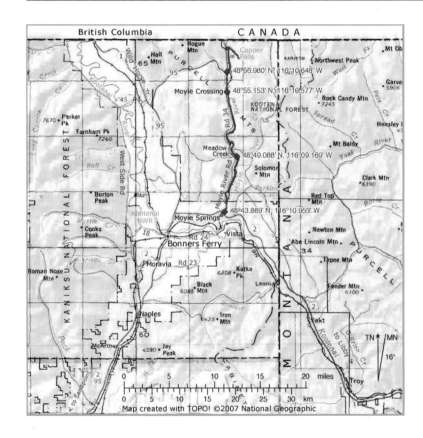

Expedition Directions

Set your GPS to display Degrees and Decimal Minutes. This expedition begins at the southern end of Moyie River Road 211 and travels north along the river to Highway 95 at the Good Grief Café. At the café, the expedition continues north for a few miles on Highway 95, then east on Road 2517 to view Copper Falls.

From Bonners Ferry, drive north on Highway 95/2 to Threemile Corner. Turn right (east) on Highway 2 and drive 5.6 miles to Moyie River Canyon Bridge. Moyie River Road is just west of the bridge.

Before you begin this expedition, stop to explore the interpretive site east of the bridge. Moyie River Canyon Bridge was built in 1964 and is a 1,223-foot-long steel truss construction. It is the second highest bridge in Idaho. Water falling from the dam spillway upstream drops a height of 212 feet (44 feet taller than Niagara Falls).

GPS: 48° 43.889' N •116° 10.953' W
Mile 0.0 •Elevation: 2,247 ft.

Turn north on Moyie River Road 211 (Road 63 on some maps) from Highway 2. The road begins as 2WD graded gravel, but about mile 1.7 it becomes a mud bog in wet weather and narrows to one-lane. Drive through a mix of private property and public land. Logging roads may not appear on maps and are not signed on the ground. Stay on the main road and drive cautiously near logging sites.

GPS: 48° 46.742' N •116° 09.674' W
Mile 4.2 •Elevation: 2,375 ft.

At this junction with Moyie River Road and 211A you can stay on Moyie River Road or take 211A as an optional side trip. Note that mileage given for main-road travel does not take this one-mile side trip into account.

A pioneer cabin is slowly reclaimed by marshlands in Idaho's Purcell Mountains.

Option: A great view of the river is accessible via 211A, a 4WD spur road. Turn east on 211A, cross the railroad tracks and drive 0.5 mile to the end of the road. An informal camp-site is situated on a bluff above the river. A short, steep trail leads down to the river (not safe for children). View the site of an old power plant and dam. Return to the main road.

North of this optional side trip, there are many unsigned spur roads leading from Moyie River Road to various river access and informal fishing/camping sites.

GPS: 48° 49.088' N •116° 09.169' W
Mile 7.5 •Elevation: 2,376 ft.

Meadow Creek Campground access road is on the right (east). The main road improves dramatically. A "Meadow Creek Ghost Town" sign is nearby noting that a village was built here in 1906. The last standing structure was removed in 1975.

At mile 7.8, Moyie River Road meets Meadow Creek Road. Bear right (north) at this intersection. The main road is in very good condition all the way from here to Highway 95, and is shown on most maps as Road 34.

At mile 8.2 you will cross a bridge over the Moyie River.

Option: At mile 8.3, Road 2541 on the right (east) is an optional side trip of about 8 miles to Deer Ridge Lookout. 4WD is required. To rent Deer Ridge Lookout Tower, go to *www.recreation.gov*.

GPS: 48° 50.364' N •116° 10.041' W
Mile 9.6 •Elevation: 2,403 ft.

Cross another bridge over the Moyie River. The road twists and turns as it follows the river, trending north. Several side roads offer camping or sight-seeing options.

Kaniksu Passage sculpture by Jeffrey Funk turns the Moyie Crossing Picnic Area into an outdoor art museum. The sculpture features bronze fish and shaped stone.

At mile 10.4, side road 2210 is on the left (west).

At mile 11.5, side road 2218 is on the left (north).

GPS: 48° 51.654' N •116° 09.488' W
Mile 12.0 •Elevation: 2,451 ft.

Twin Bridges, identified on maps, is where the road crosses Moyie River yet again (as does the Union Pacific Railroad). Gravel ends and pavement begins near here.

At mile 13.9 is the Snyder Guard Station.

At mile 15.5 is Bussard Lake.

GPS: 48° 55.153' N •116° 10.577' W
Mile 16.2 •Elevation: 2,543 ft.

The Moyie Crossing Picnic Area is one of the best picnic areas in Idaho (see photo below). Beautiful sculpture by Jeffrey Funk makes this area unique.

At mile 17.1, Road 34C is on the right (east).

At mile 17.3, the main road crosses Moyie River again.

At mile 18.1, Road 34D is on the right (east).

GPS: 48° 56.980' N •116° 10.648' W
Mile 18.4 •Elevation: 2,633 ft.

A junction with Highway 95; Good Grief Café is nearby. **ZERO YOUR ODOMETER.** Turn right (north) on Highway 95 to continue to Copper Falls.

GPS: 48° 59.349' N •116° 10.735' W
Mile 2.9 •Elevation: 2,624 ft.

Cross a bridge over the Moyie River and turn right (east) on Road 2517, signed for Copper Creek Campground, Copper Falls, Spruce Lake and Ruby Ridge. Drive southeast on Road 2517, which is graded gravel 2WD.

At mile 3.1 you will pass the entrance to Copper Creek Campground.

GPS: 48° 58.267' N •116° 08.828' W
Mile 5.3 •Elevation: 3,055 ft.

End this expedition at Copper Falls Picnic Area and Copper Falls trail access. The walking trail to the waterfall is easy and short, about 0.5 mile. Copper Falls is one of the prettiest falls in northern Idaho, dropping 225 feet in two stages. Even in winter the falls is worth viewing as it freezes into a stop-frame version of its summer self and becomes a prime ice-climbing destination.

Option 1: Return to Highway 95 and drive south to Good Grief Café. At the café, bear right (northwest) on Highway 95 and continue west to Highway 1. This is the access point for "Other Nearby Excursions" in this area (listed at right).

Option 2: The Eastgate/Kingsport Port of Entry is just a few miles north on Highway 95. If you enter Canada here, the closest large town is Cranbrook, located about 70 miles north/northeast. It is home to the Museum of Rail Travel.

Other Nearby Excursions...

Wild Horse Trail Scenic Byway
The Wild Horse Trail Scenic Byway is the Idaho section of the International Selkirk Loop. The route is based on the Kootenai Tribe's historic trails to fishing grounds at Lake Pend Oreille. Gold discoveries in 1863 greatly increased traffic on the historic path. From Sandpoint in the south to Porthill Port of Entry on the Canadian border, White Horse Trail Scenic Byway is about 59 miles long, all of it paved.

Kootenai National Wildlife Refuge
From the Good Grief Café, near the end of this expedition, drive northwest and west on Highway 95 to the junction with Highway 1. Turn right (north) on Highway 1, and watch for "Copeland" and "Sportsman Access." Turn left (west) on Road 45. Kootenai Valley contains the largest contiguous hops fields in the world. Road 45 soon meets West Side River Road. Turn left (south) on West Side River Road. Stay on the main road as it becomes Road 18, leading to the refuge headquarters. Return to Bonners Ferry via Road 18 as it turns east.

Vista Overlook
The best view we found of the Kootenai Valley was from this "Vista" on Highway 24, on the south side of the Kootenai River. In Bonners Ferry, drive south on Main Street to Ash Street; east on Ash Street to Cow Creek Road; southeast on Cow Creek Road to V60 Road. All of these streets and roads trend east/southeast and change names without much logic. But don't worry—if you accidentally go too far south on Cow Creek Road you'll loop into the foothills through idyllic ranch country and then come back to Highway 24. Continue east on V60 Road to Highway 24 (also identified as District 15 Road); pass a junction with 23 (23 is the other end of Cow Creek Road); continue east on Highway 24 past several more junctions. The Vista Overlook is signed at a pullout/parking area. A short walking trail leads to scenic views from a cliff that overlooks the valley.

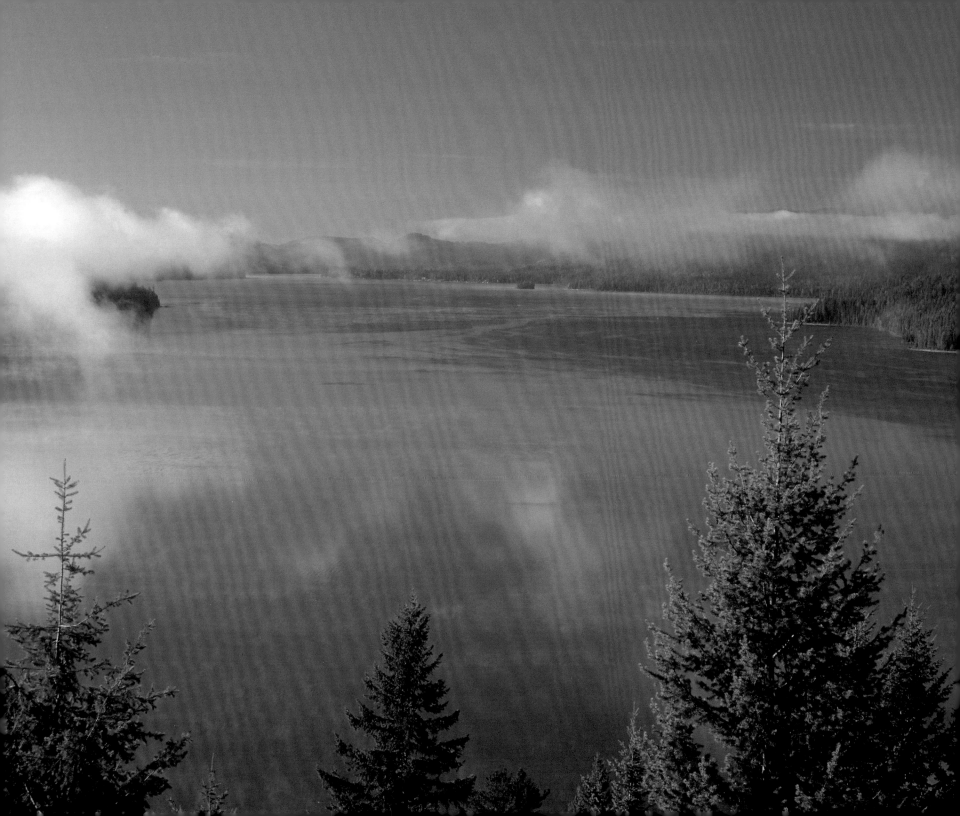

Priest Lake State Park (Lionhead Unit)
The Wigwams

When We Were There

The first part of this expedition climbs to The Wigwams, a double-peaked summit in the Selkirk Mountains east of Priest Lake. The footpath climbs 1,850 feet from the trailhead. Despite a breeze that felt like snow on the way, we were sweating when we topped out. We took sunset photos, then hurried down in the near-dark at a fast enough pace to keep hypothermia at bay. The view is worth the effort.

A few state parks are mentioned in this book, but only the Lionhead Unit of Priest Lake State Park is a featured expedition. The reasons: waterfalls, beaches that get less human traffic, old growth forests, trails to scenic mountain views, trails to beach views, and primitive campgrounds—the Lionhead area has them all. The name of this park varies all over the place, being "Lions Head" on many maps, "Lionhead Unit" in official-speak, and "Lionshead" in some references. There's also a mountain, The Lions Head (7,226 feet) and an associated Lions Head Ridge.

Lion Creek flows from the Selkirk Mountains into the northern end of Priest Lake. Waterfalls on the creek are not in a big hurry to get down as they take hundreds of steps over erosion-resistant granite. I'm not sure if I should write "Lion Creek Falls" or many "Lion Creek Waterfalls." No matter the one or the many, it is a beautiful and soothing place to visit. In autumn the waterfalls are enhanced with red maple leaves and yellow accents from willows. Perhaps because they step down in increments, these waterfalls are not identified on most maps.

Nell Shipman, an actress in silent movies, started writing and directing her own highly romantic adventure films in the 1920s. Although she had worked in Los Angeles and New York, Shipman described Priest Lake as her "Ultima Thule," relating it to Greek myths of lands at the edge of the known world, symbolizing the limit of human capabilities. It can be almost painful to watch a Nell Shipman movie. She falls through the ice and struggles in freezing water. She includes wolves, bears, a cougar and other animals as actors—with no special effects, it is all real. You can catch the flavor of her personality and her movie scripts from her comment, "The forested mountains of Idaho seemed to cascade down the slopes and carry me to their shining heights, cradle me in topmost boughs, soothe me with song…" Some of her film work was done in what is now the Lionhead Unit of Priest Lake State Park, where her movie camp "Lionhead Lodge" was also located. In 1977, Nell Shipman Point was named in her honor. There is a hiking trail from Lions Head Campground that takes you to this scenic point.

The view of Priest Lake from the Lionhead Unit of the park is classic northern Idaho: pristine waters and a forested shoreline. This photo was taken near the spot where Nell Shipman used to house the animal actors for her movies.

Know Before You Go...

This is grizzly and black bear country—see tips for avoiding bears in the "Backcountry Travel" section of this book. Cellphone coverage is available in the towns of Priest River and Sandpoint. The best time to visit is June–September. Check for forest fire activity in the summer and early autumn.

Approach Routes

- **From the town of Priest River:** North on Highway 57 to Priest Lake Information Center; east and north on East Shore Road to the northern end of Priest Lake.
- **From Sandpoint:** West on Highway 2 to the town of Priest River. See above.
- **From Bonners Ferry:** South on Highway 2/95 to Sandpoint. See above.
- **From Coeur d'Alene:** North on Highway 95 to Sandpoint. See above.
- **From Spokane, Washington:** North and then east on Highway 2 to Highway 57. See above.

Land Administration (See Appendix A)

- **National Forest Service:** Priest Lake Office
- **Idaho Fish and Game:** Panhandle Region
- **Idaho Parks and Recreation:** Priest Lake State Park
- **Chamber of Commerce:** Priest Lake

Maps (See map sources in Appendix B)

Idaho Panhandle National Forests (Kaniksu National Forest); USGS 1:24,000 topographical maps: **The Wigwams** and **Priest Lake NE**

Map Alert: For this expedition the printed map is from the 100K series, map level 4 of National Geographic software, see the 3-mile scale on the map. Most maps in this book are printed from the 500K series—don't let the scale confuse you.

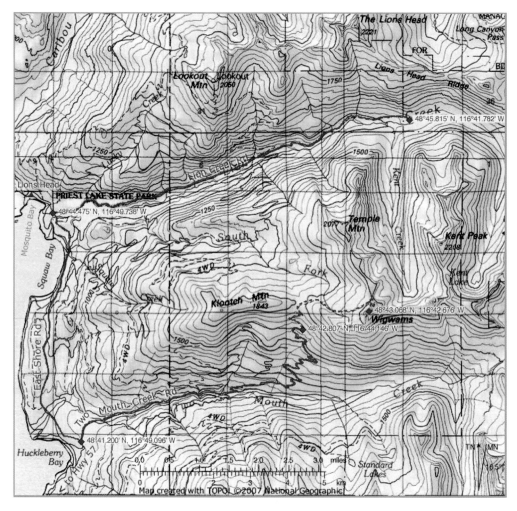

Total Miles/Road Ratings

- **Total Miles:** 18.1 (does not include backtracking to return to East Shore Road)
- **2WD paved or graded gravel/dirt:** about 8 miles (which you travel twice to cover both sections of this expedition)
- **4WD recommended:** about 7 miles. Suitable for SUV and for mountain bikes. If you are pulling a trailer, we suggest you camp at Lions Head Campground. Don't pull a trailer on trips up to Lion Creek Falls or to The Wigwams.
- **4WD required:** about 7 miles of the route to the trailhead for The Wigwams (14 miles round trip)

Expedition Directions

Set your GPS so it displays Degrees and Decimal Minutes. Priest Lake State Park is made up of three separate units: Indian Creek, Dickensheet, and Lionhead. Approach routes take you through the Dickensheet and Indian Creek areas on your way north to Lionhead. Priest Lake is surrounded by the Selkirks, and The Wigwams are in the eastern arm of the lake's mountain embrace.

This expedition consists of two parts, with one trip to see The Wigwams, and one to see the waterfalls on Lion Creek. You can arrange the order any way that you like. The Wigwams approach is first as you travel north on East Shore Road, but you may prefer to set up a base camp at the Lions Head Campground and explore from there. The campground is just north of Lion Creek Road, and about 24 miles north of the small town of Coolin.

GPS: 48° 21.200' N • 116° 49.096' W
Mile 0.0 • Elevation: 2,633 ft.

For the Wigwams, turn east on Two Mouth Creek Road (the road that parallels the north bank of Two Mouth Creek).

Navigation Alert! There are numerous entrances to Two Mouth Creek Road from East Shore Road. This entrance is the closest one to Lions Head Campground, about 3.8 miles south of Lion Creek Road. This trip begins on a 2WD road, but becomes 4WD as it climbs.

You will encounter many spur roads as you drive along Two Mouth Creek Road, some of which are not signed. Stay on the main road to mile 3.1.

GPS: 48° 41.921' N • 116° 45.607' W
Mile 3.1 • Elevation: 3,436 ft.

Turn sharply left, northwest (greater than 90° turn), to begin switchbacking uphill to the trailhead. The Wigwams 1:24,000

Beautiful, soothing waterfalls on Lion Creek step down over granite sills, enhanced with red leaves from mountain maples.

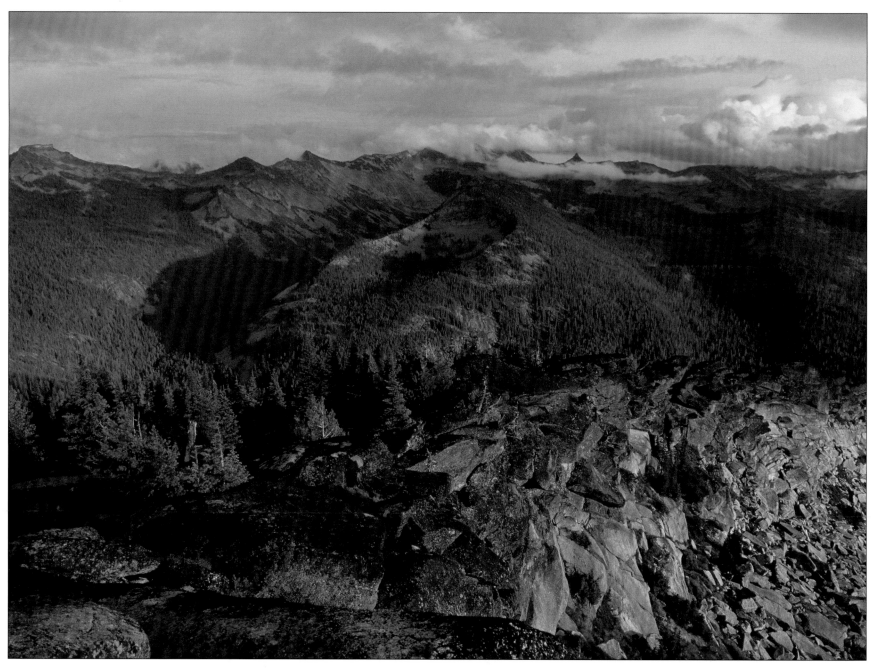

From the crest of The Wigwams, a 360° view of the Selkirk Mountains stretches to the horizon.

topographical map shows other 4WD roads in this area. Some exist on the ground, others are closed or overgrown, and some are foot/horse trails.

GPS: 48° 42.807' N • 116° 44.146' W
Mile 7.3 • Elevation: 5,176 ft.

End of the road. A small parking area (no campsites) marks the trailhead for The Wigwams. Park here and hike to the peaks. The hike is about 2.6 miles, and gains about 1,850 feet in elevation. The foot trail is visible but narrow, and is rocky and wet in spots. This is a rewarding hike even if you only explore a mile or so. There are several viewpoints along the way, as well as a variety of terrain, including rills of water, meadows, and rocky outcrops. The entire route has good potential for wildlife sightings. Glacier-carved scarps define The Wigwams (7,033 feet) and the terrain of surrounding peaks.

Backtrack to East Shore Road. Drive 3.8 miles north on East Shore Road to access the starting point for the trip up Lion Creek. **ZERO YOUR ODOMETER** at Lion Creek Road.

GPS: 48° 44.475' N • 116° 49.738' W
Mile 0.0 • Elevation: 2,490 ft.

Turn east on Lion Creek Road off East Shore Road.

Navigation Alert! There are two roads along Lion Creek, stay on the north side of the creek. This road is 2WD in good weather, 4WD in wet weather.

At mile 1, bear left at a "Y" intersection to stay on the north side of the creek.

At mile 2.2, ford two small tributaries of Lion Creek.

At mile 4, a foot trail on the left (north) leads to Lookout Mountain. Bear right to stay on the main Lion Creek Road. Ignore additional spur roads and drive to the end of Lion Creek Road.

GPS: 48° 45.815' N • 116° 41.782' W
Mile 6.9 • Elevation: 4,382 ft.

This is the end of Lion Creek Road. When we were there, there were no signs at the end of the road, but where the road was closed, a trail continued upstream. Walk a short distance beyond the closure barrier; watch for a footpath on the right (not signed) and listen for the waterfalls. Follow the footpath a few hundred feet to the creek. This set of multiple waterfalls and pools is idyllic.

Option: You can hike further up the trail to other waterfalls. The hike is pleasant along the closed two-track road. It passes a couple of dilapidated buildings built of milled lumber, and one older cabin related to mining efforts. About mile 1.8 the foot/horse path fords Lion Creek near a grove of old-growth cedar trees. More creek crossings on the trail require a cold wade. Waterfalls on upper Lion Creek are scenic, but none surpass the 200-foot-long series of veils and chutes within a quarter mile of the parking area.

Backtrack to East Shore Road and turn right (north) to the Lions Head Campground (it is signed at the entrance). There's a boat launch on Mosquito Bay. The Shipman Point Trail (named for Nell Shipman) leads through galleries of old growth forest to a sandy beach. This is the first trail on the left as you enter the campground, just past the fee station and public phone booth. For an appropriate end to this expedition, we recommend the easy walk to Shipman Point.

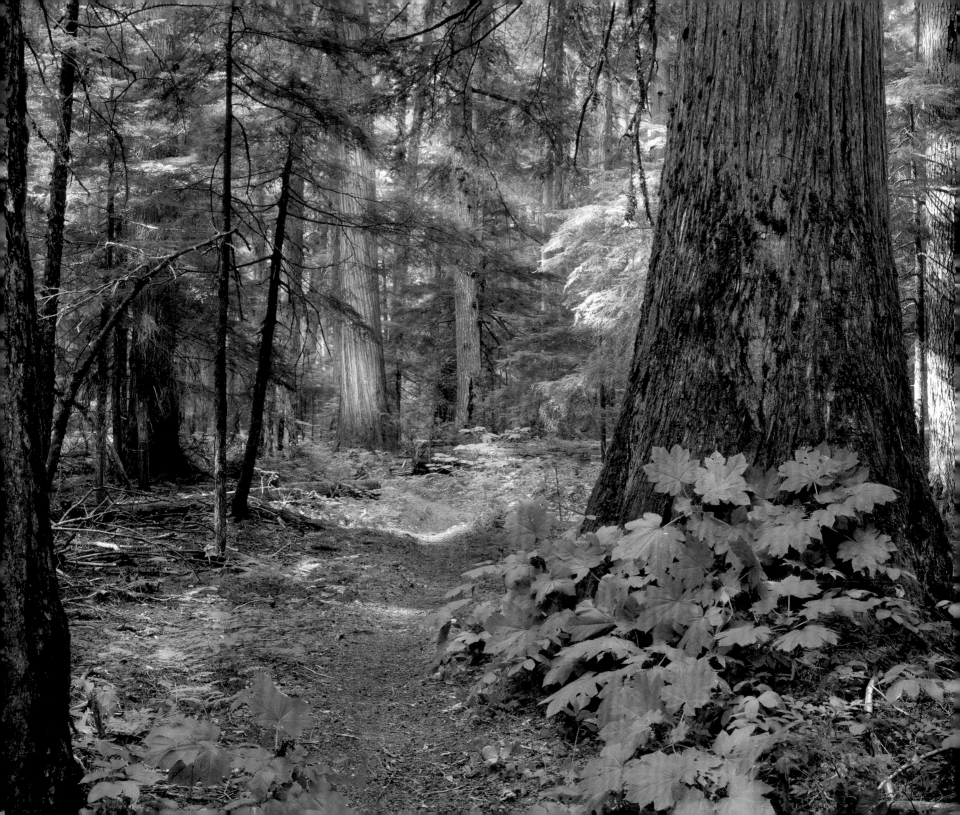

EXPEDITION 4

Upper Priest River and Falls
Selkirk Mountains

When We Were There

Whitetail deer flash their brilliant signals in a deep green forest; beargrass, tiger lilies and daisies are in bloom; minivans puff up the dirt roads with their loads of July vacationers. We are as far north as we can get without stepping into Canada. In fact, we can walk into Canada if we want to, but we don't go far on a game trail. The trail is strewn with bear scat.

In addition to the bears, this part of northern Idaho is home to the only remaining band of woodland caribou in the United States. But the forests are the show-stoppers here, with hundreds of square miles of trees that are normally found only on the Pacific Coast. Although stressed by drought, the temperate rainforest remains one of the true wonders of the world. Road corridors here are misleading—they let in a lot of sunlight and the verges fill with shrubs and small trees. Leave the road for a short hike into the forest. A soft silence and an other-worldly grandeur under the big trees will envelop you.

GRIZZLY COUNTRY

Mama grizzly rolls like a furred locomotive
trailing her fat cub as a wobbly caboose.
Pepper spray, that ludicrous weapon,
shrinks in the hand
until it's too small to hold.

The bear rises like a rug
nailed to the sky to fill her nose
with a sniff of us.

Don't move a muscle
except to avert your eyes,
the submissive gesture of every culture.
Don't run, don't trigger the predatory
chase. Speak low and soft, back away.

We need her dim eyes
to realize we're not a male griz
programmed to worse tempers
than Old Testament gods.

A breeze comes down from Canada
and brings her smell—She-Bear odor
of ripe toe jam with a hint
of old tennis shoes slow-baked.

Finally, she dismisses us.
She continues on her way, soon to be downwind.
She'll know, if she cares to,
where we are at all times.

—Trail notes by Lynna Howard

Western redcedar trees shade the trail and devil's club decorates the forest floor with prickly leaves and red berries.

51

Approach Routes

- **From Priest River:** North on Highway 57 to Nordman.
- **From Sandpoint:** West on Highway 2 to Highway 57. See above.
- **From Coeur d'Alene:** North on Highway 95 to Sandpoint See above.
- **From Spokane:** North and then east on Highway 2 to Highway 57. See above.

Maps (See map sources in Appendix B)

Idaho Panhandle National Forests (Kaniksu NF)

Land Administration (See Appendix A)

- **National Forest Service:** Priest River Office
- **Idaho Fish and Game:** Panhandle Region
- **Chambers of Commerce:** Sandpoint and Priest Lake

Know Before You Go...

See tips for avoiding bears in the "Backcountry Travel" section of this book. Some side roads shown on maps are closed in the summer months, but are open in the winter to oversnow vehicles. Some guidebooks and Forest Service pamphlets list the distance to be traveled on Road 1013 from Granite Pass to the end of the road as 11.5 miles, but it is 22.7 miles. Check for forest fire activity. Respect Salmo-Priest Wilderness borders in Washington. There is cellphone coverage in Coeur d'Alene, Sandpoint, and Spokane only. The best time to visit this area is late June–September. Mid-June and October are pushing it for the mountains, but fine for lakeshore activities.

Total Miles/Road Ratings

- **Total Miles:** 38.6 (more for optional side trips)
- **2WD paved or graded gravel/dirt:** about 4 miles paved; about 35 miles graded gravel/dirt. The road is relatively good to Roosevelt Grove of Ancient Cedars (about the first 14 miles). You can pull a small trailer over it if you don't mind a few potholes and washboards. Pulling a trailer is possible but not recommended due to narrow spots where the road is one-lane-plus wide.
- **4WD recommended:** about 18 miles (in wet weather)
- **4WD required:** in really wet weather, about 9 miles. Suitable for SUV and for mountain bikes.

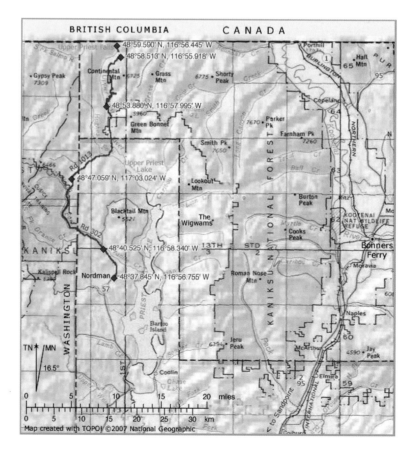

Expedition Directions

Set your GPS to display Degrees and Decimal Minutes. This expedition begins at the village of Nordman on the west side of Priest Lake (the Priest Lake Ranger Station is south of Nordman). The expedition dips into Washington as it follows Road 302 north, then crosses back into Idaho. Continuing on Road 1013, the expedition ends near the Canadian border, where Upper Priest Falls is accessible via a hiking trail. Along the way there are many opportunities for mini-hikes suitable for children and grandparents, and also trailheads for serious backpackers. Fishing spots are numerous on the countless tributaries of the Priest River.

GPS: 48° 37.845' N •116° 56.755' W
Mile 0.0 •Elevation: 2,617 ft.

From Nordman, drive north on Highway 57, which becomes Road 302. Near Nordman there is an access point for Priest Lake and Reeder Bay Campground on the right (east). Road 302 is paved for a few miles, then graded gravel. Several side roads are not noted in this log, stay on Road 302 as it bends northwest about 1.2 miles north of Nordman.

At mile 3, the entrance to Nordman Campground is on the right (east).

GPS: 48° 40.525' N •116° 58.340' W
Mile 3.9 •Elevation: 2,812 ft.

Take the left (northwest) fork here where Road 302 and Road 1341 intersect. The pavement ends. The left fork is signed for Stagger Inn and Granite Pass.

At mile 5.2 keep straight on Road 302 where Road 1362, Indian Mountain Road, comes in from the left (southwest). In this area there are many small, unsigned side roads leading to informal campsites. The main road follows the North Fork of Granite Creek and soon crosses into Washington.

At mile 10.6 Tillicum Creek Trail, High Rock Trail and Orwig Hump Cutoff are accessed via spur road 1103 on the left (west).

The main road (302) passes through some sections of old growth forest. Before the "Big Burn" of 1910, before unregulated logging, and before blister rust destroyed the white pines, much of the Panhandle area looked like the ecosystem you'll find in patches of old growth forest here.

GPS: 48° 44.479' N •117° 03.821' W
Mile 11.7 •Elevation: 3,197 ft.

Huff Lake Interpretive Site is a good place to get information on the flora and fauna in the area. A wooden boardwalk lets you explore the marsh area. Informational signs include the "Caribou Menu" of lichens, huckleberries, birch, willow, and Ross sedge. Woodland caribou leave distinctive hoofprints about five inches long. We saw some of these hoofprints near the Canadian border, but never saw the shy animals themselves.

At mile 13, Trail 379, a foot/horse trail that goes to High Rock Mountain, is on the left (west). Trail 266 to Boulder Mountain, and the spur road to Roosevelt Grove follow soon after.

At mile 13.3, the entrance to Stagger Inn Campground, Roosevelt Grove of Ancient Cedars, and Granite Falls is well-signed. We recommend a short side trip of 0.3 mile here (signs say 0.5 mile). From the campground area, trails to view lower and upper Granite Falls are short. The lower falls is accessible to anyone who can walk a few hundred feet. The grove around the falls is named for President Theodore Roosevelt. It was threatened by fire in 1926, and the campground is named after firefighters who staggered back to a base camp here after fighting surrounding blazes. About 75% of the original grove was burned. In the old growth sections that are left, trees are estimated to be around 800 years old, and a few are 2,000–3,000 years old.

After visiting Roosevelt Grove of Ancient Cedars, return to Road 302 and **ZERO YOUR ODOMETER**. Continue north on Road 302 to Granite Pass.

GPS: 48° 47.059' N •117° 03.024' W
Mile 1.8 •Elevation: 3,583 ft.

Granite Pass—mileage assumes that you have zeroed your odometer at the entrance to Roosevelt Grove. Choose the middle fork (Road 1013) at this intersection of Roads 302, 1013, and 401. Road 1013 is also signed "Upper Priest Rd." (Road 302 continues west as Metaline Rd.). Terrain here at Granite Pass is so gentle that it's hard to tell it's a "pass." Road 1013 soon enters Idaho, and the state border is signed.

At mile 2.8, snowmobile trail 656 is closed with a gate in summer. Road 1013 continues northeast along the Muskegon Creek drainage.

At mile 4.5, Gold Creek and a spur road are signed.

GPS: 48° 49.258' N •116° 58.947' W
Mile 6.4 •Elevation: 2,828 ft.

Continue straight ahead, via the right fork (east), on Road 1013. Signs note "Road Closed ahead 20 Miles." On Road 1013, cross Gold Creek via a bridge with views of Gold Creek gorge.

Option: Also at mile 6.4, Road 662 on the left (west) leads to Hughes Meadows and several trailheads. At mile 3 on Road 662, a wetlands and a cabin are located in a Caribou Recovery Area.

At mile 9.1, continue north on Road 1013 at an intersection with Bugle Pass Road 655. Road 1013 now parallels Upper Priest River. Two-track spur roads to informal campsites are hard to spot in the thick foliage.

Option: Also at mile 9.1, Road 655 (4WD recommended) takes you 22 miles over mountains to Lion Head State Park.

Sunset in northern Idaho silhouettes spruce and western redcedar trees that thrive in this area of ample rainfall.

GPS: 48° 52.445' N • 116° 57.531' W
Mile 11.4 • Elevation: 2,722 ft.

We stopped here to walk a short distance from the road into an old growth forest, taking advantage of the excellent photo opportunities. Bear scat was ubiquitous.

At mile 12, cross Cedar Creek via a bridge. An informal campsite is near the bridge.

At mile 13.3, cross Lime Creek via a bridge.

GPS: 48° 53.880' N • 116° 57.995' W
Mile 13.5 • Elevation: 2,772 ft.

This is the trailhead for Upper Priest River Trail 308, a popular trail in the Upper Priest River Scenic Area. For 8 miles the trail winds through groves of western redcedar, white pine and other conifers, with Upper Priest River running alongside. This trail meets Trail 28 near Upper Priest Falls and continues to the waterfall. We recommend this lower section to view the forest, but there's a shorter access to the waterfall from the end of Road 1013.

Beyond this trailhead the road narrows and begins to climb steeply uphill via a set of switchbacks, following the Lime Creek drainage. This part of the road is signed "Not Suitable for Trailers."

Several side roads between mile 18 and mile 20 are closed with gates during the summer months. As Road 1013 climbs, it provides great views of the Selkirk Mountains and Canada's Kaniksu Mountains.

GPS: 48° 58.513' N • 116° 55.918' W
Mile 24.7 • Elevation: 4,252 ft.

Road 1013 ends where the road is blocked by a gate. A small turnaround spot is next to a waterfall. There is no campsite at the turnaround, but there is a campsite near Upper Priest Falls if you want to backpack your gear down there.

GPS: 48° 59.590' N • 116° 56.445' W
Elevation: 3,461 ft. • [1.3 miles hiking]

We recommend this hike to Upper Priest Falls ("American Falls" on some maps) as an end to this expedition. Trail 28 departs near the end of the road to drop steeply to Upper Priest Falls. The path descends via well-cut switchbacks until it joins the main trail along Upper Priest River. Turn right (north) and head straight for Canada. The trail ends 0.5 mile from the border.

Return to Road 1013—a strenuous uphill climb on the switchbacks. Retrace your auto route back to Nordman, and continue south on Highway 57 to the town of Priest River on Highway 2. From Highway 2 you can travel east to Sandpoint, or west into Washington (and southwest to Spokane). See Expedition 3 for a nearby trip to Priest Lake State Park (Lionhead Unit) on the east side of the lake.

North-Central Idaho

The North-Central region covers Latah, Clearwater, Nez Perce, Lewis, and Idaho counties. Gospel-Hump, Selway-Bitterroot, and Hells Canyon designated wilderness areas occupy much of the terrain and are surrounded by additional public lands. Hells Canyon National Recreation Area extends into Oregon. Nez Perce, Clearwater, and St. Joe National Forests are bordered by Montana on the east, and by highway corridors and Indian reservations on the west. Major rivers that drain north-central Idaho are St. Joe, Saint Maries, Potlatch, Lochsa, North Fork Clearwater, Clearwater, South Fork Clearwater, Selway, Salmon, Little Salmon, and Snake. Expedition 5 parallels the Salmon River and then turns north to explore mining ghost towns and the Gospel-Hump Wilderness.

The Lochsa, Selway and Middle Fork of the Clearwater are all designated Wild and Scenic Rivers. Expedition 6 explores a portion of the Selway River, and climbs the Fog Mountain Road to the border of the Selway-Bitterroot Wilderness. The Selway-Bitterroot is the third largest wilderness in the Lower 48, and is separated from the even larger Frank Church Wilderness by the slender thread of the Magruder Corridor Road.

The Lochsa River Canyon (Expedition 7) gave Lewis & Clark so much trouble that they took to the ridges. Clark wrote in his journal:

"The road through this hilley Countrey is verry bad passing over hills & thro' Steep hollows, over falling timber…Some most intolerable road on the Sides of the Steep Stoney mountains, which might be avoided by keeping up the Creek [Lochsa River] which is thickly covered with under groth & falling timber."

What Lewis & Clark described as "roads" were actually Native American trails. Andrew Garcia, a young man who left the U.S. Army in 1878 and later married a Native American woman, narrated his travails on such roads in *"Tough Trip Through Paradise,"* a manuscript he left packed in dynamite boxes for posterity to find in 1948:

"I had been on trails in timber, but had never been in anything like this. We came to logs across the trail that my saddle horse refused to jump. In-who-lise [his wife] said scornfully that this was a good Injun trail and that I did not know much if I could not get my horse through a good trail like this…Cutting herself a pine sapling the size of a fish pole, she came up behind my saddle horse who had refused to leap over this fallen tree up to his breast across the trail. One crack from the sapling by In-who-lise was enough…he rears up and like a steeplechaser cleared the fallen tree."

Traveling by 4WD vehicle, even with occasional shovel and saw work, seems mild by comparison.

Some of the expeditions in this section follow routes that were pioneered by Lewis & Clark. Canoe Camp, where their Corps of Discovery built canoes with help from the Nez Perce tribe, is just a few miles from the starting point for Expedition 9.

When you drive through Idaho and see signs for Lewis & Clark this and Lewis & Clark that, you have to wonder if there was any place those guys didn't get to. Members of the Corps were in Hells Canyon in 1806. Lewis & Clark were hanging out with the Nez Perce tribe while waiting for snow to melt in

The view from Fog Mountain Road gets a fiery assist as wildfire smoke drifts into the Clearwater Mountains. The 4WD road climbs to trailheads on the border of the Selway-Bitterroot Wilderness.

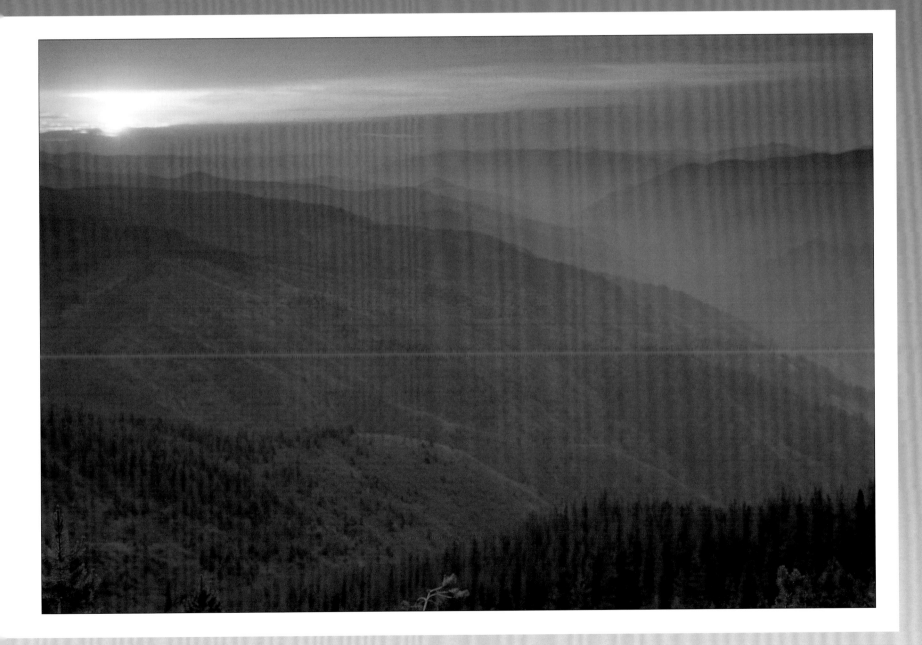

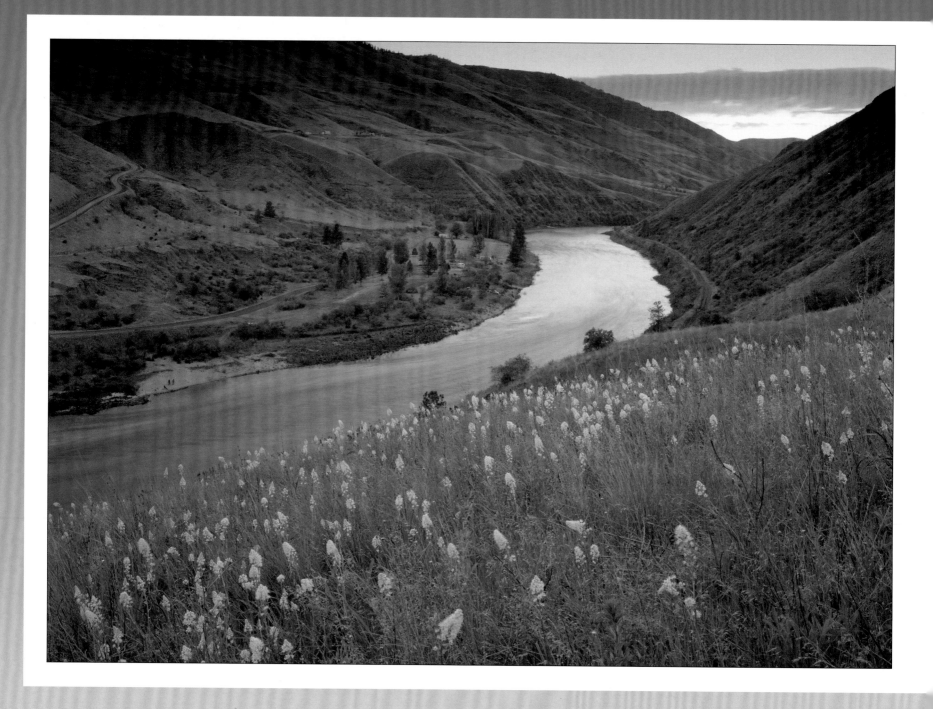

the Bitterroots. Avid anglers understand the pull to go fishing when time allows. Three members of the Corps left with Indian guides and traveled about 70 miles to fish near the confluence of the Snake and Salmon rivers. Road access to Pittsburg Landing on the Snake River is described in Expedition 11. Expedition 10 parks you on the highest edge of Hells Canyon Wilderness, which is presided over by the Seven Devils.

In addition to the Seven Devils, major mountain ranges traversed in this section are the Bitterroot Mountains, the St. Joe Mountains, the Palouse Range and Clearwater Mountains. A lot of the subranges within the Clearwater Mountains are known by other names: Moose Mountains, The Crags (Expedition 6), Sheep Mountains, Little Goat Mountains (Mallard Larkins area), and Hoodoo Mountains (White Pine Scenic Byway in "Other Nearby Excursions" in Expedition 9).

Lewiston is the biggest city in north-central Idaho, with Moscow a close second. Smaller towns on our expedition routes include Orofino, St. Maries, Riggins, Elk River, Kooskia, Kamiah, Grangeville, White Bird, and Lowell. In this north-central section, our boundary to the north is I-95. To the south, we use Riggins and the Salmon River as rough guidelines, though the line is fudged a bit to include the Seven Devils. You will have cellphone coverage in the cities and towns, but not out in the wilderness areas.

Lupine blooms splash vivid color on the open slopes of Idaho's mountains.

The Salmon River as it approaches its confluence with the Snake River in lower Hells Canyon. Beargrass and Indian paintbrush bloom above the river near the town of White Bird.

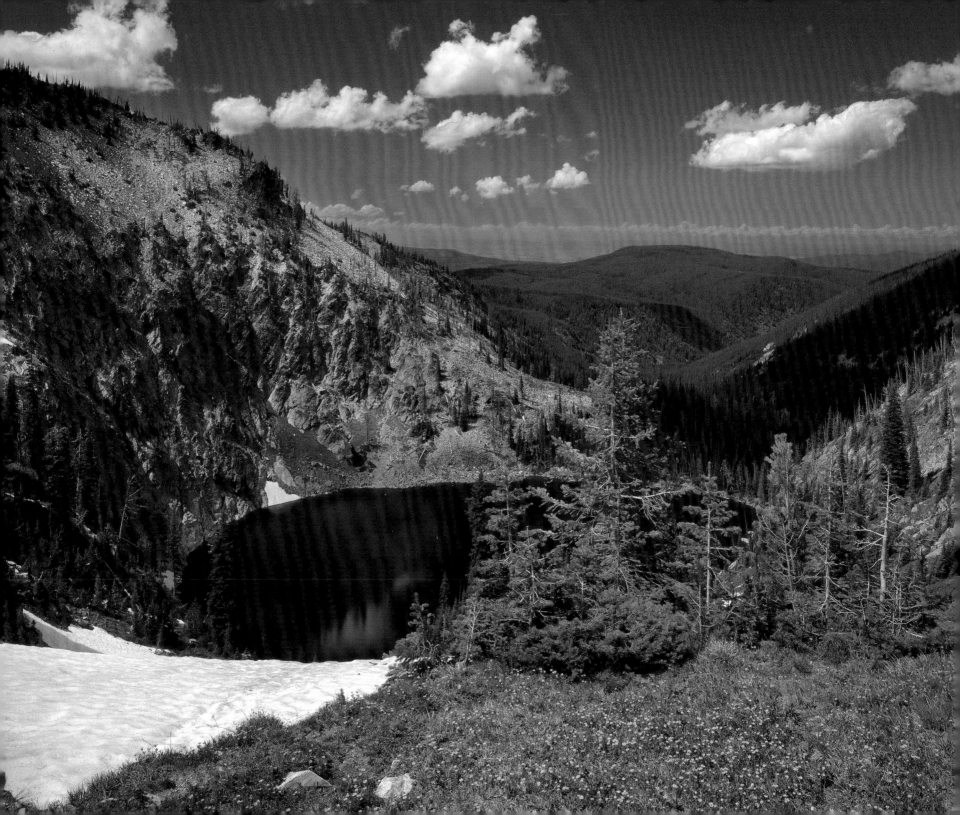

Salmon River • Florence Gospel-Hump Wilderness

Other Nearby Excursions: Nez Perce National Historic Park

When We Were There

On the last day of June we made a stop on the banks of the Salmon River. We were not very far from the border with Oregon, at an elevation of 1,800 feet above sea level. It was a simmering 100° and summer flowers had already seeded out and been toasted by the glaring sun.

As we continued our expedition and gained elevation on the way to the ghost town of Florence, the heat eased, but not by much. Gospel-Hump Wilderness, on the other hand, offered a built-in refrigerator in the form of deep snow that still blanketed northern slopes. The road corridor into the wilderness had been plowed only one-lane wide. We stopped next to a group from Northwest Youth Corps. Two young, partially-undressed guys were making snow angels and shivering. "Yeah, it was really cold! He [their supervisor] said he'd give us a buck to do it with our shirts off. The worst part's actually your feet." I offer this as proof that young men will do anything for a buck.

At the Gospel Lakes Overlook the ridge was completely exposed to the sun, and not only free of snow but home to yellow bells and glacier lilies. It was the kind of scenery we couldn't usually come by without extensive backpacking. To top it off, a bull elk with antlers of exceptional beauty sauntered into view, and calmly walked down the opposite slope to browse new grass.

As we headed further north toward South Fork Clearwater River, meltwater created an impressive waterfall at the head of Mill Creek on Hungry Ridge. It's pressing your luck to try the higher elevations in late June or early July, but the neon-green growth on the trees, rock outcrops polished by runoff or accented with snow, not to mention the wildlife out for a stroll, created a stunning picture. This expedition offered the greatest combination of terrain and weather contrasts we had experienced, and all within about one hundred miles.

Approach Routes

- **From Boise:** West/northwest on I-84 to the junction with Highway 95 North; north on Highway 95 to Riggins; east from Riggins on Big Salmon Road.
- **From Grangeville:** South on Highway 95 to Riggins. See above. This expedition can also be driven backwards, starting at Grangeville.
- **From McCall:** North on 55 to Highway 95; north on Highway 95 to Riggins. See above.
- **From Lewiston:** East on Highway 12 to the junction with Highway 95; southeast and south on Highway 95 to Riggins. See above.

Upper Gospel Hump Lake in the Gospel Hump Wilderness.
Spring flowers bloom as soon as the snow melts in July.

Maps
(See map sources in Appendix B)

Nez Perce National Forest; Gospel-Hump Wilderness

Land Administration
(See Appendix A)

- **National Forest Service:** White Bird and Grangeville Offices
- **BLM:** Cottonwood Field Office
- **Idaho Fish and Game:** Clearwater Region
- **National Park Service:** Nez Perce National Historic Park
- **Chambers of Commerce:** Riggins and Grangeville

Total Miles/Road Ratings

- **Total Miles:** 105 (88.5 + 16.5 backtrack from side trips)
- **2WD paved or graded gravel/dirt:** all the way (about 17 miles of pavement). With the exception of paved sections, the roads are narrow, mostly one-lane with some blind corners and switchbacks. Some of the switchbacks are relatively steep and long.
- **4WD recommended:** for Roads 221, 444, and 309 in bad weather. The roads are suitable for trailers in good weather —but you may not want to pull a trailer south of Florence Cemetery Historical Site (Florence townsite is within walking distance).
- **4WD required:** for most of the side roads

This is black bear country, see the bear avoidance tips in the "Backcountry Travel" section of this book. Roads in this area are heavily used during hunting season, from mid-August through October. A blaze-orange vest or hat is recommended for visits during this time. There are no gas stations along the route, so be sure to fill up in Riggins. If you are going to explore 4WD roads in this area, carry a saw to remove downed timber. There is no cellphone coverage along most of the route. The best time to visit is mid-July to early October. River runners can check *waterdata.usgs.gov/nwis* for river flow information. There are several outfitters based in Riggins that offer river trips, and their season begins earlier (see *www.ioga.org*). Check for forest fire activity in the summer and fall. Snowmobiles are allowed on most of the road corridors in winter.

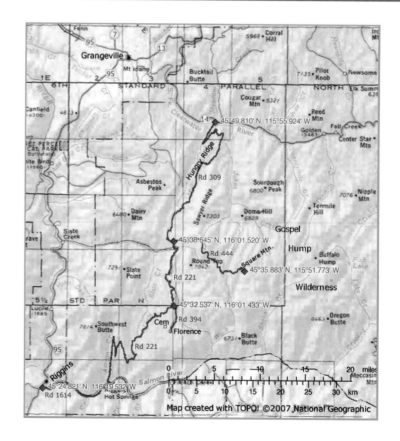

Map created with TOPO! ©2007 National Geographic

Expedition Directions

Set your GPS to display Degrees and Decimal Minutes. This expedition begins near Riggins on Highway 95, travels east on Big Salmon Road, then north/northwest on Road 221 to Florence Basin; and from Florence north to Road 444, which is a cherry-stemmed road into Gospel-Hump Wilderness. After a side trip of about 14 miles into the wilderness, the route continues north to South Fork Clearwater River and Highway 14.

GPS: 45° 24.821' N • 116° 19.532' W
Mile 0.0 • Elevation: 1,773 ft.

South of the town of Riggins, turn east on Big Salmon Road 1614. **Navigation Alert!** The entrance to this road is difficult to find because there are no obvious signs on Highway 95. A small brown and white BLM sign is hidden by trees. The road can be located by looking north of the Hells Canyon NRA sign, and also by spotting the only large bridge going east over the river. After you cross the river, the paved road is well-marked as 1614 and as Big Salmon Road. The pavement is barely two lanes wide. There are a few unsigned overlooks and riverside picnic areas. The "bars" along this part of the river are mostly banks of sand, some mixed with gravel. Signed areas are listed below:

Shorts Bar at mile 1.5 has a picnic area and boat launch.

Island Bar is at mile 3.8 and a spur road leads to informal camping.

At mile 6.1, at Rough Creek, cross via a bridge to the north side of the river.

Riggins Hot Springs Lodge at mile 9.5 is accessible via a private bridge on the south side of Salmon River.

GPS: 45° 24.129' N • 116° 09.812' W
Mile 10.0 • Elevation: 1,854 ft.

Turn left (north) on Road 221 at this junction, and **ZERO YOUR ODOMETER**. Allison Creek Picnic Area, with handicap access, is nearby, as is Spring Bar Campground on Road 1614. Signs at the junction note 23 miles to Florence, but by our route it is 27 miles to Florence Cemetery, and 29.3 miles to Florence townsite. Road 221 is the most well-maintained route with graded gravel all the way (marked incorrectly as 4WD on 100K series maps, but it is correctly shown on the Nez Perce NF map). As Road 221 follows Allison Creek, private property gives way to National Forest lands and the one-lane road climbs as the canyon narrows. Although there is a rat nest of backroads in this area, even minor junctions are signed. Most of the side roads are not noted in this log. Stay on Road 221.

Road 263 leads west to Chair Point Lookout at mile 3.

Long switchbacks begin on Road 221 at mile 6.

An informal campsite is at mile 8.3, between mileposts 58 and 57.

GPS: 45° 28.725' N • 116° 09.164' W
Mile 9.6 • Elevation: 4,985 ft.

Bear right (straight) on Road 221 at this junction with Road 536 (the side road is signed as 536 on the ground, but it is Road 535 on most maps. At milepost 56 it is signed for "Nut Basin.") Road 221 is signed for Florence and for Little Slate Saddle. Near this junction there is another informal campsite with terrific views, including a long view of the Seven Devils in Hells Canyon NRA to the southwest.

GPS: 45° 28.000' N • 116° 06.412' W
Mile 15.0 • Elevation: 5,446 ft.

At Little Slate Saddle you have two options to continue on to Florence. Road 394 on the right will get you there, but our route bears left to stay on 221 (signed for Little Slate Crossing).

There are two more junctions with roads that lead to Nut Basin, at mile 15.7 and mile 17.7. In both cases, stay on Road 221 which has now regained its directional signs for Florence. Road 643 at mile 17.7 used to be the original road to Florence, but this section is now open only because some people never give up —there are still active mining claims. Road 643 is 4WD and signed on the ground only as "Not Maintained by F.S."

> **GPS: 45° 32.537' N • 116° 01.433' W**
> **Mile 25.5 • Elevation: 6,075 ft.**

Turn right (south) on 394 at this junction of 221 with the road to "New Florence." Drive about two miles south to Road 643 (the only section of 643 that is well-maintained). There are more side roads and two-tracks here that are not noted in this log, but

FLORENCE

"Old Florence" dates back to 1861-62. There is a self-guided walking tour, but few ruins or artifacts are left, in part because the old town was stripped for salvage in 1897 and the site was sifted again for gold that had fallen through cracks in the floorboards of the buildings. Chinese miners did some of this labor-intensive work. Chinese miners buried in the cemetery were exhumed in the 1920s, their bones burned, and the ashes shipped back to China.

"New Florence" was erected a quarter-mile south of "Old Florence" in the 1890s when improved mining technology brought about 1,000 miners back to try again. Interpretive signs document the buildings, people, and mining techniques —otherwise it would all be hard to believe. Standing on the site overgrown with lodgepole pines, you can discern its boomtown past only by the remains of dredging ditches and the way the entire area for miles around is oddly humped with mounds of long-ago disturbed ground. It looks like a race of giant gophers worked the place over. Only the cemetery remains relatively intact.

Road 394 is obviously the main road south as it makes its way toward Florence Cemetery. On the way to Florence Cemetery are signs for "Old Florence" and "Boothill."

Turn right (west) on Road 643 to Florence Cemetery at the junction of Roads 643 and 394 (expedition mile 27.3). The turn is signed for the cemetery. Once you arrive, it's odd to find such a big display of civilization: there's a parking lot, interpretive signs, wooden walkways which are handicap accessible, pit toilets, picnic tables, and of course, the gravestones. One headstone records the death of a child that died at age 4 in 1863. Trees are growing in some of the old graves. We could only find one grave whose occupant was over 50 years old, "George Bannapo, died October 24, 1879, age 58 years, native of New York." A nearby grave is simply marked "Baby." Vester Scott, who died in January, 1862, was killed in a gunfight. Vester's death was typical. Cherokee Bob Talbotte's grave is here too—he was killed in a shootout in 1863, after a short career as a saloon owner.

The townsite is located about 0.5 mile south of the cemetery (expedition mile 29.3). It was as short-lived as its citizens. It was named in 1861, grew to a population of 9,000 in June of 1862, and the rush was over by 1863. After exploring the cemetery and the townsite, retrace your route back to the intersection of Road 221 and Road 394, and **ZERO YOUR ODOMETER**.

> **GPS: 45° 32.537' N • 116° 01.433' W**
> **Mile 0.0 • Elevation: 6,075 ft.**

Turn right (north) on Road 221 after backtracking to this junction of Road 221 and 394. Many side roads north of here are closed with gates.

Pavement begins at mile 4.0, Boulder Creek (milepost 36.6). Rocky Bluff Campground is at mile 9.2.

Option: Slate Creek Road 354, at mile 10, leads 17 miles west to Highway 95 and could be used to return to civilization and cut this expedition short.

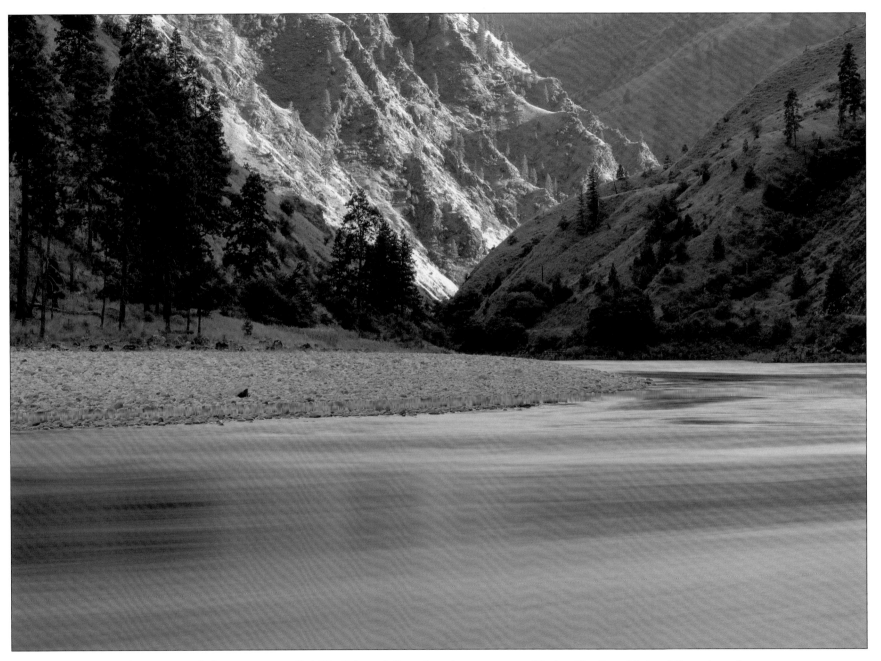

The main fork of the Salmon River, which is sometimes called "Big Salmon," flows through a canyon near Riggins. Nez Perce National Forest is on the north bank and Payette National Forest on the south. The river is fed by tributaries that flow from the Gospel-Hump Wilderness.

GPS: 45° 38.645' N • 116° 01.520' W
Mile 10.8 • Elevation: 5,371 ft.

Turn right (east) on Road 444 at this junction. Leave Road 221 for a side trip into Gospel-Hump Wilderness. Leave the pavement and turn onto a maintained gravel road. The turn is signed "Gospel-Hump Wilderness Corridor," and mileage is given to various destinations, including Square Mountain. Snowmobiles are allowed on the road in winter, but from the number of harshly-worded signs one can conclude that some riders have not been following wilderness guidelines.

There are several side roads departing Road 444 for other destinations, and there are many trailheads, all signed. This area is popular with horsemen and most of the trailheads are designed with horses in mind. Side roads are not noted in this log. At about mile 14 there are spectacular views of mountains near and far, including the Seven Devils, Salmon River Mountains, and Salmon River Canyon. At mile 14.4 (about 3.6 miles from where you turned onto Road 444), the road ceases to skirt the border of the wilderness and begins to cherry-stem into the heart of it.

GOSPEL-HUMP WILDERNESS

"Gospel" refers to a sermon preached in 1899 by William "Billie" Knox, a clerk from Grangeville. One has to wonder about a clerk whose hobby was sermonizing on Sundays to road surveyors and freighters, but he must have been very good at it because they named Gospel Peak after him. Buffalo Hump is the highest peak in the area, and so we end up with "Gospel-Hump Wilderness."

Gospel-Hump is managed by Nez Perce NF. The National Forest name is a nod to a culture more than 6,000 years old, though "Nez Perce" was devised not by the tribe, but by French trappers who identified them by their nose pendants. Linguists will note that *Nez Percés* is not pronounced "nehz-purse," but if you say "nay-pearsay" to anyone in the area they won't know what you're talking about.

In 1978 Congress designated Gospel-Hump Wilderness, 206,053 acres east of Riggins and north of the Salmon River. On the east side, road corridors separate Gospel-Hump from the Frank Church and Selway-Bitterroot Wilderness areas. Even some of those corridors are managed to preserve wilderness values, notably the Red River WMA. Below the peaks, terrain in Gospel-Hump Wilderness varies from water-starved sagebrush to forests so damp that Western redcedar trees flourish. Bring repellent for mosquitoes, and clothing that repels biting flies. Permits are required if you plan to run the Salmon River from June 20th to September 7th.

GPS: 45° 37.666' N • 115° 56.903' W
Mile 17.0 • Elevation: 7,791 ft.

Upper Gospel Lake Overlook is minimally signed with a carving on a stump. There's a small turnout for parking. This is a must-see sightseeing opportunity, located about 6.2 miles from where you turned onto Road 444.

A spur road leads to Slate Lake at mile 21.1.

Moores Station at mile 22.4 includes seven trailheads and facilities for horses.

A large parking and turnaround area for horse trailers is at mile 23.5.

GPS: 45° 35.883' N • 115° 51.773' W
Mile 24.6 • Elevation: 7,980 ft.

Square Mountain Viewpoint and a beautifully restored cabin are about 13.8 miles from your turn onto Road 444. Near the end of the road visitors can walk to the "Square Mountain Historical Lookout." Many people visit via snowmobile in the winter.

Retrace your route to the intersection of Road 444 and Road 221 and **ZERO YOUR ODOMETER**.

GPS: 45° 38.645' N • 116° 01.520' W
Mile 0.0 • Elevation: 5,371 ft.

Continue straight ahead (west) on Road 221 for a short way, about 1 mile. Watch for Road 309 on your right (northwest).

GPS: 45° 38.824' N • 116° 02.477' W
Mile 0.9 • Elevation: 5,367 ft.

Turn right (northwest) on Road 309, signed for Old Adams Ranger Station and Highway 14. Leave pavement and turn onto a graded gravel road. Free-range cattle were frequently encountered when we were there. Many side roads along this route are closed with gates, and most side roads aren't noted in this log. Some maps identify Road 309 as Hungry Ridge Road. There are beautiful, park-like stands of ponderosa pines along this route.

Old Adams Ranger Station is at mile 1.7.

Driveway Trail 431 is at mile 4.1 (between mileposts 20 and 21).

Additional trailheads, many with facilities for horses, can be found from miles 5 to 10.

Hungry Ridge and its spectacular scenery comes into view at about mile 10.

Road 1862 to Buck Meadows Trailhead is at mile 14.3.

GPS: 45° 49.810' N • 115° 55.924' W
Mile 24.5 • Elevation: 2,334 ft.

End this expedition where Road 309 crosses a bridge over South Fork Clearwater River at a junction with Highway 14. Note the considerable loss of elevation as Road 309 switchbacked its way down from Hungry Ridge. Cross the bridge over the river. Turn right (east) for Meadow Creek Campground (within sight) and Elk City (about 36 miles east). Or turn left for South Fork Campground (about 2 miles) and Grangeville (about 14 miles west). Grangeville is the nearest full-service city. Either way, the drive along South Fork Clearwater River is excellent.

See Expedition 9 "Dworshak Reservoir, Elk Creek Falls Recreation Area," for a trip that begins in Orofino, north of Grangeville. See Expeditions 10 and 11 "Hells Canyon NRA" for trips that begin near Riggins (where this expedition begins). See Expedition 6 "Selway River, The Crags of Selway-Bitterroot Wilderness" for a trip that begins northeast of Grangeville, on Highway 12.

Other Nearby Excursions...

Nez Perce National Historic Park

One of the thirty-eight sites of Nez Perce National Historical Park is close to where this expedition ends. South of Grangeville, off Highway 95, is Whitebird Battlefield, the site of a battle between Nez Perce warriors and the U.S. Cavalry.

Selway River
The Crags of Selway-Bitterroot Wilderness

When We Were There

In late August we stopped along the Lochsa River. We were weary to the bone because we left our previous campsite at 2:00 in the morning to avoid wildfires. I took a nap on a big rock next to the river. River noise covered the sound of the vehicles on Highway 12. Ah, late enough in the season for there to be no bugs—not too hot, nor too cold. My theory is that rocks are not as hard as people think they are, especially river-smoothed boulders shaped into lounger-like curves.

If it hadn't been for the smell of smoke in the air, our camp on Fog Mountain, near the border of the Selway-Bitterroot Wilderness, would have been ideal. Normally, the mountains above the Selway River are excellent star-gazing territory, with no light pollution. We crawled into our sleeping bags, planning to hike the next day from Big Fog Saddle into the wilderness. About 1:00 in the morning, the smell of smoke grew stronger. I wandered around in the dark, trying to determine if ash was falling. The moon was a slice of mandarin orange. I reluctantly woke my brother up. Wildfire is nothing to mess around with, especially if there is only one route out of the area, and that road twists down the mountain like a restless sleeper. We packed up by headlamp.

That nap on the banks of the Lochsa River later in the day remains as one of my favorite backcountry memories. It often seems to happen that way—if you let go of "The Plan" and take things as they come you get into the true spirit of adventure.

Glacier lilies and yellow bell flowers fight their way through snow drifts at the first hint of spring warmth in Idaho's highcountry.

The Selway River, Idaho's most pristine Wild and Scenic River, begins in the Selway-Bitterroot Wilderness and meets the Middle Fork Clearwater and Lochsa rivers at the small town of Lowell.

Approach Routes

- **From Lewiston:** East and southeast on Highway 12 to Orofino, to Kamiah, to Kooskia, and finally to Lowell.
- **From Moscow:** South on Highway 95 to Highway 12 near Lewiston. See above.
- **From Grangeville:** East and north on Highway 13 to Highway 12; east on Highway 12 to Lowell.
- **From Missoula, Montana:** South on Highway 93 to Lolo, west on Highway 12, over Lolo Pass, to Lowell.

Maps (See map sources in Appendix B)

Clearwater National Forest; Nez Perce National Forest; Selway-Bitterroot Wilderness (South Half)

The Clearwater NF map shows most of the route at the bottom of its "East Half" page, but it is best to switch to the Selway-Bitterroot Wilderness map at Fog Mountain Junction. There are two National Recreation Trails in the Selway River corridor: East Boyd-Glover Roundtop and Meadow Creek, and both are open to motorized vehicles (see Selway-Bitterroot Wilderness map). Fog Mountain Road is not open to ORV traffic.

Map madness: Forest Service maps identify both the Lochsa and Selway rivers as "Middle Fork of the Clearwater Wild and Scenic River System." This is correct—the two rivers do flow into the Middle Fork of the Clearwater, and they are part of the Wild and Scenic River System. However, this long name takes up so much map room that the actual river names are sometimes missing completely, or hard to find. We added the correct river names on our expedition maps.

Know Before You Go...

Check wildfire conditions. This is black bear country. Gas is available in Lowell and Syringa but the stations are not open 24 hours. The closest small town is Kooskia at the junction of Highway 12 and Highway 13. The closest full-service towns are Kamiah, Grangeville, and Orofino. No cellphone coverage once you are in the Selway River corridor. Outfitters based in Lowell provide river trips—just look for the largest concentration of rafts and kayaks. For outfitters that provide guided hunting and fishing trips, see *www.ioga.org*. The best time to visit is April–November for Selway River camping and hiking; May–July for floating the river below Selway Falls (reservations are required for running the upper Selway); July–September for The Crags. We have visited in April and found trillium blooming and shrubs along the river dressed in fresh greenery. However, Fog Mountain, the highest point on this expedition, is almost 5,000 feet higher. The road to the wilderness border is often blocked by snow until after July 4th.

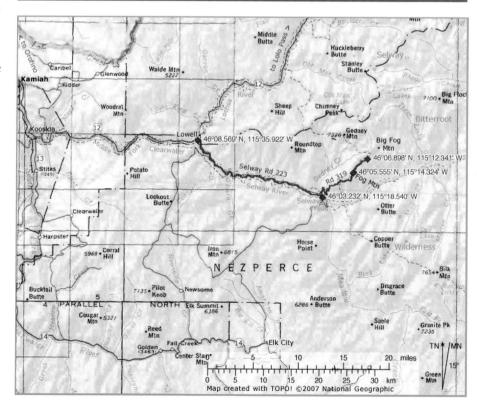

Land Administration (See Appendix A)

- **National Forest Service:** Lolo and Powell Offices; West Fork District in Montana for upper Selway float permits: (406) 821-3269.
- **BLM:** Cottonwood Field Office
- **Idaho Fish and Game:** Clearwater Region
- **Chamber of Commerce:** Kooskia

Total Miles/Road Ratings

- **Total Miles:** 30 (one way)
- **2WD paved or graded gravel/dirt:** about 7 miles paved; about 11 miles graded gravel/dirt
- **4WD required:** about 12 miles (trailers prohibited)

Expedition Directions

Set your GPS to display Degrees and Decimal Minutes. This expedition begins near the town of Lowell, at the confluence of the Selway, Lochsa, and Middle Fork Clearwater rivers. The Lewis & Clark Highway, Highway 12, is a major east-west route that crosses from Lolo, Montana to Walla Walla, Washington.

GPS: 46° 08.569' N • 115° 35.922' W
Mile 0.0 • Elevation: 1,459 ft.

Turn east on Selway River Road 223, from Highway 12, just south of Lowell, and north of Wild Goose Campground. A bridge crosses here to the north side of the Selway River. Highway 12 was not completed through this area until 1962, and the area still has a backcountry feel. Stay on the main road all the way to Fog Mountain Road.

At mile 2.9, Swiftwater Road 470 on the right (south) leads to Lookout Butte.

At mile 3.9, Johnson Bar Campground entrance is signed.

At mile 4.7, Fenn Ranger Station is signed. The building is on the National Register of Historic Places. It was built in the 1930s by the Civilian Conservation corps.

At mile 5.1, CCC Campground entrance is signed.

GPS: 46° 05.191' N • 115° 31.056' W
Mile 7.1 • Elevation: 1,542 ft.

Keep straight ahead to stay on Selway River Road at this junction with Road 1542 to Elk City. The O'Hara Campground is across

Ponderosa pines flourish on slopes above the Selway River. Speckled horsehair lichen hangs from the branches, a sign that north-central Idaho gets ample rain.

the bridge, on the south side (reservations required). Pavement ends here at O'Hara Creek, and washboards begin. The gravel/dirt road is heavily traveled by river runners and other visitors The road also narrows here. Drive carefully. Traffic from numerous campgrounds enters the main road.

At mile 8.3, Rackliff Campground.

At mile 9.7, Twentymile Bar Campground.

At mile 10.6, Slide Creek Campground.

At mile 11.1, Boyd Creek Campground, and the western end of the Boyd-Glover Roundtop National Recreation Trail.

At mile 14.7, Twentyfive Mile Bar Campground.

At mile 15.6, Glover Campground.

GPS: 46° 03.232' N • 115° 18.540' W
Mile 18.6 • Elevation: 1,725 ft.

Turn sharply left, northwest (greater than 90° turn) on Fog Mountain Road 319. The road is signed for Big Fog Saddle. In winter months administrators use a gate to close this road. Fog Mountain Junction Campground is 0.2 mile up this road. This 4WD road climbs steeply, is narrow and has few turnouts. If the road is wet, 4WD experience is required. When we were there the lower half was graded, washouts had been rocked over, and brush was cut back; but the upper half was still rocky, rutted, and narrowed by encroaching brush.

At mile 24.8, the trailhead for Trail 725 is on the left (north) leading to Gedney Creek.

Fog Mountain Saddle is at mile 25.1.

GPS: 46° 05.555' N • 115° 14.324' W
Mile 27.1 • Elevation: 6,430 ft.

Fog Mountain. A spur road leads east to a Lookout (it is not signed). This is the best informal campsite on Fog Mountain Road, and it offers the best views of The Crags (also known as "Selway Crags"), a subrange of the Clearwater Mountains. The Crags have a distinctive, serrated outline reminiscent of The

A fawn remains quiet and still to avoid predators. Its spotted coat, like dappled sunlight, helps camouflage it in Idaho's forests.

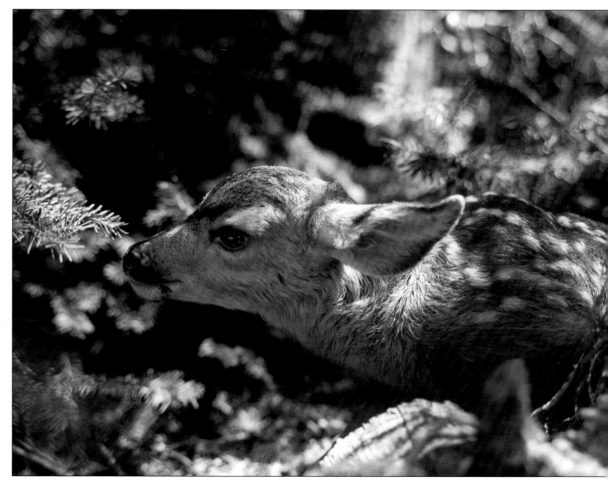

Bighorn Crags in the Frank Church Wilderness. Chimney Peak is the highest, at 7,840 feet, which is quite dramatic when you consider that most of the Clearwater Mountains roll up to 6,000-foot forested tops. Alpine lakes dot The Crags area. If you plan to hike or backpack here, you will need the Selway-Bitterroot Wilderness map.

Campgrounds along the Selway River were full when we where there, but we saw no one on Fog Mountain. Well, we saw no humans. We did see forest grouse ("fool hens") eating overripe thimbleberries and reeling drunkenly along the roadside. Wild turkeys were abundant, as were deer. From this viewpoint, the road descends to Big Fog Saddle at mile 29.8.

GPS: 46° 06.898' N • 115° 12.341' W
Mile 30.0 • Elevation: 5,863 ft.

The end of this expedition is at the end of Fog Mountain Road 319. Just beyond Big Fog Saddle is a trailhead for three trails into the Selway-Bitterroot Wilderness: Trail 31 to Cove Lakes, and into The Crags; Trail 343 to Big Fog Mountain and beyond; and Big Rock Trail 693 to Moose Meadows, with a loop to Trail 343. Big Fog Mountain Trailhead is set up to accommodate horsemen, with hitching rails and loading ramps (all this in spite of the fact that the access road is signed "no trailers").

Retrace your route, returning to Selway River Road.

Option 1: From the intersection of Fog Mountain Road and Selway River Road, we recommend a short drive to the end of Selway River Road. Turn east and drive 0.5 mile to a "Y" intersection where you have a choice of taking the right fork (Road 290) to Selway Falls Campground and Meadow Creek National Recreation Trail; or take the left fork and continue to Race Track Campground (mile 0.8), to Race Creek Campground (mile 1.5) and to the end of Selway River Road 223. From the end of the road, the hike along the Selway River is one-of-a-kind beautiful. A river that runs free, with no dams, and on which river traffic is limited, feels and looks different. Sandbars and natural wetlands enhance the shore. The hiking trail leads to the wilderness border in about 0.6 mile, an almost level walk. Backtrack toward Highway 12. See Option 2 at right.

Option 2: From the intersection of Fog Mountain Road and Selway River Road, turn west to return to Highway 12 and Lowell. Expedition 7's "Lolo Motorway/Lewis & Clark Motorway" trip begins near the Powell Ranger Station, about 66 miles east-northeast on Highway 12. The highway follows the Lochsa River, perhaps the wildest of Idaho's Wild and Scenic Rivers. At the intersection of Highway 12 and Selway River Road, you can also opt to drive west on Highway 12 to Kooskia. See Expeditions 5 and 9 for other nearby trips.

Lolo Motorway
Lewis & Clark National Historic Trail

Other Nearby Excursions: DeVoto Memorial Grove

When We Were There

On the last day of August we turned uphill from Highway 12 and drove into the Bitterroot Mountains. It was still summer along the Lochsa River, but autumn found us as we climbed. Forest fires north of us hazed the sky and enhanced the fall colors. We stopped to hike on a trail that traversed a hillside near the road. Wooden signs marked it as "Lewis & Clark National Historic Trail." Along the Lolo Motorway, there are several places where the road is the trail, and more places where the road briefly intersects the route of Lewis & Clark's Corps of Discovery.

This part of Lewis & Clark's route from St. Louis to the Pacific Coast caused the Corps a tremendous amount of suffering. From September 11-22, 1805, they struggled over "the most terrible mountains I ever beheld," as Sergeant Patrick Gass wrote. The men nearly starved, and were forced to kill and eat two of their horses. Clark wrote,

> "Several horses Sliped and roled down Steep hills which hurt them verry much…from this point I observed a range of high mountains Covered with Snow from SE to SW with their tops bald or void of timber…"

The bald mountaintops he saw were probably The Crags in what is now known as the Selway-Bitterroot Wilderness. We saw them too from our "Best View" spot on Lolo Motorway. "Motorway" is a throwback to the days when you donned goggles and a "duster" coat to "motor" on your way. Many roads were still mostly horse-and-buggy traffic. Lolo Motorway was built in the 1930s by the Civilian Conservation Corps. It follows the "*K'useyneisskit*" buffalo trail of the Nez Perce tribe, and is identified on some maps as "Nee Me Poo National Historic Trail," referring to the Nez Perce name for their people, and to their flight from U.S. Army troops in 1877. Older maps identify the road as "Lewis & Clark Motorway."

Approach Routes

- **From Lowell:** East/northeast on Highway 12 to Parachute Hill Road 569, near the Powell Ranger Station and Campground.
- **From Kooskia:** East on Highway 12 to Lowell. See above.
- **From Missoula, Montana:** South on Highway 93 to Lolo, west on Highway 12, over Lolo Pass, to Parachute Hill Road 569. Visitor information is available at the Lolo Pass Visitor Center.

Maps (See map sources in Appendix B)

Clearwater National Forest

Land Administration

(See Appendix A)

- **National Forest Service:** Lolo and Powell Offices. You can also get information at the Lolo Pass Visitor Center.
- **BLM:** Cottonwood Field Office
- **Idaho Fish and Game:** Clearwater Region

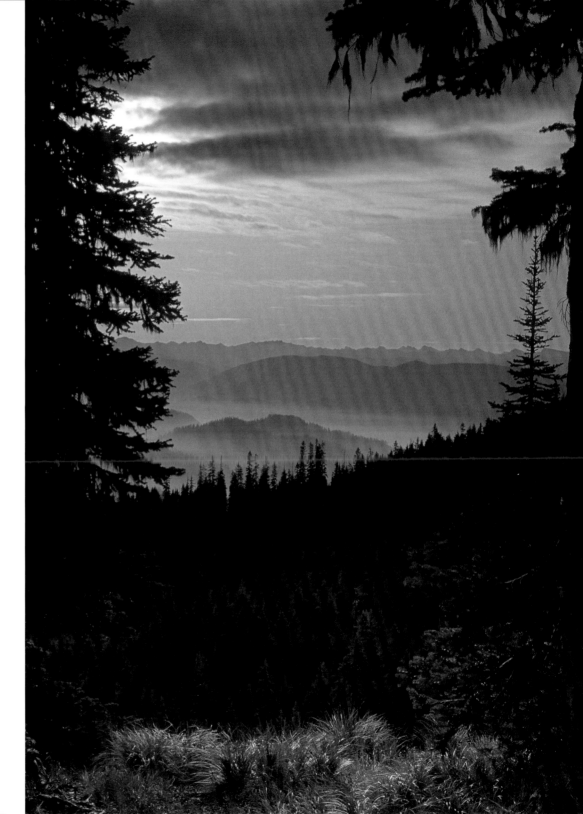

The Bitterroot and Clearwater Mountain ranges as seen near Lolo Pass, on the Lewis & Clark National Historic Trail.

Know Before You Go...

NOTE: There are no services whatsoever. Bring food, water, a good spare tire, emergency camping gear, maps, compass, GPS, shovel, saw, and so on (see "Checklists" on pp. 26-27). Lolo, Montana, and Lowell, Idaho have the nearest gas stations. You may need to carry extra gas. The route follows ridgelines and is therefore prone to lightning strikes. This is black bear country. There is no cellphone coverage. The best time to visit the mountains is early July, when the weather is damp enough to postpone wildfire season. If there are no forest fires in the area, July–September is good. Winter recreation centers around the Lolo Visitor Center on the Idaho/Montana border. The Center issues passes for snowmobile riding and crosscountry skiing.

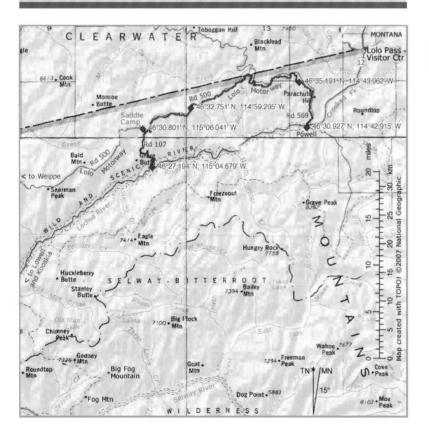

Total Miles/Road Ratings

- **Total Miles:** 44
- **2WD paved or graded gravel/dirt:** about 10 miles. Narrow gravel road is not suitable for trailers.
- **4WD recommended:** about 35 miles. Driving skills needed include expertise in backing up on a winding narrow road for as much as a quarter mile to let others pass. Most of the road is in better condition than warning signs indicate…however, there are always those few spots where rocks or ruts will cause a clearance problem for 2WD vehicles. There are also ups and downs where you can get by with 2WD, but will wish you had 4WD. Check road conditions at the Powell Ranger Station. Not suitable for trailers or large RVs.
- **4WD required:** about 35 miles in wet weather.

Expedition Directions

Set your GPS to display Degrees and Decimal Minutes. This expedition begins east of Powell Ranger Station on Highway 12. The route loops into the Bitterroot Mountains, follows the Lolo Motorway along ridgetops, and then descends again to Highway 12. At a junction with Saddle Camp Road 107 (where this expedition turns south to return to Highway 12) it is possible to continue west if you want to drive the entire Lolo Motorway. This expedition samples only 29 miles of the 73-mile-long Lolo Motorway.

GPS: 46° 30.927' N • 114° 42.915' W
Mile 0.0 • Elevation: 3,562 ft.

Turn north onto Road 569, Parachute Hill Road, off Highway 12 near Powell Ranger Station. Old signs at this intersection identify Lolo Motorway as "Lolo Divide Road." Signs also show directions and miles to some of the first landmarks on the Motorway, including Papoose Saddle and Cayuse Junction.

This area has been logged, and continues to be an active logging area. There are so many side roads it would take an entire book just to list them all. Many side roads look just like the main road in terms of condition and use. The only saving grace is that land managers have been diligent in signing most intersections. Keep in mind that you will be staying on Road 569 to Papoose Saddle, and don't expend your worry quota on intervening five-or-six-road intersections. Road 569 trends north to Rock Point Lookout Road (about mile 4.5), then northwest to Powell Junction and Papoose Saddle.

At mile 5.7 is Powell Junction, elevation 5,872 feet, signed. Keep straight on Road 569.

GPS: 46° 35.191' N • 114° 43.962' W
Mile 6.9 • Elevation: 5,646 ft.

Papoose Saddle. Proceed straight ahead on Road 500 (Road 109 on some maps) at this junction with many choices. The straight-ahead (northwest) fork is signed "Historic Lolo Trail Corridor" and "Lolo Motorway." Interpretive signs explain Leave-No-Trace camping techniques (there are no formal campgrounds here); an overview map depicts the route all the way to Kamiah or Weippe. Signs also note that there are no services for over 100 miles (the Motorway is 73 miles long, but you must travel beyond its end to find services). Wood-gathering for campfires is not allowed within 0.25 mile of the road for the next 4 miles. On some maps, Papoose Saddle is identified as Imnamatoon Likoolam.

From this point on, the Lolo Motorway travels high ridges for several miles.

GPS: 46° 35.123' N • 114° 47.924' W
Mile 12.2 • Elevation: 6,745 ft.

Our self-proclaimed "Best View from the Lolo Motorway." This is an informal, unsigned overlook. Watch for a very short spur road on the left (south) leading to an overlook. The viewpoint is about 1.4 miles west of Lost Lakes Trail 13, a trailhead with a small sign next to the road, but not identified on maps.

At mile 13.7, Snowbank Camp is signed. Excerpt from Clark's journal:

"Septr. 16th 1805 began to Snow about 3 hours before Day and continued all day the Snow in the morning 4 inches deep on the old Snow, and by night we found it from 6 to 8 inches deep …I have been wet and as cold in every part as I ever was in my life…Killed a Second Colt which we all supped hartily on and thought it fine meat."

GPS: 46° 35.930' N • 114° 51.226' W
Mile 18.0 • Elevation: 5,374 ft.

Cayuse Junction. Bear left to stay on Road 500.

GPS: 46° 34.379' N • 114° 54.588' W
Mile 22.1 • Elevation: 6,188 ft.

Bear Oil and Roots Camp. Excerpt from Lewis's journal, written on their return trip in June, 1806:

"…arrived at our encampment of September [16, 1805]… our meat being exhausted we issued a pint of bears oil to a mess which with their boiled roots made an agreeable dish."

At mile 25.1, keep straight (right fork, west/southwest) to stay on Road 500 at a junction with Road 566.

GPS: 46° 32.751' N • 114° 59.295' W
Mile 27.1 • Elevation: 6,879 ft.

Indian Post Office, near Lonesome Cove. One of the mares whose colt the men had eaten, later returned to this spot looking for her offspring. A few of the Corp's other horses followed the mare and the men spent half a day rounding them up. Rock cairns mark this spot, though they have been vandalized in the past. East of Indian Post Office, the Lolo Motorway reaches its highest point at 7,033 feet.

Moon Saddle is at mile 29.3.

GPS: 46° 31.818' N • 115° 03.947' W
Mile 32.0 • Elevation: 6,173 ft.

Keep straight ahead to continue on Road 500 at this junction with Road 588 (Road 588 leads north to Howard Camp).

GPS: 46° 31.648' N • 115° 04.653' W
Mile 32.6 • Elevation: 6,476 ft.

Stay on Road 500 in the Devil's Chair area. Side roads on the ground are not depicted on all maps.

GPS: 46° 30.801' N • 115° 06.041' W
Mile 35.6 • Elevation: 5,405 ft.

At a "T" intersection with Saddle Camp Road 107, you have the choice to continue north and west on the Lolo Motorway or turn south on Road 107 to return to Highway 12. Our expedition turns south here on Road 107, a maintained graded-gravel road.

GPS: 46° 27.194' N • 115° 04.679' W
Mile 44.0 • Elevation: 2,777 ft.

This is the end of this expedition. Saddle Camp Road 107 meets Highway 12. Turn left (northeast) for Jerry Johnson, Powell, Wendover, and Whitehouse campgrounds; also turn left for Lolo Pass, and Montana. Turn right (southwest) for Lochsa Historic Ranger Station, Wilderness Gateway Campground, Knife Edge and Apgar campgrounds, and the town of Lowell.

See Expedition 6 for a nearby excursion that includes the Selway Wild and Scenic River.

Other Nearby Excursions...

Devoto Memorial Grove

This grove of old-growth trees is three miles east/northeast of Powell Ranger Station, on Highway 12. It is named for Bernard DeVoto who compiled an abridged version of the Lewis & Clark journals in the early 1950s. The grove includes Douglas fir, grand fir, pacific yew, and the predominant western redcedar, which can live as long as 3,000 years.

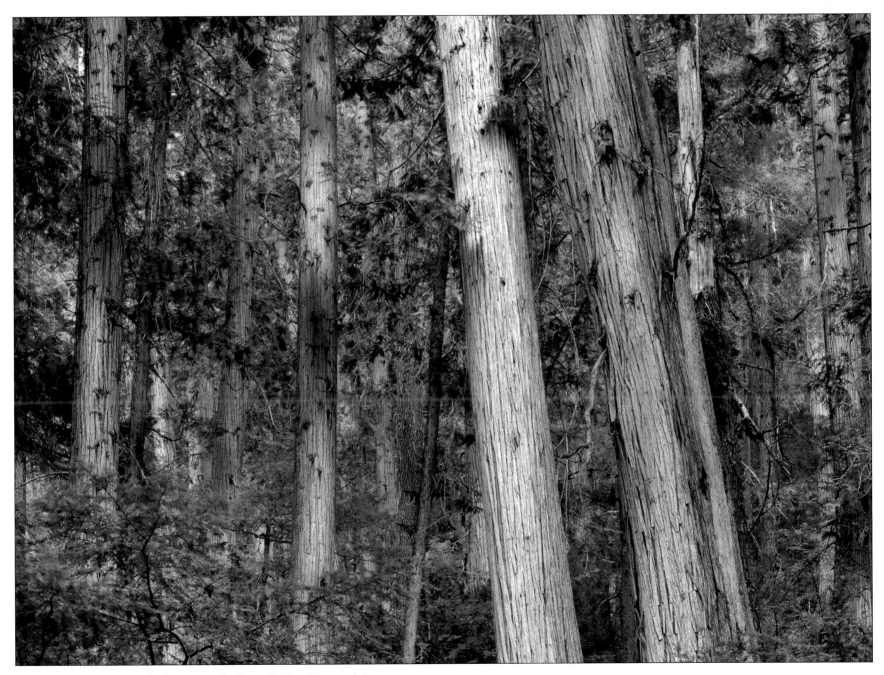

A majestic old-growth stand of western redcedar at DeVoto Memorial Grove.

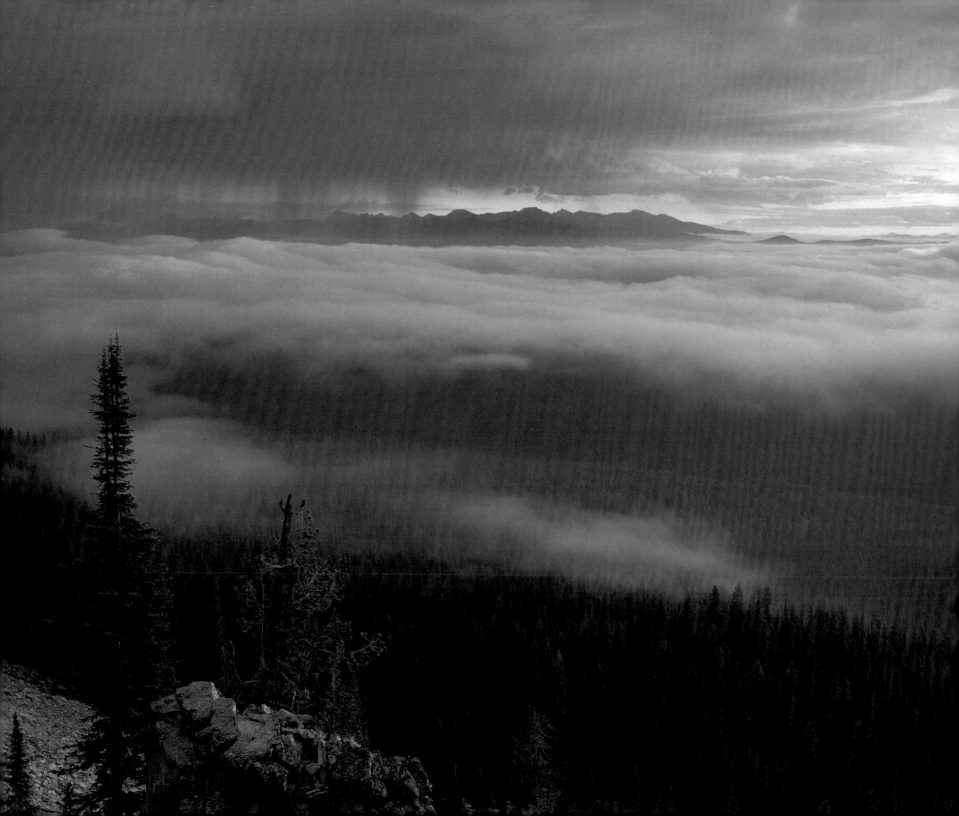

Magruder Corridor Road • Frank Church and Selway-Bitterroot Wilderness Areas

Other Nearby Excursions: Elk City Wagon Road

When We Were There

In July, before the wildfire season was in full swing, we drove the Magruder Corridor Road. This road, which goes between the Selway-Bitterroot Wilderness and the Frank Church–River of No Return Wilderness, gives visitors a sense of the sheer size of this chunk of north-central Idaho. The road stretches from near Elk City, Idaho to Montana's Bitterroot Valley. Nez Perce, Payette, Salmon-Challis, and Bitterroot National Forests manage lands near the road.

We drove though seemingly endless mountains furred with forest. Mist rose from the hidden Middle Fork of the Salmon River. Near Observation Point, burn scars, some as old as a hundred years, can be distinguished from newer burns. The old scars are yellow-green with second growth. Middle-age burns are a mix of shrubs, fireweed blooms, and the spikes of new conifers. New burns are gray-brown with vertical accents of black trees, stripped of everything but the dark column of their trunks. The slope directly below us hadn't burned in decades, but was fully one-third dead trees, torches ready to be lit. Sure enough, the area burned later in the summer.

Approach Routes

- **From Highway 14:** Turn southeast on Road 222. Drive through the Red River Wilderness Management Area toward Red River Ranger Station. Just before the ranger station, at a junction of Roads 222 and 234, bear right to stay on Road 222. South of the ranger station, at a "Y" intersection, bear left on Road 468, Magruder Corridor Road.

- **From Grangeville:** East on Highway 13 to Highway 14; east on Highway 14 toward Elk City. See above.

- **From Lewiston:** East on Highway 12 to Orofino; south on Highway 12 to Kooskia; south from Kooskia on Highway 13 to Highway 14. See above.

- **From Darby or Conner, Montana (on Highway 93):** West on West Fork Road to Magruder Corridor Road 468. From this approach, drive the expedition backwards.

Magruder Corridor Road traverses the boundary between the Frank Church–River of No Return and the Selway-Bitterroot Wilderness areas. This view from Observation Point takes in the Salmon Mountains above the Middle Fork of the Salmon River.

Maps (See map sources in Appendix B)

Nez Perce National Forest; Bitterroot NF; Selway-Bitterroot Wilderness (South Half); Frank Church–River of No Return Wilderness (North Half)

The wilderness maps are highly recommended for this expedition. Some maps identify the Selway River only as "Middle Fork of the Clearwater Wild and Scenic River System."

Land Administration (See Appendix A)

- **National Forest Service:** Elk City and Darby Offices
- **BLM:** Cottonwood Field Office
- **Idaho Fish and Game:** Clearwater Region

Know Before You Go...

The distance between service stations on this expedition is 117 miles. The closest towns with services are Elk City, Idaho, and Darby, Montana. Expect to travel about 15 miles per hour. There are some designated campgrounds along this route, but most are primitive, with no water and no trash-removal service. There are dozens of informal campsites. Weed-free-feed is required for stock. This route provides access to upper portions of the Selway Wild and Scenic River. Reservations are required for river runners. This is black bear country. Check wildfire conditions. There is cellphone coverage only in Elk City and in Darby, Montana. The best time to visit is July–September.

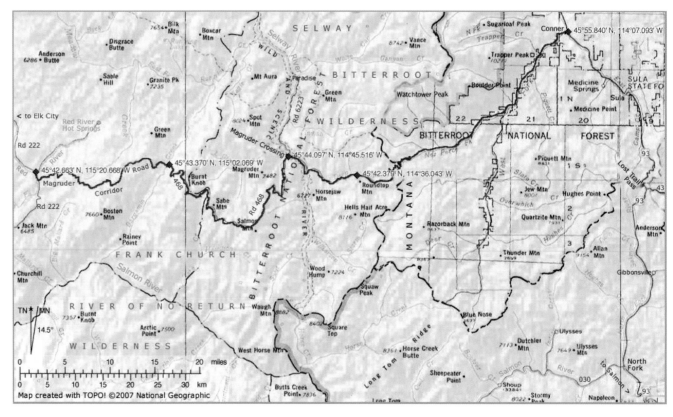

Total Miles/Road Ratings

- **Total Miles:** 108.9
- **2WD paved or graded gravel/dirt:** about 52 miles
- **4WD recommended:** 5 to 25 miles, depending on weather. Not suitable for trailers.
- **4WD required:** about 57 miles, suitable for SUVs.

Expedition Directions

Set your GPS to display Degrees and Decimal Minutes. This expedition begins near Elk City, Idaho, traverses the state through the heart of its largest wilderness areas, and emerges in Montana's Bitterroot Valley, near the town of Darby. The road begins as improved 2WD graded gravel, but becomes 4WD-recommended about mile 14, and 4WD-required about mile 19.5. Pulling a trailer is not recommended beyond Granite Spring Campground (mile 17.6), though some outfitters pull horse trailers much further.

GPS: 45° 42.663' N • 115° 20.668' W
Mile 0.0 • Elevation: 4,340 ft.
Bear left on Magruder Corridor Road 468 at a "Y" intersection about 0.4 mile south of Red River Ranger Station.

Option: At a junction of Roads 222 and 234, just north of the Ranger Station, Road 234 provides access to Red River Hot Springs, a popular campground and recreation area.

Follow Road 468 about 0.7 mile south, then east as it heads toward the Frank Church–River of No Return Wilderness. The road is improved 2WD to the border of the Frank Church, about 14 miles. There are many side roads not listed in this log. You'll be on Road 468 all the way to Montana.

Some maps identify Magruder Corridor Road as also being the Southern Nez Perce Trail. The Nez Perce people used the South Fork Clearwater River and the Red River area as hunting and fishing grounds.

Option: At mile 1.9, Road 1172 provides another opportunity to drive northeast to Red River Hot Springs.

Enter the Mountain Meadows area at mile 7.9 and stay on Road 468.

At mile 9.1, bear right (east) on Road 468 at a "Y" intersection in Mountain Meadows. Informal campsites are nearby.

At about miles 13 to 14, the road quality deteriorates and 4WD is recommended.

At mile 17.6, Granite Spring Campground offers drinking water, pit toilets, and stock facilities. From this point on, 4WD conditions on Magruder Road vary from recommended to required depending on the weather conditions and road repair work.

GPS: 45° 33.874' N • 115° 05.889' W
Mile 19.4 • Elevation: 6,766 ft.
Bear right to stay on Magruder Corridor Road 468 at this "Y" intersection with Road 285. 4WD is recommended for the descent from this intersection to Bargamin Creek. 4WD is required in wet weather.

Option: Road 285 leads northeast to Green Mountain Lookout, and continues north to various trailheads that include Selway River destinations.

GPS: 45° 43.370' N • 115° 02.069' W
Mile 23.4 • Elevation: 5,006 ft.
Poet Creek Campground. Pack animals and riding stock are not permitted. There are four camping units with pit toilets, but no water source. Camp managers and their stock are located south of the road.

At Poet Creek Campground, the Frank Church–River of No Return Wilderness is south of the road. A few miles further east the road becomes a true corridor, with the Selway-Bitterroot Wilderness north of the road. The road climbs steeply from Poet Creek. A spur road to Burnt Knob Lookout is signed (4WD only).

Dry Saddle is at mile 31.5. This is an informal camping area with a loading ramp for stock—also a trailhead for trails into the Frank Church (elevation 7,899 feet). Trail 575 offers a short hike to three lakes, Middle, Upper and Lower Trilby. The road beyond the saddle is rough and winding, and 4WD is required.

At mile 34.6, Sabe Saddle marks the boundary between several national forests.

Sabe Vista Point is at mile 37 at an elevation of 7,490 feet.

At mile 37.5, Sabe Mountain/Salamander Creek Trail is on the left (north).

At mile 40.4, Horse Heaven Saddle and Helispot is also a trailhead for Trail 28, which leads south into the Frank Church, and to the Salmon River; and a trailhead for Trail 87 north into the Selway-Bitterroot Wilderness. A rental cabin is available on Trail 28.

At mile 43.8 are Base Camp Trailhead, Salmon Mountain Lookout Trail, and the historic site of Old Salmon Mountain Ranger Station. The walk to the Lookout is only one mile. Watch for mountain goats at this high elevation (8,944 feet). Subalpine larch trees here look like evergreens, but are really deciduous, with golden needles in the autumn. Alpine lakes lie like a string of jewels in cirques under the east wall of the Salmon Mountain Ridge area.

GPS: 45° 39.918' N • 114° 48.541' W
Mile 48.8 • Elevation: 7,620 ft.
Observation Point Campground. This spot offers some of the best views along the road, including El Capitan of the Bitterroot Range.

At mile 51.2, at a trailhead near Magruder Saddle, trails lead to Magruder Mountain; and Southern Nez Perce Trail 13 leads to Salamander Creek and Little Clearwater River.

Kim Creek Saddle and Trailhead is at mile 53.1. Trail 389 leads south to the Selway River. Trail 26 leads north to the Magruder Ranger Station and to the Selway River.

GPS: 45° 44.097' N • 114° 45.516' W
Mile 60.0 • Elevation: 3,718 ft.
Magruder Crossing. Cross the Selway River on a bridge built by the Civilian Conservation Corps in 1935. Bear right to stay on Road 468. Magruder Crossing Campground is on the east side of the river. Magruder Road parallels the Selway River for about 3.5 miles.

Option: Road 6223 leads north to Paradise Campground and Ranger Station, passing on the way Beaver Point Picnic Site (with a trail to the Magruder Massacre Site), Raven Creek Campground, Indian Creek Campground, and the Whitecap Trailhead. Paradise is a popular put-in for river runners. Lloyd Magruder was carrying profits from gold mining when he was robbed and killed in 1863. Magruder had been traveling on the Southern Nez Perce Trail from Elk City to Virginia City, Montana. A friend of Magruder's tracked the murderers to San Francisco and brought them back for a trial in Lewiston. The first legal hanging in Idaho was the outcome.

The Magruder Work Center is accessed via a spur road at mile 63.5.

At mile 64.3 is Deep Creek Campground, with a trailhead nearby for Trail 37 to Beaver Jack Mountain and beyond. The bridge over Deep Creek is built of native stone. Lithuanian stonemasons and Civilian Conservation Corps members built it in the 1930s.

At mile 70.6 is the Kit Carson Trailhead for Trail 14 to Nez Perce Lookout and beyond. Informal camping is available nearby.

GPS: 45° 42.379' N • 114° 36.043' W
Mile 71.2 • Elevation: 5,023 ft.
Keep straight to continue on Road 468 at this junction with Road 224. A 14-mile section of paved road begins here. In the 1970s logging was planned for this area, but the pavement never served logging trucks. The paved road closely follows Deep Creek and is

now 2WD to its end. Even beyond the stretch of pavement the road is graded gravel. Pavement begins again near Highway 93.

Option: Road 224 leads south to Hells Half Acre Mountain Lookout, and to Hells Half Acre Saddle Trailhead.

▌ **GPS: 45° 43.024' N • 114° 30.168' W**
▌ **Mile 79.3 • Elevation: 6,587 ft.**

Nez Perce Pass—the border between Idaho and Montana; also a trailhead for Trail 627 to Castle Rock and Bare Cone Lookouts. Leave designated wilderness here. Road 468 descends into Montana's Bitterroot Valley.

At mile 84.9 access to Fales Flat Campground is signed.

At mile 87.4, we are back in civilization and there are dozens of side roads. Stay on the main road all the way to Highway 93. On many maps the road is now named "West Fork Road." It runs along Nez Perce Fork to the West Fork of the Bitterroot River.

At mile 99.4 is Shook Mountain Landing Strip.

At mile 107.6, turn right for the small town of Conner and Highway 93; or turn left and continue on West Fork Road to another junction with Highway 93 south of Darby. Darby is the nearest full-service town.

▌ **GPS: 45° 55.840' N • 114° 07.093' W**
▌ **Mile 108.9 • Elevation: 4,105 ft.**

The end of this expedition is at Highway 93. Turn south on Highway 93 to cross Lost Trail Pass and re-enter Idaho (see Expedition 25's "Other Nearby Excursions" to Bighorn Crags from North Fork, Idaho). Turn north on Highway 93 for Lolo and Missoula, Montana (see Expedition 7 for "Lolo Motorway").

Other Nearby Excursions...

Elk City Wagon Road

At the small town of Harpster, south of Grangeville and north of Kooskia, leave Highway 13. In Harpster, the Wagon Road Tour is signed at the beginning of this 53-mile route. Pick up a *"Travel the Elk City Wagon Road"* brochure and then zero your odometer so that you can follow the mile-by-mile descriptions. The single-lane dirt/gravel road is 4WD-recommended, and 4WD-required when wet. There are a few steep switchbacks, and snow may be encountered at higher elevations. Trailers are not recommended. There are no designated campgrounds, but plenty of informal camping along the route. The South Fork of the Clearwater River runs next to sections of the road. The brochure-guided tour ends near Elk City, on Highway 14, near the beginning of the Magruder Road trip. It's also possible to drive the Elk City Wagon Road backwards, beginning at Elk City.

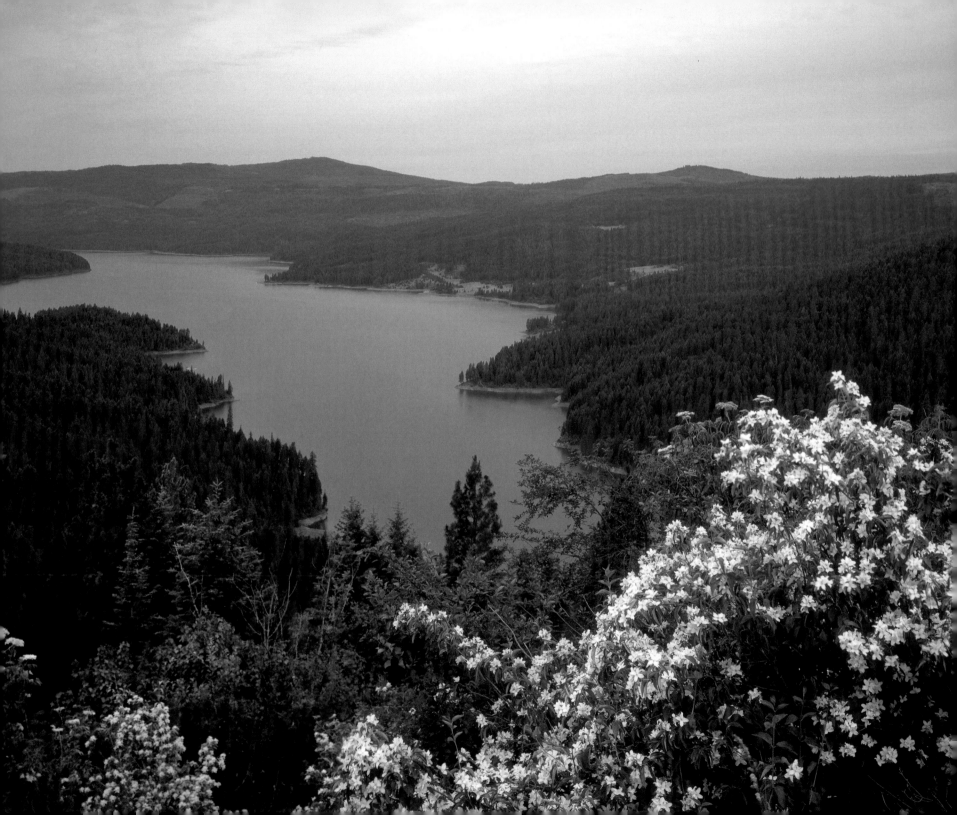

Dworshak Reservoir
Elk Creek Falls Recreation Area

Other Nearby Excursions: Old Growth Cedar Forests
White Pine Scenic Byway

When We Were There

In early July we arrive in the small town of Elk River, then find our way to Elk Creek Recreation Area. Near sunset we hike from the trailhead to the creek. Three waterfalls close together, all accessible via short trails, carve a narrow gorge. Middle Falls is the tallest at 90 feet, but if you add all the falls together you get a drop of 300 feet, the longest serial waterfall in northern Idaho. At sunset, pools reflect gold from the sky, green from a thick border of shrubs and trees, and liquid silver from the waterfalls. Eastern brook trout can be seen flitting in the shadows. Rainbow trout and westslope cutthroat trout thrive below the falls. Terrain screens the waterfalls from surrounding ORV and jeep trails. There are informal campsites along access roads to the recreation area, and one larger designated campground northeast of the town of Elk River.

Confusing names: a town in Idaho called "Elk City" is not here, that town is further south. "Elk City" is also on an Elk Creek, but that's not this Elk Creek. This Elk Creek parallels Elk River Road, but there is no river, just the creek. The town of Elk River is on Elk Creek, and the town of Elk City is on a different Elk Creek. I finally got my bearings by honing in on a major landmark, Dworshak Reservoir, to which the Elk Creek of Elk-Creek-Falls-fame contributes.

Dworshak Reservoir as seen from an overlook on the Elk River Road.

The reservoir is surrounded by seven designated campgrounds, more than a hundred informal campsites, and several boat launches, including one at Dworshak State Park. Dworshak Fisheries Complex houses the largest steelhead trout and spring chinook salmon hatchery in the world. It's open for visitors on weekdays. Outfitters based in Orofino offer guided fishing trips.

This expedition crosses Dent Bridge over an eastern arm of the reservoir. The 1,550-foot-long suspension bridge is named after a couple that homesteaded the land in 1895. Dent Bridge earned the "American Institute of Steel Construction Award of Merit, Long Span, 1972," and is listed as one of eighteen "most beautiful structures" in the United States.

The centerpiece of this expedition is water, water and more water. At Orofino, Highway 12 parallels the Clearwater River. *"Oro Fino"* means "fine gold"—the name was written as one word in the early 1900s to comply with post office regulations. It's been estimated that $10 million dollars worth of gold was extracted in the 1860s from placer deposits at Orofino Creek, a tributary of the Clearwater.

On September 20, 1805, as Meriwether Lewis travelled west along the Clearwater River, he met Nez Perce Indians. The tribe is credited with saving the lives of the malnourished Corps of

Discovery. Lewis described a meal in his journal:

*"a small piece of buffalo meat, some dried salmon, berries and several kinds of roots...one which is round and much like an onion in appearance and sweet to the taste: it is quamash, [camas] and is eaten either in its natural state, or boiled into
a kind of soup or made into a cake. After the long abstinence this was a sumptous treat."*

Canoe Camp on the Clearwater River is four miles west of Orofino on Highway 12, and is one of many Nez Perce National Historical Sites in north-central Idaho.

Approach Routes

- **From Lewiston:** East on Highway 12 to Orofino.
- **From Moscow:** South on Highway 95 to Highway 12 near Lewiston. See above.
- **From Grangeville:** East and north on Highway 13 to Highway 12; north on Highway 12 to Orofino.
- **From Bovill:** Southeast on Highway 8 to Elk River, and drive the expedition backwards.
- **From St. Maries:** South on Highway 3 to Bovill. See above.
- **From Missoula, Montana:** South on Highway 93 to Lolo, west on Highway 12 to Kooskia; north on Highway 12 to Orofino.

Maps (See map sources in Appendix B)

Clearwater National Forest; Benchmark *Idaho Road and Recreation Atlas.* Nordic skiing, ORV, and snowmobile trail maps can be picked up in Elk River.

Know Before You Go...

This is black bear country. There are gas stations in Orofino and in Elk River. Cellphone coverage only in Orofino. The best time to visit is May–October, but Dworshak Reservoir can be accessed year-round. Check for wildfire activity. Winter recreation includes snowmobile trails on most Elk River area roads; Elk River Nordic Ski trail begins near the entrance to Elk Creek Recreation Area.

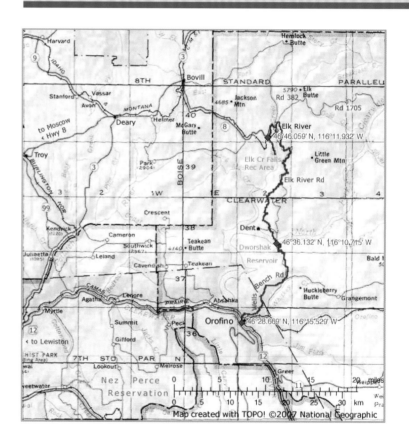

Land Administration (See Appendix A)

- **National Forest Service:** Orofino Office
- **BLM:** Cottonwood Field Office
- **Idaho Fish and Game:** Clearwater Region
- **National Park Service:** Nez Perce National Historic Park
- **Chamber of Commerce:** Orofino

Total Miles/Road Ratings

- **Total Miles:** 43.4
- **2WD paved or graded gravel/dirt:** All the way (about 22.4 miles of pavement).
- **4WD recommended:** In bad weather, for the approach to Elk Creek Falls trailhead.

Expedition Directions

Set your GPS to display Degrees and Decimal Minutes. This expedition begins near Orofino, at an elevation of 1,014 feet. The Lewiston and Orofino areas have some of the longest summers and shortest winters in Idaho. When the route heads north to Elk River it climbs to 2,860 feet, enough elevation gain to make Elk River a center for winter recreation as well. The expedition ends at the Elk Creek Recreation Area.

GPS: 48° 26.669' N • 116° 15.529' W
Mile 0.0 • Elevation: 1,014 ft.

Turn northeast off Highway 12 at the Orofino exit, signed also for Highway 7 and for Dworshak Reservoir. Cross a bridge over the Clearwater River. Turn left (northwest) on Highway 7 (also shown as Riverside Avenue and Grangemont Road on some maps).

Turn right (north) on Wells Bench Road at mile 0.3. The turn is signed for Dworshak Reservoir, Wells Bench Road, Merrys Bay, Dent Acres and Elk River. Many side roads depart from Wells Bench Road, and most of them are not noted in this log. Stay on Wells Bench Road all the way to Dent Bridge. Campground and boat launch sites along the way are signed.

GPS: 46° 36.132' N • 116° 10.715' W
Mile 15.3 • Elevation: 1,604 ft.

Dent Bridge. Cross the North Fork Clearwater River arm of Dworshak Reservoir and continue north on Elk River Road (Elk River Backcountry Byway). Pavement ends one mile north of Dent Bridge. The road continues as graded gravel, two lanes wide. Road improvement was in progress when we were there, so it may be paved when you arrive. Watch for scenic overlooks as the road climbs. Many 4WD side roads that depart Elk River Road are not noted here. Stay on Elk River Road to Robideaux Meadows area at about mile 35.

A spur road on the left (west) leads to the Dent Orchard Campground at mile 16.6.

At mile 17.4 a spur road on the left (west) leads to Dent Acres Recreation Area.

Fisher Creek Road 1272, is on the right (east) at mile 26.5.

Weitas Creek Road, is on the right (northeast) at mile 32.8.

GPS: 46° 45.449' N • 116° 10.260' W
Mile 35.0 • Elevation: 2,864 ft.

North end of Robideaux Meadows area. You have the option to bear left or right at this junction of Elk River Road and Road 4743. We suggest the right fork because it provides access to Elk Creek Campground, but either fork will lead to the town of Elk River. In town, the Lodge and General Store provide visitor information.

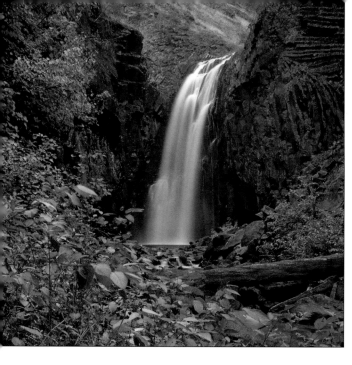

Lower Elk Creek Falls. Elk Creek cuts through distinctive volcanic formations. Basalt columns contribute to the beauty of the setting.

GPS: 46° 47.041' N • 116° 10.699' W
Mile 38.6 • Elevation: 2,860 ft.

The mileage assumes that travelers took Road 4743 to Elk Creek Campground, then turned west to town. From "downtown" Elk River, drive west on Highway 8 to the Elk Creek Recreation Area access road.

GPS: 46° 46.059' N • 116° 11.932' W
Mile 40.1 • Elevation: 2,915 ft.

ZERO YOUR ODOMETER at the junction of Highway 8 and Road 1452, about 1.5 miles west of the town of Elk River. The junction is signed for Elk Creek Falls Road (near milepost 51 on Highway 8). Leave the pavement here and turn southeast on a graded gravel road to access the Elk Creek Recreation Area. Almost immediately there are intersections with other gravel roads, including roads that lead back to Elk Creek Reservoir. Stay on Elk Creek Falls Road and follow signs for the Elk Creek Falls Trailhead. Some of the ORV trails here are part of a National Recreation Trail. There are also large parking lots suitable for unloading snowmobiles and ATVs.

GPS: 46° 47.041' N • 116° 10.699' W
Mile 2.4 • Elevation: 2,860 ft.

The end of this expedition is at the Elk Creek Falls Trailhead which is also a picnic area. Maps are displayed for trails to Upper, Middle, and Lower Elk Creek Falls. See Expeditions 5, 6, 7 and 8 for nearby trips.

Other Nearby Excursions...

Old Growth Cedar Forests

Travel north from the town of Elk River on Road 382 to get to Morris Old Growth Cedar Grove (about 6 miles). Further north on Road 382 is Giant Cedar Grove. Trees here include a western redcedar believed to be over 3,000 years old. Road 382 is 2WD in good weather, 4WD-recommended in bad weather.

White Pine Scenic Byway

Drive northwest from the town of Elk River to Bovill (17 miles). At Bovill, continue north to the junction of Highways 3 and 6. From there, you have the option of turning south or north on White Pine Scenic Byway.

South option: To Potlatch, a route that descends through a portion of the St. Joe National Forest. Stop at Giant White Pine Campground to view a felled giant. This is also the trailhead for Old Sampson Trail, a 4.5 mile ORV route in the shade of old growth trees. Palouse agricultural area, with its distinctive rolling hills, comes into view near the junction of Highways 6 and 95. Continuing south to Lewiston on 95 gives you an opportunity to drive the Old Spiral Highway, a remarkable engineering feat that used to be the only route from the Palouse Plateau down into Lewiston. The turn onto the old highway is signed.

North option: To St. Maries, a town that is full-service as well as offering its own wildlife viewing opportunities and views of the St. Joe River. The Hoodoo Mountains, a subrange of the Clearwater Mountains, are west of the St. Maries River. Near the northern end of the byway, just off I-90, is Cataldo Mission. Built in the mid-1800s, it is the oldest building still standing in Idaho (see Expedition 1 for a nearby trip).

Hells Canyon National Recreation Area Seven Devils

When We Were There

We make a mistake. A few miles short of Windy Saddle in the Seven Devils Mountains, it becomes obvious that we are the first fools on the road early in the spring. We get out and look at the snow blocking our way, and at a couple of small pine trees that have been carried by an avalanche onto the drift. We remove the trees using a hand saw, then bust through the drift. We drive a little further. Another snowdrift, more downed trees. We clear the road and go on. Around the corner, yet another drift and this time it is deeper and more than a hundred feet long. Late May is too early for a Seven Devils expedition.

Rugged is an understatement for the Seven Devils. From an elevation of about 1,000 feet on the banks of the Snake River, they rise majestically to 9,393 feet at the summit of He Devil Mountain. She Devil's summit is 9,280 feet. The high terrain of Seven Devils, about 190,000 acres in all, is designated wilderness, which is in turn part of Hells Canyon National Recreation Area. Motorized traffic is forbidden beyond the vista at Heavens Gate.

One explanation for the name "Seven Devils" comes from Nez Perce legends in which Coyote, creator of the tribe, dug Snake River Canyon to protect the Indians in the Wallowa Mountains (Oregon) from seven devils. An elaboration of this legend has it that an Indian lost in the area was surprised by a devil, and frightened by six more devils as he ran.

Approach Routes

- **From Grangeville:** South on Highway 95 to Riggins.
- **From White Bird:** South on Highway 95 to Riggins.
- **From Boise:** North on Highways 55 or 95 to New Meadows; continue north to Riggins.
- **From Lewiston or Moscow:** South on Highway 95 to Riggins.

Maps (See map sources in Appendix B)

Nez Perce National Forest

Land Administration (See Appendix A)

- **National Forest Service:** White Bird Office; Hells Canyon NRA, Riggins Headquarters; and Wallowa-Whitman National Forest (Oregon)
- **BLM:** Cottonwood and Four Rivers Field Offices
- **Idaho Fish and Game:** Southwest Region
- **Chamber of Commerce:** Riggins

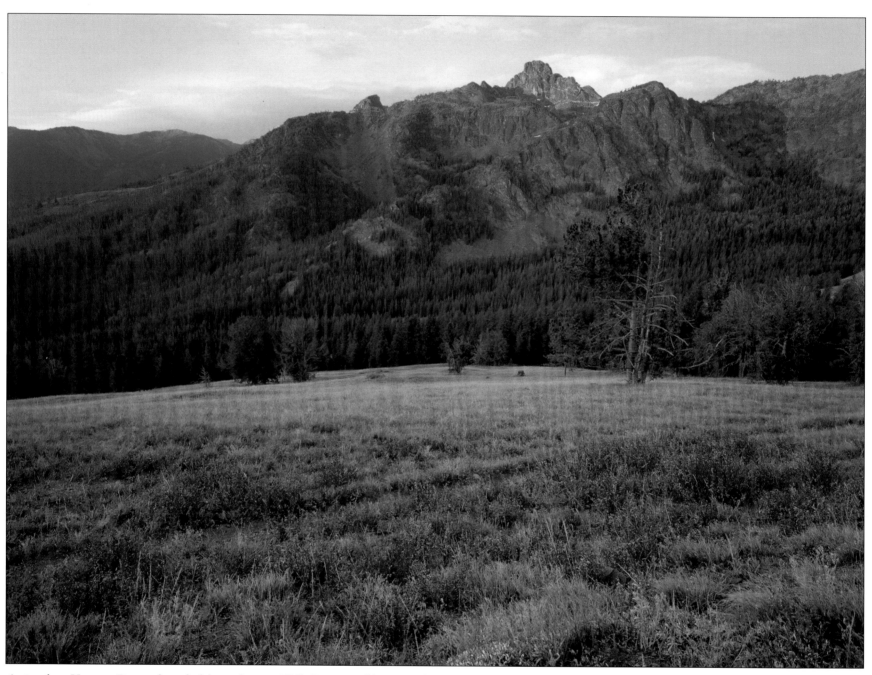

A view from Heavens Gate at the end of the road next to Hells Canyon Wilderness in the Hells Canyon National Recreation Area.

Know Before You Go...

There are gas stations in Riggins and White Bird. The road tops out over 8,000 feet above sea level. Visitors arriving from lower elevations may need to acclimate before hiking. Cellphone coverage is limited to the town of Riggins. The best time to visit is mid-July to mid-September. The road is closed to oversnow vehicles in the winter, but some people cross-country ski to Windy Saddle.

Total Miles/Road Ratings

- **Total Miles:** 18.8 (one-way)
- **2WD paved or graded gravel/dirt:** All the way
- **4WD recommended:** For steep grades. Land managers have recently improved the road for 2WD passenger car travel. However, signs on the approach note "Narrow Steep Grade. Not Suited for Trailer Traffic."
- **4WD required:** In wet weather or snow

Expedition Directions

Set your GPS to display Degrees and Decimal Minutes. This expedition begins south of Riggins, leaving Highway 95 and following Road 517. The route travels west/southwest to the Seven Devils. There are two campgrounds near the crest of the range. The road to the campgrounds is signed as not suitable for trailer traffic, but many people manage with a camper. There are usually a lot of tent campers in this area, with base camps set up for hikers and horseback expeditions. Expect primitive camping, with no water source.

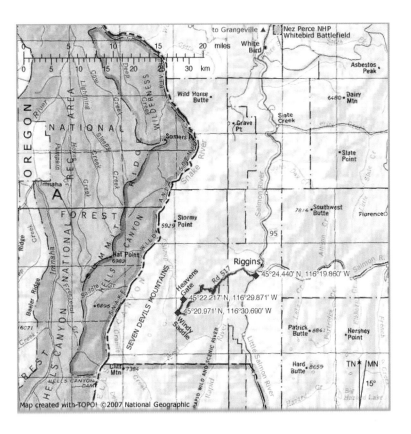

GPS: 45° 24.440' N • 116° 19.860' W
Mile 0.0 • Elevation: 1,806 ft.

Turn west onto Seven Devils Road 517, off Highway 95 near the Hells Canyon NRA headquarters, south of Riggins. The road is paved. The confluence of Little Salmon River and Salmon River is nearby. Many spur roads to private property and to informal campsites are not noted in this log.

At mile 1.8, bear left (southwest) to stay on Road 517 at this junction with Road 487.

At about mile 4, the pavement ends at the Nez Perce National Forest boundary. The road is graded gravel from here on.

At mile 4.1, Papoose Campground is on Papoose Creek.

At about mile 5, there are several informal campsites.

At mile 5.9, switchbacks uphill begin. Some side roads are closed with gates.

At mile 14.7, a steep hiking trail on the right (west) leads to Heavens Gate Vista Point.

At mile 16.6 a spur road on the left leads to Seven Devils Ranger Station.

At mile 16.9, Road 517 enters the Hells Canyon National Recreation Area.

GPS: 45° 20.971' N • 116° 30.690' W
Mile 17.1 • Elevation: 7,613 ft.

Turn right (north) to continue to Heavens Gate Vista Point. Windy Saddle Campground is next to this intersection. A spur road on the left (southwest) will lead you to Seven Devils Campground.

GPS: 45° 22.217' N • 116° 29.871' W
Mile 18.8 • Elevation: 8,132 ft.

The end of this expedition is at Heavens Gate Vista Point and trailhead.

Retrace your route back to Highway 95. Nearby trips are listed in Expeditions 5 and 11.

Thinleaf huckleberry turns a brilliant red in autumn. This low shrub loves shaded forests.

Hells Canyon National Recreation Area Pittsburg Landing

When We Were There

Hell's Canyon, May 22. The canyon is dry and hot. To escape the heat, we camp on a ridge above Pittsburg Landing. My tent fly, wet as a dishrag from its exposure to Idaho's northern rain forest, now tightens and dries. Ah, the luxury of a dry tent. Wild turkeys carry on a gobbling conversation in a pine forest below our campsite.

Informal campsites near Pittsburg Saddle are few and far between, but a 4WD road gives us access to the ridge. The spur road leads north from the main road, about 0.3 mile east of the saddle, and is depicted on the Nez Perce NF map. When we were there, hunters were camped at an informal site next to the main road. Road dust can be a problem, so I wouldn't recommend that.

If informal camping is not your idea of a good time, the campground at Pittsburg Landing is the opposite of informal. There are trailer sites, shade awnings, RV dump stations, restrooms, facilities for pack and riding stock, boat preparation and launch sites.

Not far from all the activity at the boat ramp is a protected site the Nez Perce Tribe considers sacred. Rock art and a short walking tour are on the road to the Upper Landing. Hidden in the grass, the unassuming site holds cultural treasures that are remarkable. Images on stone are enhanced by the shapes of the stones themselves. It is one of the most unusual rock art areas in the western United States. The site is thought to have been a wintering ground for hunter-gatherers as long as 12,000 years ago, and was still used

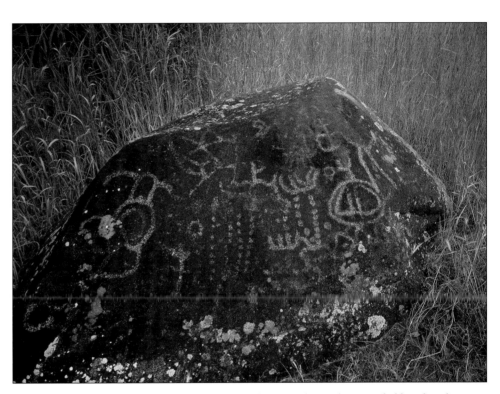

Native American rock art above Pittsburg Landing. This remarkable cultural site is of the most unusual in the western United States.

by Toohoolhoolzote's Nez Perce tribal members in 1870. Rock art that has survived is at most 2,000 years old (weathering would have erased earlier art). More sites can be viewed via boat tours on the river.

Also accessible from the Upper Landing road is a side road leading to Snake River National Recreation Trail 102. The trail offers short hikes to Kirkwood (6 miles); intermediate destinations

of 15-20 miles; and a longer jaunt of 26 miles to Granite Creek. Wear snakeproof boots and don't put your hands where your eyes can't see. In addition to rattlesnakes, there are other dangers: no potable water, poisonous spiders, poison ivy, heatstroke, and powerful river currents all threaten your life—pretty much the standard list for exploring along desert rivers—but here administrators put up pictures and signs to remind you. The scenery is heart-stopping, breathtaking, and eye-popping—so you might want to prepare for that, too. Even if you are not backpacking, we recommend a day hike on this trail as the best way to enjoy the character of the canyon and river in relative silence.

Approach Routes

- **From Grangeville:** South on Highway 95 to White Bird.
- **From Riggins:** North on Highway 95 to White Bird.
- **From Boise:** North on Highways 55 or 95 to New Meadows; north to White Bird.
- **From Lewiston or Moscow:** South on Highway 95 to White Bird.

Maps (See map sources in Appendix B)

Nez Perce National Forest; Wallowa-Whitman NF

Land Administration (See Appendix A)

- **National Forest Service:** Baker, Oregon Office; Hells Canyon NRA
- **BLM:** Cottonwood Field Office
- **Idaho Fish and Game:** Lewiston Region
- **National Park Service:** Nez Perce National Historic Park
- **Chambers of Commerce:** Grangeville and White Bird

Know Before You Go...

There are gas stations in Grangeville (30 miles) and White Bird (about 19 miles). This is rattlesnake country. The nearest medical facilities are in Grangeville. Permits are required for float trips or powerboat trips on the Snake River (these are issued by the Wallowa-Whitman National Forest Service office). There is no cellphone coverage in Snake River Canyon. This area is open year-round. You can cure spring fever by visiting in April or May, when the place is almost empty, and the weather is usually fine. The main boating season is from the Friday preceding Memorial Day to September 10.

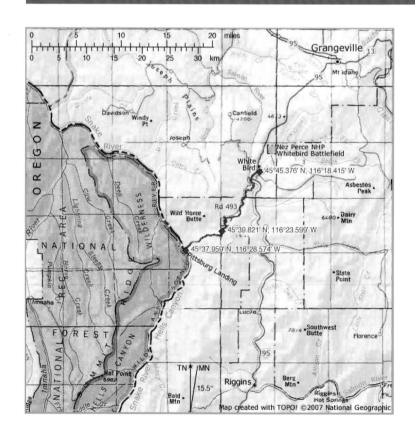

Total Miles/Road Ratings

- **Total Miles:** 19.8 (one-way)
- **2WD paved or graded gravel/dirt:** All the way
- **4WD recommended:** For steep grades
- **4WD required:** Only in wet weather, when the ascent to and the descent from Pittsburg Saddle can be slick. 4WD is also required for spur roads, or for Jeep/ATV trails in the canyon.

Even in the off season, the road to Pittsburg Landing gets a lot of traffic—boat trailers seem to top the list, with local ranchers and hunters coming in a close second. On a single-lane gravel road with a lot of twists and turns, boat trailers can provide a few harrowing moments. To be safe, it's better to pull to one side as far as you can and let them pass. There are a few turnouts, but not enough. Switchbacks include grades of up to 16%. Despite all that, the road is usually open year-round, a rarity in Idaho's back-country. It is maintained to 2WD condition most of the time. The descents are real brake-burners so gear down. Busloads of tourists use the road from June to August.

Expedition Directions

Set your GPS to display Degrees and Decimal Minutes. This expedition begins at the White Bird exit from Highway 95. Exit on the east side and drive into the small community of White Bird (population 150). From White Bird, the route passes underneath Highway 95, crosses the Salmon River, then climbs to Pittsburg Saddle on the Snake River Canyon rim. From the saddle, the road descends steeply into the canyon, ending at Pittsburg Landing at the river's edge.

Just north of White Bird is one of the Nez Perce National Historic Park sites, the Whitebird Battlefield. The exit from Highway 95 for the town of White Bird is also the access point for the historic park site.

GPS: 45° 45.376' N • 116° 18.415' W
Mile 0.0 • Elevation: 1,653 ft.

Turn east off Highway 95 at the White Bird exit. Drive into White Bird. At Cooper River Street, turn left (west). At about 0.5 mile, drive under Highway 95. Bear left and cross a one-lane bridge. Continue southwest to the bridge over the Salmon River. This part of the access route is paved.

At mile 2.3, cross the White Bird Bridge over the Salmon River and turn left (south) on Deer Creek Road 493, also signed for "Pittsburg Landing." Deer Creek Road is graded gravel. Several side roads to ranches and other private property are not recorded in this log. Stay on Deer Creek Road 493 all the way.

GPS: 45° 41.079' N • 116° 22.230' W
Mile 9.5 • Elevation: 2,746 ft.

Keep straight ahead to stay on Road 493 at this junction with Road 672 (Road 672 leads south to Cow Creek Saddle on Crooked Road). Note that the mileage given here is from Highway 95. Road 493 has mile markers that began at the bridge over Salmon River.

At about mile 10.2 from the highway Deer Creek Outfitters is signed, milepost 8.

At about mile 10.4 switchbacks uphill to Pittsburg Saddle begin. The road leaves sagebrush-covered hills and enters a mixed conifer forest.

At mile 12.3 bear right to stay on Road 493 (at a junction with Road 420, near milepost 10).

GPS: 45° 39.821' N • 116° 23.599' W
Mile 13.2 • Elevation: 4,322 ft.

Pittsburg Saddle is marked with Hells Canyon National Recreation Area border signs (near milepost 11). The views into Snake River Canyon are great from here. An unsigned hiking trail follows the ridge. **ZERO YOUR ODOMETER.** From the saddle, the road descends into the canyon.

At mile 0.2 a picnic area and informational sign provide a nice stop before the steepest section of the road. Ponderosa pines shade the picnic area. We traveled this section of road just after dawn and saw several deer, and dozens of grouse. Redtailed hawks cruised the sky.

PITTSBURG LANDING

The origin of the name pre-dates the steamboat-era. A survey map from 1867 names the landing "Pittsburgh." A seam of coal on a nearby stream has been given credit, as have mine backers from Pittsburgh, Pennsylvania. Some historians speculate that early explorers homesick for Pennsylvania may have named the landing.

Historians also debate the origin of "Hells Canyon," but I'm placing my bet on settlers who stayed (and fried) through the summer months—at least I'll give them credit for making the name stick. Congress passed the *Desert Land Act* in 1877, allowing settlers to buy 640 acres of land if they could irrigate it within three years. Settlers in the canyon became very busy digging ditches to their fields—wherever the river and the rocks gave them room to grow crops. It's hard to imagine a hotter hell than ditchdigging in Hells Canyon.

A homesteader named Mike Thomason farmed in the canyon as early as 1885. He ran the first ferry across the river, working from the Oregon side in 1891. The first homesteader on the Idaho side was Henry Kurry, who settled in the canyon in 1877. As you drive down to the landing from Pittsburg Saddle, you can still see signs of early homesteading, including irrigation ditches and some struggling fruit trees. Henry Kurry is buried in an unmarked grave near the spot where Road 493 crosses Kurry Creek. Many other homesteaders worked the land, irrigating their crops and raising cattle. Circle C Ranch owners bought the area in the 1930s. Private land was in turn acquired by the Forest Service when Hells Canyon National Recreation Area was established in 1975.

GPS: 45° 38.426' N •116° 27.996' W
Mile 5.6 •Elevation: 1,493 ft.

Pavement begins at a "Y" intersection. Bear right for Lower Pittsburg Landing and Campground. The left fork leads to Upper Landing and Campground. Near this intersection, Trail 1805 (a 4WD Jeep/ATV trail) climbs to the top of Wild Horse Ridge.

GPS: 45° 37.959' N •116° 28.574' W
Mile 6.6 •Elevation: 1,137 ft.

Lower Pittsburg Landing, Campground, and Boat Ramp. A ranger station, permit boxes, restrooms and informational signs are located in close proximity to the landing. Outfitters offer guided tours that begin here. Hells Canyon outfitters and guides are listed on websites (see Appendix A: Hells Canyon, Wallowa-Whitman NF, and Idaho Outfitters and Guides). Pack trips using horses, mules or llamas are also offered, including hunting and fishing trips in season. Jet boat or float tours on the river, aircraft above the river, and bus tours along the river are all available.

Retrace your route to the "Y" intersection above, and take the Upper Landing road to explore rock art in a unique setting. A parking lot big enough for a bus is your clue—the rock art cannot be seen from the road. Stop here and follow a foot trail and interpretive signs to view the art.

Retrace your route to Highway 95. For other nearby trips see Expeditions 5, 8, 9 and 10.

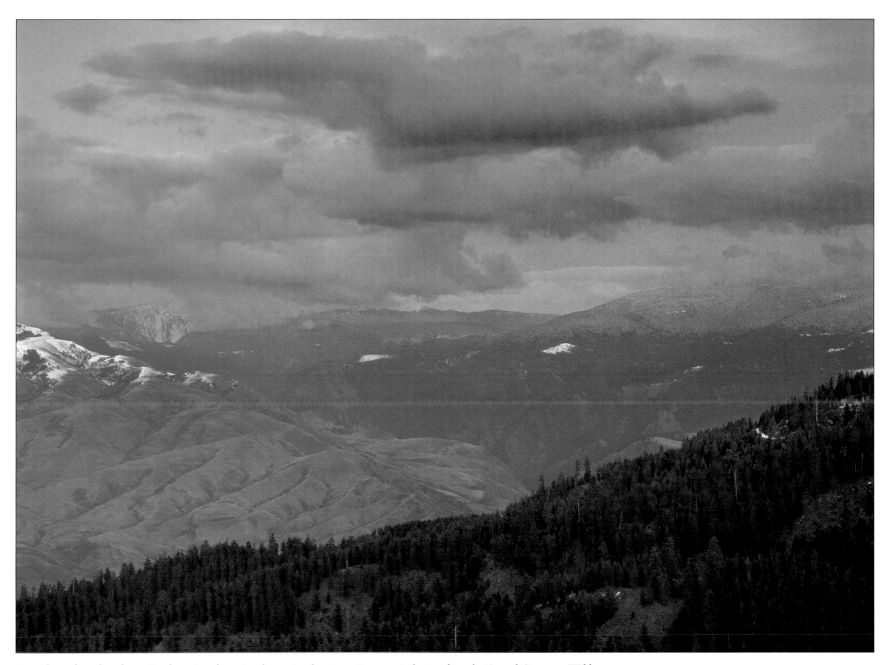

View from the ridge above Pittsburg Landing. In places, Snake River Canyon is deeper than the Grand Canyon. Wild turkeys carry on gobbling conversations in the pine forests high above the river.

West-Central Idaho

This west-central chapter features expeditions south of the Salmon River, west of Highway 93, north of Owyhee County, and east of the Idaho-Oregon border. It includes the following counties: Adams, Washington, Payette, Gem, Canyon, Ada, Valley, Boise, Elmore, Gooding, and Camas. The western half of Custer and Lemhi counties are also covered. In west-central Idaho the big-city life of Boise is balanced by wildlands that include the Frank Church-River of No Return Wilderness, Sawtooth Wilderness, and surrounding national forest, BLM, and state recreational areas.

The Salmon River Mountains are over 300 miles long and 100 miles wide. Thirty-three peaks in the range rise up over 10,000 feet above sea level. The Salmon River Mountains also include locally-named sections such as Lick Creek Mountains, Big Horn Crags, The Crags, Tango Peaks, and Grandmother Mountains. In addition to the Salmon River Mountains, west-central Idaho's highly convoluted terrain includes eight more mountain ranges. A lot of people may not know the difference between Idaho and Iowa, but many will recognize the Sawtooth Range south of the Salmon River Mountains. It is as if the Sawtooths and Sun Valley were in a different world. Think famous ski resorts, rock climbing, Hollywood stars…think Hemingway.

"Best of all he loved the fall, the leaves yellow in the cottonwoods, leaves floating in the trout streams, and above the hills the high blue windless skies. Now he will be part of them forever."
—Ernest Hemingway, Idaho, 1939

The Sawtooth Range, the jagged White Cloud Peaks, and the gentler outlines of the Boulder Mountains rim the Sawtooth Valley (see Washington Basin, Expedition 12). The valley, at about 7,000 feet above sea level, is a scenic paradise in the center of the Sawtooth National Recreation Area (SNRA). The SNRA is 778,000 acres of public land, with a designated wilderness of 217,088-acres occupying the western third.

Like the flounce on a skirt, several mountain ranges fan out south of the Sawtooths. From west to east they are: Boise Mountains, Soldier Mountains, Smoky Mountains, and Pioneer Mountains. The Trinity Mountains are a north/south ridge of the Boise Mountains that prospectors named, but most maps no longer show the name. Expedition 16 explores both the mining history in the Boise Mountains and glacier-carved cirques in the Trinity subrange.

The Boise National Forest occupies 2,265,000 acres of this mountainous landscape, with elevations ranging from 2,600 to 9,800 feet. Major rivers include not just the south and middle forks of the Salmon, but also the Boise and Payette Rivers. Some trails within the Boise National Forest are National Recreation Trails, including: William H. Pogue (motorized/nonmotorized travel), Whoop-Um-Up (crosscountry skiing), and Hull's Gulch (non-motorized travel).

Visitors will find over a hundred developed campgrounds and many more undeveloped campsites. More than 8,000 miles of streams and hundreds of lakes (plus a few reservoirs) provide visitors with opportunities for a variety of water sports ranging

A rainbow competes with the sunset to color Deadwood River in Boise National Forest.

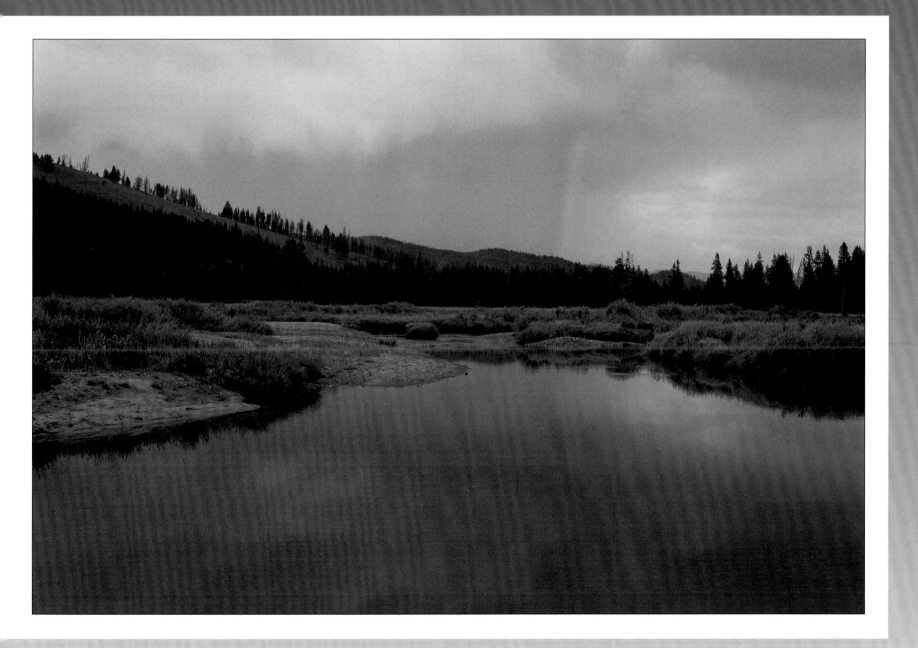

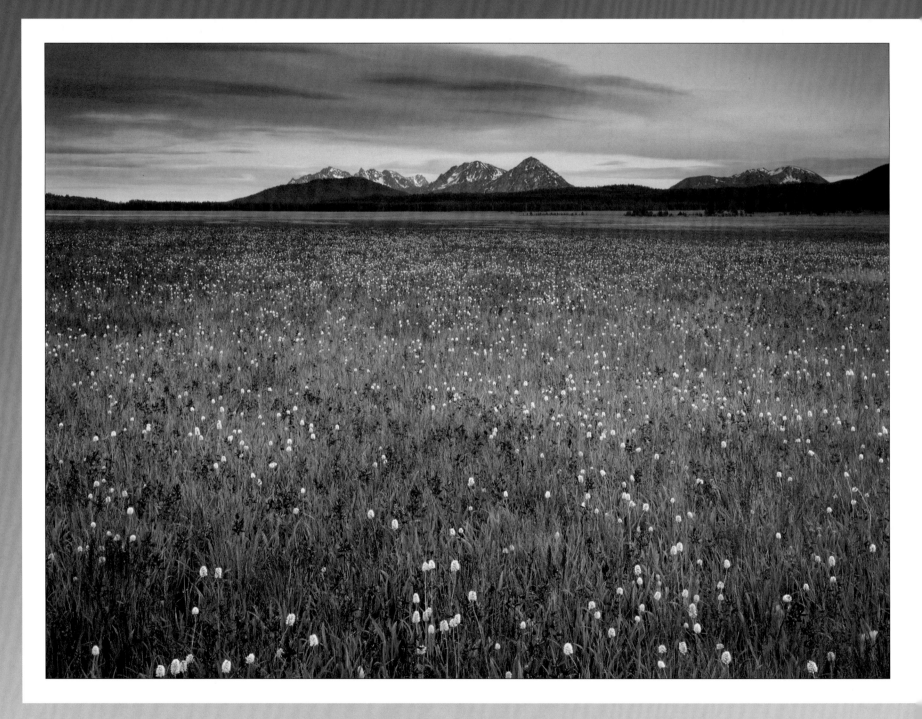

from expert-only to lazy inner-tubing on hot summer days, to fishing (it would take a lifetime to explore all of the fishing holes). Big-game hunting is also popular.

During the winter months, many backcountry roads are transformed into snowmobiling or crosscountry ski-ing trails. Snowfall may average 70 inches at higher elevations in the Boise National Forest, but the foothills are a cold desert environment with about 12-15 inches of snow. Some lower elevations remain relatively snow-free all year. Considerably more snowfall, 150-200 inches annually, graces the center of the Sawtooth National Recreation Area. This snow-bowl effect is a godsend for winter recreation, which usually extends from the end of November to the end of April.

Although our emphasis here is on exploring the backcountry, there's plenty of city life nearby. Boise and its satellite cities are an anomaly in Idaho, a true metropolitan area with high-tech industry, luxury hotels, fine restaurants and all the other amenities associated with city life. Boise glitters on the southwestern edge of this region, in direct contrast to the mountains to the north and east. Other cities and towns in west-central Idaho include Mountain Home, Stanley, Idaho City, Cascade, McCall, Wieser and Payette. Smaller commu-nities that offer supplies and gas for backcountry travelers are mentioned in the expeditions.

Right: A bull elk pauses in the shallows. By autumn, spring floods are just a memory and waterways in west-central Idaho are easier to cross.

Opposite: The Sawtooth Valley and Stanley Basin areas are a scenic paradise in the center of the Sawtooth National Recreation Area.

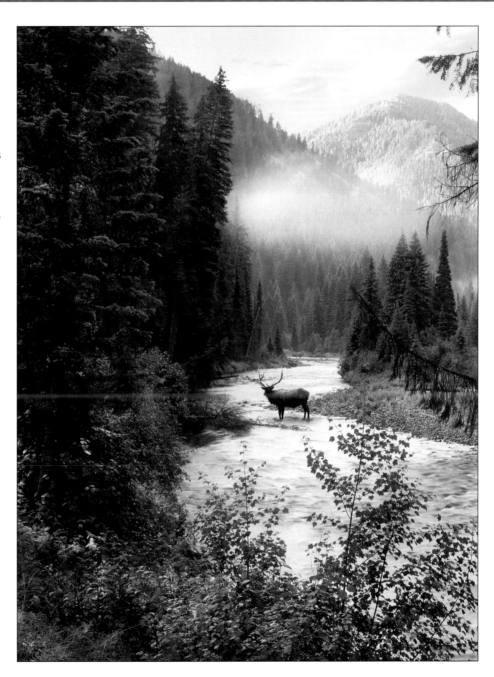

Washington Basin • White Cloud Peaks
Other Nearby Excursions: Sawtooth Wilderness

When We Were There

In the 1860s about 30,000 men and only 1,000 women lived in the Idaho Territory, a sprawling, mountainous area whose indistinct borders included present-day Idaho and Montana, and most of Wyoming. In the White Cloud Peaks area, this frontier past feels like yesterday. The peaks are found within the Sawtooth National Recreation Area (SNRA).

Most historical sources dating to the 1970s note that Washington Basin, Washington Creek, Washington Peak, and Blackman Peak are all named after a black miner who pioneered the area circa 1875. Sleuthing by Jim Ridenour, a retired geologist, reveals that mining claims reference "Washington Basin" in the early 1880s. George Z. Blackmon filed his first claim there in 1894. We can give him credit for working with a mule and a pick axe before roads existed to bring in heavier equipment, but not credit for landmark names that include "Washington." The peak named "Blackman" is a misspelling of Blackmon—and nothing is named after the "Z" of his middle initial. A tourist named John Thatcher visited Washington Basin in 1897 and later wrote an article titled *"The Black Man of Blackmon Peak,"* which was first published in 1930 in *Scribner's Magazine.* Anyone who has ever visited Washington Basin will be flabbergasted to learn that Blackmon wintered in his cabin there.

He was a negro who had been educated by a white family in Iowa and had come out with the rush of prospectors in the early eighties, located his quartz lodes and had worked them ever since. He was accustomed to pack in his supplies in the last of

A lone limber pine stump on the ridge south of Washington Peak.

August and remain for the winter snowed up until the opening of spring enabled him to pack out a few tons of ore to buy another season's provisions. I remember inquiring: "What do you do if you break a leg?" And, after some thought on his part, received the answer: "Well, we mostly don't break our legs."

More than thirty years after his first visit, Thatcher returned and was amazed to find Blackmon still working in Washington Basin: *"A long fifteen-mile climb, ten thousand feet above sea level. Familiar old cathedral peaks began to loom; a known grass meadow, an old mine-working and then a sod-roofed log cabin, and beside it a sturdy, familiar figure, a little grayer, perhaps a whit more bent, but strong—the effect of it all was somehow a little breathtaking."*

As researcher Jim Ridenour discovered, Blackmon was very industrious, filing 25 mining claims in the White Cloud Peaks, ten of those in Washington Basin. In county records, his name is seldom misspelled. George must have gotten wise to the error-prone recorders. His obituary in 1936 got it right, too (but we'll never know what the "Z" stood for).

Castle Peak is the highest peak in the White Clouds with an elevation of 11,815 feet. We got a good view of it when we climbed to Washington Peak and Croesus Peak in late July. From Washington Basin, a foot/horse trail that used to be a mule trail provides access to a saddle above Champion Lakes. From the saddle, an unofficial route climbs north to 10,519 feet at Washington Peak. From the top of Washington Peak, Blackman Peak can be seen northwest of Castle Peak. Mountain goat trails can also be

followed south and then east on the ridge that connects to Croesus Peak (10,322 ft.). Croesus Peak is named on the Sawtooth National Forest map, but not on the Horton Peak USGS topo. Hikes begin in flower-filled meadows and end on rocky summits where only lichen survives.

We saw remnants of cabins and mining digs in unlikely places. One cabin on the route to Croesus Peak was built of stone, above the treeline. Ruins can be hard to spot, and sometimes one finds rusted cans and broken bottles first. Miners seem to have universally thrown trash out their front door. Trace bits of trash back to what used to be a cabin. Ruins near the end of the road in Washington Basin include an arrastre, a primitive mill for pulverizing silver and gold ore. The arrastre is below and east of the last cabin on the main road. There are also mining ruins on Bible Back Mountain, but experience with off-trail hiking guided only by topographical maps is required to find them. It is fascinating to see these sites, but remember that taking artifacts is prohibited.

Both White Cloud Peaks and Boulder Mountains are now a proposed wilderness. Regulations allow access on established roads and trails, and Leave-No-Trace camping is required. Trail guides and camping guides can be picked up at the Ketchum or Stanley Ranger Stations. Elk, black bear, wolves, and mountain goats are some of the locals. Springtime here is late July to early August, when wildflowers fill the alpine slopes with color.

Approach Routes

- **From Ketchum/Sun Valley:** Northwest on Highway 75, over Galena Summit, then descend to a junction with Valley Road 194, south of Smiley Creek Lodge.
- **From Twin Falls:** North on Highway 93, then north on Highway 75 to Ketchum/Sun Valley. See above.
- **From Stanley:** South on Highway 75 to the junction with Valley Road 194.

Know Before You Go...

Satellite reception for GPS coordinates is difficult or non-existent along some portions of the route. This expedition is only about 17 miles, but there's a lot to see along the way, and most of the route must be driven slowly. Bring your binoculars to view mountain goats on the slopes above Washington Basin. The road ends above 9,000 feet. Be prepared for freezing night-time temperatures even in summer. This is black bear country. For possible deadfall across the road, carry a saw. Stanley is the closest full-service town. There is no cellphone coverage. The best time to visit is mid-July to late-September. Check for forest fire activity. Snowmobiles are allowed on most road corridors in winter.

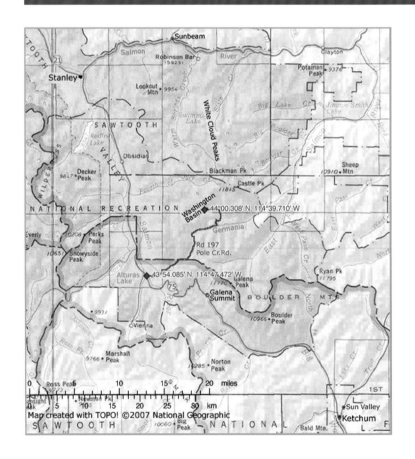

Maps (See map sources in Appendix B)

Sawtooth National Forest (Ketchum and Stanley Ranger Districts); **Sawtooth National Recreation Area;** USGS 1:24,000 topographical maps (highly recommended): **Washington Peak** and **Horton Peak**

Land Administration (See Appendix A)

- **National Forest Service:** Stanley and Ketchum Ranger Stations; Sawtooth National Recreation Area Office
- **BLM:** Challis Field Office
- **Idaho Fish and Game:** Salmon Region
- **National Park Service:** Nez Perce National Historic Park
- **Chambers of Commerce:** Stanley and Ketchum

Total Miles/Road Ratings

- **Total Miles:** 17 (one-way)
- **2WD paved or graded gravel/dirt:** about 6.5 miles
- **4WD recommended:** about 5 miles, not suitable for trailers
- **4WD required:** about 5.7 miles. This "4WD required" rating is right on the edge of being "4WD experience required" due to multiple stream crossings and long long narrow sections where drivers must be able to back up with precision to allow others to pass. Many visitors camp at lower elevations and ride ORVs up the road. Watch for ORV traffic, and be cautious around blind corners. Most of the stream crossings are easy, but two require careful placement of tires. A northeast-trending spur road near Washington Basin, not shown on any maps, is extremely steep for one short section. Not suitable for trailers.

Expedition Directions

Set your GPS to display Degrees and Decimal Minutes. This expedition begins about 0.5 mile south of the village of Smiley Creek on Highway 75, in Sawtooth Valley, north of Galena Summit. Access to this section of the Sawtooth National Recreation Area is via Pole Creek Road. The road goes over an 8,000-foot-plus summit then descends along Germania Creek before heading up again into Washington Basin on a "Jeep Trail."

> **GPS: 43° 54.085' N • 114° 47.472' W**
> **Mile 0.0 • Elevation: 7,204 ft.**

Turn east on Valley Road 194 (maintained gravel) from Highway 75. The road junction is signed for "Pole Creek Historic Ranger Station," "Sawtooth City," "Valley Rd.," and "Pole Creek Rd." This is a public road that crosses private property. There are several two-tracks (not noted in this log) leading to ranch-related buildings and stock-watering facilities. Stay on the main road.

At mile 2.4 Valley Road diverges north, and Pole Creek Road 197 begins. Bear right (east/northeast) on Pole Creek Road. Once you enter National Forest lands, there are several short spur roads that lead to campsites visible from the main road. Woodcutter regulations are posted.

> **GPS: 43° 54.754' N • 114° 44.617' W**
> **Mile 3.1 • Elevation: 7,330 ft.**

Option: A one-mile side trip leads to the "Historic Ranger Station." Improvements for visitors include handicap access, pit toilets, dog-walking area, and a bridge over Pole Creek. Return to the main road (note: side trip mileage not added to this log).

Rainbow Creek Trail access is at mile 4.9, along with an informal camping area. About a mile further, Twin Creek Trail 107 was not signed when we were there, but the spur road leading to the trailhead is easy to find.

From the ridge above Washington Basin, Castle Peak dominates the horizon.

At mile 5.2 is another access road for Rainbow Creek Trail. Rainbow Creek is signed where the main road fords it at a fairly deep ford (cross slowly). Stay on the main Pole Creek Road (straight) to continue. The road gets steeper, is only one-lane wide, and includes some blind corners.

GPS: 43° 56.173' N •114° 41.551' W
Mile 6.7 •Elevation: 7,726 ft.

Grand Prize Trail 112 is signed where it intersects Pole Creek Road. Stay on the main road, bearing left, to continue on this expedition. From this point on, the main road is "Not Advised for Trailers, Autos." 4WD is recommended. Campsites and turnouts are scarce.

At mile 9.5, Pole Creek Summit was not signed when we were there. The road tops out at about 8,500 feet and then begins a descent along Germania Creek. Some maps name the road "Germania Creek Rd." east of the summit, and some "Germania Basin," but most maps don't identify the road at all.

Option: Bear right (south) for an optional side trip on Grand Prize Trail at mile 6.7. Grand Prize is open to horse, bicycle, motorcycle, and foot traffic.

GPS: 43° 58.478' N •114° 40.188' W
Mile 10.5 •Elevation: 8,300 ft.

Stay on the main Germania Creek Road (straight). Champion Creek Trail, on the left (north) is open to foot/horse traffic only. It appears on the topo map as "Pack Trail." About 1.5 miles further, the main road fords Germania Creek twice.

GPS: 43° 58.877' N •114° 38.014' W
Mile 12.4 •Elevation: 7,883 ft.

Turn left (north) at this junction where Germania Creek Road (not signed) ends, Three Cabins Creek Trail 111 begins (signed), and Washington Basin Jeep Trail begins with a sharp turn to the north (not signed). From this point on 4WD is required, and

within 0.3 mile there is a tricky creek ford. An old bridge is collapsing at the ford, so we forded upstream of the bridge. Either way, careful placement of tires is needed.

Option: Three Cabins Creek Trail is open to horse, foot, and motorcycle traffic. It continues down Germania Creek drainage to a junction with East Fork Road on the eastern border of the Sawtooth National Recreation Area. East Fork Road leads north to join Highway 75 near Clayton.

GPS: 44° 00.253' N •114° 37.735' W
Mile 14.9 •Elevation: 8,427 ft.

A trailhead for Trail 109 is on the right. This trail leads southwest to Trail 047, a popular trail to Chamberlain Basin (not to be confused with Chamberlain Basin in the Frank Church–River of No Return Wilderness); or you can hike Trail 109 north to Trail 203 and Washington Lake. For our expedition, continue up the road to Washington Basin. On the way there are scattered ruins of past mining operations. Excellent views of Croesus Peak and Bible Back Mountain can be seen from a couple of turnouts.

At about mile 16.2 the road forks (not shown on maps and not signed on the ground), with the right fork proceeding steeply uphill. To continue on this expedition, bear left (west) at the fork.

Option: The right fork climbs to a ridge at 9,740 feet elevation, with great views and ruins of old cabins. My father identified a weathered bullet casing near one of the ruins as the type used by the U.S. Cavalry's 1873 "Trapdoor" Springfield, a gun still favored by early 1900s pioneers. A tent can be set up near weathered limber pines on the ridge, but be aware of the potential for high winds.

GPS: 44° 00.308' N •114° 39.710' W
Mile 16.7 •Elevation: 9,268 ft.

You are now in Washington Basin proper. The road crosses an unnamed tributary of Washington Creek not far from a pond that is a startling rusty color. There are several short spur roads to Black Rock Mine (debris and tumbled-down buildings) and to campsites. Continue to the end of the main road (most of the side roads also end up in the same place).

GPS: 44° 00.036' N •114° 39.758' W
Mile 17.0 •Elevation: 9,380 ft.

This expedition ends where the road ends, near one last cabin on a knoll above a shallow pond and evidence of an old earthen dam. There are several flat spots suitable for tents. This is the best spot for viewing mountain goats grazing above the basin. The foot/horse trail to the saddle below Washington Peak can be seen snaking across a steep slope to the northwest. See Expeditions 13 and 27 for nearby trips.

Other Nearby Excursions...

Sawtooth Wilderness

In 1937, the Forest Service carved out the "Sawtooth Primitive Area" that became the 217,088-acre Sawtooth Wilderness in 1972. Elevations within the designated wilderness range from 5,150 to 10,750 feet. Mount Heyburn, at 10,220 feet, is a triple-summit beauty west of Redfish Lake. Some of the best climbing in the Sawtooths is near the lake, so the Redfish Lake Lodge (the largest resort in the SNRA) has become an unofficial information center for climbers. There are over 40 official trails within the wilderness, providing about 300 miles of classic mountain hiking, and also access to rock climbing on the pink-tinged granite.

For a sampling of the wilderness close to where our Washington Basin expedition begins, turn west off Highway 75 onto Alturas Lake Road north of Smiley Creek, near milepost 169. Drive about 5 miles of paved road, passing several developed campsites at Alturas Lake. Continue on a gravel/dirt road about 1.6 miles. Park in the parking area near the creek ford. Hike Alpine Creek Trail 094.

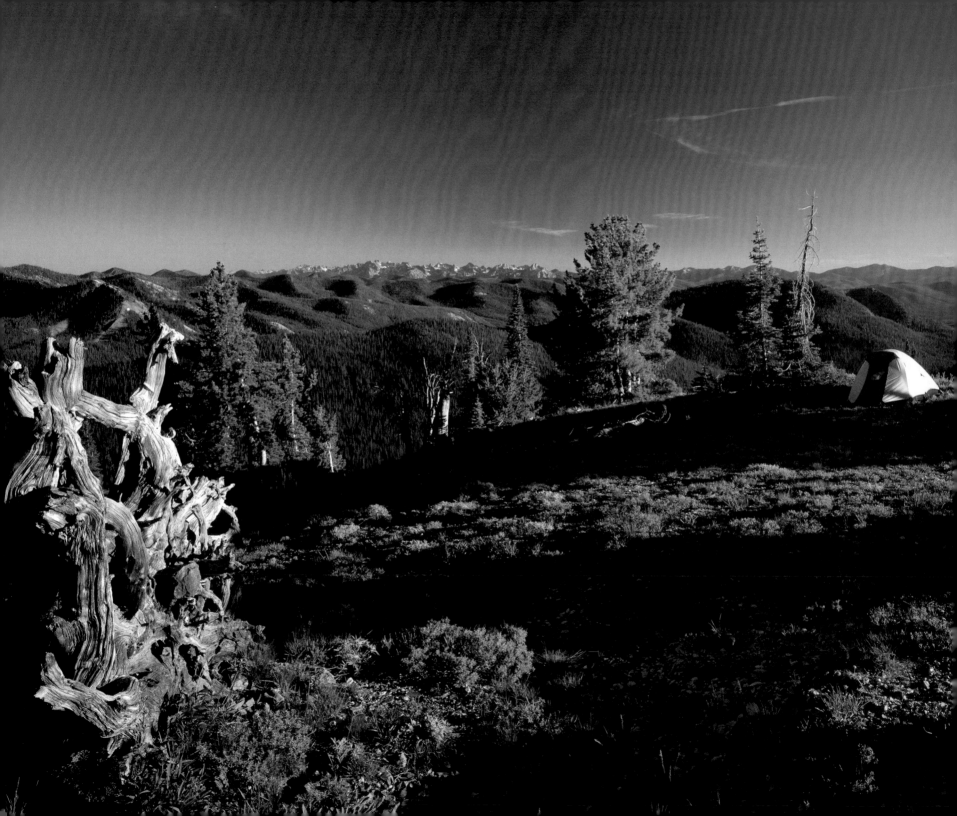

Beaver Creek–Loon Creek Corridor
Frank Church–River of No Return Wilderness

When We Were There

On July 14, we return to the road corridor that loops into the Frank Church–River of No Return Wilderness. We tried the road earlier in July, but snow stopped us at about 7,500 feet elevation, even though the valleys were sweltering. By mid-July mosquitoes are feasting on visitors in big campgrounds outside the wilderness. The town of Stanley is swarming like an ant pile: river runners, bikers, hikers, cyclists and fair goers. We enjoy socializing, then fill our vehicle with gas and head for the high country.

Snow has given way to wildflowers—a seemingly instant transformation of alpine terrain that always amazes me. Those flowers are in a hurry, knowing all too well how soon snow will return. We camp in a turnout off the spur road that leads to Feltham Point, at about 9,000 feet elevation. A breeze keeps the mosquitoes at bay, and toward sunset the temperature drops enough to stop them completely. A few limber pines cling to life at that elevation, stunted to krummholz-size if they are not in protected locations.

To the south, we see the Sawtooth Range off in the far distance, and close at hand is the impressive ridgeline of Tango Peaks. Tango Peaks are a subrange of the Salmon River Mountains; with Mount Loening, The General and Mt. Jordan all over 10,000 feet high. Cabin Peak, at 9,968 feet may be the most aesthetically impressive, with its twin summits honed like a knife. You can find the peaks, but not the name of the subrange on most maps.

Pinyon Peak Lookout offers the clearest view of Tango Peaks. The lookout is manned from about July 4th to late September. If the Ranger is not busy with forest fires, he's happy to give visitors a tour. The Lookout is grounded with twisted copper wire in case of lightning. The outhouse is anchored to rocks with steel cables to withstand the winds. This expedition brings you close to trailheads that provide foot/horse access to some of the most beautiful hot springs in the Frank Church–River of No Return Wilderness. On the wilderness outskirts, this route passes many sites related to Yankee Fork mining history.

Approach Routes

- **From Ketchum/Sun Valley:** North on Highway 75 ro Stanley; then east on Highway 75 to Sunbeam.

- **From Boise:** Northeast and east on Highway 21 to Stanley. See above.

- **From Twin Falls:** North on Highway 93; then north on Highway 75 to Stanley; then east on Highway 75 to Sunbeam.

- **From Challis:** Just south of town on Highway 93, turn southwest on Highway 75, following the Salmon River upstream. Stay west on Highway 75 to Sunbeam (about 42 miles from Challis). Note that East Fork Road, on the East Fork of the Salmon River and south of Highway 75, is marked with a picnic area near a bridge, a few miles east of the village of Clayton. East Fork Road is an excellent side trip, with many access points to seldom-visited mountains in the Sawtooth National Recreation Area.

The author's tent is a lonely outpost in the middle of the Frank Church–River of No Return Wilderness.

Maps (See map sources in Appendix B)

Frank Church–River of No Return Wilderness (southern half, issued by the U.S. Forest Service and highly recommended); **Benchmark *Idaho Road and Recreation Atlas*;** USGS 1:24,000 topographical maps (necessary for hiking or rock climbing in the Tango Peaks area): **Knapp Lake** and **Mount Jordan.**

Land Administration (See Appendix A)

• **National Forest Service:** Stanley Office (Sawtooth NF); Challis/Yankee Fork Office (Salmon-Challis NF)
• **BLM:** Challis Field Office
• **Idaho Fish and Game:** Salmon Region
• **Sunbeam Village:** see *www.sunbeamvillageresort.com*
• **Chamber of Commerce:** Stanley

Know Before You Go...

Road depictions may differ, depending on the map you use. For example, Road 172 is sometimes named "Loon Creek Summit Road" or "Beaver–Loon Creek Road" or is not named nor depicted at all. There is a lot to see along the way, and parts of the route must be driven slowly and with care. The best views are from a few miles east of Pinyon Peak to a couple of miles west of Feltham Point, where there are no designated campgrounds. Be prepared for primitive camping. There is no cellphone coverage. This is black bear country. The best time to visit is mid-July to mid-September. Check for forest fire activity. Snowmobiles are allowed on most road corridors in winter.

Mayfield Creek flows next to the 4WD road that descends from Loon Creek Summit.

Total Miles/Road Ratings

- **Total Miles:** 62.7
- **2WD paved or graded gravel/dirt:** about 19.3 miles
- **4WD recommended:** about 16.9 miles, suitable for trailers at lower elevations
- **4WD required:** about 26.5 (more if the weather is bad). This "4WD required" rating is right on the edge of being "4WD recommended" in good weather. Most of the road is better than the "narrow, rough road" and "dangerous for public travel" signs would have you believe. However, there are some sections where the road is just wide enough for one vehicle, with dramatic dropoffs on both sides. The elevation range is from about 5,300 to 9,300 feet, so there are lots of switchbacks to negotiate, and extended up or down grades. Not suitable for trailers. Some spur roads are 4WD-required.

Expedition Directions

Set your GPS to display Degrees and Decimal Minutes. The small town of Sunbeam on Highway 75 is the beginning of this expedition. A kiosk at the intersection gives visitors a rundown on mining history, attempts to dam the river for power, and local flora and fauna. Sunbeam Village can't be seen from Highway 75, but a small sign marks the entrance on Road 013. The grocery store/café/espresso bar in Sunbeam also offers books by local authors, and the owner is the manager for rental cabins. This expedition ends on Highway 21, about 19 miles northwest of Stanley.

> **GPS: 44° 16.256' N • 114° 44.069' W**
> **Mile 0.0 • Elevation: 5,984 ft.**

Turn north on Road 013 to Sunbeam Village. This is the confluence of the Yankee Fork and Salmon rivers. Road 013 is paved for about 3 miles, then two-lane graded gravel as it proceeds north. From

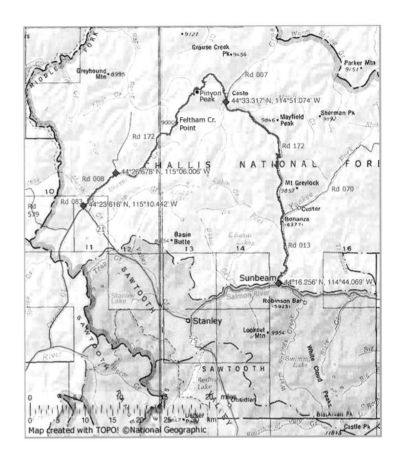

Map created with TOPO! ©National Geographic

1870 to 1911 the gold rush on the Yankee Fork boomed. Hundreds of miners once worked in mills like the General Custer, Charles Dickens, Lucky Boy, and Sunbeam. Now ghost towns, dredge tailings, and designated campgrounds are all in abundant evidence between Sunbeam and Bonanza.

At mile 0.75 is Blind Creek Campground (labeled as Wells Campground on some maps).

At mile 2.1 is Flat Rock Campground.

At mile 3.3 is Polecamp Flat Campground. There are also a few informal campsites which are not signed.

Option: At mile 4.6 a 4WD road leads east to the Custer Lookout.

THE FRANK CHURCH–RIVER OF NO RETURN WILDERNESS

Frank Church served in the U.S. Senate for twenty four years, from 1956 to 1980. He helped write legislation to protect wilderness areas and scenic rivers. Congress designated the River of No Return Wilderness in 1980. In 1984 they honored the memory of Frank Church by adding his name to it. All 2,366,757 acres of the Frank Church–River of No Return Wilderness are in Idaho.

On August 23 of 1805, William Clark wrote in his journal:

"…the water runs with great violence from one rock to the other on each Side foaming & roreing thro rocks in every direction, So as to render the passage of any thing impossible."

It was Clark's descriptions that played a part in earning the Salmon River its nickname of "River of No Return." The idea that one could perhaps float down the river, but never paddle back upstream, has also been offered as an explanation. In his 1824 journal, Alexander Ross called both the Lemhi (a tributary of the Salmon) and the main river itself "Salmon River," which fits with translations of Native American names. Runs of salmon returning from the sea were so thick in the river that pioneers of the early 1900s said they had to throw rocks at the fish to get them to move out of the way before horses could be forded across.

Today, the Middle Fork of the Salmon is the most well-known part of the Frank Church Wilderness thanks to thousands of river runners who come from all over the world to float the River of No Return.

Option: Road 070, Custer Motorway, on the right (east) leads to Custer Museum, several campgrounds, and the town of Challis. It is 4WD recommended (required in wet weather).

The Yankee Fork Gold Dredge, a restored piece of old mining equipment, sits near the intersection of Roads 013 and 172. The self-guided tour of the dredge is excellent. From the dredge, follow signs to Diamond D Ranch, Loon Creek Guard Station, and the River of No Return Wilderness. There are also signs warning of heavy truck traffic related to the HECLA Grouse Creek Gold Mine. The mine was opened in late 1994 and closed in April of 1997. The property is currently under reclamation, with no public access. As you continue north on Road 172, the road soon narrows to 1.5 lanes but is still graded gravel.

Navigation Alert! At mile 13.8, security gates and "No Trespassing" signs block access to the mine. Near the security gate and bridge, turn right to continue on Road 172 (it is not signed with a number or name, signed only as "Narrow Rough Road.")

GPS: 44° 22.344' N • 114° 43.637' W
Mile 8.5 • Elevation: 6,376 ft.

The Bonanza townsite is a combination of a few modern-day buildings and many ghost town reminders. Boot Hill Cemetery and Bonanza Cemetery are nearby, as is the Bonanza Forest Service Guard Station. The town was laid out in 1877. Pack trails from Stanley, Loon Creek, and Challis met in Bonanza.

GPS: 44° 22.754' N • 114° 43.311' W
Mile 9.1 • Elevation: 6,375 ft.

Bear left (north) at this junction where Road 013 becomes Road 172.

GPS: 44° 26.490' N • 114° 43.983' W
Mile 14.1 • Elevation: 7,178 ft.

Bear left at the junction of Roads 172 and 075. Road 075 does not appear on most maps, but is shown on the Frank Church Wilderness map. The turn is signed only as "Diamond D Ranch 16 miles." There are additional 4WD spur roads in this area, none signed, and some lead to informal campsites. Stay on the main road.

GPS: 44° 27.335' N • 114° 44.605' W
Mile 15.4 • Elevation: 7,456 ft.

Keep right at this junction of Road 172 with Road 356.

Option: Road 356 is a side trip that ends in 2 miles at a trailhead for Lightning Lake.

This junction is where the serious switchbacks to Loon Creek Summit begin. Visible from the road are old cabins dating back to pioneer mining days. In sharp contrast, there are "Oh-my-God" views of the HECLA mine as the road climbs. Diamond D Ranch owners are thorough with their signs, this one noting 15 miles to the ranch. The road was well-graded when we were there, and the switchback corners had been widened.

GPS: 44° 27.854' N • 114° 44.082' W
Mile 18.4 • Elevation: 8,687 ft.

You are now at Loon Creek Summit, with a sign that says: *"Public Notice: Wilderness Area Vehicle Travel. This road corridor offers the public a unique recreational experience by allowing vehicle travel through a wilderness area. In order to protect wilderness values, the use of vehicles and all motorized equipment is only permitted within 300 feet of the main road. All side roads, trails and meadows are closed to vehicle travel. Help protect your wilderness environment. Hunters, bighorn sheep are in this area. Be sure of your target."*

Signs here note that it's 17 miles to Sunbeam, but our mileage was 18.4.

The road is rough and narrow as it descends from the summit, not suitable for trailers for at least a few miles. The road follows Mayfield Creek drainage, portions of which have been damaged by past forest fires. There are axle weight limits of ten tons on bridges over various creek crossings. The area where China Creek meets Mayfield Creek is especially scenic in the fall. There are a few informal campsites near the road.

GPS: 44° 32.282' N • 114° 47.936' W
Mile 26.8 • Elevation: 6,244 ft.

Mayfield Yankee Fork Trailhead is on the right (east) with a small parking area. This trailhead provides access to other trails, including Trappers Fork.

GPS: 44° 32.857' N • 114° 51.016' W
Mile 29.7 • Elevation: 5,812 ft.

Loon Creek Guard Station, Diamond D Ranch (shown as "Boyle Ranch" on most maps), landing strip, corrals, and various other buildings. There's a "Pinyon Peak L.O." sign illogically placed here (the turn to Pinyon Peak is about 0.6 mile further down the road).

GPS: 44° 33.317' N • 114° 51.074' W
Mile 30.4 • Elevation: 5,746 ft.

Bear left at the junction of Road 172 and Loon Creek Road 007. The left turn is not signed as Road 172, but it is the continuation of Road 172. It is signed as "Beaver Creek–Loon Creek Rd., Pinyon Peak L.O., Stanley 54."

Option: The right fork goes to Tin Cup Campground, Phillips Creek Transfer Camp, and trailheads. A side road from the right fork leads to Indian Springs Trailhead and access to more hiking trails into the wilderness. There are many hot springs in the wilderness, including Loon, Owen Cabin, Triple Creek, Warm Springs Creek, and Shower Bath Hot Springs. There may be no better hot spring hiking area in the world.

GPS: 44° 34.440' N • 114° 55.317' W
Mile 39.8 • Elevation: 9,362 ft.

This is approximately 9.5 miles from where you turned uphill at the Loon Creek Road junction. Spur road 005 leads uphill (southeast) to Pinyon Peak Lookout. We recommend this short side trip. It's a spine-tingling cruise along a high ridgeline that culminates in 360° views of the wilderness. The lookout is also a trailhead for Trail 112 to Loon Creek Guard Station. Between here and Feltham Creek Point are some of the best views in Idaho that are accessible by vehicle.

GPS: 44° 30.760' N • 114° 58.379' W
Mile 46.1 • Elevation: 8,679 ft.

About 6.3 miles southwest of Pinyon Peak, a short spur road leads to Feltham Creek Point (elevation 9,000 feet). We recommend

this side trip, which requires 4WD. There are informal campsites (flat spots accessible to vehicles) along the spur road to Feltham Creek Point. Signs here mark the wilderness boundary.

At mile 50, about 4 miles southwest of Feltham Point, a short loop road provides access to Beaver Creek Pack Trail 033. Near the confluence of Feltham and Beaver creeks there are several informal campsites. Camping opportunities increase as the terrain changes from alpine to forested hills.

**GPS: 44°26.625' N • 115° 02.854' W
Mile 53.7 • Elevation: 6,951 ft.**

Keep straight at this intersection of Beaver Creek–Loon Creek Road 172 and Knapp Creek Cutoff Road 354. Knapp Creek Cutoff is a 4WD road that leads to trailheads for Beaver Creek, Trail Creek, Winnemucca Creek and Knapp Creek.

**GPS: 44° 26.678' N • 115° 05.912' W
Mile 56.8 • Elevation: 6,756 ft.**

Turn left (southwest) on Road 008 where Beaver Creek–Loon Creek Road 172 ends. At this end of Beaver Creek–Loon Creek Road you'll find a sign announcing:

"Beaver CR Forest Protection Rd., Passable but rough, Dangerous for Public Travel. Not Advised for Trailers or Cars."

Congratulations, you have successfully negotiated a road that is supposedly dangerous for public travel.

Road 008 leads southwest to Highway 21. Nearby Shake Creek is informal camping heaven.

Option: Road 008 also leads northeast to the Seafoam Guard Station. Part of the Seafoam area is excised from the wilderness and contains private mining property, but there are also public foot/horse trails to alpine lakes. Road 008 is 2WD, two-lane graded gravel with lots of horse trailer traffic.

At mile 58.5 and mile 60 there are more informal campsites, some posted with regulations. The Beaver Creek Campground at mile 60.2 has exceptional facilities for horses, and it is also the trailhead for Trail 021.

**GPS: 44° 24.728' N • 115° 08.997' W
Mile 60.3 • Elevation: 6,545 ft.**

Bear right at this junction to stay on Road 008. Road 003 leads to Bradley Scout Camp and Cape Horn Lakes, and is signed for those destinations.

Navigation Alert! As you near Highway 21, there are several road junctions in quick succession. Most of these junctions are numbered and named on the ground, but may not be identified on maps. For some roads the ground truth varies from maps. For example, Road 008 mysteriously becomes Road 40008 on the ground. Turn right at an intersection of Road 40008 and Road 203, then bear left at all remaining intersections until you reach Highway 21. Road 203 leads southeast, parallel to Highway 21, and provides access to the Cape Horn Guard Station. Road 40008 leads you to Road 083, which you are on for the blink of an eye before Road 083 meets Highway 21.

**GPS: 44° 23.616' N • 115° 10.422' W
Mile 62.7 • Elevation: 6,540 ft.**

End this expedition at Highway 21 and Road 083 (the junction is signed for Seafoam).

Option 1: Turn left (southeast) on Highway 21 to drive to Stanley, about 19 miles. There are several campgrounds along the way.

Option 2: Turn right on Highway 21 to drive to Lowman, about 55 miles (see Expedition 15). There are both lodges and campgrounds on the way to Lowman. See Expeditions 12 and 14 for other nearby trips.

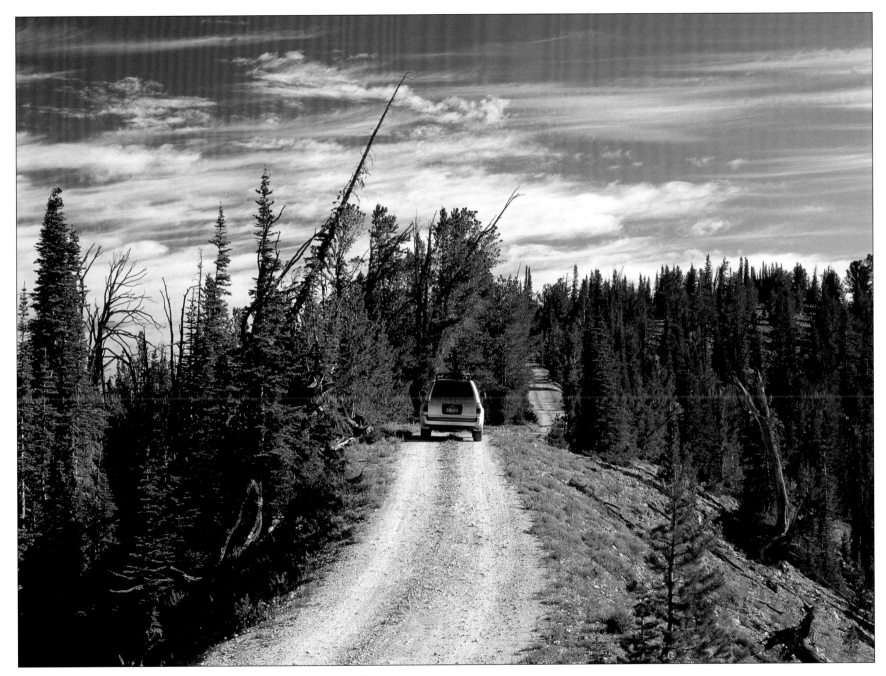

A wilderness road corridor narrows to one lane near Pinyon Peak Lookout.

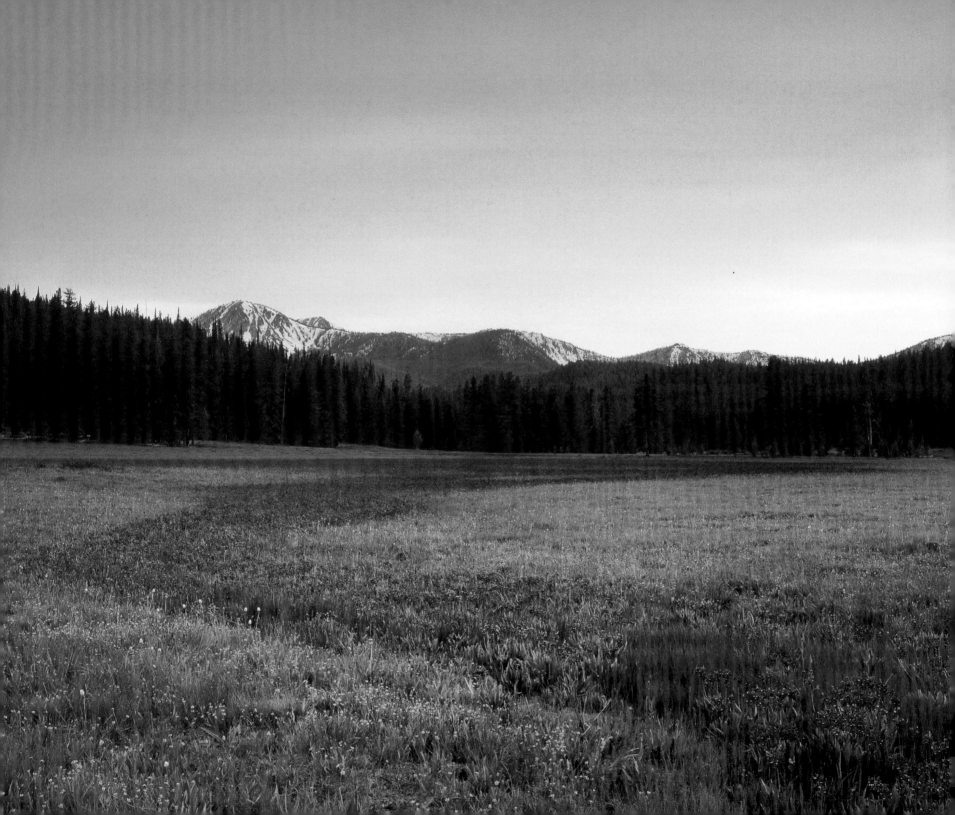

Deadwood River • Yellow Pine • Big Creek

When We Were There

In late July we arrive near the end of this expedition, at Big Creek Lodge on the western border of the Frank Church–River of No Return Wilderness. Traveling in Idaho's backcountry often feels like going back in time, but at Big Creek the effect is mind-boggling. The lodge is filled with historical artifacts—even the Amish caretakers seem to be imported from the late 1800s. John and Mary Ann Coblentz arrived in Yellow Pine as flatlanders who were surprised to find the road closed with snow in May. Here's an excerpt from a poem they wrote and read aloud to us:

> …To go thru the Pass
> Up and up and up we went
> Loaded food on a snowcat with lots of gas
> down and down we went on the other side
> …We Cook and Clean and Bake
> For People who come to see the Sights
> …trails to walk or bike
> and fishing to be done
> Wildlife to See on your hike
> …then sit on the Porch to rest
> and enjoy the Hogsback Mountain view.

Mary Ann adjusted her bonnet and concluded the presentation with "We got e-mail. E-mail me next time before you come and I'll bake you a pecan pie." The internet connection was big news in the area. We had stopped in Yellow Pine for sustenance before heading into the wilderness and found the locals in the "General Store" and café all discussing the fact that the lodge, 24 miles further into the back of beyond, had satellite internet service. Yellow Pine now has phone service, another recent improvement.

A chorus line of dark pink shooting stars blooms next to Highway 21. The display of wildflowers usually peaks in early July.

The other big news was dust, of which they have too much thanks to dirt streets. What Yellow Pine has just enough of is music. A world-famous harmonica contest and festival is held in the first week of August every year. The event is billed as a "musical celebration and camping experience." With about 40 year-round residents, no one is left out of the preparations.

Yellow Pine is about 150 miles from Boise and visitors can also

John and Mary Ann Coblentz, self-confessed Amish "Flat-landers" from back East, managed Big Creek Lodge for one summer. They fit right in with the historical lodge and the wilderness surroundings.

take advantage of the Johnson Creek Airport. At this backcountry grass strip pilots camp for free (with hot showers no less). In *"Fly Idaho,"* pilot Galen Hanselman notes that fistfights are common in Yellow Pine on a Saturday night "with usually no permanent damage." He rates the airport as possibly the best backcountry experience in the West. There are many backcountry airstrips along this route, including Stanley, Bruce Meadows, Landmark, and Big Creek.

As far as daredevil travel goes, snowmobile jockeys give pilots a run for their money. You can always tell when an area is popular for winter recreation—land managers get busy with signs and

maps. Near the beginning of this expedition, at Cape Horn Summit, "Snowmobile Smarts" were listed on signs telling riders to stay to the right; ride single file; be aware of avalanche danger; don't scare the wildlife; leave only tracks; carry topo maps; and so forth. A helpful list of survival gear included duct tape. "Avoid the Frank Church–River of No Return Wilderness, the area to the north of the groomed trail is wilderness, where no snowmobile traffic is allowed. Snowshoe or cross country ski recreation is allowed… You have been advised three times that no motorized vehicles are allowed in the Frank. On the Boise National Forest Visitor Map, this information appears, and the boundary markers repeat the information…Lowman Ranger District Officers patrol Bear Valley on snowmobiles." So there you have it, pretty much the same as the rules for summer travelers: drive your vehicle only where it's allowed, and you can go almost anywhere on your own two feet.

Bear Valley is one of the few stream systems in Idaho where wild salmon are a dominant species. Salmon travel over 800 miles to the ocean. Both fishing and hunting are prime in Bear Valley, along Deadwood River, and along Johnson Creek. We saw elk feeding when we were there. Sandhill cranes and great gray owls were among our other wildlife sightings. Gray wolves, along with black bear, moose, and deer are also year-round residents.

We were particularly taken with the lovely scenery along the Deadwood River. With its meadows for wildlife sightings, and the gently braided river reflecting sunrises and sunsets, it was made for quiet enjoyment. There are literally hundreds of informal campsites along this route, more than a dozen designated campgrounds, and many foot/horse trails into the wilderness. Planning two or three days for the trip is a good idea—time to negotiate more than a hundred miles of gravel and dirt roads and also stop to see the sights. See Expedition 13 for a trip that ends on Highway 21, only a few miles east of where this expedition begins.

Know Before You Go...

This is black bear country. Stanley is the closest full-service town to where the expedition begins. McCall and Cascade are the closest full service towns on the west side. Yellow Pine does have a gas pump (I hesitate to say gas station), but at the time this was written it was not working. Bring a saw in case trees fall across the road. There is no cellphone coverage for most of the route. The best time to visit is from July to late September. Check for forest fire activity. Snowmobiles are allowed on most of the roads in winter, and there are a few open "play areas."

Approach Routes

- **From Ketchum/Sun Valley:** North on Highway 75 to Stanley; then northwest on Highway 21 to Road 198.
- **From Twin Falls:** North on Highway 93; then north on Highway 75 to Stanley. See above.
- **From Boise:** Northeast and east on Highway 21 to Road 198.

Land Administration (See Appendix A)

- **National Forest Service:** Stanley Office (Sawtooth NF); Lowman Office (Boise NF); McCall Office (Payette NF)
- **BLM:** Challis Field Office
- **Idaho Fish and Game:** Magic Valley Region
- **Chamber of Commerce:** Stanley
- **Yellow Pine:** see *www.harmonicacontest.com/about.htm*
- **Big Creek:** see *www.bigcreekidaho.com*
- **Outfitters:** see *www.ioga.org*

Maps (See map sources in Appendix B)

Frank Church–River of No Return Wilderness (you will need both the southern and northern maps to cover this route, both of these maps are issued by the U.S. Forest Service and are highly recommended); **Boise National Forest Visitor/Travel Map; Payette National Forest** (McCall and Krassel Ranger Districts).

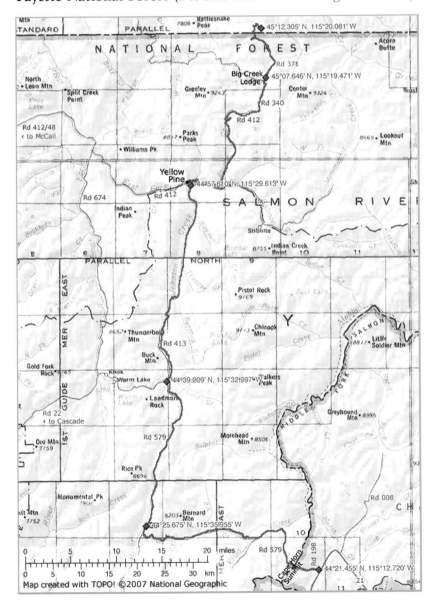

Map created with TOPO! ©2007 National Geographic

Total Miles/Road Ratings

- **Total Miles:** 106.6 (one-way)

- **2WD paved or graded gravel/dirt:** about 98 miles in good weather. Even though the roads are 2WD in good weather, an SUV or light duty truck with higher clearance is preferable. There are short sections of 8% to 10% grade between Deadwood Summit and Twin Bridges Campground that aren't suitable for trailers. There is a trailer-friendly approach to Yellow Pine from Cascade (see end of this expedition for a description).

- **4WD recommended:** about 50 miles of the above (98 miles in wet weather). There are also relatively steep grades between Yellow Pine and Big Creek, where 4WD may not be required but is recommended.

- **4WD required:** about 9 miles, including most of Smith Creek Road and access to Mosquito Ridge and Pueblo Summit at the end of the expedition. In addition, some side trips, such as the road to Thunder Mountain, require 4WD.

Expedition Directions

Set your GPS to display Degrees and Decimal Minutes. This expedition begins about 25 miles northwest of Stanley, north of the Sawtooth Range, and south of the Frank Church–River of No Return Wilderness. The route skirts the southern and western edges of the wilderness, passing through Bear Valley to approach the Deadwood River (north of Deadwood Reservoir). We follow Deadwood River to Deadwood Summit, then continue along Johnson Creek to the town of Yellow Pine. From Yellow Pine, we turn east and northeast to Big Creek, an historical site that remains one of the finest approaches to the Frank Church.

GPS: 44° 21.455' N • 115° 12.720' W
Mile 0.0 • Elevation: 6,658 ft.

Turn west on Road 198 off Highway 21. This junction is about 0.25 mile north of Banner Creek Campground. The turn is signed for Cape Horn 579, Deadwood River Road, and other destinations. Road 198 is not numbered on most maps, but does appear on the Frank Church–River of No Return Wilderness map (southern half). The road is 2WD graded gravel/dirt, two lanes wide.

GPS: 44° 21.822' N • 115° 16.108' W
Mile 3.0 • Elevation: 7,306 ft.

Cape Horn Summit. Here the road number changes to 579, and the road narrows as it descends into Bear Valley. Lola Creek Trail, county line signs, and Tread Lightly advice are posted. As you continue into Bear Valley there are numerous trailheads for foot/horse trails.

GPS: 44° 25.367' N • 115° 17.659' W
Mile 8.1 • Elevation: 6,410 ft.

Bear left to stay on Road 579. A short spur road on the right (north) leads to Blue Bunch Pack Bridge over Bear Valley Creek, and nearby Fir Creek Campground. Fishing and hunting regulations are posted. Road 579 is still 2WD, with room to pass with care, but mostly one lane.

Bruce Meadows Airstrip and a picnic area are at mile 8.9.

At mile 9.6, Road 579 meets Road 568. Keep straight on Road 579.

Option: At mile 9.6, Road 568 leads north to Dagger Falls, a campground and a boat ramp on the Middle Fork of the Salmon River.

GPS: 44° 24.478' N • 115° 21.067' W
Mile 11.4 • Elevation: 6,421 ft.

Bear right to remain on Road 579 (to Elk Creek Guard Station and Bear Valley Campground) at this junction with Road 582.

Many unsigned two-tracks leading to informal campsites are not noted in this log.

Option: Road 582 follows Bear Valley Creek southwest, and eventually joins Highway 21 at Lowman, 33 miles distant.

Elk Creek Forest Camp and cabins are at mile 14.7.

Option: Also at mile 14.7, a spur road leads north to Bear Valley Mountain Lookout.

At mile 19.2, Road 591 leads south 10 miles to Deadwood Reservoir.

GPS: 44° 25.675' N • 115° 35.955' W
Mile 28.0 • Elevation: 5,607 ft.

Go right (north) to continue on Road 579, toward Deadwood Summit and Landmark. This expedition stays on Road 579 as it parallels Deadwood River, going north. The road is one-lane wide, graded, and 2WD in good weather.

Option: Side trip south to Deadwood Reservoir on Road 555, amenities include a boat ramp and several campgrounds. Road 555 offers a better-used road to the reservoir, and also to Highway 21 (Banks-Lowman Road, 36 miles distant).

GPS: 44° 27.789' N • 115° 35.018' W
Mile 30.6 • Elevation: 5,621 ft.

The village of Deadwood, with the Valley County Sheriff's Department (emergency radio available 24 hours). Deadwood Outfitters offers trail rides, pack trips, and guided hunting and fishing trips. Rental cabins, gas and diesel pumps, and snowmobile fuel in winter can also be found here. Deadwood Outfitters is about 0.25 mile south of the old Deadwood Mine. Nearby Stratton Creek Trail is open to mountain bikes, motorcycles, foot and horse traffic. More trails lead into the Frank Church Wilderness from nearby Porter Creek Trailhead.

At about mile 34.7, Switchback Trail 009 is on the left (west) and is open to mountain bikes.

GPS: 44° 32.863' N • 115° 33.539' W
Mile 37.5 • Elevation: 6,840 ft.

Deadwood Summit. From this summit it is 10 miles north to Landmark, and you are now about 22 miles from Elk Creek Ranger Station. The road is graded dirt, one lane, and 2WD in good weather. As you descend from the summit, you enter Johnson Creek drainage. Tyndall Meadows are signed. There are several hiking trailheads between mile 40 and 42. Stay on the main road. After you cross Whiskey Creek, there are good informal campsites.

At about mile 42.5, Whiskey Creek Road 443 is signed for multiple trailheads.

At about mile 46 is the Pen Basin Campground and the Landmark USFS Airport.

GPS: 44° 39.209' N • 115° 32.997' W
Mile 46.7 • Elevation: 6,649 ft.

Stay left, on a short jog west, to continue on Road 579 at a junction with Road 447. Turns are signed for Yellow Pine, Warm Lake, and Mud Lake. Follow the signs for Yellow Pine. After you jog west for 0.3 mile, turn right (north) on Road 413 at a stop sign (civilization!). GPS coordinates given above are for the stop sign. Pavement begins here, but the road is still narrow and winding, with heavy truck traffic. Road 413 crosses a combination of private property and Boise National Forest lands as it continues north along Johnson Creek. There are several campgrounds and hiking trailheads. Unsigned spur roads are often related to logging. Between mileposts 8 and 10, Road 413 is narrow and steep with 10% grades common (and one mile of 12% grade). CB users are asked to broadcast milepost and direction of travel on CH 19. Aspen trees and ponderosa pines enhance the river views.

Landmark Ranger Station is at mile 47.3.

Buck Mountain Campground is at mile 49.3.

Trout Creek Campground is at mile 55 (between Road 413 mileposts 7 and 8). Halfway Station is at about mile 58, note Whitehorse Rapids on Johnson Creek.

Option: Road 447 (mile 46.7) leads east 0.5 mile to Landmark Airfield, two miles to Sand Creek Road and four miles to Artillery Dome Road. Artillery Dome Road cruises Pistol Creek Ridge on the wilderness border. Another option is to cut this expedition short by continuing west on Warm Lake Road: 9 miles to Warm Lake, and 35 miles to Cascade.

GPS: 44° 48.264' N • 115° 31.299' W
Mile 60.6 • Elevation: 5,273 ft.

Twin Bridges Campground and Old Thunder Mountain Road 440 are on the right (east). Stay on Road 413, crossing Johnson Creek via a bridge. Road 413 widens a little here where it is not confined to the narrow canyon. There are several ranches in the valley, including Wapiti Meadow Ranch and Guest Lodge.

Ice Hole Campground is at mile 66.6.

Deadhorse Rapids are at mile 67.3.

Johnson Creek Airport is west of the creek, at mile 68.5.

Johnson Creek Ranger Station is at mile 69.7.

Golden Gate Campground is located at mile 70.6 (near milepost 23).

Yellow Pine Campground and Pioneer Cemetery access are at mile 72.3.

GPS: 44° 57.610' N • 115° 29.613' W
Mile 72.8 • Elevation: 4,786 ft.

Bear right on Road 412 at this junction where Road 413 ends, at the south end of the town of Yellow Pine. Road 412 bends east around Yellow Pine, providing access to the main street, grocery store, etc. From this junction it is 24 miles to Big Creek Station, our next destination. After you have explored Yellow Pine, **ZERO YOUR ODOMETER** at the junction mentioned above.

From Yellow Pine, follow signs to Big Creek, and Stibnite Road. The road is no longer paved, but is well-graded dirt and gravel. Truck traffic is heavy, and the road shares a narrow canyon with the South Fork of the Salmon River. Truckers are required to

From Yellow Pine to Big Creek to the border of Frank Church–River of No Return Wilderness there are ruins of cabins and mines, remnants of pioneer days from the boom times of 1885 to the 1940s.

announce milepost and direction of travel via CB for 14 miles of narrow road. This is near the border of Boise NF and Payette NF. We're still on the Frank Church–River of No Return Wilderness map (southern half, southwest side), but not for long. Switch to the northern half map or to the Payette National Forest map.

Option: If you don't wish to continue on to Big Creek from here, you can turn left (west) on Road 412 and drive about 55 miles to McCall (4WD strongly recommended).

GPS: 44° 57.502' N • 115° 25.694' W
Mile 4.9 • Elevation: 5,279 ft.

At this junction of Stibnite Road 412 and Road 340 to Big Creek, turn left (north) on Road 340. There are a few informal campsites along the route, stands of old growth forest, and several unsigned spur roads (some lead to mines).

Mosquito Ridge Trail is at mile 9.4.

Option: At mile 4.9 bear right on Stibnite Road for a side trip to mining sites, and further on to Thunder Mountain. Road 375 to Thunder Mountain is rough 4WD for about 20 miles as it cherrystems through wilderness and climbs to over 8,000 feet. There are ruins at Thunder Mountain, and four registered historical sites in Stibnite itself.

GPS: 45° 03.481' N • 115° 24.949' W
Mile 13.6 • Elevation: 7,605 ft.

Profile Summit (Profile Gap on most maps). A low memorial is hard to see and weathered so much that it's difficult to read:

"Sam L. Willson. He prospected this Profile Gap from 1902, where his latch string was always out to sourdoughs passing through. Interred at Yellowpine, 1935."

The road descends from this summit via a long switchback. Where it crosses Big Creek there are informal campsites. "Private Property" is posted, but most of this land is national forest.

Lick Creek spur road and a trail to Lick Lake are at mile 21.

Old Edwardsburg is at mile 23.1.

GPS: 45° 07.646' N • 115° 19.471' W
Mile 24.0 • Elevation: 5,740 ft.

Big Creek Lodge and Big Creek Campground. Big Creek Ranger Station, an airstrip, and work center are also nearby. The lodge offers food, trail rides, pack trips into the wilderness, guided hunting and fishing, and the infamous internet connection. This historic lodge, built in the 1930s, is two miles from the wilderness border. Past the lodge, the road becomes Road 371 and is 2WD to Big Creek Trailhead.

GPS: 45° 09.211' N • 115° 18.168' W
Mile 26.3 • Elevation: 5,405 ft.

Turn left (west/northwest) to stay on Road 371 (identified as "Smith Creek Road" on the ground). This turn is at Big Creek Trailhead, with the foot/horse trail on the right (east). Landmarks include a bridge over the creek, wilderness boundary signs, a

memorial to Senator Frank Church, and a parking lot above the trailhead. We have rated Smith Creek Road "4WD required" but a skilled driver could coax a 2WD vehicle up it for about 4 miles in good weather. The road is single lane dirt, with grass growing in the center. Bring a saw to remove trees that fall across the road. There are several picturesque ruins of cabins and mines between here and Pueblo Summit. The road fords creek tributaries, but the fords have a rocky bottom and are shallow. Black bear droppings and other signs of bear activity were plentiful when we were there.

At about mile 30.5, turn right at a "Y" intersection signed for Mosquito Ridge Trailhead and Pueblo Summit. This is Road 373 on the Frank Church map (northern half), but the intersection of Roads 373 and 371 looks different on the ground than it does on the map. Where Road 371 continues west, signs warn "Mining Access Rd. Not Recommended for Public Use." Beyond this point the road is steeper and rockier (4WD only). Tight switchbacks lead past more cabins and to a group of buildings at Werdenhoff Mine.

GPS: 45° 11.792' N •115° 20.984' W
Mile 31.7 •Elevation: 6,684 ft.

Werdenhoff Mine and relic cabins. An intact rock crusher and an old caterpillar rigged to run a generator are testaments to miners' ingenuity. There's a nest of spur roads here, choose a middle road (not signed) that angles left (northwest) uphill. Bear right at a "Dead End" sign on this fork. The road soon switchbacks north/northeast and is both steep and rocky. "Mosquito Ridge TRHD" is signed on the left. Beyond the trailhead, the road passes more cabin ruins.

GPS: 45° 12.305' N •115° 20.081' W
Mile 34.6 •Elevation: 8,201 ft.

This expedition ends at Pueblo Summit on the border of the Frank Church–River of No Return Wilderness. There is an informal campsite near a gate. The gate blocks a road that is now foot/horse Trail 013, leading to Chamberlain Trail and other trails.

Weathered wooden signs mark the Frank Church boundary, and the view over the forested mountain ranges is excellent.

Retrace your route to Yellow Pine. There are two options for leaving Yellow Pine (below).

Option 1 to Cascade: This exit route can also be used as a trailer-friendly approach to Yellow Pine from the west side. From Yellow Pine, drive west on Road 412/48 along East Fork South Fork Salmon River (yes, that's right, the east fork of the south fork of the Salmon River). About 17 miles west of Yellow Pine, at the junction with Road 674, turn south. This is a scenic drive along South Fork Salmon River. Road 674 becomes Road 474, which becomes Road 401 (I don't know why). Turn west near the South Fork Salmon Campground where Road 401 intersects Warm Lake Road 22, and follow Warm Lake Road about 32 miles west to Cascade and a junction with Highway 55. From Big Creek Lodge to Cascade is about 88 miles. See Expedition 15 for a trip that begins at Banks, south of Cascade.

Option 2 to McCall: Begin like Option 1, but when you come to the junction with Road 674 continue west on Road 412/48 (Lick Creek Road). Road 412/48 is about 50 miles of dirt and is not recommended for trailers. It offers, however, beautiful scenery most of the way. Lick Creek Road turns south near Lick Creek Summit and makes its way past several campgrounds as well as Little Payette Lake, Payette Lake, and Ponderosa State Park before entering McCall (also a junction with Highway 55).

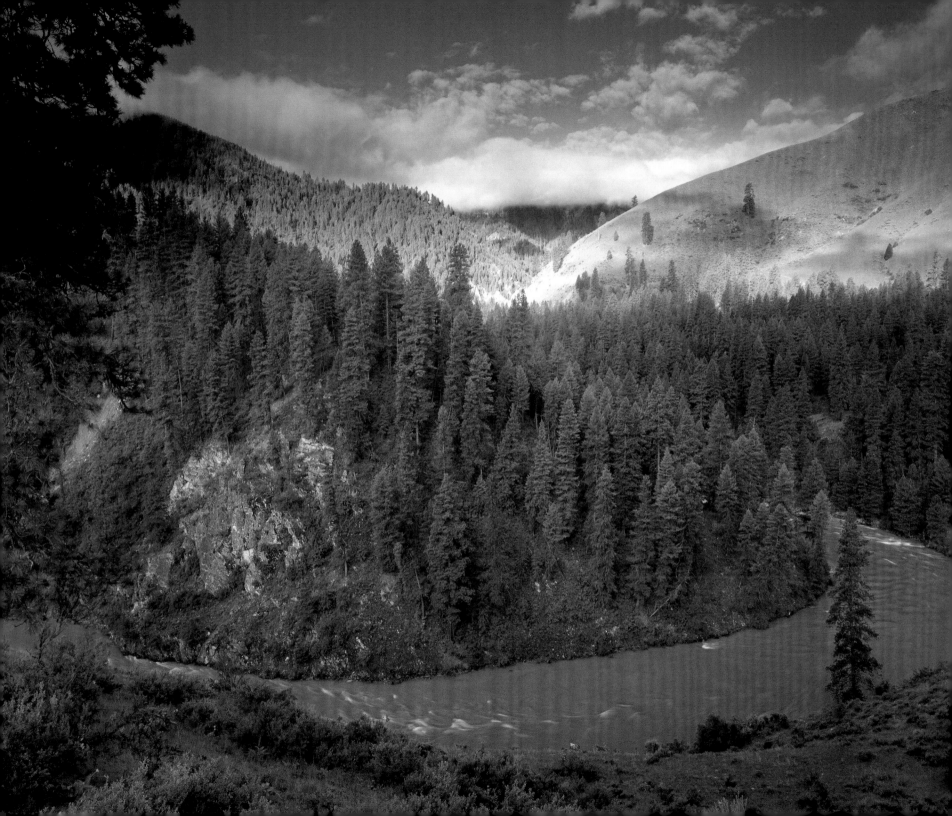

Wildlife Canyon Scenic Byway
South Fork Payette River

Other Nearby Excursions: Ponderosa Pine Scenic Byway
Idaho City

When We Were There

It's late May and South Fork Payette River is bumping down the canyon, overloaded with snowmelt and silt, eating its banks. Rain deluges the highway that runs parallel to the river—so much rain that the road feels like a launch site for cars. We slow to a crawl and watch the river for kayakers. We pass only two river runners braving the high water. One is eddied out and clinging spider-like to a rock, and one is sitting on the side of the road with his kayak. Both have that stunned, "I almost died" look.

It is late in the day so we pull into a campsite protected by umbrellas of ponderosa pine. There is even a dry spot at the base of one of the trees—perfect for relaxing to the sound of rain peppering the needles, and of floodwaters pillowing the river rapids.

Land Administration (See Appendix A)

- **National Forest Service:** Garden Valley Office
- **BLM:** Four Rivers Field Office
- **Idaho Fish and Game:** Southwest Region and McCall Subregion
- **Chamber of Commerce:** Garden Valley

Approach Routes

- **From Boise:** You can drive a loop that is all scenic byways. North on Highway 55 (Payette River North Fork Scenic Byway) to Banks; then right (east) on Wildlife Canyon Scenic Byway.
- **From Payette:** East on Highway 52 to Highway 55. See above.
- **From McCall:** South on Highway 55 to Banks. This approach parallels North Fork Payette River, with it's concentration of Class V rapids.
- **From Ketchum/Sun Valley:** North on Highway 75 to Stanley; west on Highway 21 to Lowman, and drive the expedition backwards. This is also an all-scenic-byway approach: Sawtooth Scenic Byway to Ponderosa Pine Scenic Byway to Wildlife Canyon.

Maps (See map sources in Appendix B)

You can manage this trip with nothing but an Idaho Highway Map, however the beautiful surroundings may tempt you onto side roads, and for those you do need a map: **Boise National Forest Visitor/Travel Map** or **Benchmark** *Idaho Road and Recreation Atlas.*

In springtime, the South Fork Payette River rushes full of snowmelt and silt. The river's Class IV rapids challenge kayakers and rafters.

Know Before You Go...

Although Wildlife Canyon Scenic Byway is open in all seasons, it may have a hard snow covering in winter. The two-lane road has no passing lanes and is very close to the river. Make use of turnouts for viewing the scenery. Do not pass on the curves. There is no cellphone coverage for most of the route. The best time to visit for elk viewing is in early spring and winter; for whitewater kayaking, early spring; for rafting and kayaking, summer; and autumn for fall color. Rafters and kayakers should check these websites for river flow information:
www.payetteriver.org
www.usbr.gov/pn/hydromet/index.html

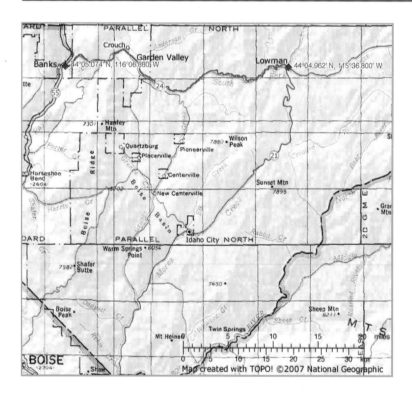

Total Miles/Road Ratings

- **Total Miles:** 34.5
- **2WD paved or graded gravel/dirt:** Paved all the way (optional side trips are 2WD graded gravel/dirt)

Expedition Directions

Set your GPS to display Degrees and Decimal Minutes. Wildlife Canyon Scenic Byway is Highway 24 between the small towns of Banks and Lowman—also known as the Banks-Lowman Road.

GPS: 44° 05.074' N •116° 06.880' W
Mile 0.0 • Elevation: 2,827 ft.

Turn east on Highway 24 (aka Banks-Lowman Road) at the intersection of Highways 55 and 24 near the small town of Banks. Signs include "Lowman 33," and "Emergency Medical Services, Crouch Ambulance 1-800-632-8000." There is a raft launch site and beach picnic area in Banks.

Deer Creek Boat Launch is at mile 4.5.
Confluence Launch is at mile 7.

GPS: 44° 06.522' N •115° 58.956' W
Mile 8.3 • Elevation: 3,025 ft.

Stay on Wildlife Canyon Scenic Byway (Highway 24) at this junction with Road 698. Where Middle Fork Payette River joins the South Fork Payette, the terrain changes. The scenic byway exits the canyon and enters wide-open Garden Valley. Idaho Whitewater Unlimited outfitters are based here. The Garden Valley Ranger Station is at the east end of the valley.

Option: Road 698 provides access to the town of Crouch and to Middle Fork Payette River. There are several designated campgrounds along Road 698.

Enter the Boise National Forest at mile 12.7.
Hot Springs Campground is at mile 13.8.

128 — *West-Central*

Fee-based parking area and visitor info kiosks can be found at mile 19.7.

GPS: 44° 04.235' N • 115° 45.489' W
Mile 23.0 • Elevation: 3,369 ft.

Option: At this junction of Summit Road 555 with Wildlife Canyon Scenic Byway, visitors can take an optional side trip north to Deadwood Reservoir, and further north to Deadwood Summit (see Expedition 14). This road also offers access via a spur road to Scott Mountain Lookout (4WD).

A turnout with an overlook for Big Falls, a Class VI rapid, is at about mile 25.3 on Wildlife Canyon Scenic Byway.

GPS: 44° 03.997' N • 115° 40.894' W
Mile 28.4 • Elevation: 3,747 ft.

Pine Flat Hot Springs and Campground. The hot springs are on the riverbank downstream of the campground. Near Pine Flats, between mileposts 28 and 29, is an additional informal campsite.

Deadwood Campground and launch site are at mile 30.5.

Wildlife Canyon Scenic Byway ends at about mile 33.

GPS: 44° 04.962' N • 115° 36.800' W
Mile 34.5 • Elevation: 3,812 ft.

The end of this expedition, at the junction of Highways 24 and 21. Lowman has a gas station, restaurant, and the Haven Hot Springs Motel.

PAYETTE RIVER HISTORY

In the early 1800s French-Canadian and British trappers explored much of what is now Idaho. Payette River gets its name from one of the French-Canadians, Francois Payette. He first went to work for John Jacob Astor in 1810 and made his way into the Payette River Basin in 1818. With Donald McKenzie and Jack Weiser, Payette trapped streams from Idaho to present-day Wyoming and Utah.

Before white trappers entered the area, Native Americans of the Northern Paiute, Shoshone, Bannock, and Nez Perce tribes used the forest seasonally. Archaeological artifacts date human occupation to about 8,000 years ago.

Discoveries of gold in the 1860s brought an influx of miners, swiftly followed by loggers and those who made money supplying them. Population pressure and land-use conflicts sparked wars between Native Americans and newcomers. Most of the Indians were eventually relocated to reservations and some aspects of their culture are only just now being recovered.

Some Native American fishing sites along the Payette still have large fish populations, though the mix has changed since the introduction of species like rainbow trout and brook trout, and changes along the river that have blocked salmon migration. The beaver population has returned—you can see beaver activity in the Garden Valley area. Elk and mule deer herds are larger than they were in pioneer days thanks to a lack of predators. Elk herds winter in the area and a good place to see them is near the Danskin River access, about ten miles west of Deadwood Campground.

Between the Danskin take-out and Big Falls upstream there are five Class IV rapids in quick succession. Big Falls itself is rated Class VI, and is listed as a mandatory portage—the 25-foot drop is deadly (some sources list the drop as 35 feet). Grant Amaral ran it once at low water (400 cfs) by breaking it into five drops. Others have gone through Big Falls and survived, but not in their boat. Archaeological excavations near Big Falls reveal that it was used by Native Americans as a fish trap constructed by nature. Chinook salmon and steelhead trout couldn't leap the falls. Present-day river runners often put in at Deadwood and take out at Danskin, and they portage around the natural fish trap.

Loggers of the late 1800s and early 1900s used the South Fork Payette River to float logs to sawmills. In 1890, seven loggers died at Big Falls. Historical photos show loggers riding logs through lesser rapids. They stood on the logs, knees flexed, with a peavey (a long pole fitted with a metal socket, a hook, and a pike) for balance. By comparison, our present-day river runners look positively sane.

WEST-CENTRAL

Option 1: Return to Boise (about 80 miles), by turning south/southeast on Highway 21 (Ponderosa Scenic Byway).

Option 2: Continue east to Stanley, about 55 miles, a scenic drive that borders Sawtooth National Recreation Area and Sawtooth Wilderness. See Expeditions 13 and 14.

Other Nearby Excursions...

Ponderosa Pine Scenic Byway • Idaho City

Highway 21 (the Ponderosa Pine Scenic Byway) offers beautiful scenery punctuated by the historic mining town of Idaho City, and the famous Whoop Um Up cross-country skiing area.

Idaho City makes the most of its colorful past, with such things as a "Cowboy Campground" and "Cowboy Parking, Horses Only." A gold dredge has been turned into living quarters south of the city. The historic section of town on Main Street still has wooden sidewalks, saddle shops, and other pioneer-days gear, as well as a Visitor Center.

For an interesting, day-long detour off Highway 21, turn east on Road 268 (Middle Fork Road) at the north end of Lucky Peak Reservoir. Continue northeast on Middle Fork Road to visit a variety of hot springs. George's Tavern at Twin Springs Resort still has a 50-years-ago atmosphere. Middle Fork Road eventually makes its way to the historic mining town of Atlanta, about 84 miles from Boise. See Expedition 16 for information on Middle Fork Road, Atlanta, and other historic mining towns.

A slice of moon lingers in early spring.

Historic Mining Towns • Trinity Lakes
Boise National Forest

Other Nearby Excursions: Lucky Peak Reservoir and Middle Fork Road, Boise River

When We Were There

In late September, rabbitbrush blooms golden-yellow around the crumbling stone foundations at Rocky Bar. The historic mining town is deserted except for a single resident carving a half moon into his outhouse door. If not for his modern-day camper, the man could be mistaken for an 1864 miner. His gray beard blows in the wind, and he is weathered into a kind of human jerky.

From Rocky Bar, we drive up James Creek Road. Light hail pelts us and bounces off the timbers edging a bridge over Elk Creek. We stop to view a waterfall where red berries, yellow willow leaves, and water-carved rocks glow in subdued light. Near the summit between Rocky Bar and Atlanta we stop again, at the memorial to Peg Leg Annie and her friend Dutch Em. The narrow dirt road is a snowy, unmarked path through lodgepole pines, and the silence is complete. We imagine the two women struggling though a blizzard in 1896. They start out walking from Atlanta, with a stop planned at the Summit House (now long gone), but lose their way. Dutch Em freezes to death and Annie's feet are later amputated. Peg Leg Annie lived for 38 more years, dying in 1934 as a near-mythological symbol of the pioneer spirit.

Approach Routes

- **From Mountain Home:** Take Exit 95 from I-84 and drive northeast on Highway 20 to Pine-Featherville Road 61.
- **From Boise:** Go southeast on I-84 to Mountain Home. See above.
- **From Twin Falls:** Go north on Highway 93 to Highway 20; then west on Highway 20 to Pine-Featherville Road 61.
- **From Ketchum/Sun Valley:** Take Highway 75 south to Highway 20; then go west on Highway 20 to Pine-Featherville Road 61.
- **From Arco:** Go west on Highway 26/20/93 to the junction with Highway 20; then drive west on Highway 20 to Pine-Featherville Road 61.

Maps (See map sources in Appendix B)

Boise National Forest Visitor/Travel Map and **Benchmark** *Idaho Road and Recreation Atlas.*

Know Before You Go...

This is black bear country. There is no cellphone coverage for most of the expedition. Carry a saw to remove downed trees on James Creek Road. The best time to visit is from mid-June to mid-September. Check wildfire conditions.

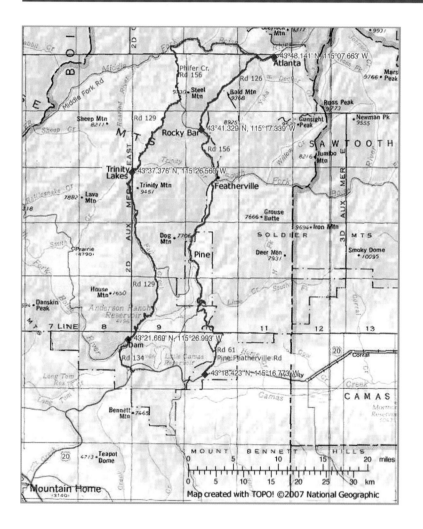

Map created with TOPO! ©2007 National Geographic

Land Administration (See Appendix A)

- **National Forest Service:** Mountain Home Office
- **BLM:** Boise District
- **Idaho Fish and Game:** Magic Valley Region
- **Chamber of Commerce:** Featherville

Total Miles/Road Ratings

- **Total Miles:** 118.5 (more with optional side trips)
- **2WD paved or graded gravel/dirt:** about 84.5 miles
- **4WD recommended:** about 34.0 miles. 4WD is highly recommended for James Creek and Phifer Creek Roads.
- **4WD required:** none except in bad weather

Expedition Directions

Set your GPS to display Degrees and Decimal Minutes. All along this route there are unsigned two-track "roads" and ATV trails. There are more roads on the ground than appear on most maps. These two-tracks are not noted except as necessary for route-finding. Unless otherwise directed, stay on main roads. You'll need a detailed overview map, like the Boise National Forest map or a topographical map atlas, to navigate through the interconnected roads in this area.

This expedition begins at the intersection of Highway 20 and Pine-Featherville Road 61, on the southern border of the Boise National Forest and the southwestern border of the Sawtooth National Forest. The expedition includes several historic mining towns, the Middle Fork of the Boise River, and the alpine terrain of Trinity Lakes Recreation Area. The Boise Mountains and Soldier Mountains of Elmore County are popular destinations for recreation, so traffic is higher on most of these backcountry roads than one usually sees in Idaho.

Historic mining towns such as Atlanta, Featherville and Pine offer more than just history. These small communities provide limited services for tourists, and Atlanta is home to outfitters specializing in trips into the Sawtooth Wilderness. Pine has a gas station, but the closest full service stations are located in Mountain Home, about 30 miles to the west, and in Fairfield, about 25 miles to the east from where this expedition begins.

GPS: 43° 18.423' N • 115° 16.773' W
Mile 0.0 • Elevation: 5,443 ft.

From Highway 20, turn north on Pine-Featherville Road 61 (signed), and continue to the intersection with High Prairie Road and Moores Flat Road. Bear left (northwest) to stay on the main road as you continue to the small community of Pine. The road is paved and two lanes wide. At about mile 7 there are great views of the valley and the mountains beyond. Mule deer, grazing cattle, sheep, and sage grouse contrast with the new construction of vacation homes and realty offices. This road also provides access to a boat ramp on Anderson Ranch Dam Reservoir; and access to Deer Creek Lodge, Curlew Creek and Deer Creek campgrounds.

Bear right in Pine at about mile 17.5 to continue to Featherville (signed). Between Pine and Featherville there are several more campgrounds and hot springs, including Dog Creek, Johnson Bridge Hot Springs, and Paradise Hot Springs.

GPS: 43° 36.285' N • 115° 15.982' W
Mile 30.0 • Elevation: 4,512 ft.

The junction of Pine-Featherville Road and Trinity Creek Road 172 (identified as Wagontown Road on some maps). Continue straight ahead to Featherville, but note the option to take a shortcut (18 miles) to Trinity Lakes here, and that in winter this is the access for the "Snopark." Featherville is a community so strung out along the road that it looks like you enter the town many times before actually seeing the "Entering Featherville" sign.

GPS: 43° 36.725' N • 115° 15.305' W
Mile 31.0 • Elevation: 4,528 ft.

Bear left at a "Y" intersection on a road signed for "Rocky Bar" and "No Winter Maintenance," at the junction of Pine-Featherville, Rocky Bar 156, and Baumgartner roads. This road junction is just a mile beyond Trinity Creek Road, and this is where you leave the paved road and travel on graded dirt/gravel that is about one-and-a-half lanes wide, with turnouts. The road winds uphill through forested areas that show signs of logging. There are many side roads, including access to Wide West Gulch, but in all cases stay on the main Road 156 all the way to Rocky Bar.

Near mile 34, a wooden sign commemorates Charles Sprittles, the last year-round resident of Rocky Bar, known as "The Mayor of Rocky Bar." The sign lists his birth as November 1880, but other records indicate he was born in Wakefield, England on November 25, 1881. Near Rocky Bar evidence of previous dredging can be seen along the creek. In places, the road is built on top of dredge tailings.

Option: There are several designated campgrounds along Baumgartner Road 227 (see mile 31) and the road follows the South Fork of the Boise River.

GPS: 43° 41.329' N • 115° 17.339' W
Mile 38.0 • Elevation: 5,272 ft.

Bear right at the junction of Rocky Bar Road 156 and James Creek Road 126, also signed for "Atlanta." Most visitors stop in Rocky Bar to tour the historic town. The hotel and jail were for sale when we were there, along with mineral and timber rights. Some of the buildings are open, but collapsing walls and roofs make them dangerous to explore. Oddly, Rocky Bar sports street signs worthy of any suburb. 4WD is recommended for James Creek Road 126 due to a few steep grades—it is not suitable for trailers. James Creek Road is a 16-mile route to Atlanta that usually has little

traffic. When spring floods wash out Middle Fork Road, Atlanta residents are forced to drive James Creek Road as a roundabout way to Boise. The waterfall on Elk Creek, Peg Leg Annie Memorial, and views all along the route make this a scenic trip.

Option: At Rocky Bar, there is another opportunity to shorten this expedition by continuing on Road 156 to an intersection with Road 129 leading 17 miles to Trinity Lakes Recreation Area (signs show the way to North Phifer Creek Road). Road 156 also continues to Middle Fork Road on the Middle Fork of the Boise River.

ROCKY BAR

Rocky Bar was established in 1863 by H.T.P. Comstock. According to some historians, this same Henry Comstock wrongfully claimed gold found by other miners in 1859 near the future site of Virginia City, Nevada. When Rocky Bar was booming, the town became the first county seat of Alturas and Elmore counties. In 1864 it had a population of about 2,500. Peg Leg Annie lived in Rocky Bar after her anesthetization-by-liquor and amputation of frozen limbs. She went on to have five children and reportedly sold whiskey to miners for her income.

A friend of mine, Dave Moss, used to sit at his Great Uncle Ed's knee to hear tales of Rocky Bar's wild days. Ed owned the bar and claimed to have looked down the barrel of a loaded .45 revolver more than once when desperate men tried to rob him. Ed went to court for the "Illegal Discharge of a Firearm in a Federal Forest" when he defended his money with a shotgun. After that, he moved to Mountain Home and found religion. Like the bar, Ed is no longer with us.

Rocky Bar was destroyed once by fire and rebuilt. But by the early 1960s the only full-time resident was Charlie Sprittles, a man who never owned a car. He died of an apparent heart attack while walking through deep snow in the winter of 1963-64. Searchers found him a few miles east of Rocky Bar when the snow melted in the spring.

GPS: 43° 43.934' N • 115° 16.501' W
Mile 42.0 • Elevation: 6,338 ft.

There's a waterfall on Elk Creek, and a wooden bridge. **Caution:** spring floods sometimes create deep holes on either side of the bridge approach.

GPS: 43° 45.696' N • 115° 13.552' W
Mile 46.0 • Elevation: 7,764 ft.

About 7 to 8 miles from Rocky Bar is the Peg Leg Annie Memorial, a stone monument with a plaque created by the Atlanta Arts Society. In addition to Peg Leg Annie, another sign honors 1870s freighters and muleskinners who brought supplies to remote Idaho mining towns. The memorials are about a mile beyond James Creek Summit (7,802 feet), but the summit sign had been destroyed by fire when we were there. Snow and other weather gauges mark the summit. Panoramic views include miles of forested mountains.

Beyond the memorials, the road begins a steep descent down the James Creek drainage, with a few tight switchbacks, blind corners, and rough areas where graders remove landslides that come down from burned-over slopes. Signs caution that it is a hazardous area. Burned trees may also fall across the narrow road. There are signed hiking trailheads for Snowline and Hot Creek, with informal camping nearby.

GPS: 43° 48.047' N • 115° 09.559' W
Mile 51.0 • Elevation: 5,202 ft.

Turn right on Middle Fork Road at this junction with James Creek Road. Before driving the few miles to Atlanta, stop at the interpretive kiosks near this road junction. 1880s mining techniques are illustrated, along with comparisons to modern reverse rotary circulation drilling that is currently used on the Atlanta Lode. John Stanley (Stanley, Idaho, is named after him) prospected for gold in the area in 1863, and the town was founded in 1864. In the 1870s, about one-third of Idaho's population was Chinese, and many of them were miners. They worked the area

with hand-operated derricks, water, and sluices. Crescent-shaped tailings are still clearly visible next to the kiosk parking lot.

GPS: 43° 48.141' N • 115° 07.663' W
Mile 54.0 • Elevation: 5,422 ft.

In the town of Atlanta there are relics from the early days of the gold rush, renovated buildings now used for vacation homes, out-fitter services for Sawtooth Wilderness adventures, campgrounds, hot springs, and a small number of hardy year-round residents—a sign put the population at 37. The town is located near milepost 67 on the Middle Fork Road. A small grocery store, a lodge, and a restaurant are usually open in summer. The Atlanta Guard Station is also a Forest Service rental cabin (see *www.recreation.gov*). Pinnacle Peaks Sawtooth Lodge has a private runway for small aircraft and helicopters.

GPS: 43° 48.047' N • 115° 09.559' W
Mile 0.0 • Elevation: 5,202 ft.

Backtrack to the junction of Middle Fork Road and James Creek Road. **ZERO YOUR ODOMETER.** The second half of this expedition travels west on Middle Fork Road to Phifer Creek Road, then up to Trinity Ridge, with a stop at Trinity Lakes Recreation Area before descending along the west side of Anderson Ranch Reservoir to reconnect with Highway 20. Middle Fork Road is marked with snowmobile icons for 17 miles west of Atlanta and is a popular winter recreation route. Queens River Campground, Transfer Camp and side road (all about 4 miles east of Atlanta) offer more recreational opportunities and another access point for the Sawtooth Wilderness.

Once you pass Weatherby USFS Landing Strip (Hot Creek) at about mile 11 from Atlanta, start watching for Phifer Creek Road.

GPS: 43° 49.144' N • 115° 21.485' W
Mile 12.3 • Elevation: 4,389 ft.

Turn left (south) on Phifer Creek Road 156, also signed for "Rocky Bar." Don't let the "Rocky Bar" sign confuse you—Phifer Creek

also leads to a junction with Road 129, Trinity Ridge Road (also at this junction, Swanholm Creek Road departs Middle Fork Road to the north). Cross the river via a bridge to the south. Caution signs near the bridge warn "No Maintenance, Steep Grades," but the road is in 4WD-recommended condition with only a few rocks and erosion bumps. It is narrow in spots and is not suitable for trailers. Just after you cross the bridge, a spur road leads to several informal campsites. Many unsigned jeep and ATV trails depart from Phifer Creek Road—these trails are not noted in this log.

Option: If you continue west on Middle Fork Road from this intersection, it is about 70 miles to Boise. See "Other Nearby Excursions" at the end of this expedition.

GPS: 43° 44.165' N • 115° 20.137' W
Mile 20.5 • Elevation: 6,995 ft.

Turn right on Trinity Ridge Road 129 at this junction. As you can see from the elevation, Phifer Creek Road 156 climbs steadily. Signs here show Featherville 14 miles distant, and Trinity Lakes 11 miles.

About a mile further, Middle Fork Boise Ridge Road 255 (also named "Roaring Fork Road" on some maps) intersects Road 129. At this narrow "Y", bear left (uphill), and stay on the main road.

Trinity Ridge Road is a real find in terms of grand views and informal camping. The road is narrow, but still 2WD in good weather. We camped on the ridge, north of the Trinity Lakes Recreation Area, to take in the sunset. Strict camping regulations, reservations for cabins, and fees are required at the lakes. If you are prepared for Leave-No-Trace camping on your own, you might opt for the solitude and long views from the ridge, then drive into the recreation area for fishing, boating, hiking and climbing.

There's a significant intersection 3 miles north of Trinity Lakes, where Road 129 meets Road 172 (Wagontown Road on some maps). Road 172 is a good snowmobile route, with a warming hut and access to Trinity Snopark near Featherville. Bear right at this intersection for Trinity Lakes Recreation Area.

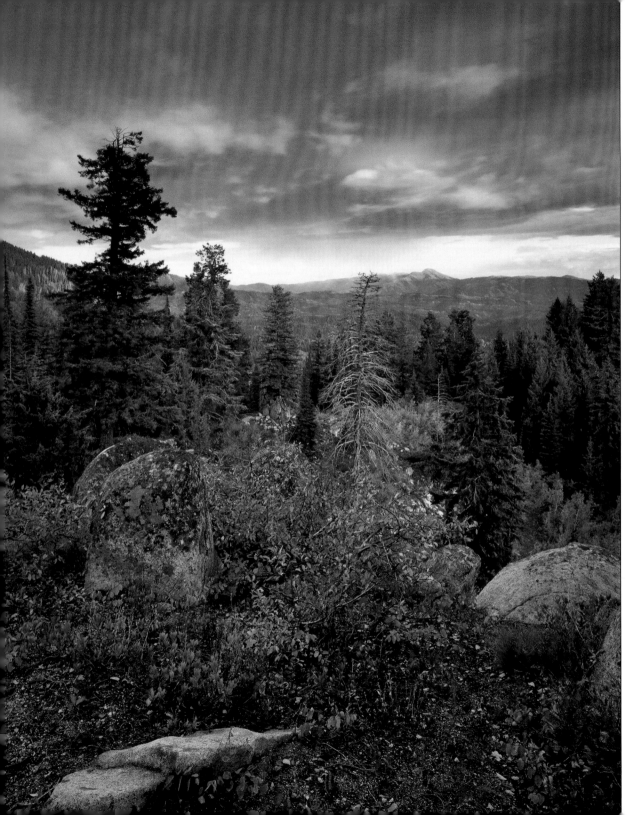

**GPS: 43° 37.376' N • 115° 26.560' W
Mile 32.0 • Elevation: 8,107 ft.**

Signs announce "Entering Trinity Lakes Area," near Little Trinity Lake picnic spot. Note that the GPS coordinates and elevation above are for the approximate *center* of the entire recreation area, not for Little Trinity Lake. Restrictions and fees are posted. There are three designated campgrounds: Big Trinity, Little Roaring, and Big Roaring. Hiking trails lead from Big Trinity Lake to Trinity Mountain (9,451 feet) and to alpine lakes in Rainbow Basin. Near the Forest Service Guard Station, the William H. Pogue National Recreation Trail 122 begins. The trail is open to foot, horse, motorcycle, and bicycle traffic. There are several "Trinity Guard Station" cabins available to rent (contact the Mountain Home Ranger District or *www.recreation.gov* for reservations).

Just south of Trinity Lakes Recreation Area is spur road 129A leading to the Trinity Mountain Lookout. The road is closed with a gate at a turnaround spot, and from there it is a two-mile hike to the lookout. You can also go on a hike from the lookout to Big Rainbow Lake.

To complete this expedition, continue south on Road 129 (now identified as Fall Creek Road on some maps). The road remains 2WD but is quite steep in spots as it

Sunset flares over the Trinity Lakes area in the Boise National Forest. This view is from the Trinity Ridge Road, south of the recreation area.

makes its way downhill to Anderson Ranch Reservoir. Gear down for the descent. On the way down, the road provides access to several hiking trails and many designated campgrounds.

Several side roads lead west—bear left at all of these junctions, including a major intersection with Meadow Creek Road. On some maps Road 129 becomes Road 123 at Meadow Creek, on other maps the number does not change, or the road is identified only as Fall Creek.

South of Ice Springs Campground, bear right to stay on Fall Creek Road as it leads to Fall Creek Lodge, several more campgrounds, and boat ramps on the reservoir. South of Fall Creek Lodge, the road number changes again to Road 113.

GPS: 43° 21.669' N • 115° 26.993' W
Mile 60.0 • Elevation: 4,202 ft.

Turn left to cross Anderson Ranch Dam on Anderson Dam Road 134. Drive Anderson Dam Road 134 to Highway 20 (about 6.5 miles south). The junction of Anderson Dam Road and Highway 20 is about 10 miles west of the starting point for this expedition. At Highway 20, turn west to go to Mountain Home; or turn east to go to Fairfield.

Other Nearby Excursions...

Lucky Peak Reservoir Recreation Area and Middle Fork Road, Boise River

Drive east/northeast from Boise on Highway 21 (Ponderosa Pine Scenic Byway) to access the Lucky Peak Reservoir Recreation Area. At the north end of Lucky Peak Reservoir, turn east off of Highway 21 onto Forest Road 268 (Middle Fork Road) for more boating and fishing opportunities along Arrowrock Reservoir. Middle Fork Road eventually makes its way to the historic town of Atlanta, about 84 miles from Boise.

As drivers parallel the Middle Fork of the Boise River, they pass through terrain that is hotter and drier than most other Idaho mountain ranges. By late April the road is frequently snow-free up to the Dutch Creek Guard Station. Higher elevations near Atlanta may be snowed in until late June. The road is 2WD graded gravel/dirt all the way, with some narrow spots and also a few blind corners. There are numerous designated campgrounds, dozens of relaxing hot springs, and a lot of unofficial campsites.

The Middle Fork of the Boise River downstream from Troutdale Campground is suitable for beginner canoeists. It is a leisurely paddle for nine river miles from the Troutdale put-in to the takeout at Badger Creek Campground (about 7 road miles). Parties of people even float the river with innertubes on hot summer days. From the intersection of Highway 21 and Middle Fork Road 268, drive about 31 miles to the put-in. Leave a shuttle vehicle at about mile 24, at Badger Creek.

WEST-CENTRAL

Southwest Idaho

A few miles west of the Duck Valley Indian Reservation, a consummate cowboy moves cows across the high desert. He is decked out in a red silk neckerchief, black hat pulled low over his brow, leather chaps, and tapaderos (leather "toe fenders" to protect boots and legs in rough brush). His horse is lightning fast through the high sagebrush, turning on a dime. The rider stays centered through all of these shenanigans as he and the horse work the cows alone.

Between the rider's hat brim and neckerchief, his face is an indecipherable shadow. He is most likely a hand from the YP Ranch. On topographical maps, part of the Owyhee Desert is named "YP Desert" after the ranch—YP is the third oldest brand in continuous use in the United States. Ranching has a long tradition here and grazing cattle or sheep are a common sight.

Near the town of Bruneau, irrigated fields extend agriculture into the desert, but the island of civilization soon gives way to miles and miles of high desert cut by rivers that hide in deep canyons. There are two main river systems, the Owyhee and the Bruneau, each with a small set of tributaries. The rivers meet the Snake River, which is also the northern border of the county, and the border between populated and barely-populated lands.

The Owyhee and Bruneau rivers have been called the most inaccessible in the lower 48 states. As we found out, river access does require a high-clearance 4WD vehicle, lots of patience, good topographical maps, and a certain laissez-faire attitude to being or getting lost. Some 4WD roads appear on 1:100,000 scale BLM topographical maps, and more appear on USGS 1:24,000 topos, but no map shows them all. Cows cut follow-each-other-mindlessly paths on top of faint two-tracks. Some of the roads

have enough tall sagebrush and rabbitbrush in the center to scrub the under carriage of even high-clearance vehicles. If it's raining, or has been raining, or is threatening to rain, think again. The 4WD roads devolve into a sort of primordial slime that's slicker than grease and more than a match for most vehicles. Owyhee Uplands Back Country Road has a good enough surface to withstand a little rain, but even it gets sloppy quickly. One April we slithered through fifty miles of mud in a specially modified truck before we got back to pavement. Jet jockeys from Mountain Home Air Force Base used us for tracking practice. Nothing else was moving for hundreds of square miles. When we stopped at a gas station, mud that looked remarkably like cow pies plopped onto the pavement.

"Owyhee" derives from Hawaiians who disappeared while exploring the area in 1819. When missionaries went to the Hawaiian Islands (then called the Sandwich Islands), they phonetically spelled the native name and came up with Owyhee. After trading posts were established on the Pacific Coast, Donald McKenzie sent three Hawaiians with other trappers into the desert in the winter to trap beaver, to trade, and to penetrate the Snake River country for the North West Company. The three men left the main party to explore unknown terrain and they never returned.

Owyhee Canyonlands is one of the largest intact shrub-steppe habitats in the Columbia River Basin, extending into Oregon. The area is home to California bighorn sheep, sage grouse, a

South Fork of the Owyhee River near 45 Ranch, where it joins the Owyhee River. The upland plateau is rolling desert, but the river canyons are rich riparian areas.

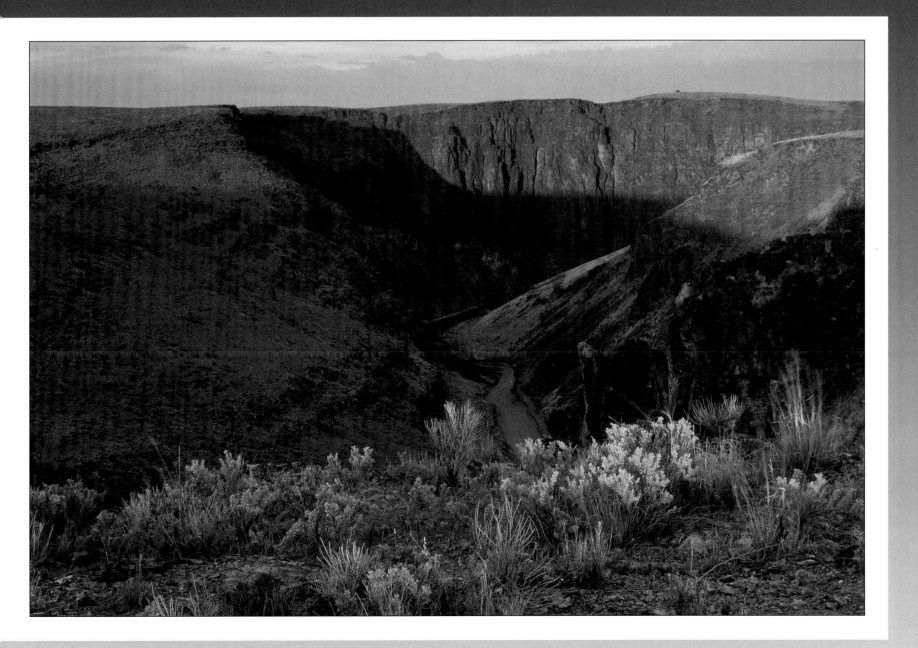

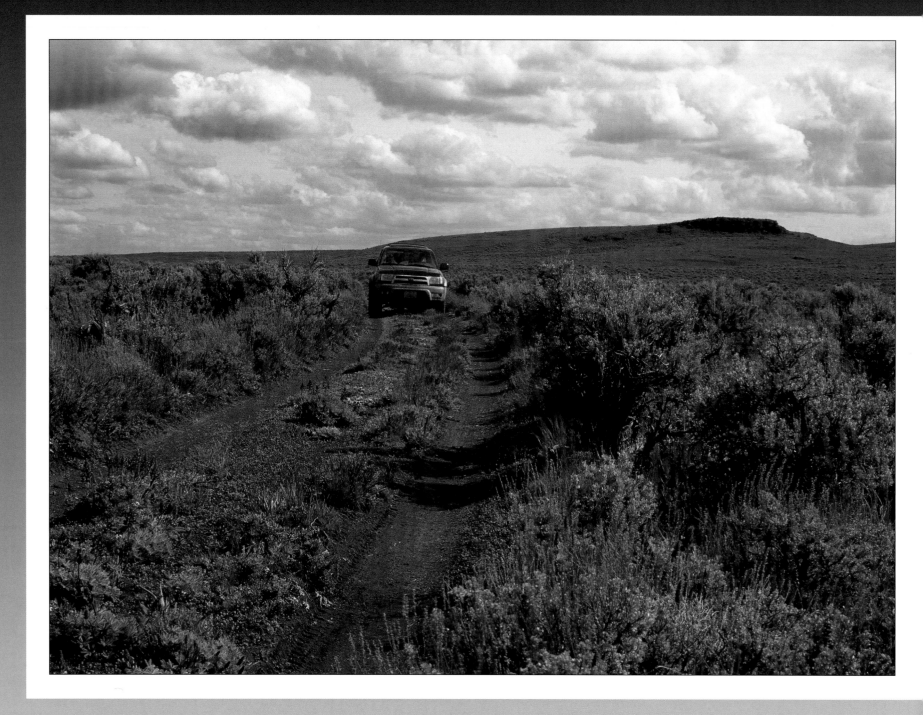

plethora of raptors, coyote, and cattle. Bluebunch wheatgrass, one of the most nutritious grasses of the desert, waves three feet high—a blue/blonde sea in places where cows haven't grazed. Rattlesnakes and other snakes live on the plateau and in the riparian areas deep in the canyons.

Zeno Canyon is one of the small tributary canyons that feed into the Big Jacks Creek and Little Jacks Creek Wilderness Study Areas. Together, Big Jacks and Little Jacks WSAs cover over 100,000 acres that the BLM manages to protect wilderness characteristics. Visitors are required to practice Leave-No-Trace camping, and vehicles should stay on the roads to protect the sensitive environment.

When we hike, I let my brother go first. Snakes seem to uncoil out of Leland's boots. I think they wait until the last second just to get the maximum startle reaction. Wear boots that protect your feet and lower legs. Wear gloves, and be careful not to put your hands into any place that your eyes can't see. Be equally wary when you select a tent site. In the canyons watch out for poison ivy.

Juniper and curlleaf mountain-mahagony woodlands decorate the uplands. There are even stands of mixed conifers in the Owyhee Mountains. Silver City, a combination ghost town and resort, is the centerpiece of the uplands. Because the town never burned, a lot of its history is preserved. The Idaho Hotel, built more than one hundred years ago, has been renovated and is open in the summer months. Structures date from the 1860s to early 1900s.

Silver City mines generated sixty million dollars of gold and silver over the course of seventy years. In the late 1800s, Silver City had about a dozen streets, seventy-five businesses, three

Emily Burns makes her way along the two-track that leads to Hicks Springs in the Owyhee Canyonlands.

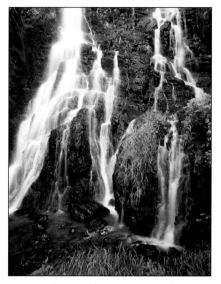

Zeno Falls, a hidden treasure in the Owyhee Canyonlands.

hundred homes, a population of around 2,500, twelve ore-processing mills, and was the Owyhee County seat.

In 1874, Silver City acquired the first telegraph and the first daily newspaper in the Idaho Territory. Telephones and electricity were also added in the late 1800s. Hundreds of mining claims were filed and the diggings still mark the hillsides. One mine boasted more than seventy miles of tunnels, all of them dug by hand. In 1977 the DeLamar Silver Mine began a modern era of prospecting that lasted until 2000. None of the mines are operating now.

The southwest region includes all of Owyhee County. On an Idaho map, the southwestern corner looks almost empty. Highway 51 traverses it north-to-south, the Owyhee Uplands Backcountry Road dips into the northwestern part, and Bruneau Dunes State Park lies on the north-central border. The nearest full-service cities are Mountain Home and Nampa, along the Interstate-84 corridor. Towns in Owyhee County include Grand View, Bruneau, and a small settlement on the Duck Valley Indian Reservation. There are gas stations at Bruneau and the reservation. These expeditions explore the least-populated area of Idaho.

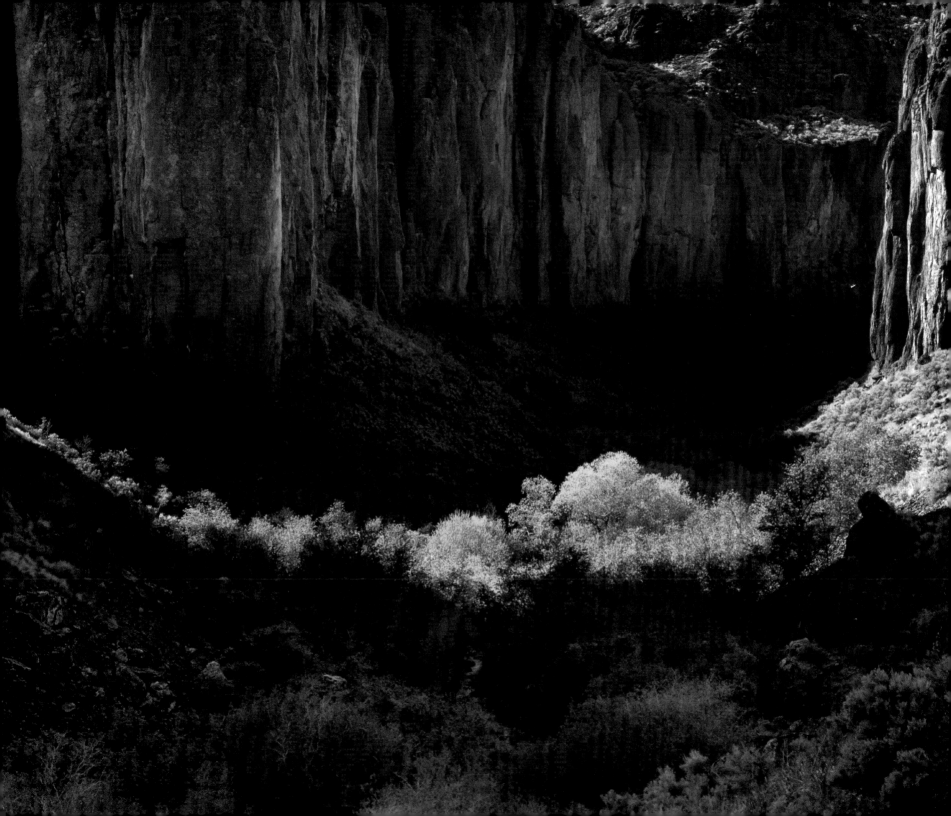

Zeno Falls • Owyhee Canyonlands

Other Nearby Excursions: Little Jacks Creek Canyon

When We Were There

In late April–early May we travel to Owyhee Canyonlands to catch the brief explosion of color that graces the desert when spring flowers bloom. To understand how surprised we are to see spring-green leaves on a grove of aspen trees, imagine a desert plateau so big that it can house an Air Force bombing range and still have room for several wilderness study areas—and in all that desert there are no trees outside the Owyhee Mountains and uplands. Small groves of aspen with lush carpets of grass beneath them surround Hicks Springs—an oasis hidden until one is right on top of it. The springs send water over a lip of stone into Zeno Canyon, where a waterfall completes the surprise on this arid adventure.

> *Taloned hawks, late for a trip*
> *to winter in Argentina,*
> *carve a sharp C in air.*
> *Desultory hunters,*
> *bibbed in black, formal,*
> *silent—but a chord is struck*
> *below the threshold of hearing*
> *by the shape of their drop*
> *from limb to shore.*
>
> —Trail notes by Lynna Howard

Spring green contrasts with rhyolite cliffs in Zeno Canyon, downstream from Zeno Falls.

Approach Routes

- **From Boise:** Southeast on I-84 to Mountain Home. Exit and drive south on Highway 51 to the small town of Bruneau; west from Bruneau on Highway 51 to the junction with Highway 78; continue south on Highway 51 to Wickahoney Road (not signed).
- **From Twin Falls:** Go west on I-84 to Exit 112; south and west on Highway 78 to Bruneau. See above.
- **From Owyhee, Nevada:** Go north on Highway 51 to Wickahoney Road.

Maps (See map sources in Appendix B)

BLM 1:100,000 quads: **Riddle** and **Sheep Creek**;
USGS 1:24,000 topographical maps (strongly recommended): **Wickahoney Crossing, Wickahoney Point** and **Hill Pasture**; and **Benchmark** *Idaho Road and Recreation Atlas.*

Land Administration (See Appendix A)

- **BLM:** Twin Falls Office
- **Idaho Fish and Game:** Southwest Region

Total Miles/Road Ratings

- **Total Miles:** 22.5 (one-way)
- **4WD recommended:** about 14 miles (good weather only)
- **4WD required:** about 8.5 miles, suitable for SUV in good weather; not suitable for the devil in really wet weather.

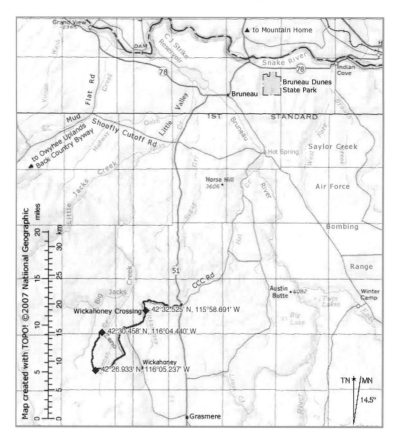

The map at left shows an unofficial hiking trail to get to Zeno Falls. The waterfall is located in Zeno Canyon.

Expedition Directions

Set your GPS to display Degrees and Decimal Minutes. All along this route there are two-track "roads" leading to ranches, cattle troughs, Wickahoney Point, etc. There are more roads on the ground than appear on most maps. These side roads are not noted except as necessary for route-finding, and most of them are not signed on the ground. Unless otherwise directed, stay on the main road.

GPS: 44° 33.162' N • 115° 53.860' W
Mile 0.0 • Elevation: 4,738 ft.

Turn west on Wickahoney Road from Highway 51. This intersection isn't signed, but Wickahoney Road is identified on maps. The turn is a few hundred feet south of milepost 45. The road is graded dirt.

Wickahoney Road turns south at about mile 6, stay on the main road. Large corrals and a loading chute are located at about mile 6.3.

GPS: 44° 32.525' N • 115° 58.691' W
Mile 6.4 • Elevation: 4,744 ft.

Stay on the main road at Wickahoney Crossing, a creek crossing that is identified on topographical maps. The crossing used to be a stage stop between Bruneau and Mountain City, Nevada. It had a post office from 1895 to 1911. *Wickahoney* is said to be a Shoshone Indian name that means "beaver."

Know Before You Go...

Gas stations are few and far between, so be sure to top off in Bruneau. Carry extra gas if you plan to explore further than Zeno Falls. We recommend traveling with two vehicles on any backcountry expeditions into the desert. See the introduction that begins this Southwest Idaho chapter for cautionary tales about the roads. Be prepared for cactus, rattlesnakes and poison ivy. There is no cellphone coverage. The best time to visit this area is late April to June, and September to October. July and August can be uncomfortably hot.

There are several spur roads leading from the main road between Wickahoney Crossing and Jimmy Cappel Hill (identified only on 1:24,000 topographical maps, but not signed on the ground). Stay on the main road to Duncan Creek Crossing. The road first climbs Jimmy Cappel Hill in a long curve, then trends south before turning southwest to cross over Duncan Creek.

GPS: 42° 27.200' N • 116° 03.584' W
Mile 15.7 • Elevation: 5,725 ft.

At Duncan Creek Crossing (named on 1:24,000 topographical maps), stay on the main road, and continue west for 1.8 miles. 4WD is recommended, and required in wet weather.

Option: Some hikers stop here and hike along Duncan Creek into Duncan Canyon. The first two miles of this canyon hike are both interesting and pleasant. But, long before you reach the tributary Zeno Canyon, the way is choked with brush so thick that you have to part it with your hands or climb over it every step of the way. Older guidebooks, and some internet sites, describe this alternate route to Zeno Falls. The bushwhacking in the canyon is underestimated in these descriptions. The winding route along the canyon floor is about 5.3 miles to Zeno Falls (one way) and includes climbing down steep drops of 6 to 8 feet. The plateau route over "The Island" (named on 1:24,000 topographical maps) is an interesting and scenic hike, but sheer, unstable cliffs prevent dropping into Zeno Canyon near the northern tip of "The Island". All caveats aside, shorter hikes in both the canyon and on the plateau offer great desert experiences in the Duncan Creek Wilderness Study Area—just don't plan to access Zeno Falls that way.

SOUTHWEST

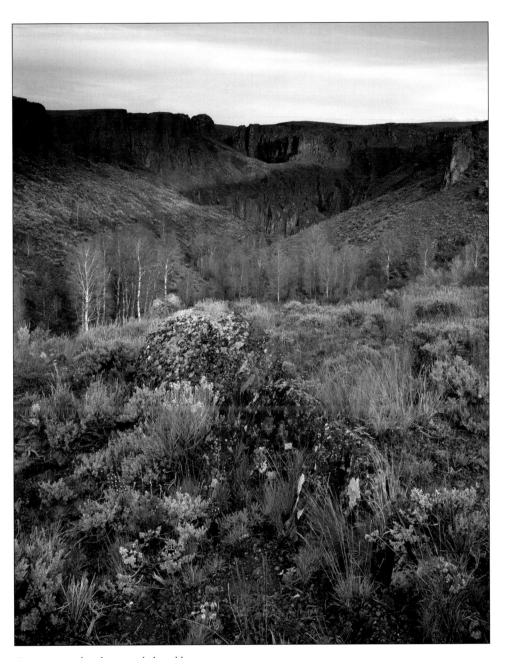

So rare as to be almost unbelievable, aspen groves and wildflowers lead the way into Zeno Canyon.

GPS: 42° 26.933' N •116° 05.237' W
Mile 17.5 •Elevation: 5,843 ft.

Turn right (northwest) at an unsigned intersection about 1.8 miles west of Duncan Creek Crossing (4WD is required). There are two entrances to this road (depicted as leading to Hill Pasture on topographical maps). GPS coordinates are given for the first (eastern) entrance. Drive north about 5 miles to Hicks Springs. Several two-tracks and 4WD roads lead from this road, including roads to Cottonwood Creek and ranch-related buildings and equipment. Be sure to stay on the main track heading north.

At about mile 4.8 from your turn north, the tops of the aspen grove at Hicks Springs come into view. Continue on toward the grove of trees.

GPS: 42° 30.458' N •116° 04.440' W
Mile 22.5 •Elevation: 5,391 ft.

Hicks Springs. A short jog to the right (east) takes you to an informal parking and camping area above the springs. Protect the riparian area by camping at least 200 feet away from the springs. Enjoy unbeatable views of the tree and shrub-filled tributary canyon that leads to the cliffs of Zeno Canyon. You can't access Zeno Falls by walking down this canyon (see the small inset map on p. 144 for an unofficial hiking trail to the waterfall).

To hike to Zeno Falls, start at the informal parking area above the springs and hike southeast, following the contour line to a point where you can descend a few hundred yards to cross a gully above another set of springs thick with shrubs (about 0.3 mile). Once across the gully, hike north/northeast, contouring around

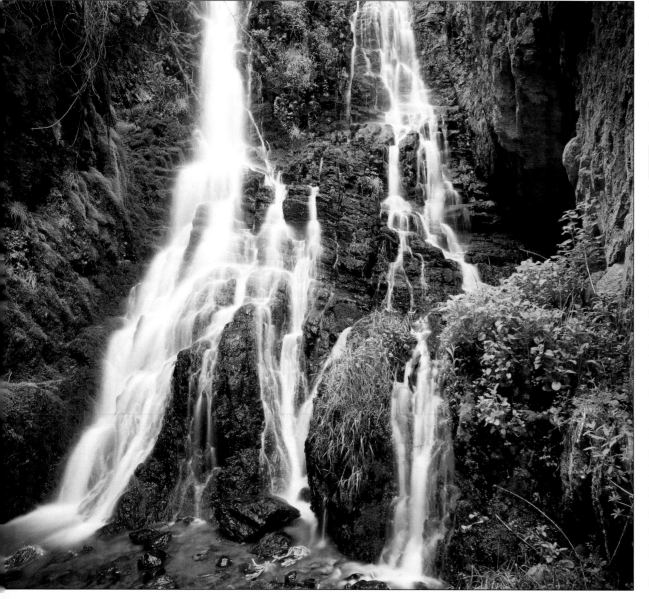

Zeno Falls

the hill and angling uphill for about 0.1 mile. There are user-created trails here, and some cow trails also. Hike southeast about 0.2 mile to a notch in the canyon wall where a short scramble provides access to Zeno Canyon. Once you're in the canyon the waterfall is just around the corner. You can hear it, feel the moisture, and see the riparian area.

Retrace your route to Highway 51.

Option 1: Turn north on Highway 51 for "Shoo Fly Off Rd." and the Little Jacks Creek Canyon excursion described at right. Also turn north to return to the town of Bruneau, to Mountain Home, or to the Owyhee Uplands Back Country Byway.

Option 2: Turn south on Highway 51 for the Duck Valley Indian Reservation and the town of Owyhee in Nevada. Also turn south for access to the Bruneau River Launch Site at Indian Hot Springs (turn southeast near Grasmere); going south also gives you access to the Garat Crossing Launch Site on the Owyhee River and the 45 Ranch Launch Site on South Fork Owyhee River. Detailed topographical maps are needed to find these launch sites. See p. 155 for more information.

Other Nearby Excursions...

Little Jacks Creek Canyon

From Highway 51, turn west on Shoofly Cutoff Road, signed as "Shoo Fly Off Rd." on the ground. Drive west 1.2 miles and turn left (south) on Vaught Road. Continue west and northwest on unsigned roads to round the northern end of the Chalk Hills (identified on topographical maps). Continue southwest along the western edge of the Chalk Hills to more unsigned roads that parallel Little Jacks Creek. The section of the canyon we explored is about 12.5 miles from Highway 51. Take the following USGS 1:24,000 topographical maps: Sugar Valley, Little Valley, Chalk Hills, Ox Lake, and Big Horse Basin.

There are no trailheads or maintained trails along Little Jacks Creek, but the canyon is accessible with a minimal amount of trial-and-error exploration.

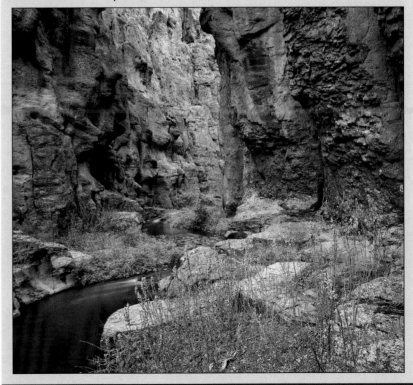

SOUTHWEST

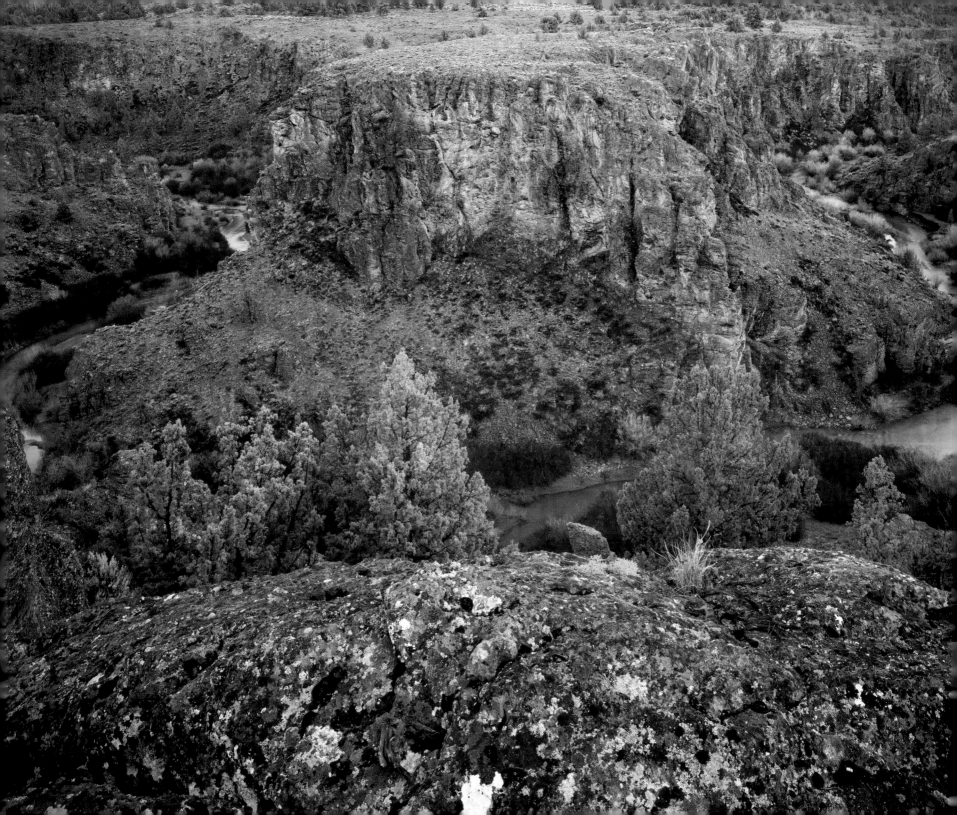

Owyhee Uplands Back Country Byway
Other Nearby Excursions: Snake River Birds of Prey NCA

When We Were There

After days of travel in the desert to the south, we're impressed by scattered forests in the uplands. Juniper-pinyon woodlands and groves of curlleaf mountain-mahogany cloak the foothills of the Owyhee Mountains. The uplands aren't quite as dry and definitely not as flat as the desert plateau. Deeply incised canyons cut both of these areas. See the introduction to this southwest region (p. 138) for a description of ghost towns and mining in the Silver City area of the mountains.

> *Shadow shape on a bare shoulder*
> *is a raptor—lazily riding a column*
> *of heated air in the cloud-dimpled sky.*
> —Trail notes by Lynna Howard

Dirt and gravel roads drop south, or explore north, from the Owyhee Uplands Back Country Byway. The byway is a maintained gravel road that is 2WD in all but the worst weather (not maintained for winter travel). It usually opens in April, when it still reminds motorists of its old name "Mud Flat Loop," a name still on signs at the eastern end of the byway. Near the Oregon border the road has the double name of "Juniper Mountain Road–Owyhee Uplands Back Country Byway."

From Grand View, Idaho, the byway drops south and west to curve around the Owyhee Mountains and then heads sharply north again to cross North Fork Owyhee River near the Oregon border. We suggest a stop at Deep Creek; and a side trip to Juniper Mountain. At Juniper Mountain you are within hiking or photo

Deep Creek, a tributary of the Owyhee River, carves a canyon through volcanic rock.

distance for three wilderness study areas: Squaw Creek, Middle Fork Owyhee River and West Fork Red Canyon. There are campgrounds, both designated and informal, near the bridge over North Fork Owyhee River.

Approach Routes

- **From Grand View:** Southeast on Highway 78 to Mud Flat Road/Owyhee Uplands Back Country Byway, turn south on the byway.
- **From Jordan Valley, Oregon:** East/southeast to Juniper Mountain–Owyhee Uplands Back Country Byway; turn south and drive the expedition backwards. This is also an approach route for Silver City, which is east then northeast from Jordan Valley to Idaho's Owyhee Mountains.

Maps (See map sources in Appendix B)

BLM 1:100,000 quad maps: **Triangle** (covers most of the Back Country Byway) and **Riddle** (for exploring the Deep Creek area and for the Juniper Mountain area side trip).

Land Administration (See Appendix A)

- **BLM:** Owyhee, Bruneau, and Four Rivers Field Offices
- **Idaho Fish and Game:** Southwest Region
- **Snake River Birds of Prey NCA:** *www.birdsofprey.blm.gov*

Know Before You Go...

Gas is available in Grand View, Idaho, and in Jordan Valley, Oregon. Signs at the eastern entrance on "Mud Flat Road" tell the tale: "No Services available next 103 miles. Carry your own food & water." There is no cellphone coverage along most of the route. The best time to visit is mid-April to October.

Total Miles/Road Ratings

• **Total Miles:** 102.8
• **2WD graded gravel/dirt:** 102.8 miles, suitable for trailers in good weather
• **4WD recommended:** for optional side trips
• **4WD required:** for optional side trips in wet weather

Expedition Directions

Set your GPS to display Degrees and Decimal Minutes. All along this route there are 4WD roads leading to canyon and mountain destinations. There are more roads on the ground than appear on most maps. These side roads are not noted except when necessary for route-finding. Stay on the Owyhee Uplands Back Country Byway for the entire expedition. If you take optional side trips, return to the byway to continue.

GPS: 42° 57.640' N • 116° 04.624' W
Mile 0.0 • Elevation: 2,497 ft.

Turn south on Mud Flat Road (the Owyhee Uplands Back Country Byway) about 2.2 miles southeast of the town of Grand View. The town is located on the Snake River, southwest of Mountain Home. On some maps Mud Flat Road is identified as Shoofly Road. On the ground it is signed as access to the byway.

A junction with Shoofly Cutoff Road is signed at mile 5.1. A turn east here would lead you back to Highway 51—stay on the Byway/Mud Flat Road for this trip.

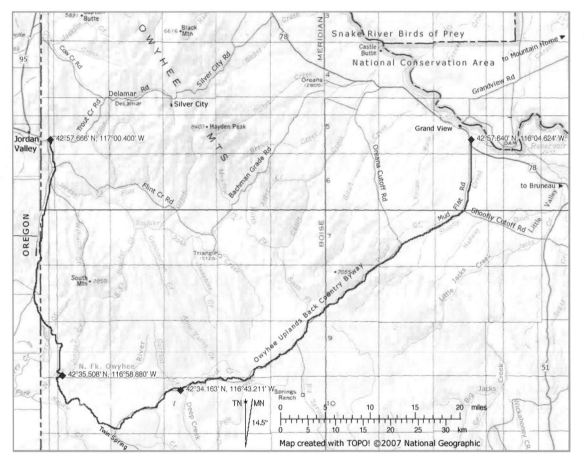

Oceana Cutoff Road is signed at mile 16. It leads north, then to Grand View—stay on the Byway.

Poison Creek Recreation Site is signed at mile 21.7. Note it has a picnic area and pit toilets.

At mile 27.7, Summit Flat is signed, 6,023 feet elevation.

Option: Antelope Ridge Road is signed at mile 33.5. A side trip here requires 4WD to travel northwest to view some old mining sites.

BLM Mud Flat Administrative Site is signed at mile 39.6.

The Byway crosses Hurry Back Creek, a tributary of Deep Creek, at mile 47.8.

GPS: 42° 34.163' N • 116° 43.211' W
Mile 50.7 • Elevation: 5,166 ft.

A spur road leads south to an informal parking and camping area. This is a short side trip that we recommend for the excellent views of Deep Creek. River runners use this spot as a put-in to canoe or kayak, (Class I-II; note that the take-out at Rickard Crossing requires 4WD). South of the Byway, Deep Creek Canyon is a miniature Grand Canyon, with vertical cliff walls. Deep Creek Wilderness Study Area is east of the canyon. The area is home to bighorn sheep.

GPS: 42° 30.992' N • 116° 53.628' W
Mile 63.0 • Elevation: 5,707 ft.

Option: Juniper Mountain Road, leading south on Twin Springs Ridge, is an optional side trip. 4WD is recommended, and required for some trailheads. Return to Owyhee Uplands Back Country Byway to continue this expedition.

Enjoy incredible views of the North Fork Owyhee River about mile 71 to 74.

A spur road leads to the North Fork Owyhee River Campground at mile 72.

GPS: 42° 35.508' N • 116° 58.880' W
Mile 73.2 • Elevation: 4,800 ft.

Cross a bridge over the North Fork Owyhee River. The Owyhee Uplands Back Country Byway switchbacks down to this bridge, then climbs again to the north side of the river, where there are some informal campsites east of the road. On most maps the road is also named Juniper Mountain Road from this point north

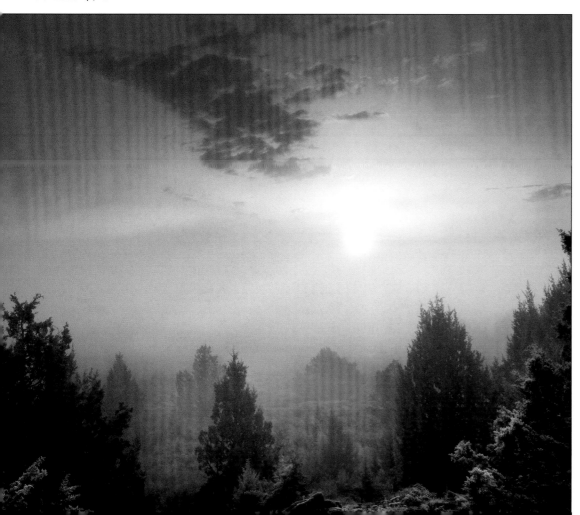

An Owyhee Uplands sunrise from along the Owyhee Uplands Back Country Byway.

to Jordan Valley, Oregon. Private property, reservoirs, and rural communities are abundant between the bridge and the town of Jordan Valley.

Cliffs Landing Strip is at mile 77.3.

Dougal Reservoir is at mile 79.2.

Cross into Oregon at mile 81.5 (the road crosses back into Idaho further north).

Smith Mountain Road is on the right (southeast); Sheep Springs Road is on the left (northwest) at mile 98.

GPS: 42° 57.666' N •17° 00.400' W
Mile 102.8 •Elevation: 4,452 ft.

The end of this expedition, where Juniper Mountain Road ends at a "T" intersection with Trout Creek Road.

Option 1: On our trip, we backtracked to camp above the North Fork Owyhee River. The next day we returned the way we came on the Scenic Byway, going to Grand View to visit the Snake River Birds of Prey NCA (see right).

Option 2: Turn right (east) then northeast, to access Trout Creek and Delamar roads to Silver City. These roads are 2WD in good weather, 4WD and muddy when wet.

Option 3: Turn left (west) for Jordan Valley, Oregon. Also turn west for Highway 95 to the Rome launch/take-out site on the Owyhee River. From Jordan Valley, a trip north on Highway 95 leads back to the Boise area.

Other Nearby Excursions...

Snake River Birds of Prey National Conservation Area

The Snake River Birds of Prey National Conservation Area (NCA) was established in 1993 to protect one of the world's densest concentrations of nesting birds of prey. Falcons, eagles, hawks, and owls are just a few of the twenty-four raptor species on about 600,000 acres along and near the Snake River. The NCA is about 20 miles south of Boise. From Grand View on the south side of the Snake River, drive northwest on Highway 78 (Murphy–Grand View Road) following the southwestern border of the NCA. Cross the Snake River on Ferry Road near Walters Ferry. Follow the river south to Celebration Park. Guffey Bridge, an historical site, is at the southern end of Celebration Park. The railroad bridge, built in 1897, has been restored for non-motorized use. The NCA has several primitive trails that are popular with bird watchers, including the River Canyon Trail. An interpretive center, boat launch, campground, and picnic area are nearby. From Guffey Bridge, travel north and east to visit the Birds of Prey kiosk south of the town of Kuna. A 56-mile driving loop named "Swan Falls" also begins at the Kuna Visitor Center. Access to Boise and to Interstate-84 is signed at Kuna.

Bruneau Canyon Rim

Other Nearby Excursions:
Bruneau Dunes State Park

When We Were There

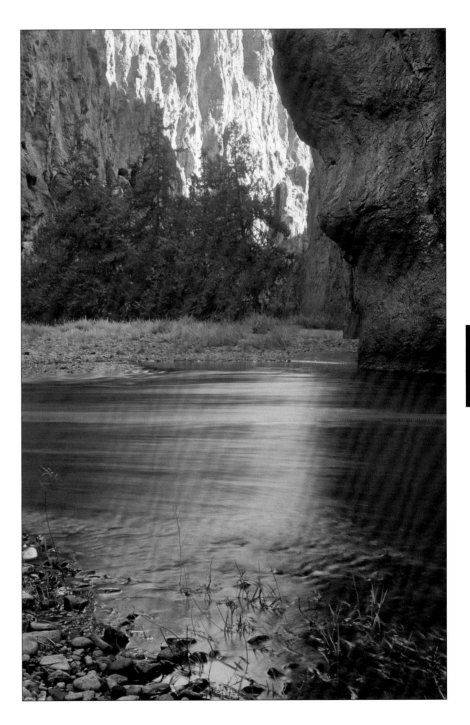

It is late April and we are seeing nothing but rocks and more rocks (even in the roads), but my brother finds one grassy shelf about thirty feet below the Bruneau Canyon rim—not just a good tent site, but one with a view you can only get in Idaho. From our camp we see swallows, eagles, and hawks flowing up-canyon in the air below us. Flocks of swallows are cast like silver drift nets in the air between us and the river far below. "How low can you go?" The bottom of the deepest gorge for its width in the United States is a good place to start.

Shifting over water-carved stone,
three-foot drops, ledges with views
that suck your eyes down—
read the book in rock,
the old morse code, the longs
and the shorts of geologic time.

—Trail notes by Lynna Howard

Bruneau is French for "brown water," and may also refer to the French trapper, Pierre Baptiste Bruneau. The name first appears in trapper John Work's journal in 1831. The canyon is deeply incised in the Bruneau-Jarbidge eruptive center. Volcanic eruptions began about 12 million years ago and volcanic activity lasted several million years. The extrusions of rhyolite were close enough in time to cool into a single, dense layer. Fine-grained rhyolite forms beautiful cliffs

Bruneau Canyon and river as seen from down in the canyon. Bruneau Canyon is the deepest gorge for its width in the United States.

SOUTHWEST

when cut by a river. Wherever there is volcanic and hydrothermal activity, chances for deposits of precious metals and gem-quality stone increase. "Bruneau Jasper" is still mined today. Bruneau River has its beginnings in the Jarbidge Mountains of Nevada, and is about 80 miles long. Sixty of the river's most inaccessible miles are crossed by only two cattle trails. We rafted the Bruneau River a few years ago and saw no other human beings for three days. The warning that rescue teams could not access the canyon was sobering. The Bruneau River flows northwest and drains into the Snake. An easy-to-find tourist destination is an overlook 19 miles from the town of Bruneau, where the canyon is 800 feet deep and 1,300 feet wide. It is deeper at many other points, including the view to which this expedition directs intrepid drivers.

The Owyhee Desert covers 15,253 square miles, including parts of Idaho, Nevada and Oregon—with a population density of about .04 persons per square mile. When you visit, you will be adding significantly to the population. However, there are signs of man here, some in the form of stone buildings built by pioneers in the late 1800s and early 1900s. Wood was a rare commodity, so builders used local lava rock. At Winter Camp on the East Fork of the Bruneau (also named Clover Creek), pioneer-era structures still stand. Bruneau historian Tom Hall says Winter Camp was named for the man who homesteaded the place, and not, as some sources claim, because it served as winter range for cattle and horses. The original homesteader's name was Winter Camp, and some locals called it "Winter's Camp." But the seasonal implication is not far off. The current rancher, Mr. Leguineche, says the place remains snow-free most of the time, and a previous owner, famous horsewoman Kitty Wilkins, ran horses there in the winter.

Be sure to close all the stock-control gates you have to pass through on this short expedition. Access through private property is by courtesy of the rancher. Do not camp or collect artifacts on private land. Mr. Leguineche says vandals stole a cornerstone from the oldest building. Civilian Conservation Corps workers had carved "Nov 2, 1932" in the stone when they arrived to do road work in the area.

Approach Routes

• **From Bruneau:** Turn southeast at the One Stop Café on Hot Springs Road (at the point where Highway 78/51 turns west). Hot Springs Road is paved for about 8 miles. Continue southeast on graded gravel (still 2WD). About 3 miles after the pavement ends, Overlook Road on the right (west) leads to a scenic viewpoint above Bruneau Canyon, and to a trailhead for Idaho Centennial Trail. Continue southeast about 19 more miles on the main road, which becomes Clover Three Creek Road. The turn west on Winter Camp Road is signed.

Maps (See map sources in Appendix B)

BLM 1:100,000 quad map: **Glens Ferry**; USGS 1:24,000 topographical maps (highly recommended): **Winter Camp** and **Austin Butte**.

Map Alert: For this expedition the printed map (left) is from the 100K series, map level 4 of National Geographic software (see 3-mile scale on the map). Most maps in this book are printed from the 500K series—don't let the scale confuse you.

Land Administration (See Appendix A)

• **BLM:** Twin Falls and Jarbridge Offices
• **Idaho Fish and Game:** Magic Valley Region

Total Miles/Road Ratings

• **Total Miles:** 10.5, not suitable for trailers
• **4WD recommended:** about 2.5 miles
• **4WD required:** about 8 miles, high clearance is recommended. In wet weather the entire route (10.5 miles) is 4WD.

Expedition Directions

Set your GPS to display Degrees and Decimal Minutes. Roads that bear the warning "4-wheel drive required, winch and 1,500 ft. cable recommended," and even more ominously, "Military Precision Bombing Area," lead across the Owyhee Desert. (*"No, Martha, we can't stop here. The Air Force will bomb your bloomers!"*) Not to worry, this expedition does cross the Saylor Creek Air Force Bombing Range, but no winch is required.

GPS: 42° 34.288' N •115° 30.419' W
Mile 0.0 •Elevation: 4,068 ft.

Turn right (west) on Winter Camp Road (signed) at the junction with Clover Three Creek Road. This intersection is about 27 miles

FLOATING THE OWYHEE AND BRUNEAU RIVERS

Kayakers and rafters run the Owyhee and Bruneau rivers through corridors of land managed by the BLM as Wilderness Study Areas. Leave-No-Trace rules apply for users of the river corridors, and permits are required. *The Owyhee & Bruneau River Systems Boating Guide* published by the BLM is a must for all river runners. 4WD is required for most access points.

On the Owyhee River, serious river rafters and kayakers schedule their trips between March and early June. Look for water levels between 1,000 and 6,000 cfs (cubic feet per second). Early June to mid-July is usually a good time for low-water runs. April is the best month for running the North Fork and Deep Creek tributaries of the Owyhee River. The Owyhee River also boasts Class V rapids.

It is best to float the Bruneau River when flows are between 500 and 2,500 at the Bruneau Gauge. The flow usually peaks about May 15, but every season varies. Bruneau River's famous "Five Mile Rapid" is Class III-IV, depending on the water level. The trip is suitable only for experienced boaters.

south/southeast of the town of Bruneau. Winter Camp Road is graded dirt/gravel, 2WD for a short distance. Ignore two-tracks cutting across the desert unless otherwise advised.

At 0.4 mile, a three-pronged meeting of dirt roads is not signed. To continue to Winter Camp, choose the middle fork. Note that the middle road is NOT the most well-traveled. This intersection is signed only for "Idaho Centennial Trail."

Soon after the unsigned intersection, open a gate across the road and continue onward. This gate is signed "Winter Camp, Leguineche…" (remember to close the gate). The road turns south and descends into East Fork Bruneau/Clover Creek Canyon. It is one-lane wide, rocky, 4WD, with mud holes when wet. Open a second gate near housing for ranch hands. Close the gate and proceed.

At mile 2.4 the road coming in from the left is one not taken from the previous three-pronged intersection. It is a rougher way into the canyon.

GPS: 42° 33.223' N • 115° 30.344' W
Mile 2.5 • Elevation: 3,917 ft.

This is the third gate to open and close, and also the site of the original Winter Camp. It's fine to stop and photograph the old structures, but do not disturb the site.

Soon after passing Winter Camp, a fourth gate requires your attention. When we were there, the gate was an iffy affair and it took two people and some baling wire to close it. Beyond this gate, the road crosses Clover Creek on a wooden bridge and heads steeply uphill. The uphill portion of the road is 4WD even in dry conditions.

Navigation Alert! At mile 3.3, at a "Y" intersection, turn right (northwest). This 4WD road does NOT appear on some maps. The left fork is shown on maps as being a better route, but on the ground the **right** fork is the way to go. Just a few hundred yards past this intersection is yet another gate, this one wide and floppy. After closing the gate, continue on the 4WD two-track with vegetation that is growing in the center, plus a cow trail woven over it. Black volcanic rocks poke up through powdery white ash. Faint outlines of long-ago fields run up to sagebrush

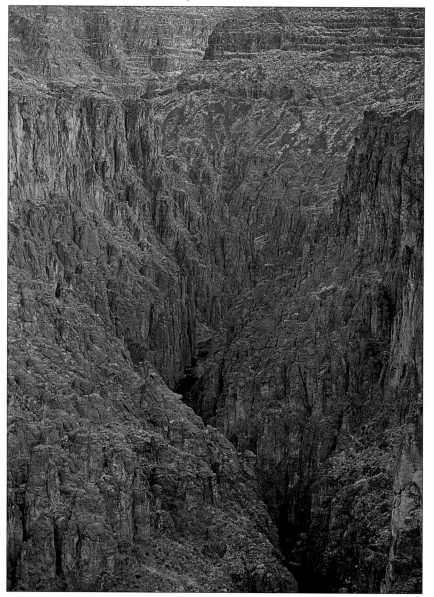

To view Bruneau Canyon, visitors must walk right up to the canyon rim. From the desert plateau above, the river and its canyon are hidden.

borders. The fields were once irrigated, but are now given over to bunch grasses and returning sage.

At mile 7 the "road" trends southwest toward Twin Lakes, playas that are identified on most maps.

At mile 7.4 a faint two-track leads southeast to Long Butte, but stay on the southwesterly two-track.

| **GPS: 42° 33.775' N • 115° 36.044' W**
| **Mile 8.2 • Elevation: 4,016 ft.**

Enter the largest playa. Mark this dry lakebed as a waypoint on your GPS so that you can find your way back. Another road enters the lakebed a few hundred yards to the south, and this is the road that appears on most maps, but is a rougher route from Winter Camp. Once you enter the lakebed, the two-track disappears (unless someone has recently driven it). Angle off to the right (northwest) to find the continuation of the two-track as it leaves the playa. In wet conditions, do not drive onto the playa, drive around it and through the sagebrush.

As you leave Twin Lakes, look right (north) to see cliffs that indicate the course of the East Fork Bruneau River. Road quality diminishes rapidly as you leave the playa, becoming little more than a cow trail. Follow the cow trail—4WD or hooves required. If you depart from the trail, mark another waypoint on your GPS. You can use the map printed in this book to proceed, but the route is dim on the ground. It is a good idea to use the terrain as a guide.

From where the cow trail disappears, travel cross-country for 0.5 to 1.5 miles to the rim of Bruneau Canyon. The final distance depends on the route you choose, or the view at which you decide to stop. If you prefer, hike to the rim instead of driving to it.

| **GPS: 42° 34.338' N • 115° 38.161' W**
| **Mile 10.5 • Elevation: 3,924 ft.**

The end of this expedition is at an unforgettable view of Bruneau River Canyon from a shelf just below the rim. Retrace your route to Clover Three Creek Road. Turn left (northwest) on Clover Three Creek Road to return to Bruneau, or to visit Bruneau Dunes State Park (below).

Other Nearby Excursions...

Bruneau Dunes State Park

Home of the tallest single-structure dunes in North America. The 470-foot-tall sand dunes were created after the Bonneville Flood swept down the Snake River about 15,000 years ago, cutting a new river channel and leaving the old channel as a repository for sand from the Owyhee Plateau.

"Tallest?" Well, you may wonder when you see that the dunes are small compared to larger dune structures. Bruneau Dunes earn their title by being special in their own category—barchan. Barchan dunes develop only where the wind blows consistently from one direction.

The park features diverse habitats in one small area: desert, dune, prairie, lake and marsh. There is a canoe launch site on the lake. Idaho's only public observatory for stargazing is located here. Vehicles aren't allowed on the dunes. There's a campground here and two cabins are also available to rent. The fee-based area is open year-round.

Access notes: The dunes are 18 miles southwest of Mountain Home, and about 8 miles east/northeast of Bruneau. From Bruneau, drive north on Highway 78/51, then west on Highway 78 to the well-signed entrance to the park.

South-Central Idaho

Although a lot of maps don't identify it, the City of Rocks Back Country Byway is one of the most culturally rich byways in Idaho. It stretches from the small town of Albion on Highway 77, through City of Rocks National Reserve, to Oakley on the west side of the Albion Mountains. Albion was the first Cassia County seat—pioneer farmers, ranchers and sheepherders settled the area in the late 1800s.

The Cassia County jail in Albion held Diamondfield Jack Davis, one of the first notorious gunmen of the era. He was accused of shooting two sheepherders during the sheep-versus-cattle wars of the late 1890s. Jack Davis survived eight stays of execution before other cattlemen confessed to the crime, and the pardon board finally turned him loose in 1902.

In the mid 1800s, south-central Idaho was known more as a way-station for wagon trains passing through. Emigrants headed for the promised lands of Oregon and California left their marks on Register Rock at the City of Rocks.

"The high, rocky and very ragged looking mountains, this valley we take the liberty to call 'Pleasant Valley.' It is a very good and pleasant place for camping."

—Leander V. Loomis, 1850

"Some of them are several hundred feet high and split from pinnacle to base by numerous perpendicular cracks or fissures. Some are domelike and the cracks run at different angles…
I have not time to write the hundredth part of the marvels of the valley or rocks…"

—Mr. Lord, 1849

"We nooned among these curious monuments of nature. I dined hastily on bread and water, and while others rested I explored and sketched some of these queer rocks."

—J. Goldsborough Bruff, 1849

"We passed through a stone village composed of huge isolated rocks…it I called the City of Rocks…sublime, strange and wonderful."

—Margaret Frink, July 17, 1850

"After dinner, a ride of two miles brought us to the outlet of this romantic vale, a very path just wide enough for a wagon, and on either side very high, jagged and thin walls of granite. This is called the Pinnacle Pass."

—J. Goldsborough Bruff, 1849

Present-day visitors to Cassia County still find it a place to rest and recreate. It's stating the obvious that City of Rocks draws rock climbers from all over the world, but not so well-known is Howell Canyon's Pomerelle Recreation Area in the Albion Mountains. The resort area is located in a section of the mountains north of Expedition 20, but is easily accessible via signed roads. There are hiking trails around Lake Cleveland for summer visitors. In the southern half of the Albion Mountains, there are fewer visitors, but the scenery is just as impressive. A side trip to Independence Lakes is described as part of the expedition.

South-central Idaho is known as "Magic Valley," a reference to the fertile volcanic soil. Water sources in the region are stretched to the limit, with dams providing hydroelectric power, irrigation canals opening a few veins in the Snake River, and

smaller rivers like Raft River almost disappearing as they keeps ranches alive along their banks. Nevertheless, water still provides some of the most dramatic scenery. The Thousand Springs Scenic Byway hits these water highlights, including waterfalls over 200 feet high, and the uncanny sight of the cleanest water on earth pouring directly out of rock cliffs (see "Other Nearby Excursions" at the end of Expedition 20).

Twin Falls County and Cassia County are covered in this chapter. The area is south of the Snake River and Interstate-84, and north of the Utah border. Small pockets of the Albion Mountains and Goose Creek Mountains are managed as outliers of the Sawtooth National Forest. The drier mountain ranges fall under the jurisdiction of the Bureau of Land Management.

Major cities in this area are found along the I-84 corridor, and include Twin Falls and Burley. Small towns like Albion, Elba, and Almo are on the City of Rocks Back Country Byway.

In City of Rocks National Reserve, case-hardened surfaces on granite create an erosion-resistant exterior—but wind, rain, freezing and thawing cycles all work to erode the rock beneath, resulting in the "fantastic shapes" that early travelers noted.

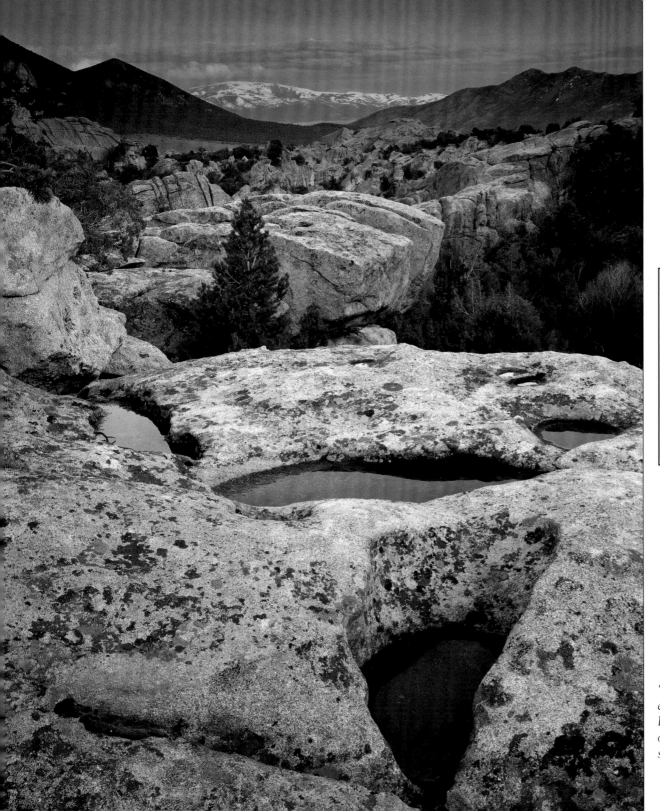

Brush this dry shrub whose name
 you don't know
and smell the spice on your hand.
Where the air trembles down the slope
 and over a rabbit's back
things are known that cities
 can never know.
 —Trail notes by Lynna Howard

"Pot Holes" in 25-million-year-old granite hold ephemeral rainwater in City of Rocks National Reserve. The highest peaks of the Albion Mountains rise over 10,000 feet and hold a cap of snow over water-starved lands below.

City of Rocks National Reserve
Albion Mountains

Other Nearby Excursions: Thousand Springs Scenic Byway

When We Were There

It's early May and there are still deep snowdrifts in the highest campsites at City of Rocks National Reserve. The lower campsites are filled with rock climbers. We hike into the heart of the rocky spires to see scruffy-looking deer losing their winter coats, and grasses recovering as they are released from the weight of snow. Every pinnacle sports a contingent of human ants and spiders.

The place is so crowded that we complete our research and drive to a seldom-used part of the Albion Mountains to camp. There's nothing like being relatively nowhere, doing relatively nothing, and enjoying everything. Springtime on the flanks of the Albion Mountains is all we need. Snow prevents our driving over Basin-Elba Pass, so we plan a later trip to complete the route information.

This expedition begins at a highway junction identified on maps as "Connor." The junction and a nearby creek are named after Brigadier General P. E. Connor. When civil war between northern and southern states was brewing, there was much debate as to which way Mormons in Utah and Idaho Territories would swing. The Secretary of War decided to place them under military supervision in 1862 and sent then-Colonel P. E. Connor to command the military district. Connor ordered that local men be arrested if they would not take an oath of allegiance to the United States government.

At Connor Junction, City of Rocks Back Country Byway leaves Highway 77 and dips between the Cotterel and Jim Sage mountain ranges. The majestic peaks of the Albion Mountains to the south-west can be seen for miles in this open country. The small town of Elba is between the Albion and Jim Sage mountains, where the loop portion of our tour begins and ends.

Almo, the town that is closest to City of Rocks, has a dual personality. By tradition it is a ranching community. Almo also plays host to international travelers. At Circle Creek, a couple next to us discussed the scenery in rapid French. The visitor center for both City of Rocks National Reserve and Castle Rock State Park is on Almo Road, at the south end of town.

City of Rocks heavy visitor traffic pounds the road into face-powder-fine dust. Where once thousands of "49ers" avoided dust by driving their wagons down multiple trails, rock climbers stick to the roads, as interested in preserving the landscape as the locals. Our expedition crosses City of Rocks, and emerges on the west side in Emery Canyon. As the road turns north toward Oakley, it briefly passes through the tightest confines of any road in the area, the gorge cut by Birch Creek. The Kelton-Boise Stageline used to pass through the gorge.

Officially, the City of Rocks Back Country Byway ends at Oakley, but our expedition turns east to cross over the Albion Mountains. Before you embark on the last leg of the expedition, you may want to stop in Oakley and take a walking tour of the historic district. Victorian-style homes and a preserved opera house make use of Oakley quartzite, which is still well-known in the construction trade today. Oakley stone is valuable because it

naturally splits into huge plates about eight feet wide and less than half an inch thick, making it perfect for stone veneers.

National reserves are part of the national park system, but are managed by local agencies. The Idaho Department of Parks and Recreation manages City of Rocks. The Reserve, authorized by Congress in 1988, is about 14,300 acres, with about half of that public property. Respect private property and follow posted regulations. Enjoy the rocks, but don't leave your hardware behind.

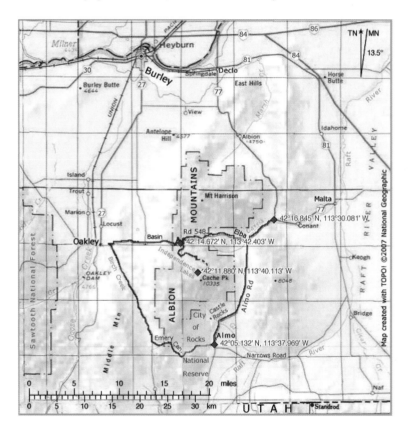

Approach Routes

- **From Boise:** East on I-84 to Declo exit 216; south on Highway 77 to Albion and to Connor Junction.
- **From Pocatello:** Southwest on I-86 to I-84; west on I-84 to Declo exit 216. See above.
- **From Twin Falls:** East on Highway 30 to Declo; south on Highway 77.
- **From Logan or Salt Lake City, Utah:** North on I-84 to Sublette exit 245; west on Sublette Road to Malta; west from Malta on Highway 77 to Connor Junction.

Maps (See map sources in Appendix B)

Sawtooth National Forest (Minidoka Ranger District); BLM 1:100,000K quad map: **Oakley**; USGS 1:24,000 topographical map (required only for side trips): **Cache Peak**.

Know Before You Go...

Camping is permitted only in designated sites. Campsites may be reserved by paying an additional fee. Gathering firewood inside the Reserve is prohibited—purchase firewood in Almo. Permits are also required for overnight use of the backcountry. Inquire at Reserve Headquarters. Hunting is permitted only on certain lands within the Reserve. Contact Idaho Fish and Game for maps and current regulations. This is rattlesnake country. In wet weather the roads can be muddy. Gas and most services are available in Almo and in Oakley. The closest full-service town is Burley. Cellphone coverage is minimal and occasional (occasionally it works and occasionally it doesn't). The best time to visit is late May to October. Summer months are ideal for hiking to Independence Lakes below Cache Peak (10,339 feet) in the Albion Mountains. Local guides and outfitters offer trail rides and guided hunts. Rock climbing outfitters from Stanley, Idaho, and Jackson, Wyoming offer climbing expeditions.

Land Administration (See Appendix A)

- **National Forest Service:** Burley Office (Sawtooth NF)
- **BLM:** Burley Field Office
- **Idaho Fish and Game:** Magic Valley Region
- **Idaho Department of Parks & Recreation:** Castle Rocks State Park and City of Rocks National Reserve

Total Miles/Road Ratings

- **Total Miles:** 59 (more for side trips)
- **2WD paved or graded gravel/dirt:** about 49 miles in good weather (about 39 miles in wet weather)
- **4WD recommended:** about 10 miles of Oakley-Elba Road. Not suitable for trailers.
- **4WD required:** in bad weather and for side trips in the Independence Lakes area. About 5 miles to Independence Lakes Trailhead—high clearance is recommended and topographical map-reading experience is required. About 6 miles along unsigned roads north of Basin-Elba Pass to explore old mining digs.

Expedition Directions

Set your GPS to display Degrees and Decimal Minutes. From Albion south, the road is identified as City of Rocks Back Country Byway.

GPS: 42° 16.845' N • 113° 30.081' W
Mile 0.0 • Elevation: 4,926 ft.

Turn right (southwest) on Almo Road at Connor Junction. For visitors coming from Utah, the town of Malta is east of this junction. Proceed west from Malta to Connor.

At mile 4, Bear left (south) to stay on Almo Road (the City of Rocks Back Country Byway) at this junction with Oakley–Elba Road 548 in the town of Elba (this junction will also be the endpoint of a loop in this expedition). Continue south to Almo. Many side roads leading to local ranches, etc. are not noted in this log.

At mile 12.4, bear right (southwest) at a triangle junction with Narrows Road.

At mile 14.1, keep straight to stay on Almo Road at this junction with a side road to Sunny Cedar Rest Cemetery.

GPS: 42° 07.373' N • 113° 37.326' W
Mile 14.4 • Elevation: 5,453 ft.

Option: Castle Rocks State Park Road on the right (west) is in the Big Cove area. Since the state park was opened, rock climbers, hikers, mountain bikers, and photographers have a new place to explore. There's a parking and picnic area near an old ranch house that serves as park headquarters.

For the main expedition, continue south (straight ahead) to Almo at this road junction.

GPS: 42° 05.789' N • 113° 37.997' W
Mile 16.5 • Elevation: 5,387 ft.

City of Rocks National Reserve Headquarters. Stop here if you need info or permits for backcountry camping. The headquarters is open April 15 to October 31. Continue south about one mile to City of Rocks Road. Castleview Campground is further south on Almo Road, a good place to check out if all City of Rocks campgrounds are full.

GPS: 42° 05.132' N • 113° 37.969' W
Mile 17.2 • Elevation: 5,351 ft.

Turn right (west) to City of Rocks. On the ground this road is identified as 3075.

Granite formations in City of Rocks National Reserve.

At mile 18.1, keep straight for the main City of Rocks area at this junction with Hoff Lane (Hoff Lane leads north to provide another access to Castle Rock State Park).

Option: Circle Creek Overlook Road is at mile 20.1, on the right. The overlook road leads to more hiking trailheads, and to additional rock climbing opportunities.

To skip Circle Creek and continue on the main expedition, bear left (south/southwest).

Camp Rock is at mile 20.6. Pioneers signed the rocks with axle grease or charcoal.

At mile 20.9 is Treasure Rock. Nearby Register Rock has some of the best-preserved axle grease signatures.

GPS: 42° 04.015' N • 113° 42.080' W
Mile 21.5 • Elevation: 6,046 ft.

Turn right (west) to stay on the main road at this junction with the road that leads to Twin Sisters.

Option: A side trip to Twin Sisters is geologically fascinating. The darker sister is about 2.5 billion years old, some of the oldest rock visible in the country. The lighter sister is only about 25 million years old and part of the Almo Pluton, an upthrust of granite that rose like a bubble through the older rocks. Off in the distance Pinnacle Pass can be seen.

Assuming no optional side trips, Bath Rock is at mile 22.8, on the main road (about 5.6 miles from the turn off Almo Road into City of Rocks). Campsite fees may be paid here (self-service). Bath Rock is a major climbing area, and many campsites are nearby. The hiking trailhead for Creekside Towers is here. Potable water is located about a mile further up the road, at Emery Canyon— look for the pump.

At mile 24, keep straight on Emery Canyon Road at this junction with Road 562 (Road 562 is a 4WD side road).

GPS: 42° 05.393' N • 113° 46.174' W
Mile 26.3 • Elevation: 6,171 ft.

Turn right (north) to Oakley. Emery Canyon Road ends at a "T" junction here. The road north skirts the western foothills of the Albion Mountains and enters a narrow defile where there is barely room for the road and Birch Creek. Stay on the main road all the way to Oakley.

GPS: 42° 14.561' N • 113° 51.830' W
Mile 38.9 • Elevation: 4,624 ft.

Turn right (east) on Basin Road at this junction with Main Street on the east side of Oakley. For the main expedition, continue east on Basin Road.

Option: Take a side trip into Oakley for the historic walking tour, which includes the Marcus Funk polygamist domicile, designed and decorated to please several wives.

At mile 39.4, jog north on Basin Road; at mile 39.6, jog east.

About mile 41 Basin Road passes through low hills, following Mill Creek.

At mile 42.8 continue straight ahead on Basin Road in the small town of Basin.

GPS: 42° 14.734' N • 113° 47.077' W
Mile 43.3 • Elevation: 5,001 ft.

Keep straight on Oakley-Elba Road (Elba Road on some maps), at this junction with Powerline Road.

At about mile 46, a 4WD road on the left (north) leads into Myers Canyon to Myers Mine. Bear right to stay on the Oakley-Elba Road. From this point on, 4WD is recommended in dry weather, and required in wet weather.

GPS: 42° 14.672' N • 113° 42.403' W
Mile 49.0 • Elevation: 7,106 ft.

Basin-Elba Pass. Go straight to stay on the main expedition. There are two side trips here. Other side roads are not noted —many provide access to informal campsites.

Option 1: Road 562, on the right (south) leads to "Pot Holes" and connects to Road 728, which leads to the Independence Lakes Trailhead. 4WD experience and map-reading skills are required. Bring Cache Peak USGS 1:24,000 scale map. Drive 4.8 miles to the trailhead. Hike 2.7 miles to the first of several lakes. The largest lake is at 9,045 feet elevation.

Option 2: Road 513 on the left (north) leads along the ridge and provides access to views of the mountains and surrounding valleys, plus several defunct mining areas. Map-reading skills and 4WD experience are required.

Back on the Oakley-Elba Road, at mile 52.1, campsites abound on Road 560, a 4WD spur road north of the main road.

At mile 52.9, near a gaging station, is a junction with Stinson Creek Road. Keep straight to stay on the main Oakley-Elba Road. From this point on, all the way to Elba, the road is usually in 2WD condition.

At mile 56.8 follow the main road as it jogs south, then east, then south, then east again.

GPS: 42° 14.871' N • 113° 33.409' W
Mile 59.0 • Elevation: 5,172 ft.

The end of this expedition, and the end of our loop at the small town of Elba. Retrace your route to Connor Junction, and north to I-84. For a nearby trip, see Expedition 26.

Other Nearby Excursions...

Thousand Springs Scenic Byway

From the end of Expedition 20, return to Declo, just south of Interstate-84. Drive west on Highway 81 to Burley and continue west on Highway 30 to Twin Falls. In Twin Falls, at the junction of Highways 30 and 50, pick up the Thousand Springs Scenic Byway and follow it west and northwest. There are several privately-operated campgrounds along the route, plus many full-service towns.

Points of interest include: Twin Falls Museum, Shoshone Falls (52 feet higher than Niagara), Perrine Bridge (the highest bridge in Idaho, with walking trails on both sides), Thousand Springs State Park, Fossil Beds National Monument/Hagerman Museum, and developed hot springs. The water pouring from the cliffs at Thousand Springs has traveled underground for hundreds of miles through the porous volcanic rock to join the Snake River (see Expedition 21, p.169, for descriptions of this "Lost River"). Hagerman Valley is known for its mild winters, and the Scenic Byway is open year-round. Guided boat tours that include both Shoshone Falls and Thousand Springs are offered by local outfitters.

East-Central Idaho

From desert to the highest peaks in the state, the terrain in east-central Idaho varies dramatically. Traveling from east to west, mountain ranges include the Beaverhead Mountains of the Bitterroot Range along the Montana/Idaho border; the Lemhi Range, one of the driest mountain ranges in Idaho; the Lost River Range where Idaho's highest point, Borah Peak, presides; and the White Knob Mountains to the east of their better-known neighbor, the Pioneer Mountains. The desert south of the mountains includes part of the Snake River Plain and Craters of the Moon National Monument.

This chapter includes most of Butte, Minidoka, Jerome, and Lincoln counties. It splits Blaine County a few miles west of Highway 75, splits Custer County along Trail Creek Road, and splits Lemhi County just west of Highway 93. Cities and towns include Arco, Carey, Hailey, Sun Valley, Challis, Salmon, Mackay, Leadore, Jerome, Shoshone, and Rupert. These communities range from small to very small. For example, the Ketchum–Sun Valley area has a population of about 6,000 year-round residents. Jerome and Rupert are just north of I-84 on the southern edge of this section. Other communities dot the highways in the valleys between mountain ranges, or mark a desert oasis on Highway 26/20. To most visitors, east-central Idaho will seem sparsely populated, and its spectacular scenery wonderfully unspoiled.

Ruins of pioneer cabins overlook the valleys. Looking out of their roughly-framed windows, you can see weather coming for fifty miles. Inside the sagging log structures are fireplaces built of native stone. Aging gray stumps surround some of the cabins for several acres, bearing witness to the search for firewood or mining timbers. Wooden chinking falls out of log walls that caught the brunt of winter winds. Pick up a remnant and you can see knife marks on the chinking, and run your finger along evidence of meticulous work.

At first glance, all the ruins look old, but the earliest can be dated by axe marks on hand-hewn logs, and by wooden pegs or hand-made nails ("square" nails). Other clues are found in debris around cabin or mine sites. In the 1860s, glassmakers

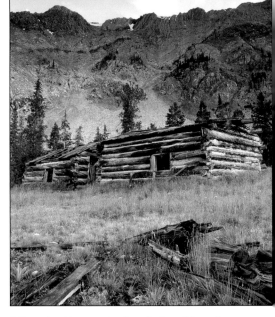

Miners' cabins can be found along Horseshoe Gulch, a tributary of Spring Mountain Canyon in the Lemhi Range. Gold, silver, and lead were mined here from the 1880s to the early 1900s. The Hahn townsite in the foothills served the miners.

began to add manganese to glass (instead of lead) to make it brighter. Glass made with manganese turns light lavender or purple when exposed to decades of sunlight. Shards of purple glass, welded tins from canned food, and bottles capped with glass stoppers instead of screw-on lids are also indicators of sites settled in the late 1800s.

Thanks to a silver mining boom along the Wood River, Hailey was the first town in the Idaho Territory to acquire electric lights

and phone service in 1883. There were active kilns and smelters in the Lemhi Valley from the 1880s to about 1911.

Before the white man "came-claimed-and-named," Native Americans roamed the entire area, establishing paths along well-traveled routes that led to salmon fishing, buffalo hunting, digging camas bulbs and other seasonal activities. Sacajawea, a young woman who played a crucial role in the success of Lewis & Clark's Expedition of Discovery, belonged to the Agaidika (salmon-eater Shoshone) tribe. She and her ancestors are honored in The Sacajawea Interpretive, Cultural, and Educational Center located in Salmon.

Much of east-central Idaho qualifies as "cold desert," receiving most of its moisture in the form of snow during the winter months. The relatively dry ecosystem preserves and reveals historical and archaeological sites. It is a great pleasure to explore what amounts to a vast outdoor museum, where one comes upon history *in situ*. Please remember that state and federal laws prohibit destruction or vandalism of archaeological sites. This includes historical buildings, old mines, and ghost towns —many of which are not signed or identified. Do not camp within or next to historical sites and leave artifacts where you found them.

Leatherman Peak (12,228 feet) still wears a cap of snow in May. The East Fork of Pahsimeroi River headwaters are near the base of the peak.

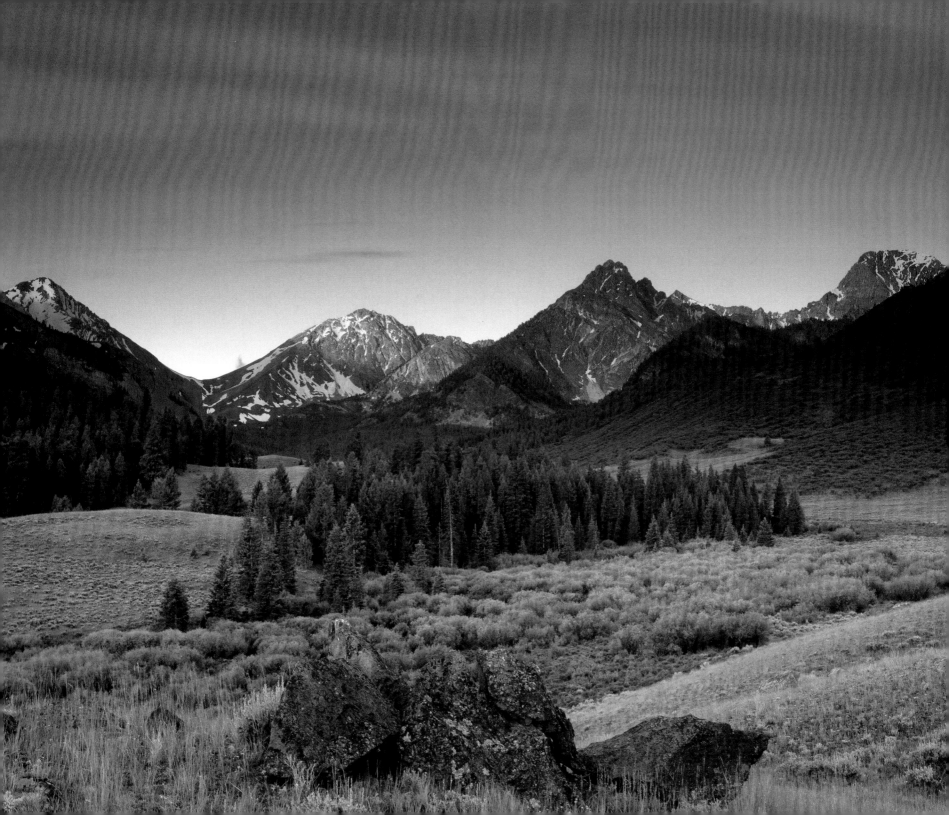

Upper Pahsimeroi • Lost River Range
Other Nearby Excursions: Sleeping Deer Road

When We Were There

In early June, views from the Little Lost and Pahsimeroi valleys include mountain peaks glazed with spring melt. The peaks look even higher than usual, reaching toward the sun in a pale sky. In a particularly dry year, we are able to access the Lost River Range a month earlier than in a year of normal snowfall. Seven of Idaho's nine peaks over 12,000 feet are bunched together here like a stone fist. For the most part, the Lost River Range and it's neighbor, the Lemhi Range, are dry mountains with sagebrush steppe lapping at their feet. But a well-watered paradise waits for those intrepid enough to find it. The nights are brutally cold in June and I wrap a fire-warmed rock and put it in my sleeping bag for comfort. The next morning, sunrise outlines frost on the meadow grass as we watch mule deer work their way down to the East Fork of the Pahsimeroi River.

Know Before You Go...

Gas stations are distant from the expedition starting point: Howe (55 miles); Mud Lake (84 miles); Challis (50 miles); Mackay (47.5 miles). There is no cellphone coverage. The best time to visit is July–September. Check wildfire conditions. Most of the designated roads are open to snowmobiles in winter.

Approach Routes

- **From Idaho Falls:** North on I-15 to exit 143; west on Highway 33 to Howe. From Howe, go north/northwest on Little Lost River Highway and Little Lost River Road to Double Spring Road. Little Lost River Highway becomes Little Lost River Road where pavement ends and gravel begins.
- **From Arco:** East on Highway 26/20 to Highway 33/22; northeast then north on Highway 33/22 to Howe. See above.
- **From Boise:** Southeast on I-84 to Mountain Home; then northeast and east on Highway 20 to Arco. See above.
- **From Twin Falls:** North on Highway 93 to Shoshone; northeast on Highway 26/93 to Carey; northeast on Highway 26/93/20 to Arco. See above.
- **From Mackay:** North on Highway 93 to Doublespring Pass Road, and navigate the expedition backwards.

Land Administration (See Appendix A)

- **National Forest Service:** Mackay Office (Salmon-Challis National Forest, Lost River Ranger District)
- **BLM:** Challis Field Office
- **Idaho Fish and Game:** Salmon Region

EAST-CENTRAL

Sunset over the Upper Pahsimeroi River area of the Lost River Range.

Maps
(See map sources in Appendix B)

Salmon-Challis National Forest (Challis National Forest); **Challis National Forest Travel Plan** (strongly recommended); BLM maps: **Borah, Salmon Recreation Area South,** and **Salmon Recreation Area North;** USGS 1:24,000 maps: **Donkey Hills NW, Doublespring, Spring Hill, Burnt Creek, Leatherman Peak,** and **Borah Peak**.

Total Miles/Road Ratings

- **Total Miles:** 64.5
- **2WD graded gravel/dirt:** about 46.9 miles
- **4WD recommended:** about 5 miles, not suitable for trailers
- **4WD required:** about 12.6 miles (more for optional side trips); 17.6 miles in wet weather. Suitable for 4WD SUV, not suitable for trailers.

Expedition Directions

Set your GPS to display Degrees and Decimal Minutes. All along this route there are two-track "roads" leading to ranches, cattle troughs, irrigation ditches, etc. There are more roads on the ground than appear on most maps. These side roads are not noted except as necessary for route-finding.

Most of the valley floors and foothills in the Little Lost River Valley and Pahsimeroi Valley are managed by the BLM and are open to public use, so there are many camping and fishing opportunities on the approach route.

Pavement returns near the starting point for this expedition, at Goldburg Creek crossing, signed for Double Spring, and nearby settlements of May and Patterson.

Map Alert: Note that there are two roads with similar names: "Double Spring Road" and "Doublespring Pass Road" which join near the eastern approach to Doublespring Pass.

This expedition begins in the Pahsimeroi Valley, on the east side of the Lost River Range. After exploring the Upper Pahsimeroi River area, the expedition continues over the crest of the Lost River Range and descends to Big Lost River Valley, ending at Highway 93, north of Mackay and south of Challis.

GPS: 44° 23.117' N •113° 38.583' W
Mile 0.0 •Elevation: 6,095 ft.

Turn west at the junction of Little Lost River Road and Double Springs Road (north of Summit Creek Recreational Site and Summit Reservoir). Note that older maps show different road names, including Goldburg Road, Summit Creek Road, Pahsimeroi Valley Road, and Farm to Market Road at this junction, but signs on the ground confirm Double Springs to the west.

GPS: 44° 24.203' N •113° 42.499' W
Mile 3.6 •Elevation: 5,803 ft.

Hatch Lane is signed. Stay on the main road and continue straight ahead to cross the Pahsimeroi River at a bridge.

GPS: 44° 23.868' N •113° 43.580' W
Mile 4.5 •Elevation: 5,944 ft.

Bear left (southwest) at a "Y" intersection, and left again at a triangle intersection that follows within about a hundred yards. A group of mailboxes marks the intersection. The junction is signed for Doublespring Pass/Upper Pahsimeroi/Mackay; May, Patterson, Little Lost River, etc.

GPS: 44° 20.836' N •113° 46.307' W
Mile 8.6 •Elevation: 6,604 ft.

Bear left at a "Y" intersection, and left again within about 0.2 mile at the junction of Upper Pahsimeroi Road 118 and Doublespring Pass Road 116. The junction is signed for Double Spring Ranch, Upper Pahsimeroi Road, and May.

At the second junction, turn left (within 0.2 mile) at the sign for Burnt Creek and Double Spring Ranch (note dead end road to ranch). This second left turn is not signed as Upper Pahsimeroi Road, but is so identified on maps. Ignore two-track ranch roads cutting out across the desert in this area. Stay on the graded gravel road that is almost two lanes wide for the next 7.2 miles.

PAHSIMEROI

According to Idaho historian John E. Rees, "*pah*" relates to water; "*sima*" to one; and "*roi*" to a grove of trees in the language of Shoshone Native Americans. Pahsimeroi is believed to be a description of a single grove of conifers growing along lower Pahsimeroi River. The upper reaches of Pahsimeroi River belie this description, with meadow grasses and thick groves of pine, fir, and shrubs. The Lost River Range is about 70 miles long, trending northwest to southeast, with only the northern end also named Pahsimeroi Mountains. The Upper Pahsimeroi area, at the headwaters of Pahsimeroi River, is south of the Pahsimeroi Mountains, near Leatherman Peak. The river flows northwest to join the Salmon River.

GPS: 44° 16.599' N •113° 39.682' W
Mile 15.8 •Elevation: 6,886 ft.

Turn right (southwest) toward the highest, steepest mountains you can see. The road becomes a single track here, still 2WD, but slower going, with rough spots, and with low vegetation in the center of the road. **Navigation Alert!** This turn is not signed.

GPS: 44° 13.206' N •113° 42.996' W
Mile 20.5 •Elevation: 7,475 ft.

Bear left (south) on a road identified with a brown/white sign as 118. This is the continuation of Upper Pahsimeroi Road, although it is not signed as such. With the gain in elevation, the desert is left behind. The scene reminds one of the Colorado Rockies.

Option: The right fork here is Road 117 over Horse Heaven Pass to a junction with Doublespring Pass Road. 4WD is required, and it is 12 miles to the junction.

WHAT'S "LOST" ABOUT LITTLE LOST RIVER AND BIG LOST RIVER?

Big Lost River rises in the Pioneer Mountains and flows northeast into the Lost River Valley. Mackay Reservoir captures and controls part of the flow. From the reservoir, the river then flows south to Arco, rounds the southern foothills of the Lost River and Lemhi ranges, turns northeast again toward lands that host the Idaho National Laboratory, and then disappears in the Big Lost River Sinks. Little Lost River is fed by tributaries from the eastern flanks of the Lost River Range and the western flanks of the Lemhi Range. It flows south and southeast to the Little Lost River Sinks near Howe—about three miles west of the Big Lost River Sinks. The two rivers meet underground.

The Little Lost River is "lost" in many places, but disappears permanently at the sinks. Antoine Godin, a half-breed trapper is credited with naming Little Lost River in 1823.

The northern edge of the Snake River Canyon looks like a stone sponge that weeps water more than a hundred miles from the Lost River Sinks. Thousand Springs, one of these weeping walls, is believed to be the major outlet where the "lost" rivers emerge from their slow percolation through porous zones of rubble sandwiched between multiple basalt lava flows that make up the northern Snake River Plain. Big Lost and Little Lost rivers are actually tributaries of the Snake River.

Before they sink out of sight, both freestone rivers provide fly-fishing opportunities for a wide variety of trout, including bull, rainbow, brook, cutthroat, and golden, in addition to mountain whitefish and grayling. Above the river valleys, small mountain lakes add to angling opportunities. More than thirty lakes are stocked with fish. Big game species such as mule deer and elk also bring sportsmen to the area.

GPS: 44° 12.300' N • 113° 43.258' W
Mile 21.5 • Elevation: 7,606 ft.

Stay on the main road, bear left. (The two-track on the right, 313, leads into a pleasant canyon, but plays out quickly.) 4WD is recommended from here on. A road sign warns "Not Advised for Trailers or Cars" as the road dips downhill. A "Wilderness Study Area" sign refers visitors to the Salmon BLM office for proposed wilderness information.

GPS: 44° 12.015' N • 113° 43.315' W
Mile 21.9 • Elevation: 7,576 ft.

Navigation Alert! Several turns must be made in quick succession. Cross Mahogany Creek via a rocky ford (there is no bridge). Mahogany Creek is signed. Bear left after the creek crossing. Immediately after, the road forks, with the right fork 318 leading a short distance upstream along the creek—bear left here to stay on the main road. Just 0.1 mile further, the road forks yet again, with Road 428 being much steeper. At this fork stay on the main road, following switchbacks east/northeast and uphill. There are multiple tracks here where drivers have been going around mud holes and rocks. The road rounds a hill and then quickly turns south again.

GPS: 44° 10.517' N • 113° 42.740' W
Mile 24.2 • Elevation: 7,680 ft.

Stay on the main road at this Challis National Forest boundary sign and "Travel Restricted Area C" notice (vehicles must stay on roads). Roads are open to oversnow vehicles in winter along designated snowmobile routes only. About 0.4 mile past the boundary sign, the road fords another creek, not signed, but named on maps as Rock Creek. The ford has a rocky bottom and is relatively easy to drive across except during periods of high water.

GPS: 44° 10.071' N •113° 42.569' W
Mile 24.9 •Elevation: 7,658 ft.

A cowboy line shack, renovated and still in use, is next to the main road. An outhouse with no door, but excellent views, overlooks a nearby corral and surrounding hills.

GPS: 44° 09.836' N •113° 42.540' W
Mile 25.1 •Elevation: 7,676 ft.

At this junction of Roads 267 and 118, bear right on 267 for the Upper Pahsimeroi Trailhead on the West Fork of the Pahsimeroi River. Road 267 is rough, rutted, steep, muddy, and rocky—but not hair-raising. Any 4WD can negotiate the road to the trailhead. A small parking area and sign mark the beginning of hiking trails to Pass Lake and Merriam Lake. Camping near the trailhead is possible, but is wetter and colder than the area along Road 118 (see option below). This trailhead appears on most maps.

Option: Bear left on Road 118 to continue up the East Fork of the Pahsimeroi River. This side trip features beautiful views of vertical cliffs, and informal camping sites on several flat spots with views that will knock your socks off. One creek ford on this route is definitely 4WD. The road ends in a high basin below Mt. Church, Mt. Breitenbach, Leatherman Peak, and Donaldson Peak. Where the road ends, a hiking trail crosses a creek (hikers must wade) and continues up-canyon. The hiking trailhead does not appear on all maps, but is marked on the ground as Trailhead 199. It is open to foot and horse travel.

GPS: 44° 07.754' N •113° 43.618' W
Mile 28.0 •Elevation: 8,172 ft.

Upper Pahsimeroi Trailhead. Road 267 ends at a parking area. The trail is signed as 089 with an old sign, and as 197 with a new sign. Trails are open to foot and horse travel only. The trail forks just past the trailhead, with the right fork leading 1.5 miles to Merriam Lake; and the left fork leading to Pass Lake in about 1 mile.

HIGHEST PEAKS IN THE LOST RIVER RANGE

Elevation in feet (and meters) above mean sea level
Borah Peak: 12,662 ft. (3,859 meters)
Leatherman Peak: 12,228 ft. (3,727 meters)
Mount Church: * 12,200+ ft. (3,719+ meters)
Mount Breitenbach: 12,140 ft. (3,700 meters)
Lost River Mountain: * 12,078 ft. (3,681 meters)
Mount Idaho: * 12,065 ft. (3,677 meters)
Donaldson Peak: 12,023 ft. (3,665 meters)
Peak not officially named on USGS maps

GPS: 44° 20.836' N •113° 46.307' W
Mile 0.0 •Elevation: 6,604 ft.

Backtrack to continue the expedition. Retrace your route back about 19.4 miles (to mile 8.6 from the starting point) to the GPS coordinates shown above. This is the junction of Doublespring Pass Road and Upper Pahsimeroi Road. **ZERO YOUR ODOMETER** and turn left on Doublespring Pass Road. On the map, this is near the junction where Double Spring Road meets Doublespring Pass Road. The expedition continues over Doublespring Pass to end at Highway 93, north of the town of Mackay. Doublespring Pass Road is graded gravel, and 2WD, but is not open in winter. On it's way across the range, the road provides access to numerous side roads, including 117 over Horse Heaven Pass, which is signed (see mile 20.5 for the other end of this 12-mile shortcut across the mountains).

GPS: 44° 13.376' N •113° 50.496' W
Mile 9.7 •Elevation: 8,318 ft.

At Doublespring Pass stay on the main road. You are now on the crest of the Lost River Range. Borah Peak, the highest point in Idaho, is south of this pass.

GPS: 44° 09.839' N • 113° 52.129' W
Mile 14.6 • Elevation: 6,874 ft.

The Earthquake Visitor Information Center. On October 28, 1983, an earthquake sent boulders crashing down from the Lost River Range, causing the largest deluge of water ever recorded after a quake in the USA, 400 billion gallons, to pour into the Thousand Springs Valley. $15 million dollars of damage was done in the Challis and Mackay areas by the quake that measured 6.9 on the Richter scale.

GPS: 44° 08.367' N • 113° 54.273' W
Mile 17.1 • Elevation: 6,381 ft.

The end of this expedition at the junction of Doublespring Pass Road and Highway 93.

Option 1: Turn right (northwest) on Highway 93 to go to Challis.

Option 2: Turn left (southeast) to go to the Mt. Borah Trailhead; or further south to Mackay and Arco. The 4WD access road for Mt. Borah Campground and trailhead at Birch Springs is about 1.9 miles south of this junction, look for Road 279. The turn is signed on Highway 93.

See Expedition 27 for a nearby trip.

Other Nearby Excursions...

Sleeping Deer Road

Where this expedition ends, turn north on Highway 93 and drive to the town of Challis. In Challis, turn west on the main street and drive to Challis Creek Road; turn north and then west on Challis Creek Road to Sleeping Deer Road (086). Sleeping Deer Road penetrates into the Frank Church–River of No Return Wilderness, ending near Sleeping Deer Mountain (9,881 ft.), about 40 miles from Challis. The road cruises a high ridge that offers views of Bighorn Crags, and of the enormous sweep of the Salmon River Mountains. Along the way, the road provides access to many hiking trails. 4WD is required, though most of the road is in 4WD-recommended condition. Snow is usually melted by mid-July. This route is shown on the USFS Frank Church–River of No Return Wilderness map, South Half.

Wet Creek and Dry Creek • Lost River Range

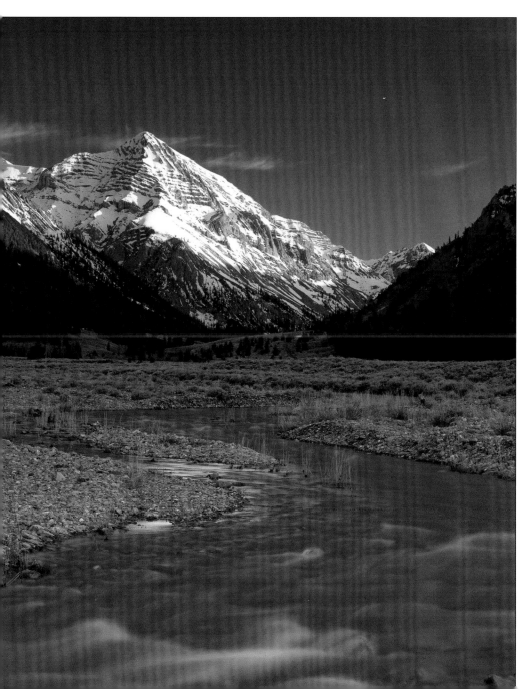

Long Lost Creek in Idaho's Lost River Range. Lofty peaks are a dramatic backdrop for this tributary of Dry Creek.

When We Were There

Crossing the creek below Castle Peak in the early morning, we walk a silvery log in a sliver of moonlight. We wait in the chilly wind for the sun to lighten the sky. Slowly, the foothills, dusty sage, and sparse grass emerge as part of an expansive landscape. Snow on McCaleb Point pinks up just before the sun breaks the horizon. A wash of pre-dawn color warms the ripples of Long Lost Creek, a tributary of Dry Creek. Dry Creek is not dry—the waterfall my brother photographs is so loud we can't hear each other speak. It's early in the season, Memorial Day Weekend, and snowmelt is still feeding the creeks. It's too early to access most of Idaho's high country, but by coming into Challis National Forest by way of BLM-administered desert, we made our way almost to the snow line before setting up camp.

This area also enjoys an extended autumn. We came back in late September and early October, when fall color blazed along the creeks and in the meadows.

> *Moon caught on the Lost River Range.*
> *Moon sprung from the foothills.*
> *Moon a licked wafer in the mouth of the sky.*
> —Trail notes by Lynna Howard

EAST-CENTRAL

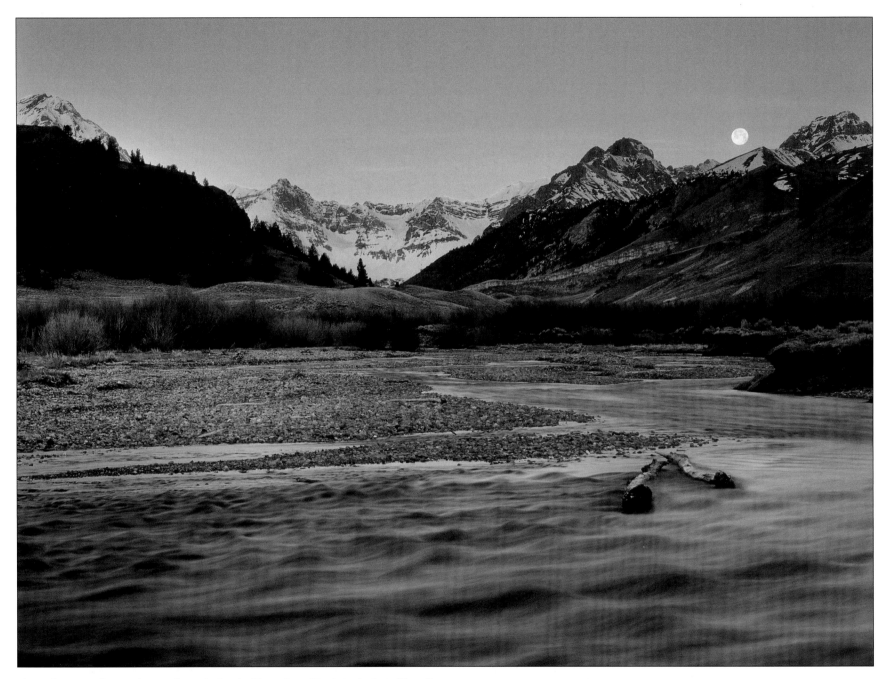

An early spring dawn colors peaks at the head of Long Lost Creek in the Lost River Range.

Howe has the closest gas station and Arco is the closest full-service town. There is no cellphone coverage. The best time to visit is May–October. Most designated roads on BLM land are open to snowmobiles in winter.

Approach Routes

- **From Idaho Falls:** North on I-15 to exit 143; west on Highway 33 to Howe. From Howe, continue north/northwest on Little Lost River Highway to Wet Creek Road, at the BLM Administration Building.
- **From Arco:** East on Highway 26/20 to Highway 33/22; northeast then north on Highway 33/22 to Howe. See above.
- **From Boise:** Southeast on I-84 to Mountain Home; then northeast and east on Highway 20 to Arco. See above.
- **From Twin Falls:** North on Highway 93 to Shoshone; northeast on Highway 26/93 to Carey; northeast on Highway 26/93/20 to Arco. See above.
- **From Mackay:** South on Highway 93 to Arco. See above.

Maps (See map sources in Appendix B)

Salmon-Challis National Forest (Challis National Forest);
BLM Salmon Recreation Area South

Land Administration (See Appendix A)

- **National Forest Service:** Mackay Office
- **BLM:** Challis Field Office
- **Idaho Fish and Game:** Upper Snake Region

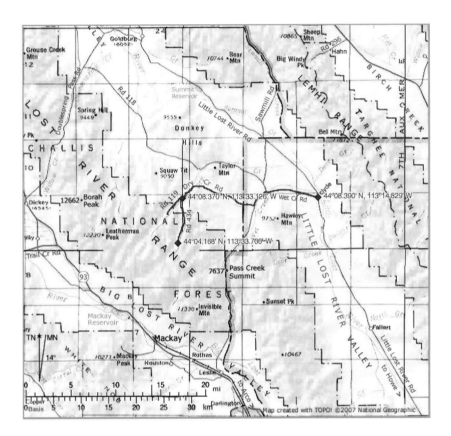

Total Miles/Road Ratings

- **Total Miles:** 25.7
- **2WD graded gravel:** about 9 miles
- **4WD recommended:** about 8 miles, suitable for trailers
- **4WD required:** about 8.7 miles, suitable for 4WD SUV

Expedition Directions

Set your GPS to display Degrees and Decimal Minutes. On the ground there are more roads than appear on some maps. The Challis National Forest map is the most accurate.

EAST-CENTRAL

GPS: 44° 08.390' N • 113° 14.829' W
Mile 0.0 • Elevation: 5,889 ft.

Turn west from Little Lost River Highway onto Wet Creek Road, which is signed for Pass Creek Road as well as Wet Creek. From the signs you can tell that it's possible to cross Lost River Range via Pass Creek Road, and drop into Big Lost River Valley. For this expedition, stay on the east side of the range.

At mile 2.6 the first of many dirt roads joins the main road from the south. Stay on the main road, Wet Creek Road, heading west. The road cruises the northern edge of Hawley Mountains, a subrange of Lost River Range. Hawley Mountain (9,752 ft.) is the dominant peak.

At mile 4.2 more roads join from the south, and most of these are signed. Stay on the main road.

At mile 5.8, more of the same, see above.

GPS: 44° 08.842' N • 113° 22.020' W
Mile 6.3 • Elevation: 6,411 ft.

Turn left (south) on Dry Creek Road (signed). This is Road 119 on the Challis NF map. Signs at this intersection indicate Sawmill Canyon Road to the north (see Expedition 23). Continue south/southwest on Dry Creek Road. Side roads lead to informal campsites and fishing spots on Wet Creek.

At mile 7.1 another access to Sawmill Canyon Road leads north. Keep straight (southwest) on Dry Creek Road. There are Wilderness Study Area signs on some of this BLM terrain.

At mile 7.9 a 4WD track on the right leads up Corral Creek. Stay on the main road.

GPS: 44° 07.704' N • 113° 23.383' W
Mile 8.2 • Elevation: 6,465 ft.

Turn right (west) to continue on Dry Creek Road at this intersection that is signed for Pass Creek to the south. Note that Squaw Springs appears on most maps—the springs are just south of this intersection. Continue west on Dry Creek Road. The road is 4WD-recommended in good weather.

At mile 10.5 a short loop road on the right provides access to informal camping on Corral Creek. Keep straight (west) on Dry Creek Road. At mile 11.7 the other end of the loop merges with the main road. A nearby 4WD track also crosses Corral Creek to the north, bear left on Dry Creek Road.

At mile 14.5 a signed 4WD road on the left (south) leads to Buck Springs. Stay on Dry Creek Road.

At mile 15.6 several roads enter from the right (north). Some make a loop around Taylor Mountain, and some meet Road 118 which descends all the way from Pahsimeroi Valley (see Expedition 21). Stay on Dry Creek Road.

At mile 16.3 the road fords a tributary of Dry Creek. Like most of the creek fords in this area, it has a rocky bottom and is shallow. Continue southwest on Dry Creek Road.

At mile 16.5 Dry Creek Road splits into two forks, but only temporarily, and they both end up in the same place. Near here the road condition is rougher and 4WD is required. The road is signed "Narrow Rough Rd."

GPS: 44° 08.370' N • 113° 33.126' W
Mile 18.0 • Elevation: 7,500 ft.

Some maps show the road ending here and becoming two pack trails at a "Y" intersection near a double creek crossing. But Road 119 continues on the right fork, and Road 434 turns south along Long Lost Creek. The double creek crossing is where Long Lost Creek joins Dry Creek. Both roads leave BLM land and enter Challis National Forest. The continuation of Dry Creek Road/Trail is closed to oversnow vehicles in winter.

Option 1: Waterfall destination (photo at right). Bear right across the creeks (shallow, rocky fords) and continue about another 2.4 miles up Dry Creek Canyon. At the creek crossings you can see a cabin that is no longer in use on the north side of Dry Creek. Park at the end of Road 119 and continue on foot. The trail is open to 4-wheelers, motorcycles and mountain bikes, but you need to be on foot to find the waterfall. There's no trail to the falls, but it's not far from the ATV trail. Hike the ATV trail, listening for the falls. The falls are hidden from view until you are right on top of them. The pool is well-shaped and inviting. It is fairly easy to clamber down the low cliff to enjoy the water. Return to the double creek crossing, then turn south to explore Long Lost Creek (see Option 2).

Option 2: Long Lost Creek, hiking trails to alpine lakes, and views of 11,000-foot-plus peaks. At the double creek crossing, **ZERO YOUR ODOMETER**, then turn south and drive Road 434 up Long Lost Creek drainage (not signed when we were there, but both the creek and the road are identified on the Challis NF map). Castle Peak, visible on the southwest side of the drainage, is actually a lower pinnacle on the long ridge of a nameless point 10,957 feet high. A nearby USGS Peak (11,982 ft.) is named McCaleb triangulation station on some maps. Jesse McCaleb worked in the area as a teamster until he died near the mountain, killed by Indians in 1878.

Road 434 fords the main channel of Long Lost Creek a couple of times—the fords are not difficult. A trailhead for Swauger Lake, Trail 091, is signed on the right (west).

GPS: 44° 04.168' N • 113° 33.700' W
Mile 5.0 • Elevation: 8,307 ft.

End this expedition at the end of Road 434. The road is closed near the start of two more hiking trails. Trail 094 leads up the

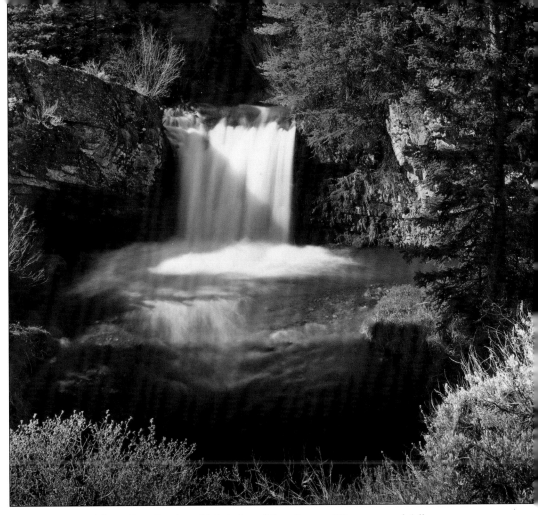

A roaring waterfall on Dry Creek in Idaho's Lost River Range. The unnamed falls are tucked into a ravine in a seldom-visited area located west of Little Lost River Valley. The waterfall was so loud that it was impossible for me and my brother to talk to each other.

EAST-CENTRAL

east side in Hell Canyon, to Shadow Lakes. Trail 194 continues up the Long Lost Creek drainage toward Castle Peak. There are many informal campsites in Long Lost Creek area, within 0.5 mile of the end of the road. Be prepared for Leave-No-Trace camping.

Retrace your route back to Little Lost River Highway. Nearby trips are described in Expeditions 21 and 23.

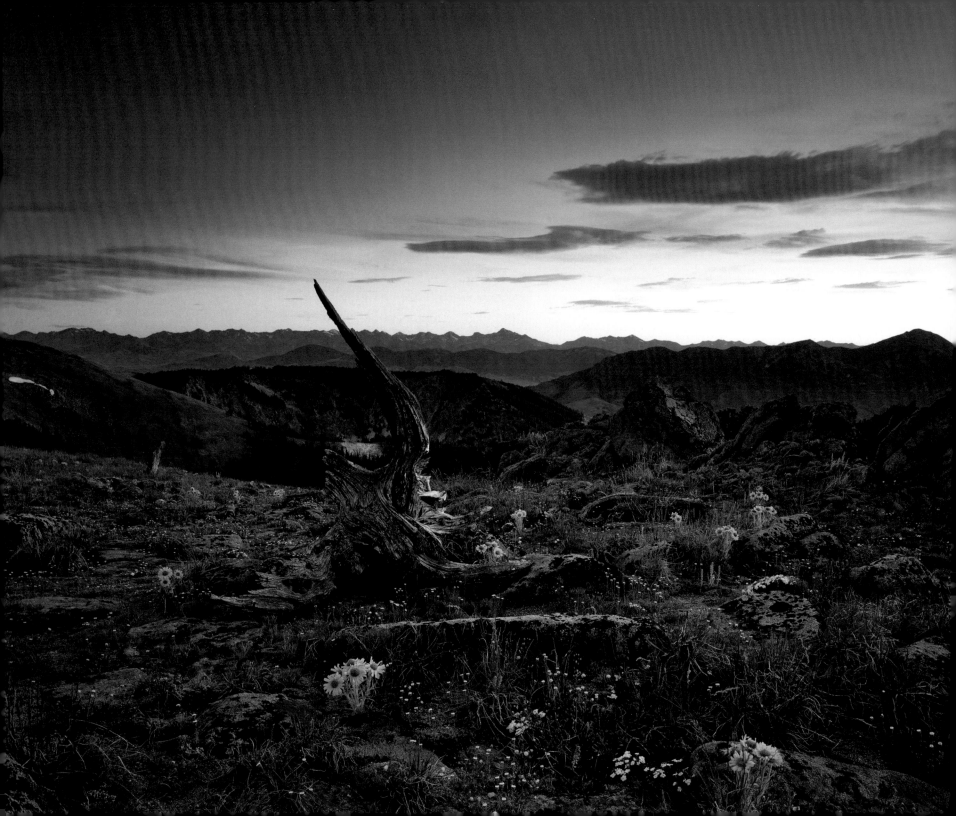

Little Lost Valley • Lemhi Range
Spring Mountain Canyon

When We Were There

After breakfast, we break camp and drive down the eastern slope of the Lemhi Range. In Spring Mountain Canyon, untracked snow covers the steep road, soft and dangerous. Deer stand in the trees just off the road, watching us work our way slowly down the mountain. The days are short in October and it's dark when we stop to set up camp below the snow line.

Back home, we look up geological reports on the crest of the Lemhi Range. Yes, some of the outcroppings of white rocks on the crest are marble. Limestone from an old seabed was pressured and heated. Rock and its many permutations also fascinated pioneers to this area. Ruins of miner's cabins and old digs were the highlight of our trip.

Hahn townsite in the eastern foothills of the Lemhi Range once served as the community center and post office for mines in the Spring Mountain Canyon area. Lead and silver deposits were discovered about 1883-1884. In the spring of 1909 the Spring Mountain Mining Company built a smelter in Hahn, which operated for 17 days in 1909 and 21 days in 1910. Mining was sporadic after 1910 and total production is estimated to be about $1 million. A slag pile, cement foundations, informational signs, and outlines of buildings are all that can be seen today at the old townsite. However, further up into the mountains, there are so many ruins that they seem to be around every corner. It is a great place to explore. Look, but don't disturb the sites—disturbing historical sites or taking artifacts is illegal.

The Hahn townsite is about 7 miles southeast of another ghost town, Gilmore (see Expedition 24). Gilmore was one end of the Gilmore and Pittsburgh Railroad, which was completed in 1910. Built to serve the Gilmore mining district, the line also extended to the town of Salmon. A golden spike ceremony was held on May 18, 1819 to celebrate the completed railway. The cost of the railway ($4,812,181.77) was equal to about half the gross production of the Gilmore mining district. The railway never recouped all the construction and operating expenses. When the Gilmore mines shut down, traffic decreased. The Great Depression was the final blow and service was suspended. Crews picked up the tracks in the spring of 1940. From the eastern slopes of the Lemhi Range, visitors can still see the outlines of the railroad.

Informal campsites line the route of this expedition, and there are a few designated campgrounds on the western side, near Little Lost River Valley. Where it crosses the range near Big Windy Peak (10,380 ft.), the road tops out at 10,007 feet, the highest road elevation in this book. To the west is a clear view of the Lost River Range, home to Idaho's highest peaks, and to the east the Beaverhead Mountains define the Continental Divide.

EAST-CENTRAL

Alpine sunflowers bloom in July at 10,000 feet elevation, on the crest of the Lemhi Range. Weathered stumps of limber pines are a testament to brutal winter conditions.

Know Before You Go...

Approach Routes

- **From Idaho Falls:** North on I-15 to exit 143; west on Highway 33 to Howe. From Howe, continue north/northwest on Little Lost River Highway and Little Lost River Road to Sawmill Canyon Road 101.
- **From Arco:** East on Highway 26/20 to Highway 33/22; northeast then north on Highway 33/22 to Howe. See above.
- **From Boise:** Southeast on I-84 to Mountain Home; then northeast and east on Highway 20 to Arco. See above.
- **From Twin Falls:** North on Highway 93 to Shoshone; northeast on Highway 26/93 to Carey; northeast on Highway 26/93/20 to Arco. See above.

Land Administration (See Appendix A)

- **National Forest Service:** Leadore Office (Salmon-Challis NF); Idaho Falls Office (Caribou-Targhee NF)
- **BLM:** Challis and Salmon Field Offices
- **Idaho Fish and Game:** Salmon and Upper Snake Regions

Maps (See map sources in Appendix B)

Salmon-Challis National Forest (Challis NF, this map is highly recommended); **BLM Salmon Recreation Area South**

Total Miles/Road Ratings

- **Total Miles:** 22.8
- **2WD graded gravel/dirt:** about 10 miles
- **4WD recommended:** about 10 miles in bad weather
- **4WD required:** about 11.8 miles (more for optional side trips); not suitable for trailers. Portions of the 4WD road may be damaged by shallow washouts, requiring care to cross, but not impassable. All of the 4WD portion is bumpy and/or rocky. My daughter said the road should have a "Jogging Bra Required" rating.

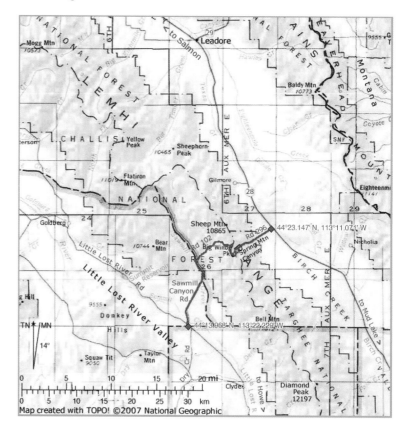

Map created with TOPO! ©2007 National Geographic

•**4WD experience required:** about one mile. Carry a saw in case you need to remove downed timber from the road. If you are the first person on the road early in the season you may also have to move rock slide debris—we moved boulders on one spring trip using a handyman jack. Later on in the season, we cruised through with no trouble at all. In October, expert driving was again required due to light snow.

Expedition Directions

Set your GPS to display Degrees and Decimal Minutes. Along this route there are side roads leading to fence maintenance, cattle troughs, and abandoned mining claims—most of these are not signed. There are more roads on the ground than appear on most maps. These side roads are not noted except as necessary for route-finding, or for recommended side trips.

GPS: 44° 33.968' N •113° 22.229' W
Mile 0.0 •Elevation: 6,263 ft.
Turn east/northeast on Sawmill Canyon Road 101 (signed as "Sawmill Rd.") from Little Lost River Road. This 2WD gravel road crosses sagebrush-covered flats near the confluence of Little Lost River and Sawmill Creek.

GPS: 44° 18.660' N •113° 20.357' W
Mile 6.1 •Elevation: 6,578 ft.
Cross the bridge over Sawmill Creek. Nearby primitive campgrounds are heavily used on holiday weekends beginning in July, and during hunting season. Bull trout catch-release signs are posted, as well as "Sawmill Creek Riparian Project" signs that explain restoration measures such as fencing cattle out, replanting native vegetation, etc. Visitors are reminded to close cattle-control gates.

At mile 6.2 a boundary sign says "Entering Challis NF".
At mile 8 the Fairview Guard Station is also signed.

GPS: 44° 20.261' N •113° 21.226' W
Mile 8.1 •Elevation: 6,767 ft.
Turn right (northeast) on Squaw Creek Road 102, signed "Squaw Creek Ridge 5 mi.". Squaw Creek Road is still 2WD at this point, but narrow. The road leads up into the Lemhi Range, leaving sagebrush behind and entering forested areas.

About mile 10, an unsigned spur road on the left (north) leads to the last informal campsite on this route to which one can pull a trailer. At this point, Squaw Creek Road is signed "Not Advised for Trailers and Cars".

At about mile 10.3 the road becomes a pile of rocks resembling a streambed, but still not requiring high clearance. Steep, tight switchbacks lead to Squaw Creek Ridge, which is usually snowed in until mid-June or later. Some old cabins are next to the road, others are accessible down short roads (some spur roads are closed to vehicles, and are now foot/horse trails). A landmark along the way is an abandoned grader that has been there for decades.

Option: If you continue northwest on Sawmill Creek Road, at mile 8.1 there are several designated campgrounds, including Timber Creek.

GPS: 44° 21.745' N •113° 16.240' W
Mile 14.7 •Elevation: 9,572 ft.
Navigation Alert! On the crest of the Lemhi Range bear right (south) and uphill on an unsigned road to continue to Spring Mountain Canyon. A spur road directly ahead was closed with downed timber when we were there. The road on your left (north) is Road 918 and signed for "Lemhi Summit".

Option: Turn left (north) and follow the Lemhi Summit Road uphill along the ridge to a grove of limber pine where there is an informal campsite. Trees at this unforgiving altitude graphically depict the prevailing winds. Leave-No-Trace camping techniques are required.

Limber pines grow at the upper limits of the treeline. High winds, rockslides, and snow avalanches can take down these stately trees. Beautiful even in death, the intricate root systems of downed trees are polished by weather to a colorful sheen.

GPS: 44° 21.009' N • 113° 15.991' W
Mile 17.6 • Elevation: 8,800 ft.

As Road 296 switchbacks steeply down into Spring Mountain Canyon, it passes several old mining claims and dilapidated structures. The cabins that appear as dots on the Forest Service map are in a meadow, north of the road. Some more modern-era buildings were once used as a church camp. At a signed intersection with Road 918 on the left (north), keep straight on Road 296 to descend. This road is open to snowmobiles from Thanksgiving to June 1.

Option: At mile 18.9 a road into Horseshoe Gulch on the right (south) leads to more cabins and pioneer-era mining debris. There are also informal campsites on this optional side trip, along with excellent views.

Bear right to stay on Road 296 at mile 20.8, at a "Y" intersection with Foothills Road on the left (north). This junction is near the informational sign for Hahn townsite. Highway 28 is within sight. Continue to the highway.

GPS: 44° 23.147' N • 113° 11.071' W
Mile 22.8 • Elevation: 6,756 ft.

The end of this expedition is at the intersection of Spring Mountain Canyon Road 296 and Highway 28 (signed).

Option 1: Turn left (northwest) on Highway 28 to access the ghost town of Gilmore (signed), the town of Leadore, and Highway 93 to Salmon.

Option 2: Turn right (southeast) to access Road 188 to the historic Charcoal Kiln Site. Also turn right for Idaho Falls.

See Expeditions 24 and 25 for nearby trips.

GPS: 44° 21.036' N • 113° 16.635' W
Mile 15.7 • Elevation: 10,007 ft.

Navigation Alert! Bear left (southeast) and downhill on Road 296 (not signed). Note the dilapidated tramway for ore carts going downhill to the east. The most obvious landmark is an old cabin in the rocky meadow at the highest road point on this route. Near the cabin a short, very steep road leads up to a viewpoint. You are on Spring Mountain, and Big Windy Peak is just south of this intersection.

Option: The 4WD road on the right (south) starts out in good condition, but is misleading—it is not the main route going into Sawmill Canyon. This road leads to more mining claims on the Spring Mountain ridgeline, and also to the head of an ATV trail (not signed at the top, but signed at the bottom) that descends to Little Lost Valley.

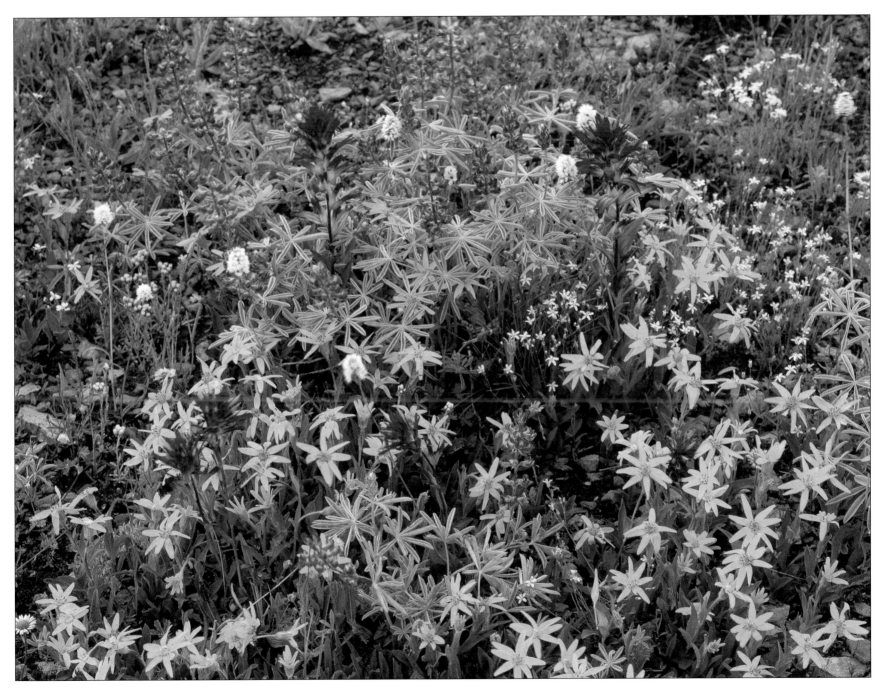

A colorful carpet of wildflowers accentuates the scenery in Idaho's high country ranges.

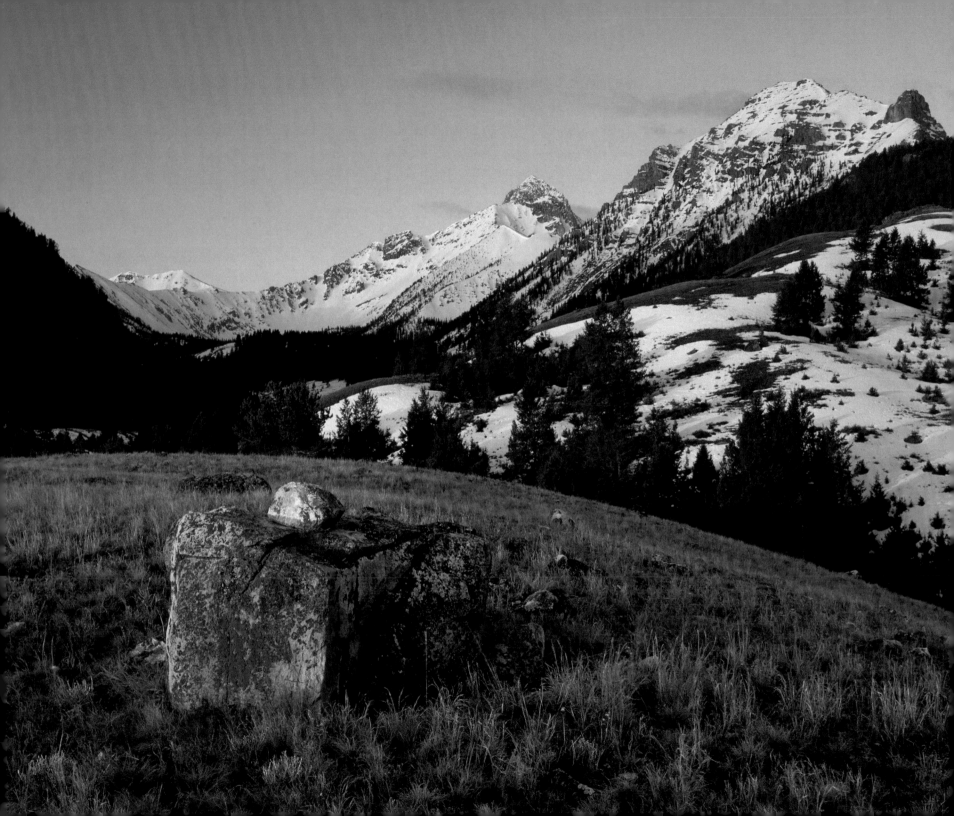

Charcoal Kilns • Bell Mountain Canyon Lemhi Range

Other Nearby Excursions: Meadow Lake

When We Were There

On the 4th of July, my brother and I drive through the small town of Leadore. I have never seen that many people in Leadore, but there they are, lined up along Highway 28 which doubles as the town's main street. They're almost ready to close the street for a parade when we happen along. We drive the parade route as people cheer our mud-spattered and road-weary vehicle. I wave the Queen Elizabeth wave.

Leadore is the closest town for this expedition. It has a gas station, convenience store, and a district office for the Salmon-Challis National Forest. The expedition is in a finger of the Targhee National Forest, but the Leadore District can supply information and maps.

In addition to mines in the nearby Spring Mountain area (see Expedition 23), the Viola lead mine was developed at the base of the Beaverhead Mountains in 1882. The mine's name still appears on most maps, but it is no longer active. Viola was second only to the Silver Valley area in northern Idaho in lead production. So much ore was being shipped to smelters in Omaha that mining engineers decided to build their own smelter. However, the smelter required fuel.

From a distance you can still discern the line that marks where Irish, Italian and Chinese loggers harvested trees to feed the kilns. New trees cover the slopes, but the color is lighter than older growth. Bricks for the kilns were made on-site in 1883 and a master bricklayer from Montana, Warren King, built sixteen beehive-shaped kilns. Only three are left standing (see photo on p. 1 of this book). Each kiln held about thirty-five cords of wood and it took a week to process the wood into charcoal. Wagons carried the charcoal across the valley. In their simplicity of design, the kilns that remain are like a work of art in the foothills of the Lemhi Range. Coal Kiln Spring surrounds them with a riparian necklace of greenery that is rare in this desert.

The entrance to Bell Mountain Canyon, the second destination on this short trip, is about three miles south of the kilns. The mountain was named for Robert Bell, a state mining inspector in the early 1900s. Bell Mountain lies in a rain shadow—terrain features to the east cause clouds to dump their moisture elsewhere. As a result, you can visit the foothills area when much of Idaho is still snowed in. Mammoth Canyon and Bell Mountain Canyon are both good "spring fever" outings. We've visited as early as April, but May is a safer bet.

Natural sculpture of lichen-encrusted limestone is a perfect foreground for Bell Mountain in Idaho's Lemhi Range.

EAST-CENTRAL

Know Before You Go...

The foothills of the Lemhi Range are rattlesnake habitat. The closest cellphone coverage is in the town of Salmon. The best time to visit is May–October. Most of the designated roads are open to snowmobiles in winter.

Approach Routes

Road 188 is signed for Charcoal Kilns, but please note that there are many desert roads leading to the kilns, most of them signed. Road 188 is the most direct and well-maintained route. It is south of Leadore and north of Lone Pine, off Highway 28.

- **From Idaho Falls:** North on I-15 to exit 143; west on Highway 33 to Mud Lake; then northwest from Mud Lake on Highway 28 to Road 188.

- **From Salmon:** Southeast on Highway 28 to Road 188.

- **From Arco:** Go east on Highway 26/20 to Highway 33/22; northeast then north on Highway 33/22 to Howe. East from Howe to Highway 22 north; northeast on Highway 22 to Highway 28; northwest on Highway 28 to Road 188.

- **From Boise:** Southeast on I-84 to Mountain Home; then northeast and east on Highway 20 to Arco. See above.

- **From Twin Falls:** North on Highway 93 to Shoshone; northeast on Highway 26/93 to Carey; northeast on Highway 26/93/20 to Arco. See above.

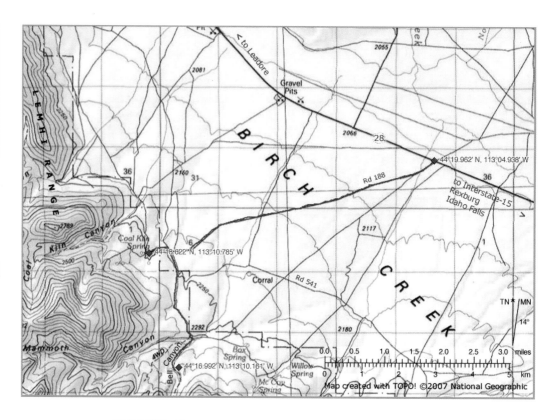

Maps (See map sources in Appendix B)

Salmon-Challis National Forest (Challis National Forest); **Targhee National Forest** (Dubois and Island Park Districts); USGS 1:24,000 topographical map: **Coal Kiln Canyon**.

Map Alert! For this chapter the printed map is from the 100K series, map level 4 of National Geographic software (see 3-mile scale on the map). Most maps in this book are printed from the 500K series—don't let the scale confuse you.

Land Administration (See Appendix A)

- **National Forest Service:** Leadore Office (Salmon-Challis National Forest); Dubois Ranger District (Targhee NF)
- **BLM:** Salmon Field Offices
- **Idaho Fish and Game:** Salmon and Upper Snake Regions

Total Miles/Road Ratings

- **Total Miles:** 10 (more for side trips)
- **2WD graded gravel/dirt:** about 8.5 miles
- **4WD recommended:** 8.5 miles (the 2WD section above if the weather is bad)
- **4WD required:** about 1.5 miles, (more for optional side trips); not suitable for trailers.

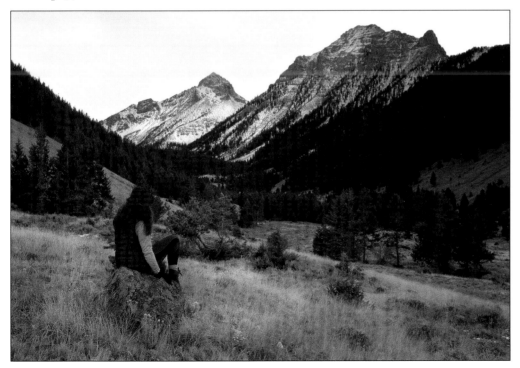

Expedition Directions

Set your GPS to display Degrees and Decimal Minutes. All along this route there are roads cutting out across the desert. Stay on the main road all the way to the kilns. From the kilns you backtrack just 0.5 mile before turning south to Bell Mountain Canyon.

GPS: 44° 19.962' N •113° 04.938' W
Mile 0.0 •Elevation: 6,745 ft.

Turn west on Road 188 to Charcoal Kilns, leaving the pavement of Highway 28 for graded gravel (2WD). (The entrance to this road is about 6.8 miles south of Road 296 to Spring Mountain Canyon, the end of Expedition 23.)

At mile 3.2 keep on the main road for "Charcoal Kilns" (Mammoth Canyon is also signed).

At mile 5, at an intersection with Foothills Road (not an official name, but in local use), there is another opportunity to turn south to Mammoth Canyon. Continue on the main road to the kilns. In a few hundred yards, yet another meeting with Foothills Road is an opportunity to turn north, but stay on the main road to the kilns.

GPS: 44° 18.622' N •113° 10.785' W
Mile 5.4 •Elevation: 7,330 ft.

Coal Kiln Springs, Charcoal Kilns interpretive kiosk, picnic area, pit toilets and parking lot. After exploring the kilns, backtrack about 0.5 mile to the first road which leads south to Mammoth Canyon.

The author resting in the foothills of the Lemhi Range.

Drive south on Road 183, signed for Mammoth Canyon (at some intersections also signed for Bell Mountain Canyon). Where Road 183 turns west to enter Mammoth Canyon, there are two ways to enter Bell Mountain Canyon instead. Choose either approach (left or right), jog around three tight turns and then enter the 4WD road to Bell Mountain Canyon.

The 4WD road into Bell Mountain Canyon soon splits. You can explore either fork, but the left fork goes further up toward Bell Mountain.

GPS: 44° 16.992' N • 113° 10.161' W
Mile 10.0 • Elevation: 7,736 ft.

The end of this expedition is at an informal campsite in a small stand of trees not far from the entrance to Bell Mountain Canyon (your mileage will be less, about 8.3, if you took the shortest route into Bell Mountain Canyon). GPS coordinates are given for a viewpoint accessible via a 0.1 mile walk up to a knoll above the campsite. The view of Bell Mountain is good, with lichen-decorated rocks in the foreground; and the view out over Birch Creek Valley to the Beaverhead Mountains on the horizon is also good. We saw antelope, mule deer, hawks and rabbits from the viewpoint.

We also recommend a side trip into Mammoth Canyon. Return to Highway 28.

Other Nearby Excursions...

Meadow Lake and Gilmore

Turn northwest on Highway 28 (toward Leadore). Go past the entrance to Spring Mountain Canyon. Turn west on Road 002, about 17 miles south of Leadore, and a few miles north of Gilmore Summit. Road 002 is signed for Meadow Lake and Gilmore. The ghost town also has a few modern-day residents. The Texas Mining District is located nearby along the east flank of the Lemhi Range. Mining began during the 1880s and most of the early production was shipped to the Nicholia lead smelter located southeast of Gilmore. The Pittsburg–Idaho and Latest Out lead-silver mines accounted for most of the Texas District production of around $17.5 million.

Road 002 is graded gravel, 2WD, and suitable for trailers, though narrow and winding in spots. It climbs 2,080 feet to a fee-based campground that has handicap-accessible features. The road is usually snow-free about mid-July. Meadow Lake lies in a glacial cirque at 9,160 feet, and is stocked with rainbow trout. Meadow Lake Peak, a 10,720-foot series of cliffs on which mountain goats graze, rises above the lake.

Storm clouds massing at sunset over Birch Creek Valley.

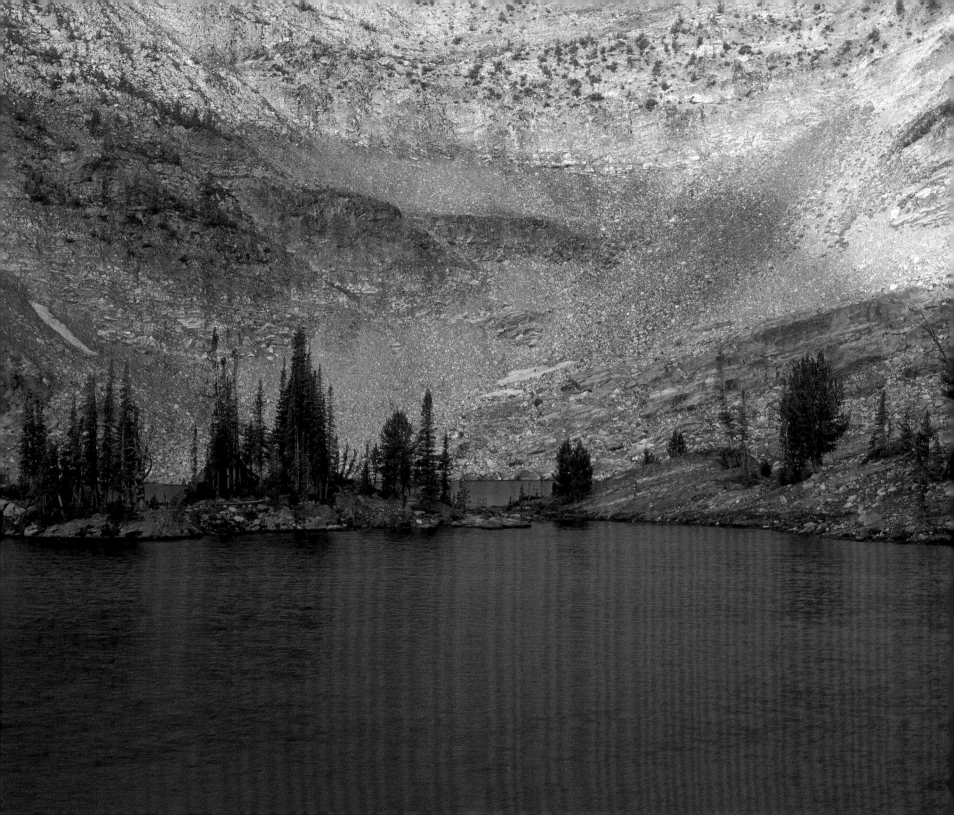

West Fork Wimpey Creek Beaverhead Mountains

Other Nearby Excursions: Sacajawea Interpretive Center
Lewis & Clark Back Country Byway •Bighorn Crags

When We Were There

In mid-July we inch our way up to the Continental Divide. It is hotter than blazes in other parts of Idaho, and I mean that literally. We can see smoke from forest fires to the northwest. Around 9,000 feet, everything changes. Alpine flowers hunker down in the wind. We put on our jackets, gloves and hats. A north-facing shelf near Highup Lakes still holds snow. Meadows and alpine lakes below us are intensely saturated with color. The ridgeline itself is sinuously artistic, running between Goldstone Mountain to the south and Pyramid Peak to the north, and is easy to walk in both directions.

We backtrack on the road to find a campsite out of the wind. The next day we put our backpacking gear together and hike to Highup Lakes. This country is as wild as it gets. The Continental Divide Trail cuts below the ridge, on the Montana side. As expected, we see no other humans at Highup and Skytop lakes. We're joined by mountain goats, eagles, pika and elk.

Skytop Lake is decorated with a small glacier, complete with blue crevasses and a dangerous, unstable section where it meets the water. Highup is actually two small lakes with a thin peninsula separating them. The setting is jewel-like, with prongs of stone holding the lakes.

On the road to the Divide, we saw signs of man in the form of old cabins. A few "modern" cabins sit near the road (still old, but renovated for use by hunters). As is usually the case, miners are the ones who pioneered the area. Remnants of their mule trails add another historical element for those that know how to spot them. Water pipes that feed cattle ranches below run alongside and above the road in West Fork Wimpey Creek Canyon. The pipes have been in use so long that they are marred by old welds and leaks.

I always remember our trips up West Fork Wimpey Creek as being quite long, but it's not far, about 14.5 miles, maybe 20 miles if you explore a couple of side roads. West Fork Wimpey Creek Road is the roughest route featured in this book. It has all of the elements of a 4WD-EXPERIENCE-REQUIRED road (see "Road Ratings" on p. 195). Add navigational challenges and stops to view the historical sites and "slow" becomes "really slow." Allow about two hours from Lemhi Valley to the Continental Divide.

Approach Routes

• **From Salmon:** Southeast on Highway 28 about 7.8 miles to N. Barracks Lane.
• **From Leadore:** Northwest on Highway 28 to N. Barracks Lane (north of Tendoy).

Highup Lakes at sunrise, just a short hike from the Continental Divide.

EAST-CENTRAL

Know Before You Go...

Unless you plan only a day trip here, be prepared for Leave-No-Trace camping. There are no facilities of any kind. Be ready for cold nights. Check wildfire conditions. This is black bear country. Cellphone coverage is available only in the town of Salmon. The best time to visit is July–September. The short hike to Highup and Skytop lakes is best in August, when you can be certain that the snow has melted.

Maps (See map sources in Appendix B)

Salmon-Challis National Forest (Salmon National Forest); **BLM Salmon Recreation Area North;** USGS 1:24,000 topographical maps: **Bohannon Spring ID-MT, Goldstone Pass MT-ID,** and **Baker**.

Map Alert! Navigation is difficult, and roads are not signed. We recommend you carry both USGS topographical maps and Forest Service maps. For this expedition the printed map is from the 100K series, map level 4 of National Geographic software (see the 3-mile scale on the map). Most maps in this book are printed from the 500K series, don't let the scale confuse you.

Land Administration

(See Appendix A)

- **National Forest Service:**
 Salmon Ranger District
 (Salmon-Challis NF)
- **BLM:** Salmon Field Office
- **Idaho Fish and Game:**
 Salmon Region
- **Chamber of Commerce:**
 Salmon

Map created with TOPO! ©2007 National Geographic

Total Miles/Road Ratings

- **Total Miles:** 14.5

- **2WD paved or graded gravel/dirt:** 1.2 miles paved; about 4 miles graded gravel/dirt

- **4WD recommended:** about 2.5 miles (4WD required if the weather is bad). Not suitable for trailers.

- **4WD experience required:** about 10.8 miles. The route requires high clearance of 8 to 10 inches in only a few spots—careful tire placement may get you around these if you have 8 inches of clearance, but you may also need to do a little road maintenance. Bring a shovel and a saw. For this trip you need an experienced driver, one who knows his/her vehicle well. A short wheel base is a plus for tight switchbacks, sharp gullies, and narrow squeezes between shrubs and trees. Where the road crosses a rock slide area there is a shelf section with a steep drop-off on one side. There are other short shelf sections and sections of very steep grades. Depending on the condition of the creek and its tributaries, there may be water spilling over into the road. Creek overflow was barely encroaching on the road when we were there—mostly it was just muddy spots (conditions hard to believe from the approach through dry sage and dust at lower elevations). The road climbs from 4,255 feet to 9,554 feet in 14.5 miles. Most of the route is 4WD—and periodically it is Hair-Raising 4WD.

Expedition Directions

Set your GPS to display Degrees and Decimal Minutes. All along this route there are two-tracks and roads leading to side canyons, springs, mining prospects etc. There are more roads on the ground than appear on most maps. It is not always easy to tell which road is the main road. Keep track of mileage, maps and GPS coordinates.

GPS: 45° 07.036' N • 113° 46.359' W
Mile 0.0 • Elevation: 4,255 ft.

Turn northeast on N. Barracks Lane off Highway 28, about 7.8 miles southeast of Salmon. Barracks Lane is paved and signed. If you miss the small sign, you'll know you have gone too far south when you see the "Halfway between the equator and the North Pole, 45th Parallel" sign. Note on the map there's also a "Wimpey Creek Road", but that is not the access to the section of the Continental Divide explored by this expedition.

At mile 0.4, bear right at a junction with North Lemhi Road. Follow N. Barracks Lane as it curves east to meet South Lemhi Road, and also Bohannon Creek Road.

At mile 1.2 turn left (northeast) on Bohannon Creek Road. The pavement ends here and graded gravel begins.

GPS: 45° 08.754' N • 113° 42.953' W
Mile 4.5 • Elevation: 4,856 ft.

Turn right (south) and go downhill on West Fork Wimpey Creek Road. **Navigation Alert!** Watch carefully for the small sign which is almost hidden by shrubs. There is a large Eagle Valley Ranch sign at a nearby cattle guard, where Bohannon Creek Road continues north. When you can see this sign, you are near the West Fork Wimpey Creek Road turn.

Descend to Bohannon Creek and cross the creek on a bridge. Follow West Fork Wimpey Creek Road (no longer signed) as it turns left (north) after crossing the bridge.

At about mile 6, enter Sawmill Gulch (identified on maps). 4WD is recommended. The dirt road now runs in the narrow gulch for about 0.5 mile, then turns sharply left (northwest) and climbs (the left turn is not signed). At the sharp left turn, a road also leads right (straight) to Sawmill Gulch Spring—don't go that way. West Fork Wimpey Creek Road jogs northwest briefly before turning east to switchback up the dry foothills. When you reach the treeline at about mile 7 you are on a ridge above the creek.

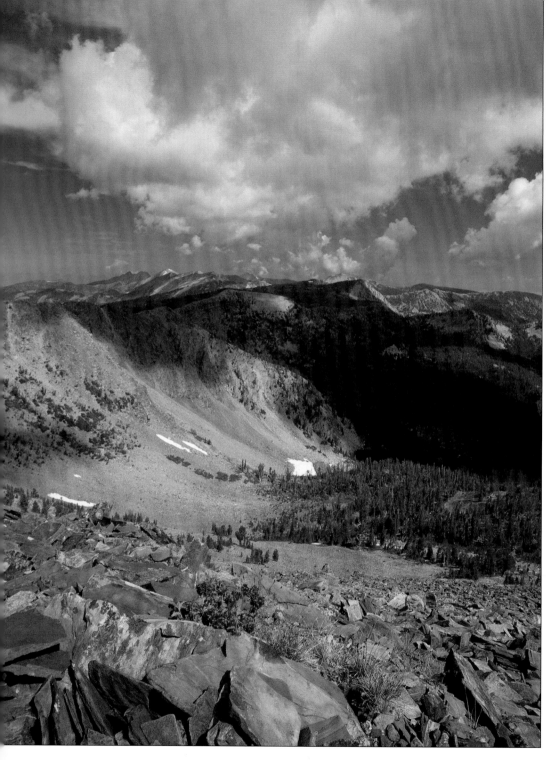

GPS: 45° 09.282' N •113° 39.794' W
Mile 8.5 •Elevation: 6,380 ft.

Bear left, uphill at a "Y" intersection (the right fork leads to Albertson Spring, which is listed on the Bohannon Spring USGS map). **Navigation Alert!** Neither fork is signed. It is easy to miss this "Y" altogether, or to mistake it for the next "Y" intersection, where you bear right.

As noted above, bear right at the **second** "Y" junction, just 0.5 mile further, at mile 9. The turn is not signed. The coordinates are 45° 09.728' N, 113° 39.765' W. Your route stays close to the ridgeline.

GPS: 45° 10.367' N •113° 39.178' W
Mile 10.0 •Elevation 7,040 ft.

Navigation Alert! Bear right at yet another "Y" intersection that comes up 0.5 mile from the last one listed above. Drive slightly downhill to enter West Fork Wimpey Creek Canyon. This turn is not signed, and the roads look similar in terms of use.

Once you are driving along the creek, the road narrows and shrubs brush the sides of vehicles. There are several small creek fords. Near most of the interesting pioneer-era cabins there are turnouts or short spur roads.

In the upper reaches of the creek drainage, the road climbs into alpine terrain. Limber pines cling to the slopes. The battered trunks and roots of downed trees weather to beautiful reds and golds. On the last long switchback before the crest, there are some flat spots in open, park-like stands of limber pine. The best informal campsites are also here.

The scenic, sinuous ridge of the Continental Divide
along the border between Idaho and Montana.

**GPS: 45° 11.238' N •113° 35.858' W
Mile 14.5 •Elevation: 9,554 ft.**

The end of this expedition is on the crest of the Beaverhead Mountains of the Bitterroot Range, on the Continental Divide along the Idaho/Montana border. A short road on the right (south) leads to a mining pit that is visible on the ridge. Walk north on the ridge of the Divide to find the unofficial trail to Highup Lakes.

Retrace your route to Highway 28. Some other nearby trips are described in Expeditions 22, 23, and 24.

Hiking to Highup Lakes: The trail route drawn on the map is approximate. There is no official trail, but a user-created trail is obvious where it leaves the Divide to drop into Montana. The hiking route is about 1.3 miles, a short but strenuous hike. The initial descent is quite steep and I suspect mountain goats also use it. Trekking poles are recommended. After about 0.25 mile of the really steep stuff, the going gets easier as you traverse along a shelf under the Divide, following approximately the 9000 to 9200 contour lines on the map. The larger of the two Highup Lakes sits at an elevation of 9,166 feet (45° 11.980' N, 113° 36.547' W).

Other Nearby Excursions...

Sacajawea Interpretive Center

The Sacajawea Interpretive, Cultural, and Educational Center is located in Salmon. The park is open year-round, and there is a picnic site near the river. The Interpretive Center is open from Memorial Day to September 23 on weekdays. The turn to the center is signed in Salmon.

Lewis and Clark Back Country Byway

Signs near Tendoy, about 20 miles southeast of Salmon, show the turn east to the Lewis and Clark Back Country Byway. This scenic byway is 39 miles long, 2WD in good weather, and is groomed for snowmobile use in winter. There were nine signs at Lemhi Pass on the Continental Divide when we were there. The pass is marked as the Montana/Idaho border, and quotes from Lewis & Clark's journals are posted. Other signs mention Shoshone Indian trails, regulations related to motorized vehicles and stock use, and the forest boundary. Sacajewea Memorial Camp is nearby. From Lemhi Pass the Byway turns north and follows the Divide before descending to Highway 28 along Warm Spring Wood Road.

Bighorn Crags

One area in the Frank Church–River of No Return Wilderness outshines all the rest—Bighorn Crags. This area is accessed via a trailhead that is easily reached by roads from the east side.

Drive north from Salmon on Highway 93 to the town of North Fork. Then go west on Highway 030 about 26 miles to Panther Creek Road 055; then south on Panther Creek Road to Yellowjacket Road 122 (about 30 miles). Then continue west on Yellowjacket Road to Yellowjacket Lake Road 113 (about 6 miles); then north on Yellowjacket Lake Road to Bighorn Crags Road 114 (about 8 miles). Bear right (northwest) on Bighorn Crags Road 1.8 miles to Crags Campground and trailhead. 4WD is recommended from Yellowjacket Road to the end of the trip. Expect steep switchbacks and sections of narrow dirt road, but no big washouts or difficult stream crossings.

Bighorn Crags top out at over 10,000 feet. Spires and ridges preside over an area rich with alpine lakes. Bighorn Outfitters offer horseback expeditions, or they'll pack your gear in so that you can hike pack-free. Even day hikes give you a taste of this spectacular landscape. The area appears on the Frank Church–River of No Return Wilderness, North Half map; and also on the Salmon National Forest Travel map.

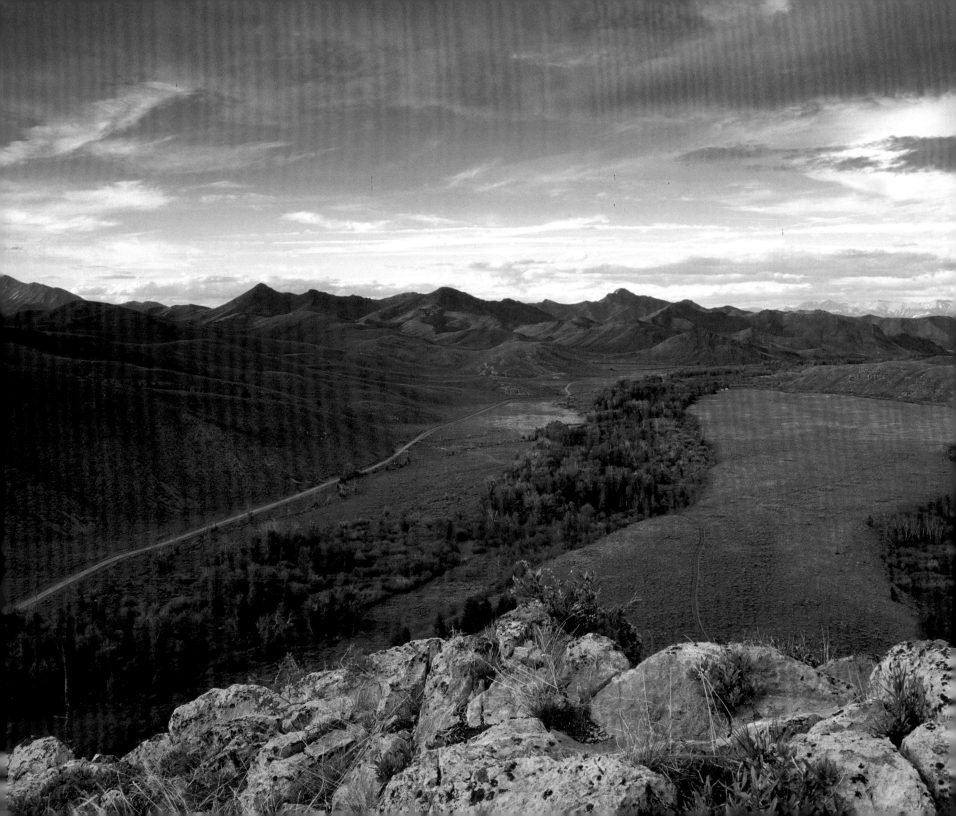

Craters of the Moon • Pioneer Mountains
Other Nearby Excursions: Copper Basin

When We Were There

As you can tell from my notes (below), the Craters of the Moon area was hot and dry when we visited there in the first week of June. After a loop into the National Monument's backcountry, where we met shepherds Roquer Ocano and Hector Medina, we continued north into the Pioneer Mountains. At Fish Creek Summit, we made our careful way around a snowdrift in the road, one last hanger-on left over from winter. We warmed up again when we dropped down to Antelope Creek and set up our camp. The beauty of this expedition is that the desert enhances your appreciation of the forests, and the mountains bring out the unique characteristics of the desert.

Idaho's Great Rift system is a series of north/northwest-trending fractures in the Earth's crust. These fractures extend fifty miles from the northern margin of the eastern Snake River Plain, southward to the river—the longest known rift zone in the United States. In 2000, President Clinton expanded the Craters of the Moon National Monument to include most of the Great Rift area. The original National Monument was established in 1924. This expedition begins about 20 miles west of the main visitor center on Highway 93/26/20. A side trip to the tourist-friendly part of the monument is highly recommended. On Goodales Cutoff of the Oregon Trail, these hardened basalt flows cut up the hooves of oxen and horses, shattered wagon wheels and tested the spirit of 1800s pioneers.

The Pioneer Mountains lie east and southeast of Sun Valley, but it's hard to believe a resort community is nearby when you're driving this expedition. The southern Pioneers, and especially this route, are true backcountry. This route also follows the southern edge of the White Knob Mountains. In both the Pioneers and the White Knobs, there are mining ruins and some current mining claims. Fishing, hunting and ORV riding in the Antelope Creek area and water recreation at Fish Creek Reservoir are popular.

Land Administration (See Appendix A)

- **National Forest Service:** Mackay Office (Salmon-Challis NF)
- **BLM:** Challis Field Office
- **National Park Service:** Craters of the Moon National Monument
- **Idaho Fish and Game:** Magic Valley and Upper Snake Regions

PERU IN IDAHO

Shorn sheep
the color of baby mice
billow the dust
around the only pond for miles.

Thin grass, lava fields,
the spew of Craters of the Moon,
shepherds from Peru
in Wal-Mart tennis shoes and
twelve dogs speaking Sheepdog
—all wait, lusting for rain.

Two shepherds speak Spanish
to their horses from Idaho.
They cruise the springing desert,
skirting boils of rock, and
nip the edges of the silence.

¿Cuántos vidas tengo?
How many lives do I have?

 —Trail notes by Lynna Howard

Antelope Creek Road leaves the Pioneer Mountains and enters Big Lost River Valley. Peaks of the Lost River Range are visible in the distance.

EAST-CENTRAL

Lava rock forms a precarious arch in the Craters of the Moon National Monument.

Approach Routes

- **From Idaho Falls:** West on Highways 20 and 26 to Arco; southwest on Highway 20/26/93 to about 5 miles east of the town of Carey.

- **From Ketchum/Sun Valley:** Southeast on Highway 75 to Highway 20; east on Highway 20 to Carey.

- **From Boise:** Southeast on I-84 to Jerome; north from Jerome to Shoshone; northeast on Highway 26/93 to Carey.

- **From Rupert/Bailey area:** Take Exit 211 from I-84; northeast on Highway 24 to Minidoka; northwest on Highway 24 to Carey-Kimama Road. Drive just the east portion of the desert loop to access Fish Creek Road.

Know Before You Go...

Gas is available in Carey and in Arco. Carey is 42 miles from Arco and 24 miles from the Craters of the Moon Visitor Center. Most maps do not clearly depict the 4WD road that climbs to Fish Creek Summit, nor the road descending from the pass to Leadbelt Creek. Respect private property along the road to Fish Creek Summit. A compass is not reliable for directional purposes in the Great Rift because of magnetic fields that distort compass readings. There might be downed timber across the upper reaches of Fish Creek Road, so bring a saw. Cellphone coverage is good only near Arco and Carey. The best time to visit is mid-June to late October. The desert loop can be driven in good weather in May, but snow closes the pass at the head of Fish Creek until mid-June, or sometimes until late June.

Maps (See map sources in Appendix B)

BLM 1:100,000 quad map (highly recommended for the desert loop): **Craters of the Moon**; **Salmon-Challis National Forest** (Challis NF), this map shows the road up Fish Creek drainage and down to Leadbelt Creek, and Antelope Creek Road, but it does not cover the southern part of Fish Creek Reservoir Road, and doesn't cover the desert loop.

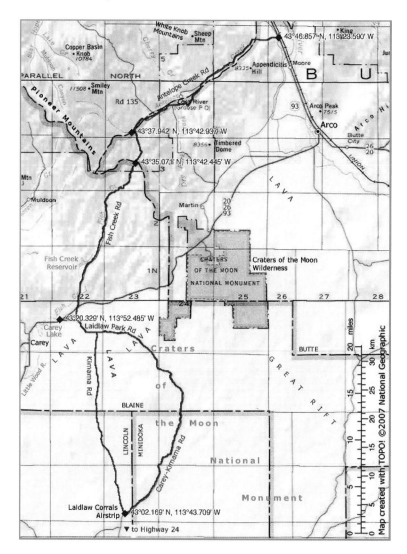

Total Miles/Road Ratings

- **Total Miles:** 104.8
- **2WD graded gravel/dirt/volcanic cinder:** about 92 miles
- **4WD recommended:** about 67 of the above 92 miles if the weather is bad
- **4WD experience required:** about 13 miles (more for optional side trips); not suitable for trailers

Expedition Directions

Set your GPS to display Degrees and Decimal Minutes. Along this route there are dozens of two-tracks leading to desert buttes, cattle troughs, mining ruins, etc. There are far more roads on the ground than appear on most maps. These side roads are not noted except as necessary for route-finding. The desert loop enters and leaves Craters of the Moon National Monument several times. Observe all posted regulations on Monument lands.

GPS: 43° 20.329' N • 113° 52.485' W
Mile 0.0 • Elevation: 4,820 ft.

Turn east on Carey-Kimama Road, leaving Highway 93/26/20 about 5 miles east of the town of Carey. This road is identified as "Laidlaw Park Road" on some maps. The main road is 2WD in good weather (graded dirt/gravel). All side roads are 4WD.

GPS: 43° 20.323' N • 113° 50.278' W
Mile 1.8 • Elevation: 4,829 ft.

Bear right (southeast) on Laidlaw Park Road at this junction with another entrance to the area from Highway 93/26/20. "Welcome to Craters of the Moon National Monument," "Absolutely No Services Available," and other informational signs are posted here, including weathered wooden signs for "Huff Creek Corrals," and a sign noting that it is 6 miles north to Fish Creek Reservoir.

GPS: 43° 19.176' N • 113° 47.561' W
Mile 4.9 • Elevation: 4,848 ft.

Turn right (south) on Kimama Road, in the area identified on some maps as Paddleford Flat. There are "Wilderness Study Area" signs near this road junction. As you travel south on the western leg of this desert loop, a few of the geologically interesting landmarks are signed. Spur roads leading to these landmarks are 4WD, crossing sharp lava rock in places.

A spur road to Wagon Butte, west, is at about mile 11.7.

A spur road completing the loop around Wagon Butte (west) is at about mile 13.4.

A spur road to The Blowout, east, is at about mile 16.4.

A spur road to Wildhorse Butte, west, is at about mile 25.

GPS: 43° 02.169' N • 113° 43.709' W
Mile 25.8 • Elevation: 4,423 ft.

Bear left (northeast) on Carey-Kimama Road at Laidlaw Corrals Airstrip. This major road junction is also signed for South Park Well, which is the next landmark on this route. As you travel north/northeast, the roadbed is red volcanic cinders beginning at about mile 34.

Option: At mile 25.8, continue south on Carey-Kimama Road to the small town of Kimama on Highway 24.

GPS: 43° 09.217' N • 113° 37.266' W
Mile 37.6 • Elevation: 4,649 ft.

South Park Well. At this landmark in an otherwise remarkably empty country there are corrals, old buildings and water tanks, but no services for visitors. Continue north on the main road.

Bear left at the roads to Hollow Top Airstrip and Little Laidlaw Park at mile 45.7.

Bear left, as above (second junction, same destinations) at mile 47.

Lava formations begin at about mile 48, and are intermittent for several miles. Stay on the main road. There is a sign for "Laidlaw Park" at mile 51, in an area identified as "Little Park" on maps, a grassy area where sheep are grazed. Lava formations narrow the road at about mile 52.

GPS: 43° 20.323' N • 113° 50.278' W
Mile 57.0 • Elevation: 4,829 ft.

This is the end of the desert loop, at the junction of Laidlaw Park Road and Kimama Road in the Paddleford Flat area (also the "Welcome to Craters of the Moon…" junction).

ZERO YOUR ODOMETER and then turn right (north) on a road that leads 1.2 miles to Highway 93/26/20. The second part of this expedition crosses the highway and continues north to Fish Creek Reservoir and beyond.

At the highway, turn right (east) for a short 0.3 mile jog to a junction with Fish Creek Reservoir Road.

GPS: 43° 21.578' N • 113° 50.031' W
Mile 1.5 • Elevation: 4,885 ft.

Turn north on Fish Creek Reservoir Road 218, leaving the pavement for two lanes of gravel that is well-graded to the reservoir. Creek crossings are bridged on the southern section of this road. The road provides access to both private and public lands. Past disputes are evident in frequent signs that read in part, "The lands in this area are privately owned, stay in established roads, leave gates as you find them. Pack out your trash. Thank you…Ask before hunting or fishing." Public land predominates the higher you climb toward Fish Creek Summit. Several unsigned roads lead to the reservoir, as well as signed roads for major access points.

Fish Creek Reservoir access road is at mile 5.7.

The Fish Creek Reservoir Boat Launch access road is at mile 7.4.

North of the reservoir the road narrows and becomes 4WD, at about mile 12. There are informal campsites at about mile 15.

The road narrows even more, and winds through trees, at about mile 18.7. The road fords Fish Creek and its tributaries multiple times. All of the creek fords require 4WD.

GPS: 43° 35.071' N • 113° 42.445' W
Mile 20.8 • Elevation: 7,390 ft.

Fish Creek Summit—the highest point on this expedition (but not signed on the ground). Views are 360° and include the Pioneer Mountains (which you are crossing); the White Knob Mountains to the north in the middle distance; and the Lost River Range on the horizon. You are now in Challis National Forest, having left BLM-administered lands at lower elevations. Signs remind visitors to stay on designated roads and trails, most of which are also open to oversnow vehicles in winter. As you proceed downhill to Leadbelt Creek, the road is not signed, but on maps it remains 218. This one-lane dirt road looks to be infrequently graded, and is rough in spots, muddy and rutted when wet. Gear down for the descent. Beaver dams in the streams sometimes cause overflow in or near the road.

A side road is signed as, "Dead End Road 3 Miles, Dry Fork, Sawmill Canyon," at mile 22.7.

GPS: 43° 37.942' N • 113° 42.937' W
Mile 25.3 • Elevation: 6,734 ft.

Turn right (northeast) to cross a bridge over Antelope Creek at this junction of Road 218 (now identified on the ground as Leadbelt Road) and Antelope Creek Road 137. At this junction "Fish Creek Summit" is also finally identified, with directional signs up Leadbelt Road. Before you reach the bridge there are several large informal campsites, with short roads leading to flat areas not far from the creek. The nearest designated campground is Iron Bog, to the left (northwest) on Antelope Creek Road. **ZERO YOUR ODOMETER** at the bridge over Antelope Creek. Antelope Creek Road is well-maintained gravel.

GPS: 43° 39.461' N • 113° 40.264' W
Mile 3.3 • Elevation: 6,480 ft.

The junction of Bear Creek Road and Antelope Creek Road. This expedition follows Antelope Creek Road east to Highway 93.

Option: Bear Creek Road to the northwest is a popular side trip that leads to Cherry Creek Summit Road (see "Other Nearby Excursions"). "Prohibitions" and "Special Orders" are posted at an "Information Center." It takes half an hour to read them all, an indication that Bear Creek Road leads to more heavily used areas that are also accessible from Ketchum and Sun Valley (see Expedition 27).

"Leaving Challis National Forest" is signed at mile 4.2, private property begins here.

Antelope Valley Airstrip is at mile 6.2.

"Cherry Creek" is at about mile 10.6 (not the same as Cherry Creek Summit Road).

Pavement begins about mile 18.

GPS: 43° 43.499' N • 113° 32.029' W
Mile 12.5 • Elevation: 5,993 ft.

Option: Whaddoups Canyon Road and Sheep Mountain are signed on the north side of Antelope Creek Road. Sheep Mountain is located at the southern end of the White Knob Mountains. A ditch requires 4WD and careful adjustment of your approach angle at the entrance to this optional side trip.

GPS: 43° 43.499' N • 113° 32.029' W
Mile 22.2 • Elevation: 5,993 ft.

The end of this expedition, at the junction of Antelope Creek Road 137 and Highway 93. Expeditions 21 and 27 are also nearby.

Option 1: Turn right (southeast) on Highway 93 for Arco.

Option 2: Turn left (northwest) for Mackay.

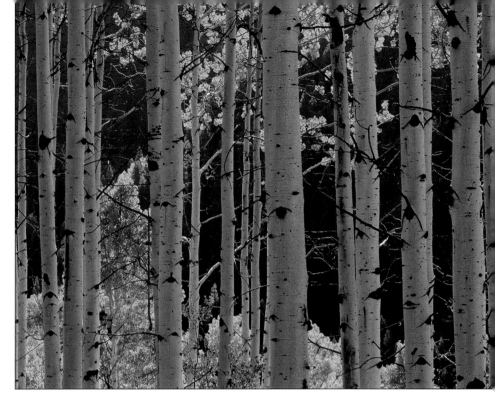

An aspen grove begins to show its fall colors.

Other Nearby Excursions...

Copper Basin

This side trip can be approached from the south via Bear Creek Road 135 from Antelope Creek Road; or from the north via Road 135 from Trail Creek Road 208. 4WD is recommended for this route. The approach from Trail Creek Road (see Expedition 27) follows the East Fork of Big Lost River, and also offers access to trailheads for Wildhorse Lakes via a spur road. The Wildhorse gray wolf pack formed in 1998. There are now wolves in the Alder Creek area of the White Knob Mountains, as well as in the Cherry Creek area of the Pioneer Mountains. Copper Basin is also home to wolves. The area has been used for mining and cattle grazing for many decades, but there are still scenic places to camp, fish and hike.

EAST-CENTRAL

Sun Valley • Trail Creek Road • Big Lost River

When We Were There

It's the first day of October and we are traveling on the iffy side of luck. The vagrant warmth and rough grace of autumn can change in a matter of hours to winter. Sunshine glints off of the leaves at the Hemingway Memorial; sleet pounds down on the Boundary Creek Campground and then just as suddenly stops; a pale lace of snow falls on willows along Trail Creek; a coat of white covers conifers at Trail Creek Summit; and Dutchman-blue sky makes brief appearances before clouds move the show to another slope.

Signs a few miles east of Sun Valley proclaim Trail Creek Road to be "Not Maintained in Winter. Not Maintained for Passenger Vehicles. Trailers not recommended." On most backcountry roads next to highly civilized towns, warning signs indulge in a certain degree of exaggeration. The road is roomy compared to a lot of unsigned mountain roads, with only a few narrow spots. We share the road—snow and all—with several passenger cars that are moving slowly but steadily uphill.

The slow pace is good for soaking up the scenery, and for enjoying the bits of civilization we brought with us from Ketchum and Sun Valley: fancy coffee, tiramisu…just the basics for survival.

Land Administration (See Appendix A)

- **National Forest Service:** Ketchum Ranger Station (Sawtooth National Forest); Lost River Ranger Station (Salmon-Challis NF)
- **BLM:** Shoshone and Challis Field Offices
- **Idaho Fish and Game:** Magic Valley and Upper Snake Regions
- **Chamber of Commerce:** Ketchum/Sun Valley

Approach Routes

- **From Stanley:** South on Highway 75 (Sawtooth Scenic Byway) to Ketchum.
- **From Idaho Falls:** West on Highway 20 to Highway 75; north on Highway 75 to Ketchum.
- **From Twin Falls:** North on Highway 93; north on Highway 75 to Ketchum.
- **From Boise:** Southeast on I-84 to Mountain Home; east on Highway 20 to Highway 75; then north on Highway 75 to Ketchum.

Maps (See map sources in Appendix B)

Sawtooth National Forest (Ketchum and Fairfield Ranger Districts); **Salmon-Challis National Forest** (Challis NF).

Know Before You Go...

Check wildfire conditions. Cellphone coverage is available only in Ketchum/Sun Valley and in Mackay. The best time to visit is June to late September for backcountry road travel. Return in winter to ski in the area where the first ski lift in the United States was constructed. Cross-country skiers enjoy The Harriman Trail, an 18-mile corridor in the upper Wood River Valley. The valley is also a favorite fly-fishing destination in the summer and autumn.

EAST-CENTRAL

Trail Creek Road is a thin line climbing to Trail Creek Summit on its way from Sun Valley to Big Lost River Valley. "Spring" wildflowers bloom from late June to early July, while snow lingers in shadowed ravines.

Total Miles/Road Ratings

- **Total Miles:** 42.7
- **2WD paved or graded gravel/dirt:** about 19.6 miles paved; 23.1 miles graded gravel. 2WD only in good weather, expect steep grades.
- **4WD recommended:** about 20 miles of the 23.1 miles of graded gravel noted above. The steep drop-off on one side of the road flusters some drivers.
- **4WD required:** for optional side trips only.

Map created with TOPO! ©2007 National Geographic

Expedition Directions

Set your GPS to display Degrees and Decimal Minutes. This expedition begins in Ketchum. Pause here for a "Historic Walking Tour" that includes buildings constructed from 1880 to 1936. Maps can be obtained at the Chamber of Commerce on Main Street. Ketchum and nearby Hailey are great sources for replenishing backcountry supplies and equipment.

GPS: 43° 40.836' N • 114° 21.862' W
Mile 0.0 • Elevation: 5,851 ft.

Turn northeast on Sun Valley Road from Highway 75 (Main Street in Ketchum).

Sun Valley Lodge is at mile 1.4.

Keep straight ahead (northeast) at the Dollar Road stoplight.

The Ernest Hemingway Memorial is at about mile 2, right (south).

Boundary Creek Campground and nearby day use area are near mile 3. Sun Valley Road also becomes Trail Creek Road near the day use area. The pavement ends here.

GPS: 43° 44.052' N • 114° 18.217' W
Mile 5.3 • Elevation: 6,221 ft.

Option: Corral Creek Road 137 is on the right (south). It leads to the Pioneer Cabin Trailhead.

Go northeast on Trail Creek Road for the main expedition.

A side road on the left (north) leads to Cottonwood Flats and informal camping at about mile 7.3.

Narrow, steep road warning signs are posted at about mile 8. Falling rock and fiber optic cable warning signs are also posted. You know you are really in wild country when you run across a fiber optic cable sign!

GPS: 43° 46.332' N • 114° 16.375' W
Mile 8.6 • Elevation: 6,496 ft.

Just past the first narrow road warnings an unsigned overlook on the left (north) is a good place to stop for a view of Trail Creek, beaver dams, and wildlife. The Boulder Mountains are north of the creek and the Pioneer Mountains are south. As it climbs, Trail Creek Road narrows in spots, but there are frequent turnouts.

GPS: 43° 49.558' N • 114° 15.790' W
Mile 12.9 • Elevation: 7,897 ft.

Trail Creek Summit is signed. Here you'll leave Sawtooth National Forest and enter Challis National Forest. Watch out for free-range cattle as you descend from the summit. Trail Creek Road 208 still bears the same name, but now follows Summit Creek.

Park Creek Road and Campground is on the left (north) at mile 13.7.

Mile 15, Little Fall Creek Road (4WD) is on the left (north).

Big Fall Creek Lake Road is on the left (north) at mile 15.5. Waterfalls on the route make this a fun side trip for photographers.

Phi Kappa Creek Road and Campground is on the right (south) at mile 17.

Option: Road 128, North Fork Big Lost River, is on the left (north) at mile 19.4 and again at mile 20.2. The road is 2WD for several miles, then 4WD-required.

There are several intersections in close proximity between mile 19.4 and mile 21. For this expedition, stay on Trail Creek Road, still heading northeast. Big Lost River now runs on the south side of the road (looking more like a stream than a river).

GPS: 43° 55.558' N • 114° 07.105' W
Mile 23.4 • Elevation: 6,906 ft.

Option: Road 135 to Copper Basin, Wildhorse, and Antelope Pass is well-signed on the right (south). Road 135 is the best side trip off Trail Creek Road. For a description of Copper Basin, see "Other Nearby Excursions" in Expedition 26. The road is 2WD in good weather. The Wildhorse Lake area is accessible via a spur road off Road 135. 4WD is required.

Near mile 24, shortly after the junction with Road 135, Trail Creek Road leaves Challis National Forest and enters desert areas administered by the BLM. Continue northeast toward Highway 93. There are excellent views of the Lost River Range, including Idaho's highest peak, Mt. Borah.

The Deep Creek Recreation Area is on the right (south) at about mile 24.8.

Twin Bridges Landing Strip is on the left (north) at mile 25.7.

There are several jeep trails on this drier side of the mountains, and some are open year round. Recreation areas include Garden Creek, a designated BLM site, and many informal sites along the Big Lost River. The White Knob Mountains are south of the road.

Bartlett Point Road is on the right (south) at mile 31.1.

Chilly Cemetery Road is on the left at mile 38.9.

GPS: 44° 04.012' N • 113° 50.078' W
Mile 42.7 • Elevation: 6,364 ft.

The end of this expedition is at the junction of Trail Creek Road and Highway 93.

Option 1: Turn left (north) for the Borah Peak Trailhead, the town of Challis, and Doublespring Pass Road. Doublespring Pass Road, which crosses the Lost River Range, is about 6.5 miles north on Highway 93 (see Expedition 21).

Option 2: Turn right (south) for Mackay Reservoir (about 10 miles) and the town of Mackay (about 13 miles).

Eastern Idaho

Eastern Idaho is bound by Yellowstone National Park and Grand Teton National Park on the east side, where it shares borders with Wyoming and Montana. Henrys Lake Mountains and Centennial Mountains mark the curve of the Continental Divide where it turns north and west along the Idaho/Montana border. These mountain ranges host some of the most scenic portions of the Continental Divide Trail. Expeditions 28 and 29 cross the Divide, offering rare vehicular access to this alpine terrain. In Expedition 30, the access roads have impressive views of the Grand Tetons. Waterfalls visited here include Mesa Falls and Cave Falls. Cave Falls is our only destination inside Yellowstone National Park, but other nearby expeditions can easily be extended to include Yellowstone's western entrance.

Tributaries of the Snake River flow southwest into the Snake River Plain from the high country of this eastern corner of Idaho. Henrys Fork of the Snake is the most well-known. It is named for Andrew Henry, who trapped beaver in the area from 1809 to 1811. He later built Fort Henry near the present town of St. Anthony. Another waterway is Camas Creek which flows through Camas Meadows, one of many areas that are also on the Nez Perce National Historic Trail.

The Nez Perce National Historic Trail crosses what are now state lines several times. Our expeditions in this chapter do the same. We cross from Idaho into Montana and back again, and the same for Wyoming. Idaho counties included in this Eastern Idaho section are Clark, Fremont, Madison, Teton and Jefferson. For more excursions to the south, refer to the Southeast Idaho chapter.

The soldier camp was alarmed. The bugle sounded quickly. The warriors were yelling and shooting fast. They had circled the soldiers' horses, stampeding them. The soldiers were now also firing in every direction. Some young men had gone in to cut loose the horses tied, and I, Yellow Wolf, was one of them…Mounting, I followed silently as I could with my three captured horses…After traveling a little way, driving our captured horses, sun broke. We could begin to see our prize. Getting more light, we looked. Eeh! Nothing but mule—all mules! … The place we took General Howard's mules is called Kamisnim Takin [Camas Meadows].

—Yellow Wolf, August 20, 1877

Cities near this area include Idaho Falls, Rexburg, St. Anthony, Ashton, and Driggs in Idaho; and West Yellowstone in Montana. Smaller communities through which our expeditions pass are Dubois, Island Park, Macks Inn, Swan Valley in Idaho; and Lima in Montana. In some cases, there are long distances between service stations—you will want a full tank of gas at the start of an expedition.

Lower Mesa Falls drops 65 feet on the Henrys Fork of the Snake River. The river carves its way through old volcanic flows near Yellowstone National Park.

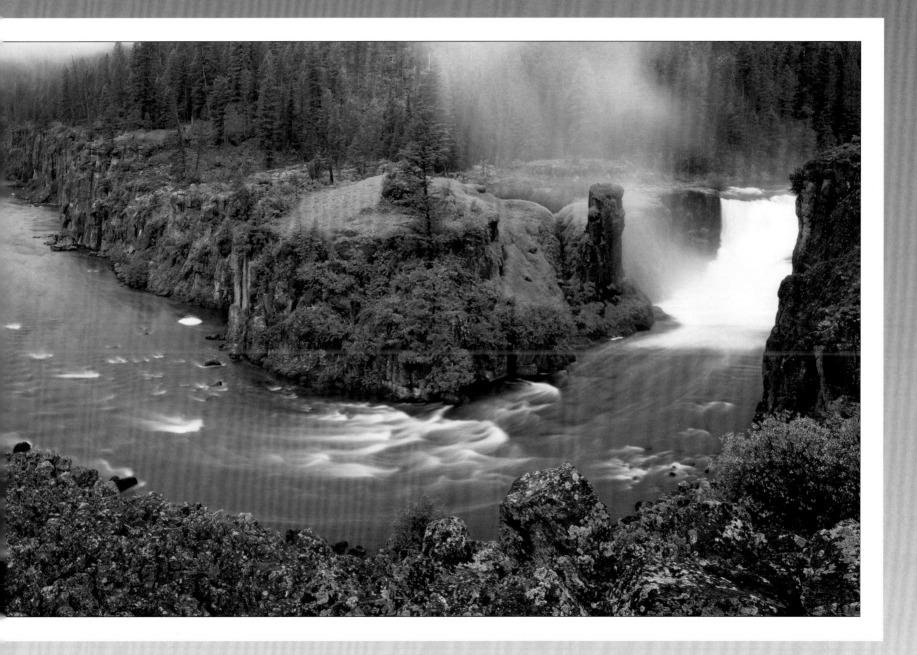

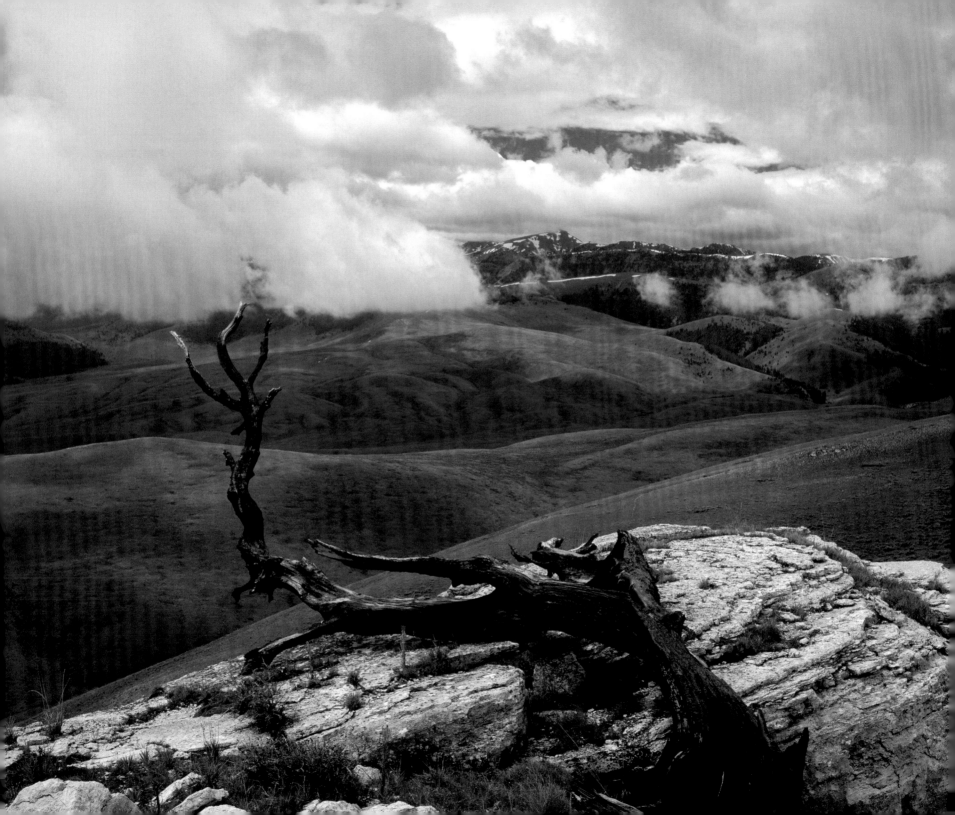

Medicine Lodge Road • Beaverhead Mountains

When We Were There

In mid-September, we stopped at Edie School on Medicine Lodge Road. The place was empty except for a galaxy of flies on a lace-curtained window. The window looked out on dry grass waving knee-high in the schoolyard, with the Beaverhead Mountains blue in the distance. Cows were fenced out, and someone had taken care to place vintage school books on the desks. I opened a book worn grimy by the children of ranchers long gone. *Fact and Story Readers: Book Six* opened to the poem *"Roadways"* by John Masefield. The last stanza of the poem reads:

My road calls me, lures me
West, east, south, and north;
Most roads lead men homewards,
My road leads me forth.

Outside the one-room school, an outhouse was painted to match, with cream-colored lapped-wood walls and forest-green trim. The path worn to the outhouse was still visible—packed ground that even rabbitbrush and sage found hard to colonize.

All along Medicine Lodge Road, ranches old and new are the norm until the road climbs to the inhospitable terrain of the Continental Divide. The Beaverhead Mountains of the Bitterroot Range run east-west from Interstate-15 to Bannack Pass, then dip sharply south, like a thumbs-down signal. The thumb holds mountains that rival those of the Lost River Range. Scott Peak, at 11,393 feet, is the highest. Medicine Lodge Road climbs to great views of these peaks. At Bannack Pass this expedition descends into Montana.

Where this expedition ends, you are only about 15.5 freeway miles from where Expedition 29's "Red Rock Pass Road" begins. We have shown the routes for Expeditions 28 and 29 on one shared map.

"Medicine Lodge Pass" is a reference to Native American sweathouses that used to exist along the creek. Bannock, Lemhi-Shoshone, and other tribes, including the Nez Perce, were familiar with the area. The Nez Perce (Nee-Me-Poo) National Historic Trail (NPNHT) commemorates the 1877 flight of the non-treaty Indians from eastern Washington across Idaho, Montana, and Wyoming. Many of the sites where skirmishes were fought with the U.S. Army are near this expedition.

The name "Dubois" is used for a city in Wyoming as well. The communities in both Idaho and Wyoming were named for Fred Thomas Dubois, a settler who moved to the Idaho Territory in 1880. Dubois served as a U.S. Marshall, as a territorial representative to Congress, and was elected to the U.S. Senate in 1891. His surname derives from French-Canadian ancestry, and you may recognize *"Bois"* in Boise—French for wood or timber.

Approach Routes

- **From Idaho Falls:** North about 50 miles on Interstate-15 to Dubois.
- **From Dillon, Montana:** South on Interstate-15 to Dubois.
- **From Salmon:** South on Highway 28 to Highway 22; northeast on Highway 22 to Medicine Lodge Road.

From the Continental Divide at Bannack Pass, long views into Idaho and Montana include the snaking spine of the Beaverhead Mountains of the Bitterroot Range.

EAST

Know Before You Go...

Unless you plan only a day trip here, be prepared for Leave-No-Trace camping. There is one campground on the Idaho side, Webber Campground (a side trip into the foothills below Italian Peak and Scott Peak). Check wildfire conditions. This is black bear country. Gas is available in Dubois, Idaho, and in Lima, Montana. Cellphone coverage is available only in the town of Dubois. The best time to visit is July–September. Bannack Pass may be blocked with snow until July 4th or later, but in years of low snow accumulation, the pass may be accessible earlier. Designated roads are open to snowmobiles in winter.

Note: the map below indicates the routes for both Expeditions 28 and 29.

Maps (See map sources in Appendix B)

Targhee National Forest (Dubois and Island Park Districts); **Beaverhead/Deerlodge National Forest** (Dillon, Montana, District). If you plan to hike on the Continental Divide, you should also add these USGS 1:24,000 topographical maps: **Snowline, Lima Peaks, Edie Creek, Fritz Peak, Gallagher Gulch, Deadman Lake, Eighteen Mile Peak, Cottonwood Creek,** and **Morrison Lake**.

Map Alert! The similarly named "Bannock Pass" (more than 50 miles to the north) is also on the Continental Divide (note the Bannock with an "o"). This expedition crosses the Bannack Pass with an "a."

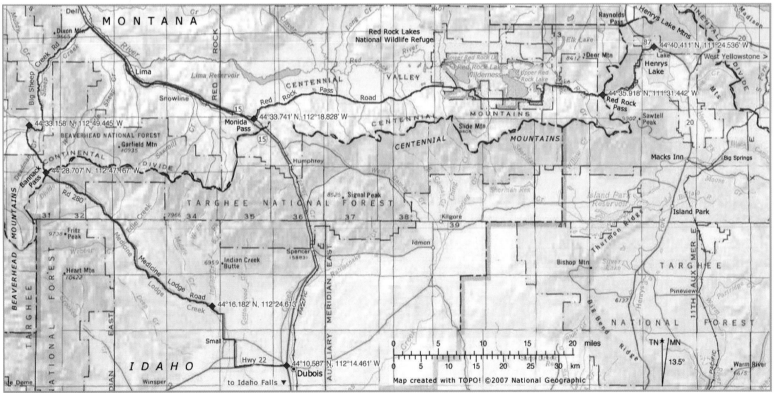

Land Administration (See Appendix A)

- **National Forest Service:** Dubois Ranger District (Targhee National Forest)
- **BLM:** Upper Snake Field Office
- **Idaho Fish and Game:** Upper Snake Region

Total Miles/Road Ratings

- **Total Miles:** 73.4 (more for side trips)
- **2WD paved or graded gravel/dirt:** paved about 35 miles; graded gravel/dirt about 18 miles
- **4WD recommended:** about 10 miles (4WD is required in bad weather). Not suitable for trailers.
- **4WD required:** about 10-12 miles. Near Bannack Pass, the road is in rougher condition. Descending from the pass on the Montana side, the road is rated 4WD-required, though you may squeak by with 2WD when it's completely dry, only to be faced with fording Deadman Creek, which does require 4WD. The descent from Bannack Pass is signed "Impassable When Wet." Drivers with a lot of 4WD experience can negotiate the descent in semi-wet conditions.

Expedition Directions

Set your GPS to display Degrees and Decimal Minutes. All along this route there are unsigned two-tracks and roads. There are more roads on the ground than appear on most maps. Most side roads are not listed in the directions below, unless necessary for navigation. Medicine Lodge Road is paved at lower elevations, and is a main road that is fairly easy to follow. This expedition approaches the Continental Divide from the Idaho side, crosses the Beaverhead Mountains of the Bitterroot Range at Bannack Pass, and descends into Montana, ending at the small town of Lima, Montana. Clark County, Idaho, has a population of about 1,000 and about 650 of them live in Dubois. Traffic is light.

GPS: 44° 10.587' N • 112° 14.461' W
Mile 0.0 • Elevation: 5,161 ft.

Take Exit 167 from I-15 at Dubois. Drive west on Highway 22. A rest area and gas station are near the exit.

Option: Nez Perce Trail and Lost Gold Scenic Trail are also signed at the exit. The Lost Gold Scenic Trail is east of this expedition, and includes the opal mine at Spencer, as well as historical sites.

At mile 0.3, Small Road, on the right (north) also leads to Medicine Lodge Road, but we are taking the easy route on Highway 22. Continue straight ahead (west) on Highway 22.

GPS: 44° 10.432' N • 112° 21.555' W
Mile 6.0 • Elevation: 5,103 ft.

Turn right (north) on a road signed as "Medicine Lodge 5 miles." The intersection is also signed, "Open Range, Watch for Stock." This road is paved, but there is no center line and the pavement is broken.

This route passes many side roads, including Shenton and Roland. Stay on the main road until you come to Small Road.

GPS: 44° 13.041' N • 112° 21.572' W
Mile 8.9 • Elevation: 5,246 ft.

Turn left (west) at this junction with Small Road (on some maps this is Medicine Lodge Road).

At mile 10.1, at the settlement of Small, turn right (north) on Medicine Lodge Road. Note that north of Small, Medicine Lodge Road is also identified as Doschades Cow Camp Road.

At mile 12.9, follow Medicine Lodge Road as it turns from north to west. This is where Doschades Cow Camp Road ends its temporary partnership with Medicine Lodge Road.

GPS: 44° 16.182' N • 112° 24.613' W
Mile 14.7 • Elevation: 5,542 ft.

Bear left (west) at this junction with Indian Creek/Middle Creek Road (Roads 205 and 204). Stay on Medicine Lodge Road as it enters a shallow canyon with rocky walls.

At about mile 25, pavement ends on Medicine Lodge Road and graded gravel begins.

GPS: 44° 22.423' N • 112° 36.171' W
Mile 29.1 • Elevation: 6,260 ft.

Keep straight on Medicine Lodge Road (though it is not signed) at this junction with Road 196 to Webber Creek Campground, on Weber Creek Road (spellings differ).

Option: Turn left (southwest) to Webber Creek Campground, and a trailhead for Trail 111, which is open to foot, horse, and motorcycle traffic. Road 196 is maintained gravel (2WD). There are old cabins along this side road, including one with a sod roof. The campground (about 5 miles from the turn) is small, with only three sites and a handicap-accessible pit toilet. Oversnow vehicles are allowed on the road in winter.

At mile 29.4 on the main road, near the road junction described at mile 29.1, is Edie School, a historic site. The school is an open, unattended museum. Please respect all artifacts. 4WD is recommended as the road climbs.

GPS: 44° 24.637' N • 112° 38.613' W
Mile 32.6 • Elevation: 6,464 ft.

Keep straight on Medicine Lodge Road at this junction with Irving Road 187. The junction is signed for Bannack Pass, ahead, and for Irving Creek, northeast.

GPS: 44° 25.713' N • 112° 40.191' W
Mile 34.8 • Elevation: 6,552 ft.

Medicine Lodge Road jogs briefly west, before turning north again at this junction with Fritz Creek Road 199. Follow Medicine Lodge Road north, signed for "Divide Creek."

Beyond this junction, the road is not well-maintained and is muddy and rutted when wet. 4WD is required in wet weather or for "spring" travel. In late June and early July, we've found remnants of snowdrifts here. Travertine rock quarries are near the road. The road is identified on some maps as "Bannack Pass Road" and on other maps as Road 280.

At mile 36.6, enter Targhee National Forest where the road name officially changes to Road 280.

At mile 39.8, stay on the main road (straight) at a junction with Road 195.

At mile 40.2, Divide Creek Trailhead access is on the left (west) along with Cow Camp site. Stay on the main road, signed for "Bannack Pass."

GPS: 44° 28.707' N • 112° 47.167' W
Mile 42.1 • Elevation: 7,670 ft.

Bannack Pass. Continental Divide Trail signs, weathered almost to blanks, mark the trail east and west of the pass. Road 8265, a 4WD two-track, travels the ridge a short distance both east and west. 4WD is required to descend, **4WD extreme experience is required when wet.** Wielders of shotguns have ventilated the signs. The Continental Divide Trail is 111, with Deadman Lake 6 miles to the west. The road is now "Bannack Pass Road" on most maps.

At mile 45, ford Deadman Creek. The ford has a rocky bottom, but the creek runs about a foot deep at low water, and the banks can be muddy. Just before the ford, on the right (east) is an old cabin. Side roads lead to informal camping along both banks of the creek. The ford is not signed.

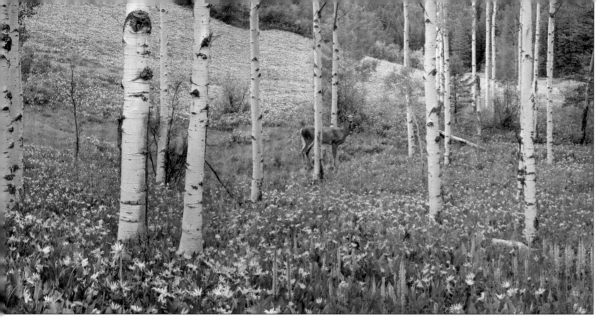

A young doe makes her way through a springtime meadow of arrowleaf balsamroot to drink at a nearby creek. Aspen groves in eastern Idaho let in enough sunlight to encourage spring flowers.

Several side roads beyond the ford lead to fishing holes and campsites.

At mile 48, bear right to stay on Bannack Pass Road at a junction with Nicholia Creek Road. Nicholia Creek is an optional side trip worth exploring, especially for anglers.

At mile 48.2, bear right again at this second junction with Nicholia Creek Road. There are several intersections piled practically on top of one another here. Keep heading north until you come to Big Sheep Creek Road.

GPS: 44° 33.158' N • 112° 49.445' W
Mile 48.4 • Elevation: 6,810 ft.

Turn right (east) on Big Sheep Creek Road. Bannack Pass Road ends here.

Option: Roads leading west and northwest approach the Continental Divide and provide access points for Nicholia Creek, Morrison Lake, Rock Creek, Tex Creek, and the Continental Divide Trail.

Sheep Creek Road, or Big Sheep Creek Road (depending on the map or ground sign you are looking at), is signed as "Narrow Winding Road." It is 1.5 lanes wide in most sections, graded gravel (2WD). From this road junction to Interstate-15, there are many side roads that explore canyons (Pileup Canyon, Caboose Canyon, etc.), and one designated campground, Deadwood Gulch.

At mile 57.1, bear right to stay on Big Sheep Creek Road 302 at a junction with Road 325. Road 325 goes deeper into Montana. There are more side roads as you approach I-15. Stay on the main road to a junction with West Side Frontage Road.

GPS: 44° 42.382' N • 112° 41.170' W
Mile 65.6 • Elevation: 6,024 ft.

Turn right (southeast) on West Side Frontage Road. Follow West Side Frontage Road as it parallels I-15 to the small town of Lima. The road is paved.

The end of this expedition is at mile 73.4, at the Lima exit/entrance to I-15. Lima has a gas station and café.

Option 1: Drive south on I-15 to Monida Pass, and exit there if you want to continue on the Red Rock Pass trip in Expedition 29. Also drive south on I-15 for a trip described in Expedition 30.

Option 2: Drive north on I-15 for Dillon and Butte, Montana.

EAST

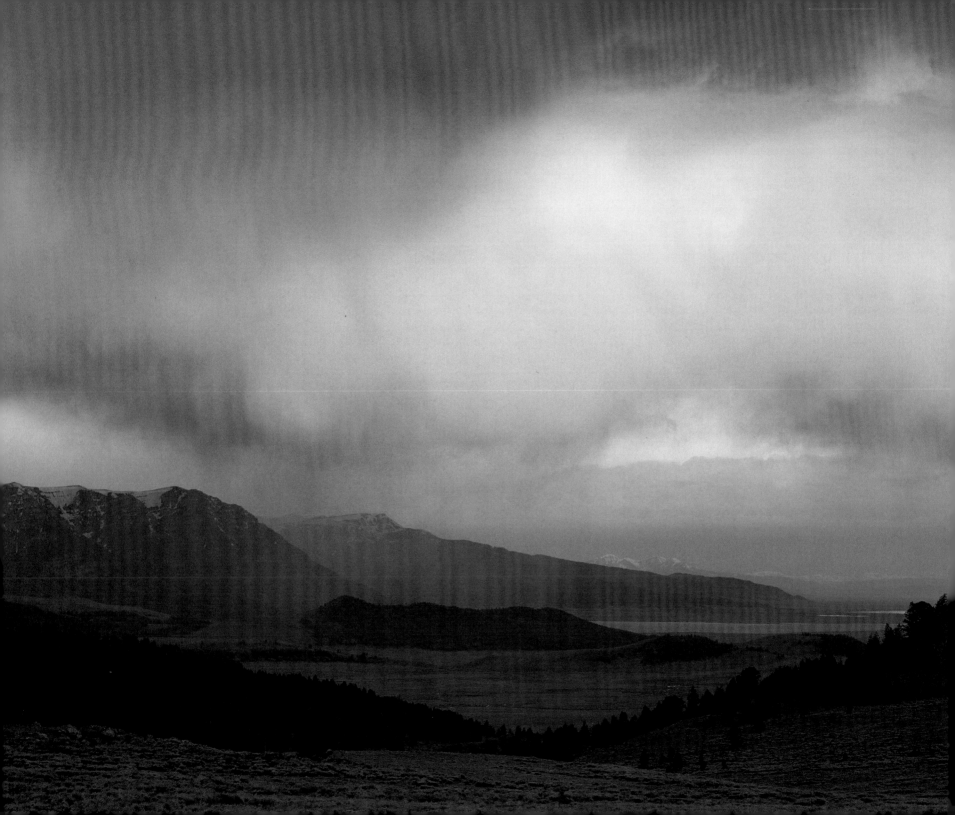

Red Rock Pass Road • Centennial Mountains
Other Nearby Excursions: Harriman State Park

When We Were There

Above the trees, a rowdy wind struck snow off the crest of Nemesis Mountain, stringing sunlit crystals across the sky. Nemesis is one of the peaks in the Centennial Mountains, an east-west range that marks the Idaho/Montana border not far from Yellowstone National Park. This trip begins about 15.5 miles south of where Expedition 28 ends. The map for this expedition (see p. 212) is shared with Expedition 28.

Expedition 29 follows Red Rock Pass Road along Montana's Centennial Valley, then re-enters Idaho at Red Rock Pass. The route provides access to a unique wildlife refuge centered around Lower and Upper Red Rock Lakes. The core of the refuge is also a designated wilderness. Red Rock Lakes are famous as trumpeter swan habitat. About 500 birds stay year-round, and migrating trumpeter swans from Canada swell the numbers by another 2,000 in the winter.

From Red Rock Pass, our route rounds the northern edge of Henrys Lake. The expedition ends at Highway 87, about 20 miles from the town of West Yellowstone, and about 15 miles from the resort of Macks Inn.

Gas is not available on Red Rock Pass Road, nor at Monida on Interstate-15 where this expedition begins. The closest gas stations are in Lima, Montana, and near the junction of Highway 87 and Highway 20.

Approach Routes

- **From Idaho Falls:** North on Interstate-15 to Monida, Exit 0.
- **From Dillon, Montana:** South on Interstate-15 to Monida, Exit 0.
- **From West Yellowstone:** West on Highway 20 to Highway 87; then north on Highway 87 to Henrys Lake Road and drive the expedition backwards.
- **From Macks Inn or Island Park:** North on Highway 20 to Highway 87. See above.

Maps (See map sources in Appendix B)

Targhee National Forest (Island Park, Ashton, Teton Basin, and Palisades Districts) and **Beaverhead/Deerlodge National Forest** (Dillon, Montana District).

Know Before You Go...

To view the Red Rock Lakes area in comfort, you will need to bring mosquito repellent and/or bug-net hats and clothing. This is black bear and grizzly bear country. Cellphone coverage is available only at Macks Inn or in West Yellowstone. The best time to visit is July–September. Island Park, on the Idaho side, is snowmobile heaven in the winter. Most of the trails are open to mountain bikes in the summer.

EAST

Sunset over Centennial Valley, as seen from the Idaho/Montana border at Red Rock Pass. Red Rock Lakes National Wildlife Refuge, host to trumpeter swans, occupies the valley floor.

Land Administration (See Appendix A)

- **National Forest Service:** Island Park Ranger District (Targhee National Forest)
- **BLM:** Upper Snake Field Office
- **Idaho Fish and Game:** Upper Snake Region
- **Idaho Parks & Recreation:** Harriman State Park
- **National Park Service:** Red Rock Lakes National Wildlife Refuge; *www.fws.gov/redrocks/*

Total Miles/Road Ratings

- **Total Miles:** 55.5
- **2WD paved or graded gravel/dirt:** all 55.5 miles in good weather
- **4WD recommended:** about 50 miles in wet weather

Expedition Directions

Set your GPS to display Degrees and Decimal Minutes. This expedition begins at Monida Pass on Interstate-15, on the Idaho/Montana Border.

**GPS: 44° 33.741' N • 112° 18.828' W
Mile 0.0 • Elevation: 6,786 ft.**
Exit from I-15 at Monida Pass, Exit 0, and drive east to the railroad track crossing and **ZERO YOUR ODOMETER** there. The pavement soon ends and the rest of Red Rock Pass Road is 2WD graded gravel.

Not all side roads from Red Rock Pass Road are noted in this log.

**GPS: 44° 35.946' N • 112° 08.698' W
Mile 9.9 • Elevation: 6,684 ft.**
At this junction of Red Rock Pass Road and Price Peet Road, keep straight on Red Rock Pass Road.

Option: Price Peet Road 1805 (Road 207 on some maps) leads south from Red Rock Pass Road, climbing steeply up to the Continental Divide. The graded road is 4WD recommended.

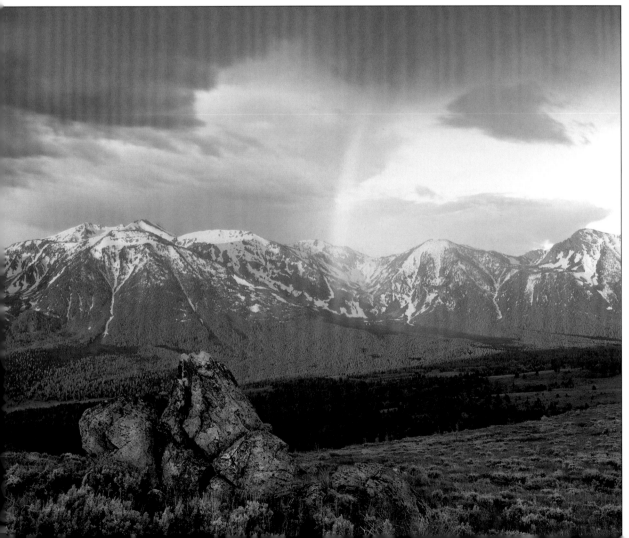

Sunset and rainbows color the Centennial Mountains on the Continental Divide. Views from Antelope Basin Road, near Red Rock Pass, are on the Continental Divide National Scenic Trail.

GPS: 44° 36.605' N • 111° 51.481' W
Mile 25.3 • Elevation: 6,705 ft.

At this junction of Red Rock Pass Road and Lower Lake Road, keep straight on Red Rock Pass Road.

Option: Lower Lake Road, on the left (south), is an optional side trip. The turn is signed.

At about mile 28, the refuge headquarters and visitor information center are signed.

At mile 31.8, Shambo Stagecoach Historical Site, near Shambo Pond is signed.

At about mile 32.5 is Upper Lake Campground.

At mile 38.3, on the left (north), is Elk Lake Road leading to a resort area.

At mile 40.5, Antelope Basin Road, on the left (north), is a 4WD optional side trip.

GPS: 44° 35.918' N • 111° 31.442' W
Mile 45.4 • Elevation: 7,120 ft.

Red Rock Pass. Continental Divide Trail, Idaho/Montana border, and "Bear Aware" signs mark the pass. Red Rock Pass Road is signed as Road 053 on the ground. Continue straight ahead on Red Rock Pass Road.

GPS: 44° 37.085' N • 111° 27.175' W
Mile 49.0 • Elevation: 6,549 ft.

Turn left (north) on Henrys Lake Road 055. Red Rock Pass Road 053 continues east/southeast to meet Highway 20.

GPS: 44° 40.411' N • 111° 24.536' W
Mile 55.5 • Elevation: 6,533 ft.

The expedition ends at Highway 87. Turn right (southeast) to access Highway 20.

Option 1: At Highway 20, turn left (northeast) for West Yellowstone, a gateway to Yellowstone National Park.

Option 2: At Highway 20, turn right (south) for Macks Inn, Big Springs, Island Park, and Harriman State Park. Also turn right to access Mesa Falls Scenic Byway (see Expedition 30).

Other Nearby Excursions...

Harriman State Park

Railroad entrepreneurs from New York brought their families to Island Park for world-class trout fishing. Their favorite fly-fishing spot is still known as "Millionaire's Hole." Edward H. Harriman, Chairman of Union Pacific Railroad, was one of the investors. Harriman died in 1909, but his family continued to visit every summer. Their descendants later deeded the land to the State of Idaho. Eight miles of the Henrys Fork of the Snake River runs through the park and is home to trumpeter swans year round. Hiking and crosscountry ski trails include about 22 miles of marked routes. Harriman is located on Highway 20, an easy ten-minute drive from Macks Inn.

EAST

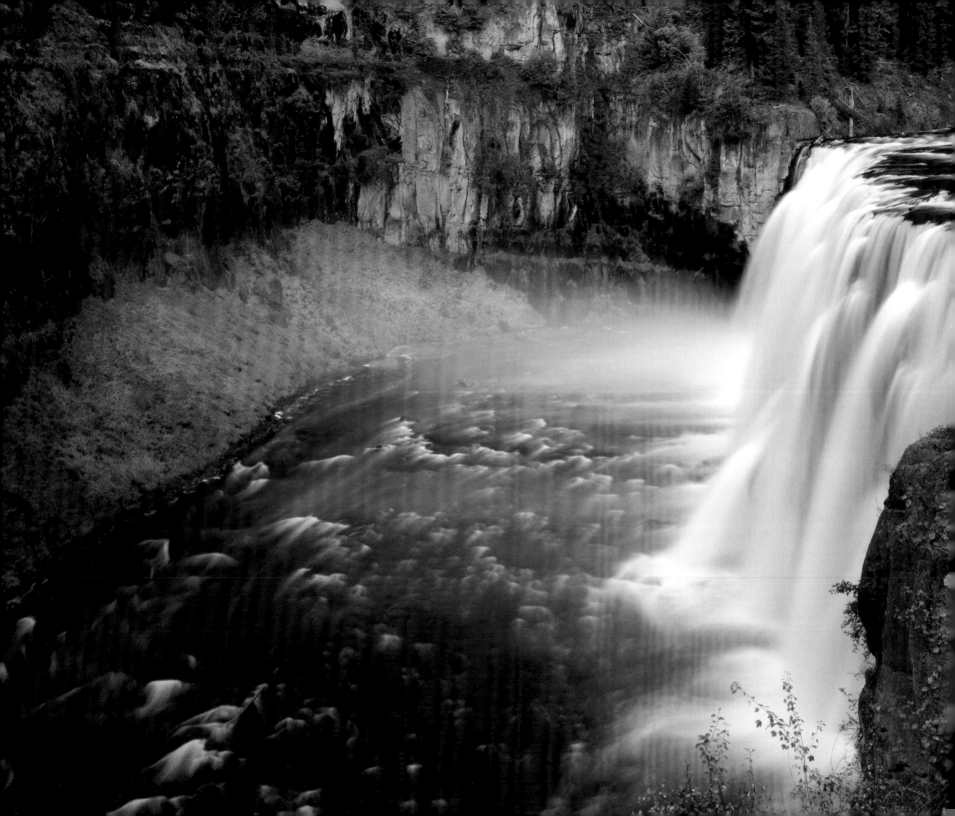

Mesa Falls Scenic Byway •Cave Falls

When We Were There

Autumn in waterfall country—great spills of volcanic rock are cut with time and a liquid knife. Mesa Falls, both upper and lower, are powerful. Two million years ago, the Yellowstone Hot Spot created huge volcanic eruptions beneath what is now Island Park. About 1.3 million years ago, an eruption spewed ash into the air, creating a layer many hundreds of feet deep. Mesa Falls Tuff is that pale ash, now a light-reflecting cliff that backdrops Upper Mesa Falls.

Upper Mesa Falls is surrounded by boardwalks, viewing platforms and interpretive signs on the east shore of Henrys Fork of the Snake River. "Upper Mesa Falls is the largest undisturbed waterfall in the entire Columbia River system," as the sign says, and once you're standing next to the falls, you believe it. The upper falls drops 114 feet and is an impressive 200 feet wide, pouring between 387–967 million gallons of water per day over basalt ledges. Most of the water comes from Big Springs, that quiet-seeming spot near Macks Inn where families stop to let their children look at trout, or watch a moose munching sloppy greens. Big Springs pumps 120 million gallons of water per day.

A 4WD road used to lead from Upper Mesa Falls parking area to a spot near Lower Mesa Falls. This road is now closed, but people still use it as a hiking trail. Lower Mesa Falls' roaring current and loose rock are dangerous. It is safer to look from the Grandview Overlook off of Mesa Falls Scenic Byway.

A few miles from Upper Mesa Falls is a gorgeous pond, one of dozens on the rim where the Yellowstone caldera overlaps Island Park and Mesa Falls calderas. The pond is a secret garden and a photographer's delight. Getting there requires 4WD or a short hike (and precise use of GPS and maps). It is a side trip with no tourists or signs—not even an official road. The pond is shown only on the Snake River Butte 1:24,000 USGS topographical map (we have included an access map to it on p. 224) and is a highly-recommended side trip.

Cave Falls is southeast of Mesa Falls, in Yellowstone National Park. The road is accessible from Mesa Falls Scenic Byway. If you suffer from sign-deprivation after visiting the beautiful pond, you can make up for it at Cave Falls. There are sixteen signs: half of them demand money, and the other half tell you what you cannot do. Horses are included in the no-no's—Bechler Trailhead is not a stock trailhead. Plunking down your $12 to $25 and obeying all the rules is well worth it. The waterfalls and foot trails on the Bechler and Falls rivers should be on your list of things-to-do-before-I-die. Both rivers are full and swift, but haven't yet worn themselves a significant canyon. Bechler River lies at the edge of Yellowstone's extensive lava fields, where drop-offs are steepest and the precipitation is heaviest.

The road to Cave Falls meanders through wheat, hay, and barley farms for miles. As if in obeisance, almost every house faces the Grand Tetons. I try to avoid using the corny word "majestic," but here it earns its keep. The approach route is paved for the last few miles to Cave Falls because you have entered another country —The Park.

Bear tracks with long claws reveal a grizzly's passage on the trail at Cave Falls. Firearms are forbidden, but canisters of bear spray are not. The next morning, three moose join our camp which is reassuring as far as guessing the bear's whereabouts. To the trio of moose we added antelope, buffalo, elk, eagles, swans, geese, ducks, owls, deer and coyotes to our wildlife sightings on this expedition.

Upper Mesa Falls on Henrys Fork of the Snake River.

EAST

Know Before You Go...

Mosquitoes thrive in Island Park, and have about a two-week season of intense activity in July. To view the waterfalls and ponds in comfort, bring mosquito repellent and/or bug-net hats and clothing. This is black bear and grizzly bear country. Gas is not available on the Mesa Falls Scenic Byway, nor on Cave Falls Road, but there are plenty of towns nearby on Highway 20. Ashton is the closest full-service town. Cellphone coverage is available in Ashton and near Macks Inn. Autumn is the best time to visit Island Park. Cold nights kill the insects, and traffic on the highway diminishes. About mid-September to early October is best. Be prepared for early snowstorms. Late May to mid-June is also a good time. We have visited as late as November, but had to drive through slush and mud to see the sights. Winter trips by snowmobile and crosscountry skiing are also popular. Mesa Falls is a spectacular sight in the winter. Bear Gulch Snopark, east of Ashton, marks the spot where snowplows stop clearing the Mesa Falls Scenic Byway and it becomes a groomed snow trail.

Approach Routes

- **From Idaho Falls:** North on Highway 20 to Mesa Falls Scenic Byway.

- **From West Yellowstone, Montana:** West then south on Highway 20 to Mesa Falls Scenic Byway.

- **From Boise or Twin Falls:** East on I-84 to I-86; northeast on I-86 to Idaho Falls; north on Highway 20 to Mesa Falls Scenic Byway.

- **From Salmon:** Southeast on Highway 28 to Highway 33; east on Highway 33 to Highway 20; north on Highway 20 to Mesa Falls Scenic Byway.

- **From Jackson Hole, Wyoming:** West on Highways 22 and 33 to Victor; north on Highway 33 to Driggs and Tetonia; north from Tetonia on Highway 32 to Highway 20; north on Highway 20 to Mesa Falls Scenic Byway.

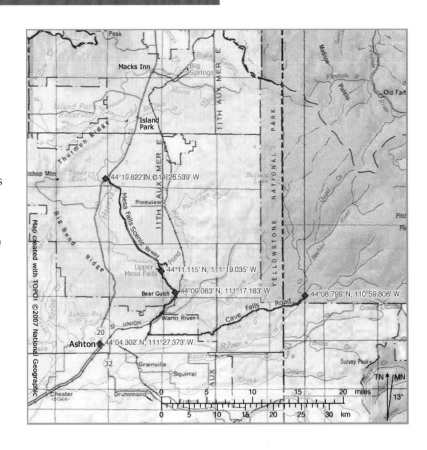

Maps (See map sources in Appendix B)

Targhee National Forest (Island Park District); **Yellowstone National Park;** USGS 1:24,000 topographical map (for a side trip to the nameless pond, see Mile 12.4): **Snake River Butte**.

Land Administration (See Appendix A)

- **National Forest Service:** Island Park and Ashton Offices (Caribou-Targhee NF)
- **National Park Service:** Yellowstone National Park
- **Idaho Fish and Game:** Upper Snake Region
- **Idaho Parks & Recreation:** Harriman State Park

Total Miles/Road Ratings

- **Total Miles:** 51.3 (plus about 22 miles of backtracking)
- **2WD paved or graded gravel/dirt:** paved, about 36 miles; graded gravel/dirt about 14 miles
- **4WD recommended:** about 14 miles in wet weather
- **4WD required:** about 1.5 miles for a side trip to a pond

Expedition Directions

Set your GPS to display Degrees and Decimal Minutes. This expedition begins at the signed junction of Highway 20 and Mesa Falls Scenic Byway (Highway 47). There are two entrances to the Scenic Byway near Harriman State Park. Our expedition begins 0.9 mile south of Harriman's main entrance, and about 19 miles north of Ashton. Visitors can drive the expedition backwards if they prefer to start at the town of Ashton on Highway 20.

GPS: 44° 19.822' N • 111° 26.539' W
Mile 0.0 • Elevation: 6,134 ft.

Turn east on Mesa Falls Scenic Byway. Informational signs are posted near a large parking area (snowmobile parking in winter). The scenic byway trends southeast towards the waterfalls. The road is paved.

At mile 2.6 is Osborne Springs Campground. Many side roads, including those leading to informal campsites are not listed in this log. Stay on Mesa Falls Scenic Byway to Road 150 (Warm River Road).

GPS: 44° 11.780' N • 111° 19.361' W
Mile 12.4 • Elevation: 5,971 ft.

Turn left (east) on Warm River Road 150, and **ZERO YOUR ODOMETER**. This is the short side trip to a nameless pond which is mentioned at the beginning of this expedition. 4WD is required, and you will need to watch both mileage and GPS to find the pond. The map on p. 224 shows the access route. The pond is shown only on the Snake River Butte 1:24,000 USGS topographical map. At the turn onto Road 150, signs note that Pole Bridge Campground and Warm River Spring are about six miles away. This is one of many routes to Pole Bridge Campground, so other side roads bear similar signs.

Drive just 0.9 mile east on Road 150. Views of the Tetons are good enough to be distracting. Watch carefully on the right (south) for a two-track with grass growing in the center. Turn south onto this unsigned two-track. The entrance is tricky, with a bar ditch to cross at an angle. Continue south on the two-track for 0.6 mile. When you see the pond on the right (west), stop and walk. Note that the distance from Road 150 is only about half a mile, so you may want to hike to the pond, leaving your vehicle parked in a small flat area next to Road 150.

EAST

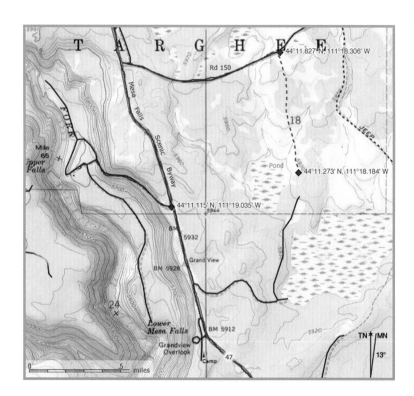

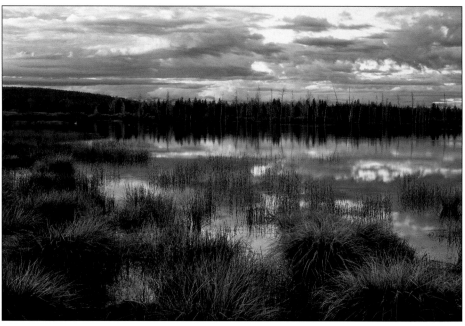

The mirror-still waters of a nameless pond in east Idaho's Island Park area (see map at left). This pond is also a stop for migrating birds in the autumn.

Return the way you came. At the intersection of Road 150 and Mesa Falls Scenic Byway, **ZERO YOUR ODOMETER AGAIN**. Proceed south on the byway.

GPS: 44° 11.115' N • 111° 19.035' W
Mile 0.9 • Elevation: 5,938 ft.

Turn right (west) at the signed entrance for "Mesa Falls Scenic Area, Upper Falls." Drive about one mile to the parking area near the lodge (this is a fee area, $3.00 for parking). John Hendricks, a driver for stagecoaches to Yellowstone Park, homesteaded the area around Mesa Falls in 1901. His wife and children did not feel safe around the falls, so the property was sold to Snake River Power & Light Company. The company built Mesa Falls Lodge as a stage stop and hotel for visitors to Yellowstone National Park. Montana Power bought the site in 1936, but power company plans for a hydroelectric dam fell by the wayside. A Forest Service Historic

Preservation project rebuilt much of the building, using the same style and materials as the 1904 original. Now named "Big Falls Inn," the center is on the National Register of Historic Places.

After viewing Upper Mesa Falls and the inn, return to Mesa Falls Scenic Byway, and **ZERO YOUR ODOMETER**. Continue south on the byway.

GPS: 44° 10.599' N • 111° 18.839' W
Mile 0.6 • Elevation: 5,917 ft.

Lower Mesa Falls Grandview Overlook and Campground. After viewing Lower Mesa Falls, continue southeast on the Mesa Falls Scenic Byway.

GPS: 44° 09.083' N • 111° 17.183' W
Mile 3.2 • Elevation: 5,623 ft.

Bear Gulch Snopark, campground, trailhead, picnic area, etc. In winter, Mesa Falls Scenic Byway is plowed from Ashton to this

point. The snowmobile trail to Upper Mesa Falls is just over three miles. There are also Nordic ski trails in the area, including Warm River Trail. For summer use, a railroad bed has been repurposed as a mountain biking trail.

Continue on the Mesa Falls Scenic Byway as it turns southwest along Warm River.

At mile 3.4, Warm River Campground is on the left (south).

At about mile 5, the Mesa Falls Scenic Byway leaves Warm River and crosses an agricultural area.

GPS: 44° 05.112' N •111° 20.874' W
Mile 6.5 •Elevation: 5,602 ft.
Turn left (east) at this junction of Mesa Falls Scenic Byway (Highway 47) and Marysville Road (also E 1400). The turn is signed for Cave Falls, Rock Creek Girls Camp, Yellowstone National Park, and the Bechler Ranger Station. The road is paved. **ZERO YOUR ODOMETER** at this junction.

GPS: 44° 05.097' N •111° 13.951' W
Mile 5.7 •Elevation: 5,656 ft.
Keep straight (the middle fork) on Cave Falls Road where Marysville Road ends and Cave Falls Road begins. Road 243 is the right fork (south) and Road 506 is the left fork (north) to Porcupine Ranger Station. The road is 2WD in good weather. Stay on the main road as you pass multiple side roads.

At mile 9.6, Road 470 leads north to Rock Creek Camp.

At mile 10.5, Horseshoe Lake Road is on the left (north).

At mile 13.9, Beaver Lake Road is on the left (north).

At mile 15.2, Goose Lake Road is on the right (south).

At mile 16.6, the road crosses over the state line and enters Wyoming. Beyond this point the road is paved again, though narrow, and with few turnouts.

At mile 16.7, the Bechler Ranger Station is on the left (north). If you do not already have the necessary permits for entering Yellowstone NP, registrations for hiking (if needed), or have not paid campground fees (if necessary), stop at the ranger station and fork over your cash.

At mile 18.4 you will pass the Cave Falls Campground entrance. Cave Falls Overlook is nearby.

GPS: 44° 08.799' N •110° 59.806' W
Mile 20.0 •Elevation: 6,332 ft.
Enter Bechler River Parking Area and Trailhead. There are informational signs posted at the end of Cave Falls Road.

Retrace your route to the junction of Mesa Falls Scenic Byway and Marysville Road. **ZERO YOUR ODOMETER**.

GPS: 44° 05.112' N •111° 20.874' W
Mile 0.0 •Elevation: 5,602 ft.
Turn left (southwest) after backtracking to the junction with Mesa Falls Scenic Byway (Highway 47).

At mile 1.1, follow Highway 47 (the Mesa Falls Scenic Byway) as it turns sharply west. The highway is also now identified as Atchley Road.

At mile 4.2 you will pass the small town of Marysville.

At mile 5.1, keep straight at a junction with Highway 32. Highway 47 (Mesa Falls Scenic Byway) is now also Highway 32 as it heads west to Ashton.

Option: Turn left (southeast) on Highway 32 to access the Teton Scenic Byway, Driggs and Teton Valley.

GPS: 44° 04.302' N •111° 27.373' W
Mile 6.1 •Elevation: 5,253 ft.
The expedition ends at Highway 20, on the west side of Ashton. The Ashton office of the Caribou-Targhee NF is at the intersection.

Option 1: Turn left (southwest) for Idaho Falls. See Expedition 31 for a nearby trip.

Option 2: Turn right (north) for Harriman State Park, Island Park, Macks Inn, and West Yellowstone.

Southeast Idaho

Terrain features in southeastern Idaho make a big statement. Grays Lake National Wildlife Refuge is the largest hardstem bulrush marsh in North America. The Caribou Mountains are over sixty miles long and twenty miles wide. No reservoir has a more scenic setting than Palisades. Idaho's Snake River Mountains lie along the western edge of the approach, and the reservoir backs water up to the foothills of the Caribou Mountains. Not far to the northwest is Jackson Hole; and to the west is Wyoming's Salt River Range. Our expedition explores terrain above the west side of the reservoir, in the Caribou Range, and then drops into the basin that holds Grays Lake. A fall color tour in the Caribou Range is one of the best in Idaho.

In the extreme southeastern corner of the state, and crossing into Utah, is Bear Lake. The Oregon Trail–Bear Lake Scenic Byway circles the lake. Montpelier, Idaho is home to the National Oregon-California Trail Center. Thirteen Oregon Trail sites are near Soda Springs, a full-service town south of Grays Lake.

Southeastern Idaho includes Bear Lake, Power, Bingham, Caribou, Franklin, Oneida, Bonneville, and Bannock counties. The largest cities are along the I-15 corridor and include Pocatello, Blackfoot and Idaho Falls. Our expedition is close to the Wyoming-Idaho border. It is easy to extend the expedition into neighboring states, including some wilderness areas located in northern Utah and Wyoming.

(Left) *An understory of mountain maples turns brilliant red early in the season, before aspen trees have come into their full golden glory. The Caribou Range offers some of the best fall color in Idaho.*

(Right) *Caribou Mountain (9,803 feet) presides over yellowing aspen groves.*

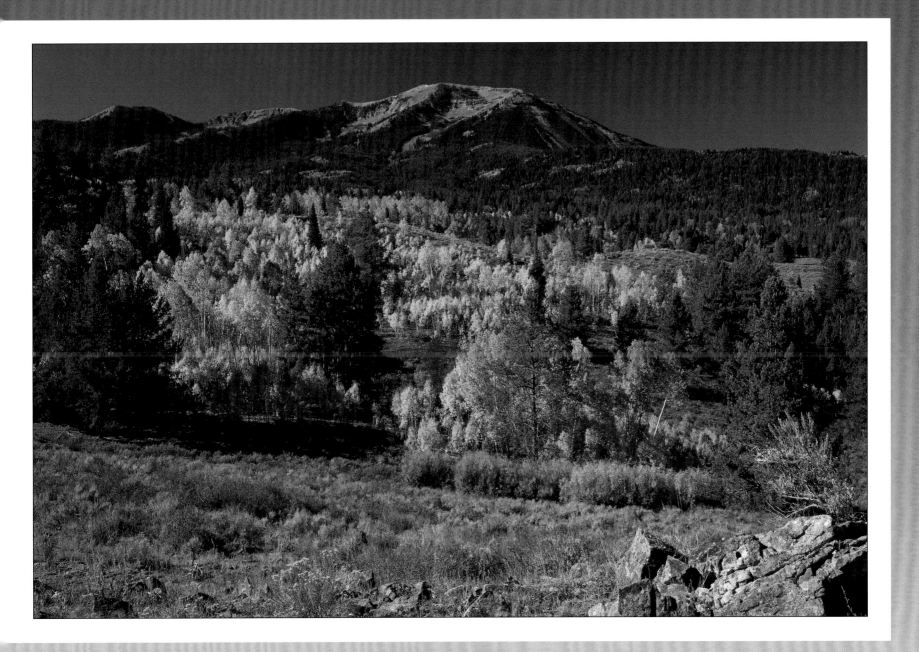

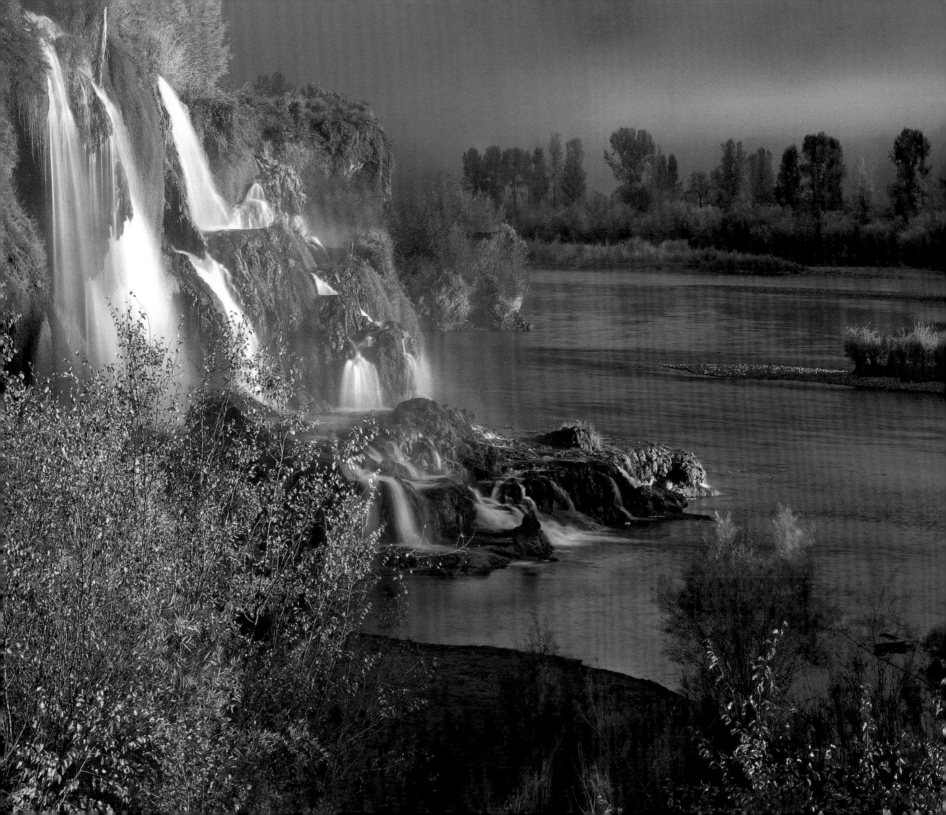

Fall Creek • Snake River • Caribou Range

When We Were There

In autumn, a gray wolf mottled like the river rocks he eases across, doesn't notice us at first, thanks to the noisy rush of water. When he finally spots us, he turns to stare across the river, swiveling his ears. The wolf decides we're of no interest and resumes nosing around, generally following the track of a deer we saw earlier.

Fall Creek Falls on the west side of the Snake River is still playing host to a few anglers, also of no interest to the wolf. Fishermen cast into pools near the base of the falls and watch trout leap. The waterfall is impressive both for its perfection and its height. Travertine, a color-banded limestone formed in caves and hot springs, supports Fall Creek as it drops sixty feet into the South Fork of the Snake River. This whole area, so close to Yellowstone National Park, used to be over the Yellowstone hotspot before tectonic plate movement slid it west. There's still a warm springs about three miles upstream from the falls. Fall Creek Falls is a natural work of art, with perfectly spaced tiers of travertine and enough flow to mist an emerald garden of moss and grass.

From the shores of the Snake River, we drive backroads that climb into the Caribou Range. Red mountain maple and many colors of aspen and willow leaves enhance the scenery. Caribou City, our destination, is a ghost town surrounded by stunted aspens and conifers. Gold was discovered there in 1869, but the mining season was short and water for placer mining was in short supply. Miners, some of them Chinese, stuck it out until the early 1900s. One lonely cabin remains standing—amend that to "partially standing." Signs of placer mining, rusting equipment, and bits of broken glass tell the tale of the past.

Fall Creek Falls decorates sixty feet of travertine as it joins the South Fork of the Snake River.

We camp about a mile from Caribou City—the only other humans we see are black bear hunters that pass by just after dawn the next day. Our descent from the Caribou Range ends at Grays Lake. "Where's the lake?" is the first thing that comes to mind.

"Gray's Lake is not a lake at all but a great marsh, covered with from a few inches to 2-3 feet of water, in the center of which rises the mountain, Bear Island… Gray's Lake is a fine muskrat territory and probably the only serious opposition to making it a bird refuge will come from those people who have been accustomed to reap the annual fur harvest."

—Notes from a survey conducted June 10, 1929,
by Charles C. Sperry and A. C. Martin,
U.S. Biological Survey

Many ducks, including canvasback, cinnamon teal, and mallard, nest here—up to 5,000 little quackers may wobble after their mothers every year. Trumpeter swans were also introduced and have been thriving. But the marsh is famous for is its sandhill cranes. The largest nesting population in the world arrives at Grays Lake in early April. Migrating cranes also stop by on their way south, boosting the crane population to as many as 3,000 in the fall.

The lake was named for John Grey, a respected Iroquois leader and fur trader. Grey may have explored Grays Lake about 1818—there's some dispute about which "John Grey's Lake" or "Grey's Hole" is referred to in historical documents. Grays Lake was more of a lake in the 1800s. In the early 1900s canals were built to drain portions of it. The lake receives few visitors, and facilities for tourists are scarce. The shore road that is part of this expedition offers some of the best viewing opportunities. There is also an overlook next to refuge headquarters in Wayan.

SOUTHEAST

Know Before You Go...

Check on wildfire conditions. There are gas stations close to the beginning of this expedition, but the closest full-service town at the end of the expedition is Soda Springs, 34 miles south of Grays Lake. Cellphone coverage is available only in Swan Valley and Soda Springs. The best time to visit is September for a fall color tour. Late June to early October is fine for camping, ATV riding, fishing, hiking, and horseback expeditions. Many roads and trails are open in the winter for oversnow vehicles.

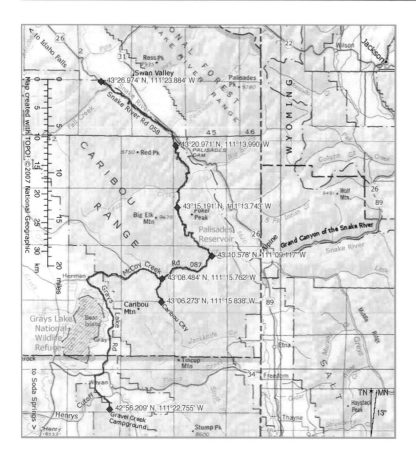

Approach Routes

- **From Idaho Falls:** East and southeast on Highway 26 (exits from I-15 are signed for Jackson Hole; the section of Highway 26 closest to Idaho Falls is also called Yellowstone Highway). Turn off Highway 26 near a bridge over the Snake River, on Road 058.
- **From Pocatello:** North on I-15 to Idaho Falls. See above.
- **From Jackson, Wyoming:** South on Highway 26/89 to Alpine; north on Highway 26 along the eastern shore of Palisades Reservoir; pass Swan Valley; cross Snake River bridge and turn left (southeast) on Road 058.

Maps (See map sources in Appendix B)

Caribou-Targhee National Forest (Montpelier and Soda Springs Ranger Districts). USGS 1:24,000 topographical maps (boaters and anglers may want these maps as they show river miles on the Snake River): **Conant Valley, Swan Valley,** and **Palisades Dam**.

Land Administration (See Appendix A)

- **National Forest Service:** Caribou-Targhee Office
- **U.S. Fish & Wildlife Service:** Grays Lake National Wildlife Refuge
- **Idaho Fish and Game:** Upper Snake Region

Total Miles/Road Ratings

- **Total Miles:** 77
- **2WD paved or graded grave:** paved, about 10 miles; graded gravel about 47.5 miles
- **4WD recommended:** about 12 miles (4WD is required in wet weather)
- **4WD required:** about 7.5 miles (to Caribou City and back again). This is rated 4WD experience required in wet weather.

Expedition Directions

Set your GPS to display Degrees and Decimal Minutes. This expedition follows Snake River Road 058 as it closely parallels the river southeast to Palisades Dam. Near the dam, the route turns up into the Caribou Range. We visit the ghost town of Caribou City then descend to Grays Lake.

GPS: 43° 26.974' N • 111° 23.884' W
Mile 0.0 • Elevation: 5,258 ft.

Turn southeast on Road 058 from Highway 26, near the bridge. The turn is signed for Spring Creek Boat Landing and Caribou National Forest. This is a winter-travel-restricted area, indicating that oversnow vehicles must stay on designated roads. Spring Creek Boat Landing can be seen soon after you leave the highway. The road is graded dirt and gravel, one-lane wide with turnouts, 2WD in good weather.

Option: At mile 1.2, Fall Creek Road 077, on the right (southwest), leads to Skyline Ridge, a popular side trip.

GPS: 43° 26.434' N • 111° 22.624' W
Mile 1.2+ • Elevation: 5,272 ft.

Cross Fall Creek on a wooden bridge—watch for a very small parking area just past the bridge. Park and view Fall Creek Falls. There is no official viewing area, but user-created paths lead to the edge of the cliff. Anglers usually approach the falls by boat. Beyond the falls there are two more small turnouts, and one unsigned spur road that can be used for parking. After viewing the falls, continue southeast on Road 058, identified as "Snake River Road" on some maps.

At mile 2.4, Falls Campground and Picnic Area is on the left.

Beyond the campground, Road 058 crosses a mixture of private property and public lands. Stay on the main road.

At mile 4.8, Squaw Creek 4WD road is on the right.

At mile 6.2, Indian Creek Road is on the right (a rough 4WD spur road).

At mile 7, Long Gulch Road 059 leads to Camp Ta-man-a-Wis Boy Scout Camp.

At mile 12, Camp Little Lemhi, another Boy Scout Camp, is signed.

GPS: 43° 20.971' N • 111° 13.990' W
Mile 12.9 • Elevation: 5,466 ft.

Bear right (southwest, uphill) to stay on Road 058 at this junction with Road 277 (not numbered on maps). Road 277 provides access to the river near the dam.

At mile 14, Russell Creek Trail 037 is on the right and is open to foot, horse and motorcycle travel.

At about mile 14.4, Calamity Point ATV trails and loop roads begin. Calamity Summer Home Area is near the northern end of Palisades Reservoir.

At mile 15.1 Tag Alder Trail 279 is on the right.

At mile 15.4 is the southern end of loop roads/ATV trails on Calamity Point.

GPS: 43° 19.739' N • 111° 13.281' W
Mile 15.6 • Elevation: 5,953 ft.

Turn right (south) at a "T" intersection to stay on Road 058 at this junction with Road 076 to Calamity Campground and Highway 26 (Road 076 crosses the river via Palisades Dam). On some maps Road 058 is now named Bear Creek Road.

At mile 18.3 is the Snake River Boat Club special-permit boat ramp. Additional private property and driveways in this area complicate driving around blind corners.

At mile 20.7 is a gaging station. Nearby Road 281 (not shown on maps) leads to informal camping on an arm of the reservoir.

At mile 21.3 is Bear Creek Campground on the right (west); bear left to stay on the main road, which is rougher, narrower and rocky—4WD-recommended from here on. Beyond the Bear Creek Campground entrance, Road 058 is named Elk Creek Road on some maps.

At mile 22 is the Pine Creek 045 trailhead for Landslide Creek and Reservoir.

| **GPS: 43° 15.200' N • 111° 13.748' W**
| **Mile 23.2 • Elevation: 6,016 ft.**

Bear left (southeast) to stay on Road 058 at a "Y" intersection with Road 863 (Road 063 on some maps). The left fork is signed "Elk Creek Rd." and shows the direction to McCoy Road. About 25 feet beyond this intersection, the trailhead for Trail 159 is on the left.

Option: Road 863/063 follows West Fork Elk Creek and provides access to Big Elk Mountain, 6 miles distant.

At about mile 26, Poker Peak trailhead is on the left and is restricted to hiking in summer.

| **GPS: 43° 12.596' N • 111° 12.728' W**
| **Mile 27.2 • Elevation: 7,172 ft.**

Jensen Pass (not identified on maps, but signed on the ground). This is the summit between Elk Creek and Jensen Creek. The road descends from here to follow Jensen Creek to McCoy Creek. Signs note that bow hunting season begins September 10.

At mile 32.1, Thunder Mountain Trail 002 (4WD) is on the left. Bear right to stay on the main road, now named Jensen Creek Road on some maps, but still Road 058.

| **GPS: 43° 10.576' N • 111° 09.116' W**
| **Mile 33.0 • Elevation: 5,733 ft.**

Turn right (west) at this "T" intersection where Road 058 ends. Follow McCoy Creek Road 087 to Caribou Basin (signed). The road improves considerably here. In good weather McCoy Creek Road is 2WD graded gravel. The road parallels McCoy Creek.

Option: A left turn on McCoy Creek Road leads to McCoy Creek Campground on Palisades Reservoir, to Highway 26, and to the small town of Alpine (with access further northeast to Jackson, Wyoming).

At mile 35.2, Fish Creek Trail 005 is on the left (south).

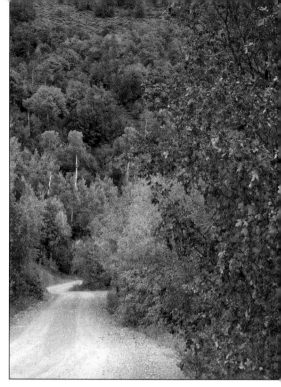

Backcountry roads in the Caribou Range offer one of Idaho's best fall color tours. Mountain maples, rare in Idaho, add their candy-apple red to the scene.

At mile 36.6, Canyon Creek Trail 003 is on the right (north).

At mile 38.5, Bald Mountain Trail 109 is on the left (south).

At mile 38.8, Bald Mountain Guard Station is signed.

| **GPS: 43° 08.484' N • 111° 15.762' W**
| **Mile 40.6 • Elevation: 6,420 ft.**

Turn left (south) on Road 165 (Anderson Gulch Road). The road is identified on the ground, but not on most maps, and is signed for Caribou City. This side road is narrow and steep, and soon becomes 4WD-required. When wet, the road is very slippery, and off-camber sections require an experienced driver **(4WD experience is required when wet)**. As the road climbs to Caribou City it offers the best views available of Caribou Mountain.

| **GPS: 43° 06.273' N • 111° 15.838' W**
| **Mile 44.4 • Elevation: 6,888 ft.**

Caribou City ghost town. "Cariboo" Fairchild lent his name to the area in 1870. Fairchild had previously prospected for gold in Canada's Caribou Range, hence the nickname. Early maps of the area spell it "Cariboo City." Like many mining towns, the wooden structures burned and that accounts in part for the few remains. Chinese miners arrived in Cariboo City in 1872, a sign that the easy pickings were gone.

After viewing the ghost town area, return to McCoy Creek Road and **ZERO YOUR ODOMETER**. Turn left (west) on McCoy Creek Road.

Option: Jackknife Basin Trail, and Trail Creek Trail continue higher from Caribou City. The trails were open to motorcycles and 4-wheelers when we were there.

GPS: 43° 09.138' N • 111° 19.306' W
Mile 3.9 • Elevation: 6,390 ft.

Bear left to stay on McCoy Creek Road at this junction with Brockman Road 077. Caribou Basin Guard Station is at this intersection. Signs here indicate the direction to Herman, the next landmark on our route.

Keenan City ghost town site is at about mile 5.2.

GPS: 43° 08.355' N • 111° 25.704' W
Mile 10.5 • Elevation: 6,429 ft.

Turn left (south) on Grays Lake Road and follow the eastern shore of Grays Lake National Wildlife Refuge. Stay on Grays Lake Road all the way to Highway 34.

At mile 13.1 is Willow Creek Road.

At about mile 17 the graded gravel road ends and pavement begins.

GPS: 42° 59.660' N • 111° 23.489' W
Mile 22.8 • Elevation: 6,391 ft.

Turn right (west) on Highway 34, signed for Soda Springs; left (east) is signed for Freedom, Wyoming. Drive just 1.1 miles west on Highway 34, watching for a sign on the left (south) for Wayan Loop.

At mile 23.9 turn left (south) on Wayan Loop to access Gravel Creek Campground (signed at the turn as 5.2 miles distant). This road is paved.

At mile 26.6 turn left, on Henrys Cutoff Road (also identified as part of Wayan Loop on some maps), drive just 0.3 mile to Gravel Creek Road.

At mile 26.9, turn right (south) on Gravel Creek Road. This road is not paved but is in excellent 2WD condition. Follow Gravel Creek Road to Gravel Creek Campground. You are back on National Forest land, in Grays Range.

GPS: 42° 56.209' N • 111° 22.755' W
Mile 28.6 • Elevation: 6,630 ft.

End this expedition at Gravel Creek Campground, which is open May–October. This is the closest campground to the southern end of Grays Lake, and the only place to stay if you want more opportunities to view wildlife at the lake. To get back to civilization, see the four options below..

Option 1: Return to Highway 34 and drive east to visit the Grays Lake National Wildlife Refuge headquarters in Wayan. From Wayan, roads lead south into Grays Range if you want to do some more exploring. There is a campground in Mill Canyon. You can also continue east on Highway 34 to Highway 89 in Wyoming.

Option 2: The closest full-service town is Soda Springs. Return to Highway 34 and drive west along the shore of the lake. Stay on Highway 34 as it turns sharply south to Blackfoot Reservoir and Soda Springs (about 34 miles to Soda Springs). Along the way, the almost-doesn't-exist town of Henry is signed "Historic Henrys Store…established 1892. W. Jim Chester."

Option 3: See Option 2, then continue south from Soda Springs on Highway 30 to Montpelier, traveling a section of the Oregon Trail–Bear Lake Scenic Byway.

Option 4: See Option 2, then continue west from Soda Springs on Highway 30 to the town of McCammon and Interstate-15. This is also a section of the Oregon Trail–Bear Lake Scenic Byway.

Next page: *Grays Lake National Wildlife Refuge. The marsh is famous for its sandhill cranes and hosts the largest nesting population in the world.*

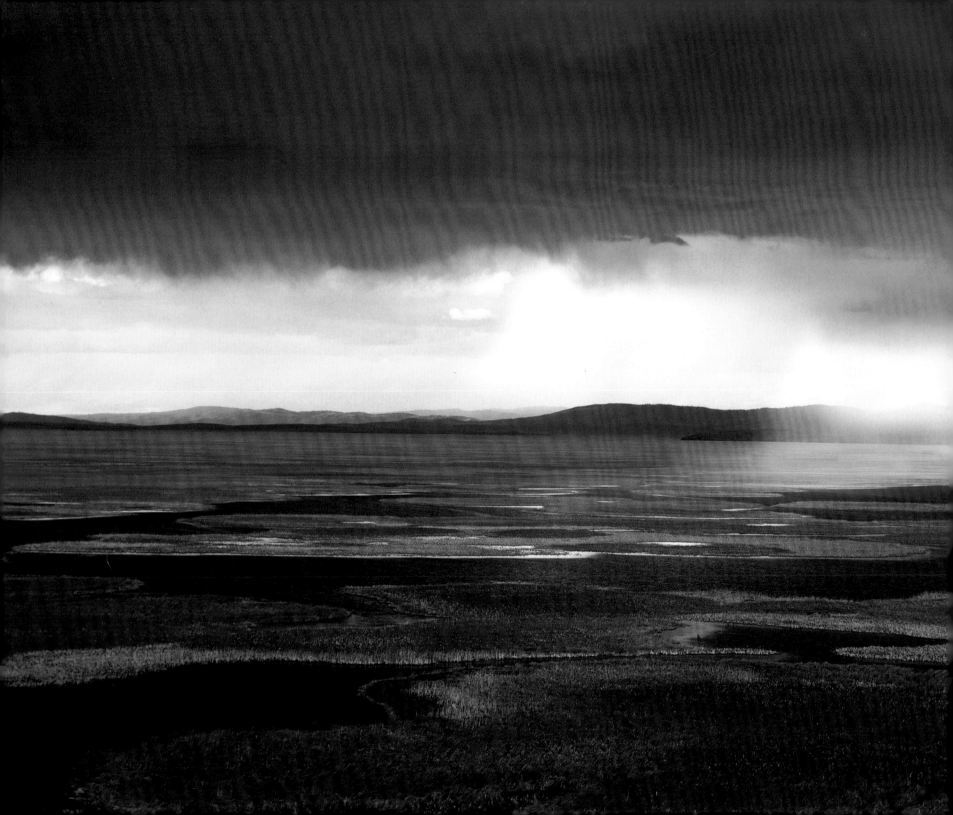

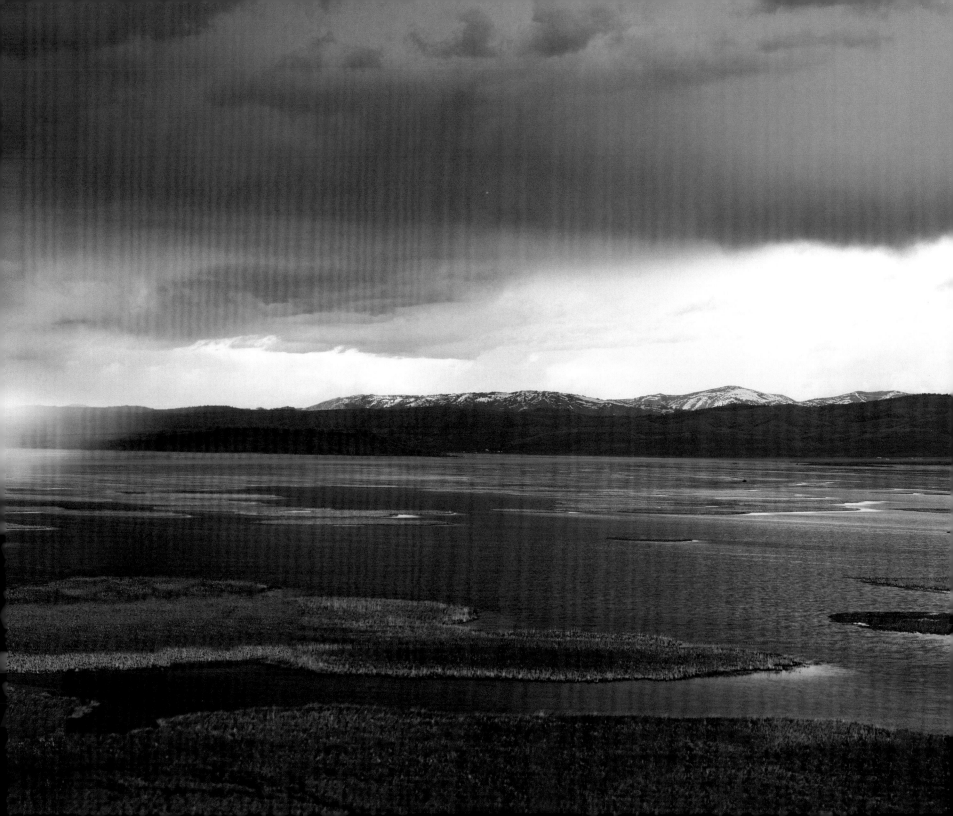

Appendix A *Resources for Additional Information*

■ NATIONAL FORESTS

Boise National Forest
1249 S. Vinnell Way, Boise, ID 83709
(208) 373-4100 •*www.fs.fed.us/r4/boise*
Other Offices:
 Boise: (208) 384-3200
 Cascade: (208) 382-7400
 Emmett: (208) 365-7000
 Garden Valley: (208) 462-3241
 Idaho City: (208) 392-6681
 Lowman: (208) 259-3361
 Mountain Home: (208) 587-7961

Caribou-Targhee National Forest
1405 Hollipark Drive, Idaho Falls, ID 83401
(208) 524-7500 •*www.fs.fed.us/r4/caribou-targhee*
Other Offices:
 Ashton: (208) 652-7442
 Dubois: (208) 374-5422
 Island Park: (208) 558-7301
 Malad: (208) 766-5900
 Montpelier: (208) 847-0375
 Palisades: (208) 523-1412
 Pocatello: (208) 236-7500
 Soda Springs: (208) 547-4356

Clearwater National Forest
12730 Highway 12, Orofino, ID 83544
(208) 476-4541 •*www.fs.fed.us/r1/Clearwater*
Other Offices:
 Kamiah: (208) 935-2513
 Kooskia: (208) 926-4275
 Lewiston: (208) 799-5010
 Moscow: (208) 882-2301
 Pierce: (208) 464-2573
 Potlatch: (208) 875-1131
 Powell: (208) 942-3113

Idaho Panhandle National Forests (Coeur d'Alene/St. Joe/Kaniksu)
3815 Schreiber Way, Coeur d'Alene, ID 83815
(208) 765-7223 •*www.fs.fed.us/ipnf*
Other Offices:
 Avery: (208) 245-4517
 Bonners Ferry: (208) 267-5561
 Clarkia: (208) 245-6068
 Priest Lake: (208) 443-2512
 Sandpoint: (208) 263-5111
 Silverton: (208) 752-1221
 St. Maries: (208) 245-2531

Kootenai/Kaniksu National Forests
1101 U.S. Highway 2 West, Libby, MT 59923
(406) 293-6211 •*www.fs.fed.us/r1/kootenai*

Lolo National Forest
Building 24, Fort Missoula, Missoula, MT 59804
(406) 329-3750 •*www.fs.fed.us/r1/lolo/*
Lolo Pass Visitor Center:
Highway 12, Lolo, MT 59847
(208) 942-1234 •*visitmt.com*

Nez Perce National Forest
Route 2, Box 475 • 1005 Highway 13
Grangeville, ID 83530
(208) 983-1950 •*www.fs.fed.us/r1/nezperce*
Other Offices:
 Elk City: (208) 842-2245
 Kooskia: (208) 926-4258
 Salmon River District: (208) 839-2328
 White Bird: (208) 839-2211

Payette National Forest
800 W. Lakeside Avenue, McCall, ID 83638
(208) 634-0700 •*www.fs.fed.us/r4/payette*
Other Offices:
 Council: (208) 253-0100
 New Meadows: (208) 347-0300
 Weiser: (208) 549-0200

Salmon-Challis National Forest
1206 S. Challis Street, Salmon, ID 83467
(208) 756-5100 •*www.fs.fed.us/r4/sc*
Other Offices:
 Challis/Yankee Fork: (208) 879-4100
 Leadore: (208) 768-2500
 Mackay: (208) 588-3400
 North Fork: (208) 865-2700

Sawtooth National Forest
2647 Kimberly Road East, Twin Falls, ID 83301
(208) 737-3200 •*www.fs.fed.us/r4/sawtooth/*
Other Offices:
 Burley: (208) 678-0430
 Fairfield: (208) 764-3202
 Ketchum: (208) 622-5371
 SNRA: (208) 727-5000
 Stanley: (208) 774-3000

Wallowa-Whitman National Forest
1550 Dewey Avenue, Baker City, OR 97814
(541) 523-6391 •*www.fs.fed.us/r6/w-w/*
Hells Canyon NRA: *www.fs.fed.us/hellscanyon/*
Hells Canyon info: (509) 758-0616
Non-commercial float permits: (509) 758-1917
Non-commercial powerboat permits: (509) 758-0270

■ BUREAU OF LAND MANAGEMENT *(www.id.blm.gov)*

Boise: (208) 384-3300
Bruneau: (208) 384-3300
Burley: (208) 677-6600
Challis: (208) 879-6200
Coeur d'Alene: (208) 769-5000
Cottonwood: (208) 962-3245
Four Rivers: (208) 384-3300
Idaho Falls: (208) 524-7500

Jarbidge: (208) 736-2350
Owyhee: (208) 896-5912
Pocatello: (208) 478-6340
Salmon: (208) 756-5400
Shoshone: (208) 732-7200
Snake Rivers Birds of Prey: (208) 384-3300
Twin Falls: (208) 735-2060
Upper Snake: (208) 524-7500

■ U.S. FISH AND WILDLIFE SERVICE

Grays Lake NWR
74 Grays Lake Rd., Wayan, ID 83285
www.npwrc.usgs.gov/grayslk

Southeast Idaho NWR Complex
4425 Burley Drive, Suite A
Chubbuck, ID 83202
(208) 237-6615

Others:
Bear Lake NWR: (208) 847-1757
Camas NWR: (208) 662-5423
Minidoka NWR: (208) 436-3589
Oxford Slough: (208) 847-1757

■ BUREAU OF RECLAMATION

Hydromet data (river flow information)
www.usbr.gov/pn/hydromet/index.html

■ IDAHO FISH AND GAME

600 S. Walnut, Boise, ID 83712
(208) 334-3700 •*fishandgame.idaho.gov*

Clearwater Region
3316 16th St., Lewiston, ID 83501
(208) 799-5010

Magic Valley Region
319 South 417 East, Jerome, ID 83338
(208) 324-4359

McCall Subregion
555 Deinhard Lane, McCall, ID 83638
(208) 634-8137

Panhandle Region
2885 W. Kathleen Ave., Coeur d'Alene, ID 83815
(208) 769-1414

Salmon Region
99 Hwy. 93 N., Salmon, ID 83467
(208) 756-2271

Southeast Region
1345 Barton Rd., Pocatello, ID 83204
(208) 232-4703

Southwest Region
3101 S. Powerline Rd., Nampa ID 83686
(208) 465-8465

Upper Snake Region
4279 Commerce Circle, Idaho Falls, ID 83401
(208) 525-7290

■ IDAHO PARKS AND RECREATION
www.idahoparks.org
www.parksandrecreation.idaho.gov

Bear Lake State Park
(208) 847-1045 •*www.bearlake.org*

Bruneau Dunes State Park
27608 Sand Dunes Rd., Mountain Home, ID 83647
(208) 366-7919

Castle Rocks State Park
P.O. Box 169, Almo, ID 83312
(208) 824-5519

City of Rocks National Reserve
P.O. Box 169, Almo, ID 83312
(208) 824-5519 •*www.nps.gov/ciro*

Dworshak State Park
Box 2028, Orofino, ID 83544
(208) 476-5994 •(866) 634-3246

Harriman State Park
3489 Green Canyon Rd., Island Park, ID 83429
(208) 558-7368 •*www.idahoparks.org*

Old Mission State Park
Trail of the Coeur d'Alenes, Box 30, Cataldo, ID 83810
(208) 682-3814 •(208) 686-7045
friendsofcdatrails.org/CdA_Trail

Priest Lake State Park
314 Indian Creek Park Rd., Coolin, ID 83821
(208) 443-2200 •(866) 634-3246
www.idahoparks.org/parks/priestlake.aspx

Thousand Springs Park
(208) 837-4505 •*www.idahoparks.org*

Twin Falls County Parks & Recreation
(208) 734-9491 •*www.twinfallscounty.org*

■ NATIONAL PARK SERVICE
The NPS manages, in conjunction with the BLM, other public lands, and not just national parks.

California National Historic Trail
324 South State St., Suite 200, Box 30
Salt Lake City, UT 84111
(801) 741-1012 ext. 119 or 116 •*www.nps.gov/cali*

Craters of the Moon National Monument
P.O. Box 29, Arco, ID 83213
(208) 527-3257 •(208) 732-7200
www.nps.gov/archive/crmo/wildpurpose.htm

Hagerman Fossil Beds National Monument
P.O. Box 570, Hagerman, ID 83332
(208) 837-4793 ext. 5227 •*www.nps.gov/hafo*

Lewis & Clark National Historic Trail
601 Riverfront Drive, Omaha, NE 68102
(402) 661-1804

Minidoka Internment National Monument
P.O. Box 570, Hagerman, ID 83332
(208) 837-4793 ext. 5227 •*www.nps.gov/miin*

National Oregon-California Trail Center
Montpelier, Idaho •(866) 847-3800
www.oregontrailcenter.org

Nez Perce National Historic Park
39063 U.S. Hwy. 95, Spalding, ID 83540
(208) 843-7001 •*www.nps.gov/nepe*

Oregon National Historic Trail
324 S. State St., Suite 200, Salt Lake City, UT 84111
(801) 741-1012 ext. 119 or 116 •*www.nps.gov/oreg*

■ GENERAL INFORMATION

Official Idaho Travel and Tourism Guide
Division of Tourism Development
700 West State St., Boise, ID 83720
(208) 334-2470 •*www.visitidaho.org*

Idaho Department of Lands
www.idl.idaho.gov

Idaho Department of Water Resources
322 E. Front St., Boise, ID 83720-0098
(208) 287-4800 •*www.idwr.state.id.us*

Idaho Outfitters & Guides Association (IOGA)
P.O. Box 95, Boise, ID 83701
(208) 342-1438 •*www.ioga.org/*

Idaho Scenic, Historic and Back Country Byways
itd.idaho.gov/Byways

Idaho Transportation Department
Division of Highways, Road Reports
(888) 432-7623 •*511.idaho.gov*

Leave No Trace Center for Outdoor Ethics
P.O. Box 997, Boulder, CO 80306
(303) 442-8222 or (800) 332-4100 •*www.lnt.org*

Tread Lightly! Inc.
298 24th St., Suite 325, Ogden, UT 84401
(801) 627-0077 •(800) 966-9900
www.treadlightly.org

FLY IDAHO! **Q.E.I. Publishing, Inc.**
Box 1236, Hailey, ID 83333
(208) 788-5176 •(800) 574-9702
www.flyidaho.com

Northwest Youth Corps
2621 Augusta St., Eugene, OR 97403
(541) 349-5055 •*www.nwyouthcorps.org/*

National Interagency Fire Center
Boise, ID •(208) 387-5050
geomac.usgs.gov/ •*www.nifc.gov/nicc/*

■ SNOW SAFETY

Many backcountry roads in Idaho become snowmobile or cross-country ski trails in the winter. Check snow conditions and avalanche danger before you go.

Avalanche Safety and Avalanche Conditions
www.avalanche-center.org/

Cyberspace Snow & Avalanche Center
www.csac.org

Island Park and West Yellowstone Snow and Avalanche Information
islandparksnow.net/

NOAA Weather Forecasts, Warnings, and Advisories
www.weather.gov/view/states.php?state=id&map=on

Panhandle Backcountry Avalanche Conditions
www.fs.fed.us/ipnf/visit/conditions/backcountry/

Sun Valley Area Avalanche Bulletin
www.avalanche-center.org/Bulletins/Idaho/avalanche.php
(208) 788-1200 ext. 8027

Peaks over 12,000 feet are bunched like a stone fist in the Lost River Range (Expedition 21).

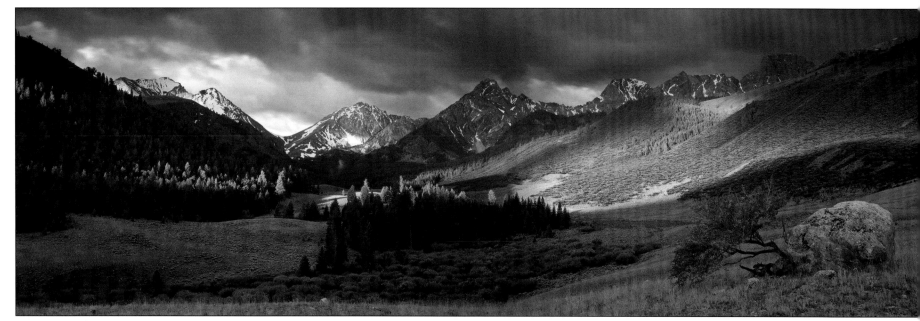

Appendix B Map Sources

NATIONAL GEOGRAPHIC MAPS
Maps in this book were created with TOPO! software
© 2007 National Geographic Maps (*www.topo.com*).

To order mapping software online:
natgeomaps.com

U.S. FOREST SERVICE
Forest Service maps are available at most of the offices
located in Idaho. See Appendix A for locations and
contact information, and to order maps by phone.

To order maps online:
www.fs.fed.us/recreation/nationalforeststore/

Palisades and Teton Basin area (eastern Idaho) maps
may be downloaded from:
*www.fs.fed.us/r4/caribou-targhee/caribou-targhee/
palisades/maps*

U.S. GEOLOGICAL SURVEY (*www.usgs.gov*)
To order maps online: *store.usgs.gov*

You can also query and view maps at:
edcsns17.cr.usgs.gov/EarthExplorer

Call for more information: 1-(888) ASK-USGS

BENCHMARK MAPS
34 North Central Ave., Medford, OR 97501
(541) 772-6965 •*www.benchmarkmaps.com*
Author's note: These maps have particularly clear and
easy-to-read topographical and road features.

BUREAU OF LAND MANAGEMENT
BLM maps are sometimes for sale at district and field
offices listed in Appendix A. You can also get maps
online or by phone from the Map Center at the Public
Lands Information Center.

To order online: *plicmapcenter.org/ID/*

To order by phone: (877) 851-8946

The BLM Public Room in Boise is located at
1387 South Vinnell Way. To order maps by phone:
(208) 373-3889.

DeLORME MAPPING
Idaho Atlas and Gazetteer
(800) 561-5105 •*shop.delorme.com*
The *Idaho Atlas and Gazetteer* is available at many retail
outlets and book stores across Idaho.

BACKCOUNTRY AIRSTRIP INFORMATION
FLY IDAHO!
Q.E.I. Publishing, Inc., Box 1236, Hailey, ID 83333
(208) 788-5176 •(800) 574-9702 •*www.flyidaho.com*

GPS WAYPOINTS
For GPS info and answers to frequently-asked questions:
www.gpswaypoints.co.za/FAQ_basic.htm

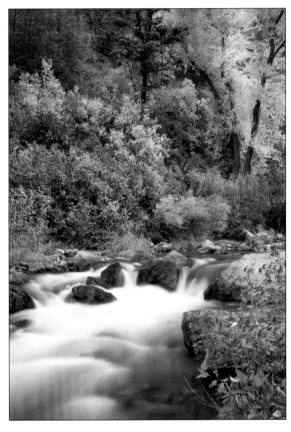

*Palisades Creek is one of many streams that feed
Palisades Reservoir. Expedition 31 explores the
Caribou Range west and south of the reservoir.*

The Shipman Point Trail in Expedition 3 winds its way through old growth forest on its way to Nell Shipman Point on Priest Lake.